Cambridge Companions to Culture

The Cambridge Companion to Modern German Culture
edited by EVA KOLINSKY *and* WILFRIED VAN DER WILL

The Cambridge Companion to Modern Russian Culture
edited by NICHOLAS RZHEVSKY

The Cambridge Companion to Modern Spanish Culture
edited by DAVID T. GIES

The Cambridge Companion to
Modern Spanish Culture

edited by
DAVID T. GIES

PUBLISHED BY THE PRESS SYNDICATE OF THE UNIVERSITY OF CAMBRIDGE
The Pitt Building, Trumpington Street, Cambridge, United Kingdom

CAMBRIDGE UNIVERSITY PRESS
The Edinburgh Building, Cambridge CB2 2RU, UK http://www.cup.cam.ac.uk
40 West 20th Street, New York, NY 10011–4211, USA http://www.cup.org
10 Stamford Road, Oakleigh, Melbourne 3166, Australia
Ruiz de Alarcón 13, 28014 Madrid, Spain

First published 1999
Reprinted 2000

Printed in the United Kingdom at the University Press, Cambridge

Typeset in 9/13 pt Lexicon (The Enschedé Font Foundry), in QuarkXPress® [SE]

A catalogue record for this book is available from the British Library

Library of Congress Cataloguing in Publication data
The Cambridge Companion to modern Spanish culture / edited by David T. Gies.
 p. cm.
Includes index.
ISBN 0 521 57408 0 (hardback)
ISBN 0 521 57429 3 (paperback)
1. Spain – Civilization – 20th century.
2. Spain – Civilization – 19th century.
3. Arts, Spanish.
4. Arts, Modern – 20th century – Spain.
5. Arts, Modern – 19th century – Spain.
I. Gies, David T., 1945– .
DP48.C233 1999 946'.07–dc21 98–35991 CIP

ISBN 0 521 57408 0 hardback
ISBN 0 521 57429 3 paperback

For JANNA

who is discovering
the complexities of
modern Spanish culture

Contents

List of illustrations xii
Notes on contributors xiii
Acknowledgements xvii
Chronology of major events xviii
Glossary xxv

Modern Spanish culture: An introduction *1*
DAVID T. GIES

I **Culture: center and periphery**

1 What does it mean to study modern Spanish culture? *11*
STEPHANIE SIEBURTH

2 Spain as Castile: Nationalism and national identity *21*
E. INMAN FOX

3 A cultural mapping of Catalonia *37*
TERESA M. VILARÓS

4 The Basque Country *54*
PHILIP W. SILVER

II **Culture and history**

5 History, politics, and culture, 1875–1936 *67*
JOSÉ ÁLVAREZ JUNCO

6 History, politics, and culture, 1936–1975 *86*
CAROLYN P. BOYD

7 History, politics, and culture, 1975–1996 *104*
SANTOS JULIÁ

III Culture and prose

8 Narrative in culture, 1868–1936 *123*
ROBERTA JOHNSON

9 Narrative in culture, 1936–1975 *134*
RANDOLPH D. POPE

10 Narrative in culture, 1975–1996 *147*
JO LABANYI

11 Culture and the essay in modern Spain *163*
THOMAS MERMALL

IV Culture and poetry

12 Poetry and culture, 1868–1936 *175*
RICHARD A. CARDWELL

13 Poetry and culture, 1936–1975 *187*
ANDREW P. DEBICKI

14 Poetry and culture, 1975–1996 *198*
CHRIS G. PERRIAM

V Culture and theater

15 Theater and culture, 1868–1936 *211*
DRU DOUGHERTY

16 Theater and culture, 1936–1996 *222*
PHYLLIS ZATLIN

VI Culture and the arts

17 Painting and sculpture in modern Spain *239*
JOSÉ MARTÍN MARTÍNEZ

18 Culture and cinema to 1975 *248*
KATHLEEN M. VERNON

19 Culture and cinema, 1975–1996 *267*
PETER W. EVANS

20 A century of Spanish architecture *278*
LUIS FERNÁNDEZ-GALIANO

21 Spanish music and cultural identity *287*
ROGER D. TINNELL

22 To live is to dance *298*
LAURA KUMIN

VII **Media**

23 The media in modern Spanish culture *309*
PHILIP DEACON

Index 318

Illustrations

1 Pablo Picasso, *Before* (1900) (the Yoshii Gallery, New York, Artists' Rights Society, New York) *xxx*

2 Pablo Picasso, *After* (1900) (the Yoshii Gallery, New York, Artists' Rights Society, New York) *xxxi*

3 Spanish Autonomous Regions (Tourist Office of Spain, New York) *13*

4 Ignacio Zuloaga, *The Mayor of Torquemada* (Paris, Musée Rodin; photo by Adam Rzepka) *23*

5 *España*, Civil War poster (Abraham Lincoln Brigade Archives, Brandeis University) *88*

6 The Spanish Royal Family (photo *El País*) *106*

7 Francisco Franco (Foto Oronoz, Madrid) *136*

8 Title page, *Nueve novísimos poetas españoles*, ed. J. M. Castellet *189*

9 Poster for García Lorca's *Yerma* (Fundación García Lorca, Madrid) *213*

10 Program cover for Buero Vallejo's *La doble historia del Dr. Valmy* *233*

11 Still from Berlanga's *Bienvenido, Mr. Marshall* (Filmoteca Española, Madrid) *250*

12 Interior of Rafael Moneo's Museo de Arte Romano in Mérida (photo by Lluis Casals, Barcelona) *285*

13 Compañía Nacional de Danza (photo by Paco Ruiz, Madrid) *300*

Notes on contributors

JOSÉ ÁLVAREZ JUNCO is Prince of Asturias Professor of Spanish History at Tufts University. His main publications include *La ideología política del anarquismo español* and *El emperador del paralelo*. His current research deals with cultural and social aspects of Spanish political life in the late nineteenth and early twentieth centuries, with special emphasis on nation-building processes.

CAROLYN P. BOYD is Professor and Chair of the History Department at the University of Texas at Austin. She is the author of *Praetorian Politics in Liberal Spain* and *Historia Patria: Politics, History, and National Identity in Spain, 1875–1975*.

RICHARD A. CARDWELL is Professor of Modern Hispanic Literature at the University of Nottingham, and Member of the Real Academia Sevillana de Buenas Letras. His studies are concerned with the history of ideas and comparative and post-structuralist theories applied to the lyric from romanticism to the Civil War.

PHILIP DEACON teaches Hispanic Studies at the University of Sheffield. His published research centers on culture and ideology in eighteenth- and twentieth-century Spain, principally in the fields of censorship, drama, and the media. His edition of Moratín's play *El sí de las niñas* appeared in 1995.

ANDREW P. DEBICKI is Dean of the Graduate School and International Programs and University Distinguished Professor of Spanish at the University of Kansas. He has held various fellowships (American Council for Learned Societies, National Endowment for the Humanities, National Humanities Center, Guggenheim); he has published seven books of criticism about Hispanic poetry, as well as numerous articles and several edited volumes.

DRU DOUGHERTY is Professor of Spanish at the University of California, Berkeley. He is the author of *Un Valle-Inclán olvidado*, *Valle-Inclán y la*

Segunda República, and (with Francisca Vilches) *La escena madrileña entre 1918 y 1926, El teatro en España entre la tradición y la vanguardia*, and *La escena madrileña entre 1926 y 1931*.

PETER W. EVANS is Professor of Hispanic Studies at Queen Mary and Westfield College, University of London. He is the author of *Women on the Verge of a Nervous Breakdown*, *The Films of Luis Buñuel: Subjectivity and Desire*, and the co-author (with Bruce Babington) of *Blue Skies and Silver Linings: Aspects of the Hollywood Musical*, *Affairs to Remember: The Hollywood Comedy of the Sexes*, and *Biblical Epics: Sacred Narrative in the Hollywood Cinema*.

LUIS FERNÁNDEZ-GALIANO is an architect, professor at Madrid's School of Architecture, and editor of the journals *Arquitectura Viva* and *AV Monographs*. Author of several books – among them *La quimera moderna* and *El fuego y la memoria* – he writes on architecture for *El País*, and has lectured extensively in Europe and America. He has been Cullinan Professor at Rice University, and a visiting scholar and critic at the Getty Center in Los Angeles, Princeton University, Harvard University, and the Berlage Institute of Amsterdam. In 1997 he was inducted into the Real Academia de Doctores.

E. INMAN FOX is Professor of Hispanic Studies at Northwestern University. Recipient of Spain's Orden de Isabel la Católica and the Fine Arts Gold Medal, he has authored *Ideología y política en las letras de fin de siglo* and *La invención de España. Nacionalismo liberal e identidad nacional*, among many other studies on contemporary literature and thought.

DAVID T. GIES is Commonwealth Professor of Spanish at the University of Virginia. He has written or edited twelve books and more than 175 articles and book reviews, and is the editor of the journal *Dieciocho*. His latest publications are *The Theatre in Nineteenth-Century Spain* (also translated into Spanish), an edition of the works of Moratín the Elder, and *Negotiating Past and Present*, an homage volume for Javier S. Herrero.

ROBERTA JOHNSON is Professor of Spanish and Director of the Hall Center for the Humanities at the University of Kansas. She has published books on Carmen Laforet, Gabriel Miró, and Azorín's libraries. She is also the author of *Crossfire: Philosophy and the Novel in Spain, 1900–1934*. Her research has been supported by the National Endowment for the Humanities and the Guggenheim Foundation.

SANTOS JULIÁ is Professor of the History of Political Thought and Director of the Department of Social History and Political Thought at the Universidad Nacional de Educación a Distancia in Madrid, Spain. His most recent books include *Manuel Azaña, una biografía política, Madrid, historia de una capital*, and *Los socialistas en la política española, 1879–1982*.

LAURA KUMIN, a former contemporary Spanish dancer, is a writer, dance educator, and arts administrator based in Madrid. Co-founder and director of the Certamen Coreográfico de Madrid, a national showcase for new work in contemporary dance and ballet, she created the Madrid Regional Arts Council's dance department in 1989, and directed it until 1996.

JO LABANYI is Professor of Modern Spanish Literature and Cultural Studies at Birkbeck College and Director of the Institute of Romance Studies, University of London. She has published various books on nineteenth-century and contemporary Spanish fiction, has co-edited *Spanish Cultural Studies: An Introduction*, and is currently completing *The Politics of the Family in the Spanish Realist Novel* and a book on 1940s Spanish cinema.

JOSÉ MARTÍN MARTÍNEZ is Associate Professor of Contemporary Art at the University of Valencia, Spain. He has published several studies on the sculptor Andreu Alfaro, as well as articles and contributions to catalogues of art exhibits.

THOMAS MERMALL is Professor of Spanish at Brooklyn College and the Graduate School of the City University of New York. He is the author of the first Spanish critical edition of José Ortega y Gasset's *La rebelión de las masas, Las alegorías del poder en Francisco Ayala*, and *La retórica del humanismo: la cultura española después de Ortega*.

CHRIS G. PERRIAM is Professor of Hispanic Studies at the University of Newcastle, England. He has written on Francisco Brines, Ana Rossetti, and Luis Antonio de Villena (*Desire and Dissent. An Introduction to Luis Antonio de Villena*).

RANDOLPH D. POPE is Professor of Spanish and Comparative Literature at Washington University in St. Louis, and the main editor of the *Revista de Estudios Hispánicos*. He is the author of *La autobiografía española hasta Torres Villarroel, Novela de emergencia: España, 1939–1954*, and *Understanding Juan Goytisolo*.

STEPHANIE SIEBURTH is Associate Professor of Romance Studies and Women's Studies at Duke University. Her publications include *Reading La Regenta* and *Inventing High and Low: Literature, Mass Culture, and Uneven Modernity in Spain*.

PHILIP W. SILVER is Professor of Spanish at Columbia University. He is the author of numerous studies on contemporary Spanish literature and culture, including *Ortega as Phenomenologist: The Genesis of Meditations on Quixote, Nacionalismos y transición: Euskadi, Catalunya, España*, and *Ruin and Restitution: Reinterpreting Romanticism in Spain*.

ROGER D. TINNELL is Professor of Spanish and Chair of Foreign Languages at Plymouth State College. He is the author of *An Annotated*

Discography of Music in Spain before 1650, Federico García Lorca y la música: Catálogo y discografía anotados and *Catálogo anotado de música española basada en literatura española*, among other publications.

KATHLEEN M. VERNON is Associate Professor of Hispanic Languages and Literature and Director of the Latin American and Caribbean Studies Center at the State University of New York at Stony Brook. She is the author of numerous studies on Spanish cinema. Her study of Spanish women directors, *Out of the Shadows: Women's Cinema in Spain, 1935–1996*, is forthcoming from Greenwood Press.

TERESA M. VILARÓS is Associate Professor at Duke University where she teaches Spanish Cultural Studies. Her publications include *El mono del desencanto: Una crítica cultural de la transición española (1973–1993)* and *Galdós: Invención de la mujer y poética de la sexualidad*. She is currently working on a book on post-nationalism, hybridity, and the cultures of immigration in contemporary Catalonia.

PHYLLIS ZATLIN is Professor of Spanish at Rutgers, The State University of New Jersey. She has published articles, books, editions, and translations related to contemporary Spanish theater, cross-cultural approaches to theater, and contemporary Spanish women writers. In 1997 she was given a special award from the SGAE for her work promoting Spanish theater in the United States.

Acknowledgements

It is a cliché – but none the less true for being so – that many individuals and institutions play roles in the creation of any book. While it is impossible to recognize publicly the generosity of every person involved in this *Cambridge Companion to Modern Spanish Culture*, I would be seriously remiss not to mention those friends and colleagues who helped answer queries, search for arcane details, track down copyright permissions, or provide general support during the long gestation period of this book. In addition to the authors of the individual essays, who bore with me through many months of pestering and editing and clarifying details, I am grateful to the following people for their kind and selfless contributions: María Celeste Delgado-Librero, Janna O. Gies, Dorothy "DJ" Joba, Cristina Della Coletta, Carrie Douglass, David Flores, Vanessa Guibert, Alison P. Weber, Pedro Álvarez de Miranda, Virginia Catmur, Debbie McDaniel, and Patty Decourcy.

Chronology of major events

1825–1850 Formation and development of Spain's musical theater,
including the *zarzuela*

1841 Birth of Felipe Pedrell, the most influential figure in Spain's recent
musical history

1850–1867 Publication of Modesto Lafuente's liberal historiography,
Historia general de España

1854–1888 Publication of the works of Antonio Cánovas del Castillo on the
reign of the Habsburgs and the decadence of Spain

1859 Design of the Pla Cerdà in Barcelona

1867 Birth of Manuel de Falla, Spain's most celebrated composer

1868 The September Revolution temporarily ends the Bourbon monarchy;
Queen Isabel II abdicates the throne

1871 Gustavo Adolfo Bécquer's *Rimas* appear posthumously

1873 Declaration of the First Republic

1875 Restoration of the Bourbon monarchy under Alfonso XII;
Núñez de Arce publishes *Gritos de combate*

1876 Founding of the Institución Libre de Enseñanza

1882 Publication of Ernest Renan's "Qu'est-ce qu'une nation?"

1883 Publication of *La cuestión palpitante* by Emilia Pardo Bazán

1884 Publication of *La Regenta*, by Leopoldo Alas ("Clarín")

1885 Alfonso XII dies at the age of twenty-eight

1886–1887 Publication of *Fortunata y Jacinta*, by Benito Pérez Galdós

1890 1 May: First May Day celebration

1892 Sabino Arana Goiri publishes *Bizcaya por su independencia*; plan for the
Ciudad Lineal in Madrid by the architect Arturo Soria; terrorist
attempt against General Martínez Campos in Barcelona

1894 Basque Nationalist Party formed; Jacinto Benavente premières his
play, *El nido ajeno*; Angel Pericet Carmona, patriarch of several
generations of distinguished dancers, choreographers, and teachers,
opens his first dance academy in Seville

1895 Publication of *En torno al casticismo*, by Miguel de Unamuno;
 beginning of the war in Cuba
1896 The publication of Rubén Darío's *Prosas profanas* and *Los raros* attracts
 wide attention in poetry circles; first cinema program shown in
 Madrid and Barcelona; first Spanish film shot by A. Promio Jimeno
1897 Angel Ganivet publishes *Idearium español*; Prime Minister Antonio
 Cánovas del Castillo assassinated
1898 Defeat in the colonial wars as symbolic of the "Problem of Spain";
 Adrià Gral founds the Teatre Intim, an amateur group devoted to
 "artistic theater" in Barcelona; Ganivet commits suicide in Helsinki
1899–1911 Publication of Rafael Altamira's *Historia de España y de la civilización
 española*
1901 The première of Benito Pérez Galdós's *Electra* is a political sensation in
 Madrid
1902 Accession to the throne of King Alfonso XIII; several important books
 appear: Manuel Machado's *Alma*, Juan Ramón Jiménez's *Arias tristes*,
 Miguel de Unamuno's *Amor y pedagogía*, Azorín's *La voluntad*, Ramón
 María del Valle-Inclán's *Sonata de otoño*, and Baroja's *Camino de perfección*
1903 Publication of Antonio Machado's *Soledades*
1904 José Echegaray wins the Nobel Prize for Literature
1906 31 May: King Alfonso XIII marries Victoria Eugenia of Battenberg,
 grand-daughter of Queen Victoria of England; failed anarchist
 attempt on the lives of the royal couple
1907 Picasso paints *Les Demoiselles d'Avignon*, which initiates the Cubist
 revolution in painting
1908 Publication of *El Greco* by M. B. Cossío
1909 Hispano Films builds first film studio in Spain
1909 26 July: Beginning of "Tragic Week" repressions in Barcelona
1910 The Centro de Estudios Históricos is founded by the government;
 publication of Ramón Menéndez Pidal's *La epopeya castellana a través de
 la literatura española*; publication of the first "Clásicos Castellanos"
1912–1915 Publication of essays by Azorín, collected as *Lecturas españolas*,
 Clásicos y modernos, *Los valores literarios*, and *Al margen de los clásicos*
1914 Publication of *Meditaciones del Quijote*, by José Ortega y Gasset; Antoni
 Gaudí creates the Parque Güell in Barcelona
1914–1918 Spain remains officially neutral in the First World War, but
 divides loyalties between Allies and Germans
1915 *El amor brujo*, Manuel de Falla's first flamenco ballet, premières at the
 Teatro Lara in Madrid with Pastora Imperio in the lead role
1916 Juan Ramón Jiménez publishes *Diario de un poeta recién casado*
1917 General strikes against government lead to political crisis; Gregorio
 Martínez Sierra opens the Teatro de Arte in Madrid's Teatro Eslava;
 Antonio Machado publishes an enlarged edition of *Campos de Castilla*

1920 Ramón del Valle-Inclán publishes *Luces de bohemia* in the political
 review *España*
1921 Publication of *La España invertebrada*, by José Ortega y Gasset; Federico
 García Lorca publishes *Libro de poemas*; new outbreak of the Moroccan
 War results in massive slaughter of Spanish troops
1922 Celebration in Granada of the Concurso de Cante Jondo, an event
 which helped to restore the prestige of Spain's gypsy music; Jacinto
 Benavente is awarded the Nobel Prize for Literature
1923 Military coup d'etat led by General José Miguel Primo de Rivera
 abolishes the 1876 constitution and initiates a seven-year dictatorship;
 first regular radio programs broadcast from Madrid's Radio Ibérica
1925 Ortega publishes *La deshumanización del arte*, marking an important
 moment in the history of vanguard art
1926 The experimental theater group El Mirlo Blanco, directed by Cipriano
 de Rivas Cherif, is founded in Madrid
1928 Ernesto Giménez Caballero founds the Cine-Club España; Antonia
 Mercé, the incomparable "La Argentina," presents her Ballets
 Espagnols de La Argentina, the first repertory Spanish dance
 company, in Paris
1929 The "talkies" arrive in Madrid; the Teatro Apolo – "cathedral of the
 género chico" – closes; Mies van der Rohe designs the German Pavilion
 for the World Fair in Barcelona
1930 Civil uprisings culminate in the fall of Primo de Rivera
1931 General elections result in the abdication of Alfonso XIII and the
 proclamation of the Second Republic
1933 Federico García Lorca's first commercial hit, *Bodas de sangre*, premières
 in Buenos Aires
1934 5 October: Revolutionary uprisings in Catalonia and Asturias
1935 Sound technology for film established in Spain
1936 Eduardo Torroja designs the Zarzuela racetrack in Madrid
1936 17 July: An insurrection begun in Morocco against the Republican
 government initiates the Spanish Civil War
1936 29 September: General Francisco Franco is named General-in-Chief
 and Chief of State in the Nationalist zone
1936–1939 During the Spanish Civil War Luis Buñuel directs films for the
 Republican side; Benito Perojo and Florián Rey direct musical
 features in Berlin
1937 The Spanish Pavilion, designed by Josep Lluís Sert, opens in Paris
1937 17 April: Unification of FET y de las JONS
1938 Wartime press law initiates subservience of all publications to
 Francoist ideology, imposing censorship and strict control; the
 Supreme Board of Film Censorship created

1939 1 April: Victory of the nationalists; end of the Civil War, beginning of the Franco regime

1940s–1950s Age of the *copla* and the *canción ligera*; beginning of several important Spanish music festivals (Granada, Santander, San Sebastián)

1941 Escuela Oficial de Periodismo established to train and control journalists; obligatory dubbing into Spanish of all foreign films is mandated

1942 Camilo José Cela publishes *La familia de Pascual Duarte*; creation of the official Spanish newsreel, the Noticiario Cinematográfico Español, called the "NO-DO"; showing of the newsreel before the feature film is made compulsory in all cinemas within Spain

1944 Carmen Laforet publishes the Premio Nadal-winning novel, *Nada*; publication of Dámaso Alonso's *Hijos de la ira* and Vicente Aleixandre's *Sombras del paraíso*; first issue of *Espadaña* appears

1947 Founding of the national film school, the IIEC

1947 6 July: Referendum on the Law of Succession

1949 Première of Antonio Buero Vallejo's play, *Historia de una escalera*

1951 Cela's ground-breaking *La colmena* is published in Buenos Aires; Ministerio de Información y Turismo created, reasserting total government control of media; a week of Italian neo-realist films is shown at Madrid's Institute of Italian Cultures

1952 Publication of the *Antología consultada de la joven poesía española*

1953 Publication of Claudio Rodríguez's poetry collection, *Don de la ebriedad*; première of Alfonso Sastre's play, *Escuadra hacia la muerte*

1953 27 August: Concordat signed with the Vatican

1953 26 September: Bilateral Pact of Madrid signed with the United States

1955 Publication of Blas de Otero's *Pido la paz y la palabra*; Salamanca Conversaciones de Cine; Bardem's *Muerte de un ciclista* wins the Fipresci Prize at the Cannes Film Festival

1956 Rafael Sánchez Ferlosio publishes *El Jarama*; government-run television service (TVE) launched, adding a second channel in 1965

1957 Three important artist collectives are formed: Grupo Parpalló (Valencia), Grupo El Paso (Madrid) and Equipo 57 (Paris and Córdoba)

1958 Eduardo Chillida (sculpture) and Antoni Tapiès (painting) are awarded top prizes at the Venice Biennale

1959 ETA (Euskadi ta Askatasuna) founded

1959 21 July: Economic stabilization plan announced

1960s Spanish rock music comes of age, with a multitude of groups and stars, and the accompanying artists who write protest music (against the Franco dictatorship)

1960 Appearance of José María Castellet's anthology *Veinte años de poesía*

española; Buñuel's film *Viridiana* wins the Golden Palm Award at Cannes; two major art exhibits – "New Spanish Painting and Sculpture" at MOMA in New York and "Before Picasso, After Miró" at the Guggenheim Museum in New York – focus international attention on Spanish artists

1961 Luis Martín-Santos publishes *Tiempo de silencio*

1962 Mercè Rodoreda's novel *La plaça del Diamant* is published; première of Lauro Olmo's play *La camisa*; Els Joglars theater group founded

1964 Gabriel Aresti publishes *Harri eta herri* (Stone and [a] People)

1966 New laws of the press significantly relax the effects of censorship; first Spanish stagings of the plays of Bertold Brecht

1966 14 December: Referendum on the Organic Law of the State

1967 First annual Sitges Theater Festival

1968 Euskera Batua, the first unified standard for the Basque language, is developed by the Basque Academy; Spanish première of Weiss's play *Marat-Sade*

1969 22 July: D. Juan Carlos de Borbón designated as Franco's successor

1970 Juan Goytisolo publishes *Reivindicación del conde don Julián*; publication of José María Castellet's *Nueve novísimos poetas españoles*

1973 Víctor Erice directs *El espíritu de la colmena*; Antonio Gades presents his choreographic interpretation of García Lorca's *Bodas de sangre*

1973 20 December: Assassination of Admiral Luis Carrero Blanco by ETA militants

1974 Carlos Saura's film *La prima Angélica* is awarded the Special Jury Prize at Cannes, while in Madrid eight right-wing youths attempt to steal the film. Two months later, a bomb explosion sets fire to a cinema in Barcelona where the film is being shown

1975 Carlos Saura directs *Cría cuervos* and José Luis Borau directs *Furtivos*; Jorge de Oteiza publishes *¡Quosque tandem...! Ensayo de interpretación estética del alma vasco*; censorship rules allow nudity on stage

1975 20 November: Death of Francisco Franco and end of dictatorship

1975 22 November: Juan Carlos I proclaimed king of Spain

1976 Juan Marsé's novel *Si te dicen que caí* confiscated on its publication in Spain (it had been previously banned in Spain and published in Mexico); Adolfo Suárez named Primer Minister; launch of the innovative independent daily newspaper, *El País*

1977 Vicente Aleixandre wins the Nobel Prize for Literature; establishment of the Spanish Musicological Society; amendment to the 1976 Law of Political Reform formally abolishes censorship; Spanish Communist Party legalized

1977 15 June: The first general elections since February 1936 are held

1977 25 October: The Pactos de Moncloa are signed in Madrid; Law of Political Reform signed

1978 Inauguration of the Centro Dramático Nacional; creation of the Ballet Nacional de España, Spain's national dance company

1978 6 December: The Constitutional Referendum is passed by an overwhelming popular vote

1979 The Basque Autonomous Community receives its Gernika Autonomy Statute; Editorial Cátedra publishes the anthology *Joven poesía española*; Spain begins negotiations for incorporation into the European Economic Community; founding of the Ballet Nacional Clásico (later known as the Ballet del Teatro Lírico Nacional) under the direction of Víctor Ullate

1980s "La movida" (a strong new wave of pop music and culture); rise of regional and city authorities' cultural promotions

1981 Antonio Gades and Carlos Saura collaborate on a film version of *Bodas de sangre*, the first of a trilogy of joint works which includes *Carmen* and *El amor brujo*; Picasso's "exiled" painting, *Guernica*, returns to Spain from its temporary home at MOMA in New York

1981 29 January: Adolfo Suárez resigns as Prime Minister

1981 23 February: Attempted coup d'etat by Antonio Tejero and disgruntled Civil Guard troops

1982 The first annual Feria Internacional de Arte Contemporáneo, "Arco '82," takes place in Madrid; the young painter Miquel Barceló shows his work at the Dokumenta 7 in Kassel, Germany

1982 28 October: The PSOE wins the general elections; Felipe González is elected Prime Minister

1983 Regional television begins in the Basque Country

1984 Creation of the National Center for New Tendencies of the Stage; regional television begins in Catalonia

1985 Julio Llamazares publishes his first novel, *Luna de lobos*; Spain signs into the European Community

1986 Visor (Madrid) publishes the anthology *Posnovísimos*; Hiperión (Madrid) publishes a second revised edition of *Las diosas blancas: Antología de la joven poesía española escrita por mujeres*; Antonio Muñoz Molina publishes his first novel, *Beatus Ille*; the referendum ratifying Spain's incorporation into NATO is passed; the Museo de Arte Romano in Mérida created by Rafael Moneo; the modern art museum, Centro de Arte Reina Sofía, opens in Madrid

1987 Torremozas (Madrid) publishes *Panorama antológico de poetisas españolas*

1988 Three independent, commercial television companies allowed to compete with state-run RTVE

1989 Basque author Bernardo Atxaga wins the National Prize for Literature with the Spanish version of *Obabakoak*; Camilo José Cela wins the Nobel Prize for Literature; in Valencia the Instituto Valenciano de Arte Moderno opens

1990 Alvaro Pombo publishes his major novel, *El metro de platino iradiado*;
 Nacho Duato is invited to head the Compañía Nacional de Danza

1992 Spain hosts the Olympic Games (Barcelona), the International Expo
 (Seville), and the Cultural Capital of Europe (Madrid); Visor publishes
 the anthology *Fin de siglo*

1995 The National Literary Prize first awarded to a novel in Catalan (Carme
 Riera's *Dins el darrer blau*)

1996 The PP wins the general elections, replacing the PSOE; José María
 Aznar is elected Prime Minister; Editorial Crítica (Barcelona)
 publishes *La nueva poesía (1975-1992)*; Antonio Muñoz Molina elected to
 the Spanish Real Academia

1997 October: Inauguration of Frank O. Gehry's Bilbao Guggenheim
 Museum; reopening of the Teatro Real opera house in Madrid

Glossary

alta comedia nineteenth-century drawing-room drama

AP Alianza Popular (Popular Alliance)

Ateneo literary institution founded in Madrid in the early nineteenth century

Azorín *nom-de-plume* of José Martínez Ruiz

bachillerato high-school degree

baserri Basque family farmhouse

benaventino adjective describing well-made plays of the 1940s that end with scenes of reconciliation

cacique, caciquismo local political boss; system of dominance by the local boss

cafés cantantes song halls, cabarets, popular in late nineteenth and early twentieth centuries

canción española love ballad

canción ligera pop rock

canción protesta protest song

cantautor flamenco singer–songwriter

cante jondo gypsy deep song

casoniano adjective describing escapist theater of the 1940s and 1950s

castellano Castilian (including the language of Castile, i.e. "Spanish")

casticismo puritan traditionalism

catalanisme Catalan nationalist sentiment

catalanitat "Catalan-ness"

Caudillo "Leader" (refers to Franco only)

CAV Comunidad Autónoma Vasca (Basque Autonomous Community)

CDN Centro Dramático Nacional (National Drama Center)

CEDA Confederación Española de Derechas Autónomas (Spanish Confederation of Autonomous Rightist Parties)

Centro de Estudios Históricos Center for Historical Studies

cine cruzada "crusade" cinema in favor of the Nationalist cause during the Civil War

Clarín *nom-de-plume* of Leopoldo Alas
CNT Confederación Nacional de Trabajadores (National Confederation of
 Workers) (anarcho-syndicalist)
consignas journalists' orders (during Franco regime)
copla popular song
Cortes Parliament
costumbrismo literary and artistic movement that sought to portray the
 national character through depictions of popular customs and local
 color
caudernillo five-sheet gathering
culturalismo the sometimes deliberately extreme cultivation of high-brow
 intertextuality
cuplé type of popular cabaret song
cursi vulgar, shabby–genteel
Dau al Set group of surrealist artists based in Barcelona in the late 1940s
destape nudity (used to refer to films and plays in which nudity for nudity's
 sake was the norm)
El Paso artists' collective based in Madrid in the late 1950s
Equipo 57 artists' collective based in Paris and Córdoba in the late 1950s
Equipo Claraboya group of left-wing poets of the 1970s
Equipo Crónica group of anti-Francoist artists (1964–1981)
escuela bolera bolero school
españolada hybrid film genre of romantic comedy and/or melodrama
 incorporating regional, primarily Andalusian, song and dance;
 regarded critically by cultural and film historians
esperpento grotesque form of tragedy developed by Valle-Inclán
ETA Euskadi ta Askatasuna (Basque Freedom and Homeland)
etarra an ETA sympathizer
europeización "Europeanization" (modernization, in terms of secular
 culture, democratic institutions, educational reform, scientific
 research and attention to economic problems)
Euskadi the Basque Country
Euskera the Basque language
FAI Federación Anarquista Ibérica (Iberian Anarchist Federation)
Falange Fascist political party
farsa trágica tragic farce
felipismo style of government of Felipe González
Feria Arco annual art show
FET y de las JONS Falange Española Tradicionalista y de las Juntas de
 Ofensiva Nacional Sindicalista (Traditionalist Spanish Falange and
 Juntas of the National–Syndicalist Offensive)
FNTT radicalized rural branch of UGT

folklórica style incorporating folkloric elements; may refer to a singer of
popular ballads

folletín serialized novel

FTRE Federación de Trabajadores de la Región Española (Federation of
Workers of the Spanish Region)

fueros chartered rights

GAL police-sponsored clandestine anti-terrorist group

garcilacistas poets working to restore and reinterpret the Renaissance love
poet Garcilaso de la Vega

Generalitat Catalan government

género chico one-act play based on lower-class urban life, frequently comic or
satirical

género ínfimo erotic music-hall performance

gitano/a gypsy

Gloriosa, la the "Glorious Revolution" of September 1868

guardia civil Spanish rural police

HB Herri Batasuna (political wing of ETA)

IIEC Instituto de Investigaciones y Experiencias Cinematográficas
(Institute of Cinematographic Investigation and Experimentation)

Institución Libre de Enseñanza Institute of Independent Education, a
school founded in 1876 which supported secular education

Juego Floral, Joc Floral poetry competition

juguete cómico comic genre joining Spanish farce and French vaudeville

Juntas Militares de Defensa Military Defense Committees

latifundia large estate

Liga de Educación Política loosely structured movement created by Ortega y
Gasset to reform Spain intellectually and culturally, via a program to
regenerate basic education to be implemented by the Republican
government

maquis people who lived in the mountains, in rebellion against established
authority

Movement, the word used to describe Francoist political party and
supporters

movida strong new wave of pop music and culture associated with Madrid in
the early 1980s

neopurismo "neo-purism": tightly controlled, intellectual celebratory poetry,
mid-1970s to late 1990s

noucentisme Catalan classicist reaction to modernism

novísimos a group known as the "newest poets," published in an anthology
by José María Castellet in 1970

nueva poesía social new social poetry, associated with *poesía de la experiencia*,
mid-1970s to late 1990s

Opus Dei ultra-conservative Spanish secular religious group founded by J.
 Escrivà de Balaguer in 1928
Parapalló artists' collective based in Valencia in the late 1950s
payo non-gypsy
PCE Partido Comunista Español (Spanish Communist Party)
PNV Partido Nacional Vasco (Basque Nationalist Party)
poesía de la experiencia poetry of experience, mid-1970s to late 1990s
poesía del silencio poetry of silence, tightly controlled, intellectual, mid-1970s
 to late 1990s
posfranquismo post-Francoism
posnovísimos a group of poets writing from the mid-1970s to the early 1980s
postistas avant-garde group of poets writing in the 1940s
PP Partido Popular (Popular Party; successor to the AP)
progre modern, progressive
pronunciamiento coup d'etat
PSE Partido Socialista de Euskadi (Basque Socialist Party)
PSE Partido Socialista Español (Spanish Socialist Party)
PSOE Partido Socialista Obrero Español (Spanish Socialist Workers' Party)
RCM Real Conservatorio de Música (Royal Conservatory of Music)
Real Academia Española Spanish Royal Academy
Reconquest the recovery of land lost to the Moors between the eighth and
 fifteenth centuries
Renaixença Catalan cultural renaissance
Requeté paramilitary wing of the Carlist Traditionalist Communion
RNE Radio Nacional de España (Spanish National Radio)
romance folk ballad
RTVE Radiotelevisión Española (Spanish Radio-TV)
sainete one-act popular comedy with colorful depiction of working-class
 types
sardana Catalan national dance
Sección Feminina women's section of the Falange
Semana Trágica, Setmana Tràgica Tragic Week, July 1909, Barcelona
sevillana Andalusian folkdance
SGAE Sociedad General de Autores y Editores (General Society of Authors
 and Editors)
tablao flamenco dance performance
tertulia social gathering
tradición clásica poetry in new classical style, mid-1970s to late 1990s
Transition, the Spain's movement toward democracy following the death of
 Franco in 1975
tremendismo crude realist style of writing associated with Camilo José Cela's
 novel *La familia de Pascual Duarte*

TVE Televisión Española (Spanish TV)
UCD Unión de Centro Democrático (Union of the Democratic Center)
UGT Unión General de Trabajadores (General Workers' Union) (socialist)
ultraístas, ultraísmo avant-garde poets, poetry
verismo frank depiction of manners
villancico Christmas carol
zarzuela musical comedy, often nationalistic

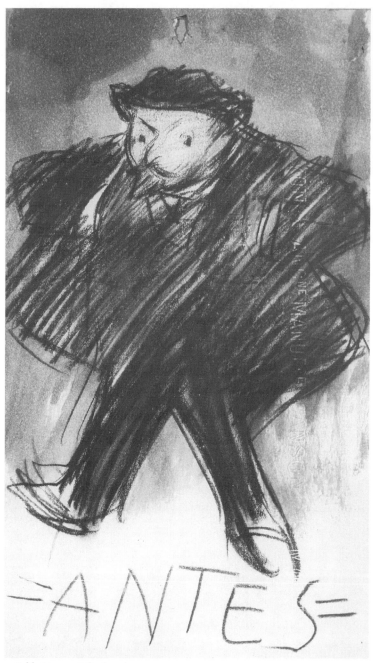

1. Pablo Picasso, *Before* (1900)

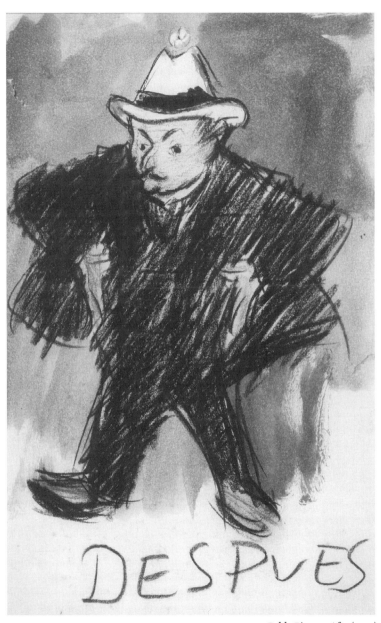

2. Pablo Picasso, *After* (1900)

DAVID T. GIES

Modern Spanish culture:
An introduction

Suddenly, Spain seems to be exporting culture. While the death of
Generalísimo Francisco Franco in 1975 failed to usher in the radical shift
in literature and the arts predicted by many observers of Spanish culture,
it did mark a real conceptual change in Spain's image of itself and of the
world's image of Spain. The political and historical phenomenon known
as "the Transition" carried Spain away from its old image as a backward,
slightly bumbling country toward a new image as a modern, democratic,
chic, and vigorous cultural center. For many years, Franco's tourism
industry had sold Spain as "different," and indeed it was, but not in the
way government officials hoped it would be perceived. Spain, slow to
return to the international community of nations following the devastat-
ing Civil War (1936–1939) and the repressive years of the Franco dictator-
ship (1939–1975), was different in the sense that politically it had not kept
up with the rapid move into the modern world experienced in the rest of
Europe and was viewed as a pariah among modern nation–states. Spain
remained closed to many international influences and proudly put forth
its "difference" in images of what Kathleen Vernon in her essay in the
present book calls the *españolada*, that is, the clichéd, tradition-ridden
view of flamenco girls, hot-tempered males, sunny beaches, and sculpted
landscapes. *La España de pandereta* (the Spain of the tambourine) – the
romantic and Catholic land of Bizet's fiery Carmen and Zorrilla's amor-
ous but repentant Don Juan – was issued forth as the fetichized image of
the "real" Spain. Why? As José Luis Aranguren noted in 1975, "post-war
Spain, incapable, obviously, of cultural construction . . . retrieved from
'the disasters of war' a part of its former culture, in order to readjust it and
prolong it."[1] The Franco establishment intensified this usage by control-
ling the official means of production of culture and by turning the image

into a weapon to be used against what were frequently referred to as the forces of the "anti-Spain." What Philip Deacon writes in his essay in this book concerning television is equally true for other cultural areas; in cultural matters, "ideology rather than expertise was uppermost." According to Ángel Llorente, "as in other fascist regimes, in the Spanish regime official culture was transformed into propaganda and into a tool of the politics of domination."[2] By the end of the Franco period, serious intellectuals even felt obliged to pose the question, "Does a Spanish culture exist?"[3]

Yet slowly, in the post-Franco period, the world began to discern a country less dominated by images of flashing-eyed dancing girls, black-clad widows, and charging bulls, than by the original color palate and thematics of film makers such as Pedro Almodóvar – putative leader of the so-called *Movida* (literally, "stirring"), an amorphous stirring up of traditional cultural expression in the late 1970s and early 1980s[4] – the swirling fashions of Sybilla, the theatrical extravaganzas of the Fura dels Baus (which dazzled the world at the opening ceremony of the Barcelona Olympics in 1992), the provocative – often outrageous – works of writers such as Rosa Montero, Bernardo Atxaga, Antonio Muñoz Molina, Eduardo Mendoza, Ana Rossetti, Almudena Grandes, Fernando Arrabal (among many others), and the political wizardry of King Juan Carlos, Adolfo Suárez, and the Socialist governments of Felipe González.

Spain was no longer "different," but it was also not exactly the "same" as anything else. Just below the surface of this vigorous new Spain lurked years of tension, conflict, triumph, and defeat which form the complex threads which make up the fabric of the country today. This "new" Spain hardly rose up out of the void. Since all historical categories tend to be arbitrary – "generations" and "movements" are generally invented by critics and historians for their own convenience *a posteriori*, and do not normally serve as accurate reflections of some objective historical or literary reality – it seems fair to choose the parameters of what is "modern" and to define them. Thus, while the present book's starting date of 1868 might seem to be an arbitrary and ideological choice (Hayden White claims that "Every representation of the past has specifiable ideological implications"),[5] it is nonetheless a good starting point since it does mark an important shift in modern Spanish history and culture. The "Glorious" Revolution of 1868 ejected the by then despised and immoral Queen Isabel II from her throne with the cry "No more Bourbons," and ushered in a period which witnessed the middle class's rapid move to the center of

power. It was the 1868–1874 sexennial which witnessed what Ángel Bahamonde and Jesús A. Martínez call "the construction of the democratic state,"[6] initiated by "the democratic revolution."[7] Even Leopoldo Alas ("Clarín") understood by 1891 that the revolution of 1868 was "a national movement which awakened the conscience of a great country."[8]

Following 1868, several historical markers appear which serve as convenient sign-posts for a discussion of contemporary history and culture. While various historians and critics would insert their own dates – for some, 1875 (the restoration of the Bourbon monarchy; this is where Álvarez Junco begins his look at modern Spanish history) would come to mind as rapidly as 1898 (the loss of the last three Spanish colonies in the New World), while others might argue for 1927 (the poetic Generation of 1927 is one of the classic literary groups), 1942 (Cela's dark, groundbreaking novel, La Familia de Pascual Duarte), 1949 (Buero Vallejo's watershed play, Historia de una escalera, or 1982 (the arrival of the first post-Franco Socialist government) – in this book the general chronological markers will be reduced to three: 1868, 1936, and 1975. The year 1868 signaled the passage from one political world-view to another. The year 1936 marked the obvious and undeniable beginning of a bloody civil war which in reality was merely the culmination of tensions and tears which had rendered Spanish society unworkable by the mid-1930s.[9] And 1975 witnessed the end of Francisco Franco's life and dictatorship, although clearly the move away from repression and toward democracy had begun as early as the 1960s. Other significant dates will insert themselves in the discussions which follow in this book. For example, the much-debated "Generation of 1898" began its own redefinition of history and literature in an attempt to make sense of what appeared to be the unraveling of polite society at the end of the century; authors, politicians, and thinkers grappled with the idea of "Spain," of what it was, where it had come from, and where it was going.

Tension fuels the fire of creativity. When one looks at the history of Spanish politics and literary and artistic accomplishments, one is struck by the tensions which arise from the clash of expectations. Spain's history is riddled with conflict, with tension springing from the confrontation of the old with the new, of tradition with progress, of conservative with liberal, of Spain with "anti-Spain," of modern with post-modern. This duality has been known as "las dos Españas" (the two Spains), that is, a mindset formed in the late eighteenth century which dominated the country's development for generations (the writers of the Generation of

1898 termed it *españolizantes* [Spanishizers] vs. *europeizantes* [Europeanizers], for example).[10] Spain's struggle for modernity produced numerous cataclysmic milestones – of which 1868, 1898, 1936 and 1975 are merely the most obvious – which have transformed those two Spains into multiple Spains, into a fragmented, multi-cultural society which nonetheless still (on the whole) conceptualizes itself as the sum total of its long and rich cultural and political history. As Helen Graham and Jo Labanyi have pointed out, "culture is – as the Civil War would show so dramatically – a form of struggle."[11] The dates put forth here are clearly dates which mark that struggle.

Raymond Williams states:

> culture is one of the two or three most complicated words in the English language. This is so partly because of its intricate historical development, in several European languages, but mainly because it has now come to be used for important concepts in several distinct intellectual disciplines and in several distinct and incompatible systems of thought.[12]

"Culture" will be used here in a restricted sense, one referring to "the general body of the arts" and to "the intellectual side of civilization," meanings also ratified by Williams,[13] who does however warn against trying to select "one 'true' or 'proper' or 'scientific' sense and dismissing other senses as loose or confused" (*Keywords*, p. 91). Still, the essays which follow will attempt to stay focused on the "intellectual side of civilization," to determine how men and women have taken their past and transformed it into a present and a future. Some recognition will be given to what is called "low" or "popular" culture, interwoven into the discussions of the more "intellectual side" of Spanish civilization, but folkloric culture, mass culture, and popular culture – what the Spanish dictionary defines as "the traditional life of the people" – are properly the subjects of a different book.[14]

What is more, it was precisely in the years immediately following the Revolution of 1868 when a sense of "culture" as the cultivation of one's intellectual faculties became current in Spain.[15] Previously, "culture" was a word used to encompass meanings ranging from "to cultivate" (in an agricultural sense) to referring to "a cult." Slowly, the word took on broader meanings, including what one dictionary defines today as "the sum total of ways of living built up by a group of human beings and transmitted from one generation to another,"[16] while a prior definition in the same work encompasses "the quality in a person or society that arises

from a concern for what is regarded as excellent in arts, letters, manners, scholarly pursuits, etc." That "etc." is telling, for it opens the horizon from the past to the future, from what is quantifiably "excellent" to what is "regarded as excellent" in a number of fields. That is, "culture" came to mean man's intellectual, artistic, scientific, and industrial accomplishments.

The readers of the following pages will find twenty-three discrete but overlapping essays on Spanish history and culture. Subsequent to a serious inquiry into the meanings of words as charged as "modern," "Spanish," and "culture" by Stephanie Sieburth, three voices (those of E. Inman Fox, Teresa Vilarós, and Philip W. Silver) look at the *locus* of culture, that is, where and how culture resides in modern Spain. Claims have been made for the existence of one "Spanish" culture, while equally compelling claims have been made for a multiplicity of cultures which include regional history and expression. To set the discussion of literature and the arts which will predominate in this book in an historical context, three historians (José Álvarez Junco, Carolyn P. Boyd, and Santos Juliá) look at the historical moment, and how politics and culture converged during the (arbitrary) time periods assigned to them (1875–1936, 1936–1975, 1975–1996). Following that, readers will discover detailed discussions of narrative (by Roberta Johnson, Randolph D. Pope, Jo Labanyi, and, for the essay, Thomas Mermall), poetry (Richard A. Cardwell, Andrew P. Debicki, and Chris G. Perriam), and theater (Dru Dougherty and Phyllis Zatlin). Other aspects of modern culture and the arts are analyzed by José Martín Martínez (painting and sculpture), Kathleen M. Vernon and Peter W. Evans (cinema), Luis Fernández-Galiano (architecture), Roger D. Tinnell (music), and Laura Kumin (dance). And finally, one of the most important components in the propagation of modern culture – the media – is deftly synthesized by Philip Deacon.

Culture rests uneasily at the juncture of past and future. Rather than some sort of objective reality, culture – a people's culture, a national culture, a mode of expression, a way of being – is a mental construct which fuses together elements of myth and history, desire and projection, imagination and accomplishment. The present book attempts to bring together past and future in a cultural way, that is, to describe and interpret the contemporary culture of Spain while offering judgments and discriminations about what might be constituted as excellent. Such value judgments are not made by the authors of the pieces included here, but rather by the writers who participate in the construction of Spain's

national culture. As Inman Fox points out in his essay on "Spain as Castile" – following Benedict Anderson's wise lead[17] – culture itself is an interpretation, indeed, an invention. And Spanish culture has variously been interpreted as unified and closed; Castile-centric; predominantly southern (Andalusian); universal; unique; a loose confederation of several autonomous regional elements; or a marker of national identity. What it is, of course, is all of the above.

What Spain is, where it came from, and, even, where it might be headed are the subjects of this book. The authors of the various chapters have not limited themselves to looking only at the best-known creators of Spanish culture (what the academic community calls the "canonical authors"), but they have also taken into account the broad range of creative activity which is shaping Spain's view of itself, and consequently, the world's view of Spain in literature, painting and sculpture, dance, cinema, the media, and music. This book must necessarily look at culture in an historical context, that is, attempt to help the reader understand the political realities and policies of those who would attempt to direct and control cultural production, and those who interpret and consume it. The issues outlined here are complex, and they mark not only Spain's conception of itself (and hence its artistic self-expression and behavior), but also the world's conception of Spain. From the traditional – and besieged – center (Castile), to the periphery (predominantly, Catalonia and the Basque Country, although Galicia, the Valencian region, and Andalusia all make claims for cultural autonomy),[18] Spanish culture is a rich amalgam of tastes and needs and expressions which make up that rather amorphous concept called "Spain." The debate between those who still seek a unity in Spanish culture and those who insist on a plurality of "cultures" remains as lively today as it was in the late nineteenth century. Yet surely Spain has finally achieved what Aranguren called for in 1975: "cultural decentralization" (*Cultura española*, p. 223). It is hoped that readers of the following essays will see that Spain in a new light, and reflect upon the producers, consumers, and controllers of culture in a country which continues to exercise a powerful pull on the imaginations of travelers, and of teachers and students of "culture."

NOTES

1. José Luis Aranguren, *La cultura española y la cultura establecida* (Madrid: Taurus, 1975), p. 160.

2. Angel Llorente, *Arte e ideología en el franquismo 1936–1951* (Madrid: Visor, 1995), p. 45.

3. See the monographic issue of *Cuadernos para el Diálogo* 42 (August 1974).

4. J. L. Gallero defines the *movida* as an "ambiguous and imprecise phenomenon . . . but which overnight changed a rather sleepy city into a supreme emblem of modernity . . . a city which was clearly predisposed [to such a transformation] because of the climate of optimism which the arrival of democracy had spread through all of Spanish society." *Sólo se vive una vez: Esplendor y ruina de la movida madrileña* (Madrid: Ardova Ediciones, 1991), p. 9.

5. Hayden White, *The Tropics of Discourse* (Baltimore, MD: Johns Hopkins University Press, 1978), p. 69.

6. Angel Bahamonde and Jesús A. Martínez, *Historia de España siglo XIX* (Madrid: Cátedra, 1994), p. 523.

7. J. A. Piqueras Arenas, *La revolución democrática, 1868–1874* (Madrid: Alianza, 1992).

8. Leopoldo Alas, "El libre examen y nuestra literatura presente," pp. 62–76 in *Solos de Clarín* (Madrid: Librería Fernando Fé, 1891), p. 62. Repr. in Clara E. Lida and Iris M. Zavala (eds.), *La revolución de 1868: Historia, pensamiento, literatura* (New York: Las Américas Publishing Co., 1970), p. 387.

9. See Paul Preston, *The Coming of the Spanish Civil War: Reform, Reaction, and Revolution in the Second Republic* (2nd edn., London: Routledge, 1994).

10. See Javier Herrero, *Los orígenes del pensamiento reaccionario en España* (2nd edn., Madrid: Alianza, 1985).

11. Helen Graham and Jo Labanyi, "Editor's Preface," pp. v–viii in Helen Graham and Jo Labanyi (eds.), *Spanish Cultural Studies* (Oxford: Oxford University Press, 1995), p. vii.

12. Raymond Williams, *Keywords: A Vocabulary of Culture and Society* (New York: Oxford University Press, 1985), p. 87.

13. Raymond Williams, "The Idea of Culture," pp. 29–56 in Peter Davison, Rolf Meyersohn, and Edward Shils (eds.), *Literary Taste, Culture, and Mass Communication*. 2 vols. (Cambridge: Chadwyck-Healey, 1978), vol. 1, p. 29. Cited by Stephanie Sieburth, *Inventing High and Low: Literature, Mass Culture, and Uneven Modernity in Spain* (Durham, NC: Duke University Press, 1994), p. 5.

14. Real Academia Española, *Diccionario de la lengua española* (Madrid: Espasa-Calpe, 1992), p. 441.

15. Sieburth, *Inventing High and Low*, p. 4.

16. *The Random House Dictionary of the English Language* (2nd edn., New York: Random House, 1989), p. 488.

17. See Benedict Anderson, *Imagined Communities. Reflections on the Origins and Spread of Nationalism* (2nd edn., London: Verso, 1991).

18. Juan Linz noted in 1973 that "A complete analysis of the tensions between periphery and center would require a study of those regions where some of the conditions for the emergence of nationalism existed – particularly a linguistic diversity and some potential grievances against the central government – but where the awakening of a national consciousness did not succeed. Such an analysis would have some of the advantages of a controlled experiment. Unfortunately, the lack of success of the limited attempts of arousing such a consciousness limits the available information." "Early State-Building and Late Peripheral Nationalisms against the State: The Case of Spain,"

pp. 32–116 in Shmuel Noah Eisenstadt and Stein Rokkan (eds.), *Building States and Nations*, vol. II (Beverly Hills, CA: Sage Publications, 1973), p. 84. As readers will note from the essays of Silver and Vilarós, many such analyses have been undertaken since the arrival of democracy and the rise of the autonomous regions. For example, see Clare Mar-Molinero and Angel Smith (eds.), *Nationalism and the Nation in the Iberian Peninsula: Competing and Conflicting Identities* (Oxford: Berg, 1996).

FOR FURTHER READING

Amell, Samuel (ed.). *Literature, the Arts, and Democracy: Spain in the Eighties*. Rutherford, NJ: Farleigh Dickenson University Press, 1990.

Colmeiro, José F. (ed.). *Spain Today: Essays on Literature, Culture, Society*. Hanover, NH: Dartmouth College, 1994.

Labanyi, Jo. *Culture and Society in Modern Spain*. London: University of London, 1993.

Lida, Clara E. and Iris M. Zavala (eds.). *La revolución de 1868: Historia, pensamiento, literatura*. New York: Las Américas Publishing Co., 1970.

Ramos Gascón, Antonio (ed.). *España hoy*. 2 vols. Madrid: Cátedra, 1991.

Smith, Angel. *Historical Dictionary of Spain*. Lanham, MD: Scarecrow Press, 1996.

Vines, Cristina. *La cultura en la España contemporánea*. Madrid: Edelsa, 1992.

I

**Culture: center
and periphery**

1

What does it mean to study modern Spanish culture?

Since the present volume deals with *modern Spanish culture*, it seems crucial to reflect upon the relationships between those three words and the theoretical consequences of how we choose to define *culture*. I will look first at the changes in the meaning of the word *culture* in the modern period and then raise some of the theoretical questions that underlie recent scholarship on such topics as high and low culture, gender and culture, culture and politics, and what we mean when we talk about Spanish culture.

The first thing we must do as critics of "modern Spanish culture" is to recognize that the concept of *culture* which underlies our academic endeavors is itself a modern one.[1] Raymond Williams has reminded us that prior to the late eighteenth century, the word *culture* did not refer to a static state, or to a standard of intellectual perfection, but to a *process*. *Culture* was a synonym for cultivation, and could refer to plants, animals, or human faculties. Williams reads the transformation of the meaning of the word *culture* as a defensive move responding to the vast economic and social changes unleashed by the industrial revolution – materialism, emphasis on utility, the organization of the working class, and other factors (we might add changes in the role of women). It is important to recall that one of the pre-modern meanings of culture was related to "cult" in the sense of reverence or adoration. This meaning would remain embedded in the new idea of culture, as a higher spiritual state which could be achieved through reading "the best that has been thought and said," in Matthew Arnold's famous phrase. The realm of "culture" would thus become a sacred preserve which would protect beauty and tradition from the reigning chaos and overwhelming change. In a society in the process of secularization, this idea of culture would play a key role in

legitimizing the dominance of the educated élites over a working class that was learning to read.[2] The very drive to attain "culture," to preserve "culture," to study "culture" as we are doing in this volume, then, is a modern one whose history dates to the late eighteenth and early nineteenth centuries.

The word *culture* came to be accompanied over time by modifiers such as "high," "mass," "folk," or "popular." These terms are responses to the consequences of modernization and are recognized in current scholarship as highly problematic. First, the term "mass culture" responds to increased literacy and to changes in class and gender relations, as well as to the development of new technology that made fiction and other cultural products more widely available. Mass culture was (and still often is) associated in the minds of bourgeois writers and critics with corruption, promiscuity, cultural decline, or working-class revolution, and is a preferred subject of their invective. Technological progress is thus equated with cultural decline in a way which we must find suspect, but which persists today. "Folk" or "popular" culture was a bourgeois invention; as industrialization transformed people's way of life, their relation to place, and the landscape surrounding them, there arose a nostalgic impulse to find a category of illiterate "folk" still untouched by modern technology and to catalogue, preserve, and study their cultural artifacts. "Folk" and "high" culture, then, were imagined as "authentic," unsullied by the contamination of modernity and "mass" culture.[3]

In actual fact, of course, these artificial separations did not hold water in the ambiguous and messy arena of everyday life. Some of the main detractors of serial novels (Galdós and Clarín, for example) published their own work serially. New, would-be "highbrow" writers got their work known in the late nineteenth century through the Monday literary supplement of *El Imparcial*, through the same technology that produced the *folletín* (serialized novel). The growing audience for literary works had practiced its reading skills on the *folletín*, as Jean-François Botrel has argued.[4] And "folk" culture, like the *romances* (folk ballads) which were passed down through oral tradition, now circulates through the "mass" media of records and CDs by groups like Nuevo Mester de Juglaría.

Williams notes that by the present day, the word *culture* has three commonly used meanings. The first, most narrow one is "the general body of the arts"; the second is "the intellectual side of civilization" which includes philosophy, religion, and science as well as the arts. The broad-

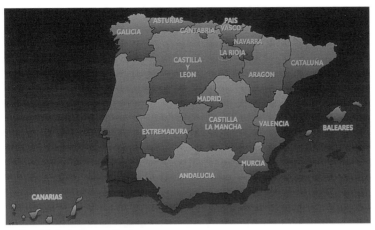

3. Spanish Autonomous Regions

est term, used in sociology and cultural anthropology, is that of "a whole way of life" ("Idea of Culture," p. 29). These three frames, like a series of Chinese boxes, result from different assumptions about what are worthy objects of study and from methods of study which are peculiar to different disciplines. This leads me to reflect on what kinds of frames we, as cultural critics in the twentieth-century *fin-de-siècle*, put around our study of literature and the arts, and what happens if we adopt other kinds of frames. The following thoughts, then, are a meditation on what changing the nature of the frame has brought to the study of modern Spanish culture in recent years, through the impact of new interdisciplinary currents such as cultural studies and feminist criticism.

Until relatively recently, modern peninsular Hispanism, like all literary studies influenced by the New Criticism, used the narrow frame of "the general body of the arts" as its field of study. Of course, critics related literature to the political events of the day, but in relatively broad strokes. One studied writers, or groups of writers whose work, for a variety of reasons, had been defined as worthy to enter the canon. This led to superb readings, from formalist to psychoanalytic and deconstructive, of specific literary works, and to studies of the intertextual relations among them; it also led to a thorough familiarity with the relationships among writers, their evaluations of one another's work, their collaborations on journals, etc. The political questions posed often related to how free writers were to publish their works or have them performed within a given time period.

In the last twenty years, the new focus on mass cultural forms such as serial novels, radio songs, television programs, movies, and the like has led scholars to ask radically new questions of the literary works they had been studying all along, as well as leading them to new objects of study. First of all, it has now become evident that it is impossible to differentiate in any clearcut way between "highbrow" genres and "lowbrow" ones. The highbrow novel shares suspense-creating strategies and techniques of character creation with the serial novel or the *telenovela*. Texts written for a small educated élite become films and the original novels then become bestsellers (think of the recent Spanish television serialization of Clarín's great novel *La Regenta*, which in its day did not circulate widely). And contrary to the clichés which say that mass culture is reactionary and "highbrow" literature is progressive, there may be significant overlaps in ideology between "highbrow" novels and the mass cultural forms they most attack. One pioneering work in this area was Alicia Andreu's book,[5] which enriched our view of Galdós's work in multiple ways by looking at the broader context of fictional production in Galdós's day. We learned that Galdos's ideology about female conduct overlapped in great measure with that of the conservative domestic novelists of his day, who propagated the ideal of the "ángel del hogar" (angel of the house). We learned that even those Galdosian characters who break that conventional mold must be understood against the backdrop of the domestic ideal propagated in the serialized fiction and women's magazines which were widely read in Galdós's time. We learned to see the ways in which Galdós's gender and class background shaped his fiction.[6]

The question of gender relations is of crucial relevance to the high/low division. Andreas Huyssen has pointed out how modernism, beginning with Flaubert, creates a dichotomy between men as producers of high culture and women as consumers of mass culture. Ironically, at the same time that women are described in scientific discourse as closer to nature than men (and therefore more volatile, fragile, etc.), another insistent connection is made between women and the technological world. Women are seen as intrinsically voracious shoppers for all those consumer goods now available through mass reproduction.[7] They are also addicted to trashy serial novels, according to another staple discourse of the day, and this takes them away from their duties as wife and mother. This invented dichotomy between men and women serves to blame women for the consequences of industrialization, but it also has another, more literary consequence. Catherine Jagoe has shown that male writers

are most intense in their identification of women with a degraded mass culture precisely at the time when women novelists in Spain were gaining prominence, respectability, and a large share of the market. It may have been a tactical response on their part, she suggests, to denigrate the kinds of literature women wrote, and cultivate a different aesthetic which they would define as more highbrow and "virile." They did this with such success that nineteenth-century women novelists were erased from Spanish literary histories and are only now being rediscovered by scholars.[8] To consider the high/low opposition in culture, then, and to cast suspicion on its viability, is also to suspect that underlying that division is the desire to preserve other hierarchies – those of gender and class. But the association of women with mass cultural products persists even today.

So we now know that the high/low division has always been a questionable one, that it has been used to maintain other kinds of hierarchies such as gender roles or class divisions. Cultural critics of post-modern Spain will often find that the high/low question seems to have lost its relevance, along with so many other questions which were staples of earlier Spanish literature. It will be interesting to ask of the new Spanish literature the question of whether the high/low opposition persists in any way. Do poems which rewrite and parody magazine ads depend on the reader's recognition of a difference between high and low? Which writers are most recognized in Spain today, and what values are behind their incipient canonization? Are they recognized for the same qualities once valorized in earlier authors, or for different ones? What kind of debt does the new Spanish novel have to earlier "highbrow" literature, even where it seems to fuse seamlessly with mass cultural genres?

Another question which destabilizes the narrowly defined meaning of culture is the question of who has access to various cultural products. In the nineteenth century, we must look at the difference in literacy rates between inhabitants of major cities and inhabitants of rural areas. Yet literacy rates do not in themselves tell us what people are reading, what they can afford to purchase, or whether they had a lending library available. Jean-François Botrel's recent work reminds us of the multiple factors involved in access to specific books. How much influence did the church have in a given town, for example, and did that determine what the local bookstore sold? In what periods and in what social spaces did people read aloud, and how many illiterate people might have become familiar with stories through this? Botrel further demonstrates how

access to a given work could change over time. A novel might begin its life as a *folletín* published in installments and widely available and later be bound in an expensive volume available only to the rich. Or it might be published initially in a leather-bound expensive edition and later find its way into a collection for workers costing one *peseta*.[9] Much study still needs to be done on reading in twentieth-century Spain, to find out, for example, how large a public a novel by the contemporary novelist Miguel Delibes might have had. The question of libraries is also crucial. Many Spaniards who had never been able to read books before gained access to them during the Second Republic and the Civil War, because more lending libraries were established in those years than at any time in Spanish history, before or since.[10]

The question of the possible relationships of culture to politics has multiple exciting consequences for the cultural critic. There are many ways to understand both the term *culture* and the term *politics*; I will allude here only to some of the possible permutations. If we look at politics as the operations of a state apparatus, we can ask what kinds of cultural production were encouraged by the state and for what purposes. For example, in the eighteenth century, Jovellanos and other men of the Enlightenment sought to hierarchize cultural production, to define audiences by socio-economic rank, and to try to use the theater as a means of social control by educating the audience into certain kinds of behavior and values. This attempted control of the populace's leisure time extended even to regulating the kinds of seating available in the theater.[11] Or we might look at what kinds of objectives Felipe González's governments pursued through the film-making subsidies provided by the Ministry of Culture. Or one might study the economic and political reasons behind Franco's support for a culture of soccer and bullfights, not to mention the slogan, for external consumption, that "Spain is different," which forefronted flamenco, bullfighting, and isolation from the modern world.

If we look at politics as a term which describes not simply what happens in governments but the relations between classes, the presence or absence of social movements, the transformation of the relations between the sexes – that is, as part of the "practice of everyday life," new questions emerge. The richest period to study the links between cultural production and social movements would, of course, be the Civil War period, where culture and education were seen as key weapons against fascism, and where the Republican government and the revolutionary

parties alike incorporated both élite and unknown writers into their enterprises.[12] We might also study the role of protest songs, which circulated clandestinely on copied tapes in the last years of the Franco regime, later becoming available on records.

Of course, cultural products can often serve as an escape from politics. One common cliché about mass culture is precisely that people watch television or read romance novels as pure "escapism" (a concept which needs to be analyzed to determine what one is escaping from and why). Yet élite culture can also serve as an escape. Modernist writing, for example, fled from the market and its values of utility and consumability through the creation of difficult literary texts which aimed at self-sufficiency (Huyssen, *Great Divide*, p. 47). The reader who gets lost in such texts might escape just as effectively from the pressing concerns of "reality" as the reader of romances. Carmen Martín Gaite makes clear in *El cuarto de atrás* (The Back Room) that mass cultural texts – Conchita Piquer's *coplas* (popular songs) in this case – can provide a vehicle of political protest and resistance rather than an escape into a more pleasant world. Finally, George Lipsitz reminds us that even when art transports us into another world with different, less repressive rules, this may constitute more than just a temporary escape: "Culture can seem like a substitute for politics, a way of posing only imaginary solutions to real problems, but under other circumstances, culture can become a rehearsal for politics, trying out values and beliefs permissible in art but forbidden in social life."[13]

We can apply such a statement to the functioning of diverse cultural phenomena, ranging from Coney Island in the United States, which at the beginning of the century helped to break down Victorian codes of conduct within the confines of an amusement park; to texts by Antonio Machado or Jean-Paul Sartre which circulated clandestinely during the Franco regime; to the kinds of women's magazines which circulated during the Spanish Republic and which fed the young Martín Gaite's dreams of the kind of independent woman she wanted to become. If we now try to relate the narrowest meaning of culture given by Raymond Williams ("the general body of the arts") to the broadest ("a whole way of life"), we will be led in fascinating directions. What is the difference between singing along with a radio song in an era where one lives on tiny rations of lentils and green beans, and singing along with a radio song in an era of abundance like the present one?[14] How do we theorize what the consumption of mass culture means in those situations? And what do we

get when we ask what it means that Valle-Inclán wrote *Luces de bohemia* (Bohemian Lights) at the height of popularity of the *cuplé*?[15] How does the rise of tourism in Spain affect the content and the form of the novelist Juan Goytisolo's work (see Sieburth, *Inventing High and Low*, chapter 4)? Teresa Vilarós's forthcoming cultural history of the post-Franco Transition takes a similarly holistic approach that yields fascinating results.[16]

Finally, we might think about the questions that arise from the coupling of the words *Spanish culture*. Both Spain itself and Hispanism have often tended to limit their frame of reference to the country itself, to be unconsciously lulled by the Francoist refrain of "Spain is different" and neglect even to make the comparison with other countries. In recent years, however, highly suggestive studies have focused on Spain and its culture as understandable *in relation to* Europe or Latin America. Noël Valis's work on *lo cursi* (vulgar imitations of genteel culture) has shown how nineteenth-century Spain as a nation had an insecurity about its place in the world which was mirrored in its own insecure middle class; both suffered from that complex called *quiero y no puedo* (I want to but can't).[17] This frame of reference gives us new ways to talk about everything from the proliferation of *cursi* detail in certain novels to the self-conscious incorporation of popular forms in would-be élite literature. We can also relate Spanish writers' frustration at not being recognized in Europe with the content of some of their novels.[18] So we are invited to think about how Spain is different and why.[19] Still, we must also think about the areas of overlap and mutual influence between Spain and other countries. Finally, we might examine Spain's way of thinking about itself in relation to other countries.[20]

In conclusion, we might say that the question of how we study modern Spanish culture is a matter of frames and of hierarchies. Recent theory has made us conscious of the kinds of frames we impose on our analysis. We are now aware of the many options we have when we become interested in a given kind of cultural production – do we want to do a detailed analysis of the inner workings of a text or a genre, or do we want to relate it to other cultural, social, or political phenomena? And why do we choose one frame over another? We have also become aware that our ingrained hierarchizing tendency, which prompts us to dismiss certain kinds of cultural production as unworthy of analysis, needs to be subject to analysis itself, to see what kinds of ideological assumptions we are making. Which is not to argue that the latest gossip magazine to roll off Spanish presses is of equal value to *La Regenta*, but rather to argue that the

two have a lot more in common than we might have been willing to acknowledge twenty years ago.

NOTES

1. The history of meanings of the word *culture* both in Spain and outside it, as well as the problems attending the high/low division, are developed in greater detail in the introduction to Stephanie Sieburth, *Inventing High and Low: Literature, Mass Culture, and Uneven Modernity in Spain* (Durham, NC: Duke University Press, 1994).

2. Raymond Williams, "The Idea of Culture," pp. 29–56 in Peter Davison, Rolf Meyersohn, and Edward Shils (eds.), *Literary Taste, Culture, and Mass Communication* (2 vols., Cambridge: Chadwyck-Healey, 1978), vol. I.

3. Morag Shiach, *Discourse on Popular Culture* (Stanford, CA: Stanford University Press, 1989), pp. 1–18.

4. Jean-François Botrel, "La novela por entregas: unidad y creación de consumo," pp. 111–155 in Jean-François Botrel and Serge Salaün (eds.), *Creación y público en la literatura española* (Madrid: Editorial Castalia, 1974).

5. Alicia Andreu, *Galdós y la literatura popular* (Madrid: Sociedad General Española de Librería, 1982).

6. Catherine Jagoe developed further the question of gender in Galdós's work, and its relation to both mass cultural texts and political debates on the role of women. *Ambiguous Angels: Gender in the Novels of Galdós* (Berkeley and Los Angeles, CA: University of California Press, 1994).

7. Andreas Huyssen, *After the Great Divide* (Bloomington, IN: Indiana University Press, 1986), pp. 47–62. For an excellent discussion of discourse on women and luxury in Spain, see Bridget Aldaraca, *El ángel del hogar: Galdós and the Ideology of Domesticity in Spain* (Chapel Hill: North Carolina Studies in Romance Languages and Literatures, 1991), chapter 3. For a wider context, see Rachel Bowlby, *Just Looking: Consumer Culture in Dreiser, Gissing, and Zola* (New York: Methuen, 1985).

8. Catherine Jagoe, "Disinheriting the Feminine: Galdós and the Rise of the Realist Novel in Spain," *Revista de Estudios Hispánicos* 27 (1993), pp. 225–248.

9. Jean-François Botrel, "Narrativa y lecturas del pueblo en la España del siglo XIX," *Cuadernos Hispanoamericanos* 516 (1993), pp. 69–91.

10. Blanca Calvo, "Memoria de la modernidad," pp. 9–12 in *La lectura pública en España durante la II República* (Madrid: Biblioteca Nacional, 1991).

11. Wlad Godzich and Nicholas Spadaccini (eds.), *The Institutionalization of Literature in Spain*. *Hispanic Issues* I (Minneapolis, MN: The Prisma Institute, 1987), pp. 20–21.

12. The debates during the war about the relationship of art to propaganda were fascinating. See Francisco Caudet (ed.), *Hora de España* (Madrid: Turner, 1975).

13. George Lipsitz, *Time Passages: Collective Memory and American Popular Culture* (Minneapolis, MN: University of Minnesota Press, 1990), p. 16.

14. On daily life in post-war Spain, see Rafael Abella, *La vida cotidiana en España bajo el régimen de Franco* (Barcelona: Argos Vergara, 1985).

15. See Serge Salaün, *El cuplé (1900–36)* (Madrid: Espasa-Calpe, 1990).

16. Teresa Vilarós, *El mono del desencanto: Una crítica cultural de la transición española* (Barcelona: Siglo XXI, 1998).

17. Noël M. Valis, "Adorning Women: The Feminine as *cursi*." Paper presented at the Modern Language Association Convention in Washington, DC (29 December 1989).

18. I have found this idea fruitful in analyzing Galdós's *La desheredada*; see *Inventing High and Low*, chapters 1 and 2.

19. I have suggested that one productive way to think about this is uneven modernity, a modernization that comes in fits and starts, but which always co-exists with important pre-modern political and economic structures. See *Inventing*, pp. 41–42 and 230–244. The concept of uneven modernity had already been used by Julio Ramos to describe parts of Latin America. Julio Ramos, *Desencuentros de la modernidad en América Latina* (Mexico: Fondo de Cultura Económica, 1989).

20. See in this regard Jesús Torrecilla, *El tiempo y los márgenes: Europa como utopía y amenaza en la literatura española* (Chapel Hill: North Carolina Studies in Romance Languages and Literatures, 1996); and *La imitación colectiva: Modernidad vs. autenticidad en la literatura española* (Madrid: Gredos, 1996).

FOR FURTHER READING

Clark, T. J. *The Painting of Modern Life*. Princeton, NJ: Princeton University Press, 1984.

Felski, Rita. *The Gender of Modernity*. Cambridge, MA: Harvard University Press, 1995.

Guillory, John. *Cultural Capital: The Problem of Literary Canon Formation*. Chicago, IL: University of Chicago Press, 1993.

Minnich, Elizabeth. *Transforming Knowledge*. Philadelphia, PA: Temple University Press, 1990.

Mukerji, Chandra and M. Schudson (eds.). *Rethinking Popular Culture*. Berkeley, CA: University of California Press, 1991.

2

Spain as Castile: Nationalism and national identity

A salient characteristic of the European nation–state is its multiple
cultural identities which share a socio-political space – laws, economy,
values, symbols, and traditions – where the activities of the state endow
the population with a corporate sense and the intellectual or élite create
an identity by defining and promoting a nationalist language, or dis-
course, and a culture which provides images and ideas for ordering ways
of thinking and believing. The separate cultural identities co-exist in the
overarching nation–state, but they seek local power and cultural parity.

In the case of Spain, toward the end of the nineteenth century the
country found itself in transition between a proto-industrial economic
structure and industrialization, a transition that brought with it a chang-
ing social structure defined by the consolidation of a monied middle
class, an emerging organized working class, and the instability of the
traditional *petit bourgeois*. On the other hand, the political structure,
characterized by an ineffective administration, a corrupt electoral
system, an illiteracy of some 75 percent, and an antiquated educational
system, was unable to develop in Spain a capitalist democracy of the level
of the rest of Europe. At the same time, the country found itself entangled
in colonial wars which it lost – the so-called Disaster of 1898 – leaving the
national treasury seriously diminished.

All of this brought forth an extraordinary group of intellectuals
devoted to defining the "problem of Spain" in the context of an historical
national identity and to national regeneration through modernization,
always, however, in the spirit of national unity. This crisis also led to a
resurgence of ideological movements seeking autonomy, unity, and
identity in the "historical" regions of Catalonia, the Basque Country, and
Galicia.

The regional nationalisms in Catalonia and the Basque Country were to a great extent products of industrial and economic development along with the formation of an important urban middle class in Barcelona and Bilbao. The economic development in Catalonia was characterized by a dissatisfaction with the politics and the administration of the Restoration and its Castilian-centric ideology, the basic thesis of the Catalan nationalists being related to the idea that the problem of Spain was founded in Castilian primacy and that the weaknesses and virtues of Castile were interpreted as if they were those of Spain. In addition, the evolution of the political nationalism of the Catalans coincided with a purely cultural one throughout the later years of the nineteenth century (the *Renaixença*). On the other hand, the ideological hegemony of Basque nationalism, with a political program informed by conservative Catholicism, was a defensive reaction against what was seen as a harmful influence of liberalism in Basque society and the Spanish immigrants who were considered to be agents of change with socialist and secular values. There are also marked differences between the Basque and the Catalan situation arising from their national histories and from the historical relationship of the Basques to the nation–state of Spain, closer and more active than that of the Catalans. Toward the turn of the century, Galicia was less developed than Catalonia and the Basque Country, and its emerging nationalism was characterized by a revival of its traditional culture and of Galician as a literary language, and claims that its Celtic origins distinguished the Galician from the other peoples of Spain.

In spite of the fact that the concepts of "nation" and "nationalism" are often ambiguous, one can safely say that during the latter half of the last century and the first half of this one, there existed in Spain a political nationalism with a functional and pragmatic sense of generating loyalty toward a nation–state which in its form was essentially liberal-democratic; and that at the same time there was an accompanying cultural nationalism, of more emotional and ideological characteristics, which was an artifact in the service of political life.[1] What follows is a study of the process of this Spanish nationalist project of a liberal political nationalism with an important and highly developed cultural component which defines the "nation's" identity. My approach is more or less theoretical, with an emphasis on the definition and role of national culture.

As an introduction, I will lay out my understanding of the concepts "nationalism," "nation" and "culture," and their interconnection.

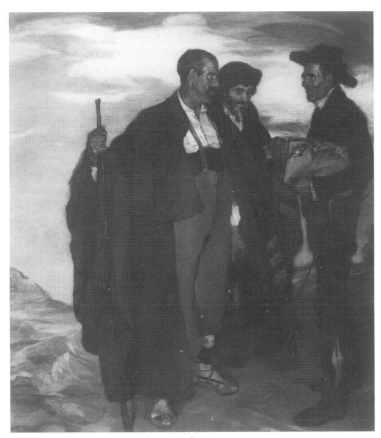

4. Ignacio Zuloaga, *The Mayor of Torquemada*

Parenthetically, it is not without significance that the use of the words together became common only toward the end of the nineteenth century, when there was a change in Europe in the importance of the relationship between state and cultural identity.

Benedict Anderson proposes that the age of nationalism was born with the secular transformation of the eighteenth century, when the idea of "civilization" as the way of understanding historical continuity replaced the ideas based on religion.[2] Among the changes brought about by the Enlightenment, Anderson emphasizes the importance of the commercial development of the printed word, which provided the basis for national consciousness by creating a unified way of communication and understanding among individuals, and by giving a sense of permanence

to language – even creating languages of power – through books and other forms of reproduction. For Anderson, then, "nation" and "nationalism" are cultural artifacts; and to understand them we need to know how they have come into historical being. That is, the "nation" is defined as an imagined political community. Ernest Gellner goes even further, by arguing that nationalism is not the awakening of nations to self-consciousness, but rather the opposite: that nationalism invents nations where they do not exist.[3] It follows that all interpretation of culture is historically contingent; that is, there are historical–political reasons for the invention of cultures.

It is understood, then, that people belong to the same nation if and only if they share the same culture, where culture in turn means a system of ideas and signs and associations and ways of behaving and communicating. In other words, nations are the artifacts of a people's convictions and loyalties and solidarities. Therefore, there exist groups which *will* themselves to persist as communities, where nationality is defined in terms of a shared culture. It is nationalism which engenders nations, not the other way round. And the fusion of will, culture and polity becomes the norm. In this respect, nationalism often imposes a high culture on society (where, in fact, previously a popular culture dominated). While nationalism often establishes itself in the name of a putative folk culture, the diffusion of the invented culture is founded on a school-mediated, academy-supervised idiom.[4] Renan argued that a nation is a large collection of people such that its members identify with the collectivity without being acquainted with its other members, and without identifying in any important way with sub-groups of that collectivity.[5] Boundaries of nations are *not* dictated by language, geography, race, religion, or anything else. Nations are made by human will; a nation is a "moral consciousness." European nations came from centralization, according to Renan, leading to what was, in fact, an amnesia toward historical and cultural differences. The modern nationalist, therefore, wills his or her identification with a culture, which has been and is promoted as a collective identity.

Now, the equation of "state–nation–people" impressed its character on Europe with the rise of liberalism and the making of the liberal state, particularly during the period 1830–1880. It is significant that in these years the European balance of power was transformed by two great powers based on the "principle of nationality": Germany and Italy. Still, the reasons for considering some to be "nation–states" and others not

were unclear (and Renan directed his essay toward establishing them). It turns out, however, that the decisive criteria for liberal nation-making *were not* necessarily ethnicity, language, or common history. Nobody ever denied the actual multi-nationality or multi-linguality or multi-ethnicity of the oldest and most unquestioned nation–states: that is, Great Britain, France, and Spain.

Common language was often not a criterion for nationhood, except, of course, insofar as it was used by the rulers and the educated. Nevertheless, language became central to the modern definition of nationhood. For where an élite literary and administrative language exists, it can become an important element of national cohesion. When it is put into *print*, it becomes even more powerful. In this context, we should remember that a common language does not naturally evolve, but is constructed and when forced into print appears more permanent, more "eternal" than it really is.[6] It was only at the end of the nineteenth century, mainly through German influence, that nationalism sought the rediscovery of the people, the vernacular (*volkheit*), stressing ling_____ community and a sense of historic mission or de_____ covering popular tradition and converting it into ___ was the work of the ruling class or the élite. We now know, for instance, that the German folk tales, supposedly collected by the distinguished philologist Grimm and his brother, were, in fact, written by them. Other examples of another ilk of national tradition as the work of the ruling class are Catalan and Basque nationalisms. With what has been said up until now, it is not surprising, then, to find that Hobsbawm, an acute analyst of nations and nationalism, talks about them in terms of *program*, *myth*, and *reality*.

Nationalism, then, is intimately related to culture, often even defining it or inventing it. The concept of culture used here – and that pertinent to nationalism – is not that which derives, in anthropological circles, from social life (or a theory about the way in which a group of people in fact behave) or the social legacy the individual acquires from his group (i.e. learned behavior), or an abstraction from behavior. Rather it is the interpretation – like all definitions of culture – of a way of thinking, feeling and believing: an interpretation which is derived from the cultural products themselves – history, literature, art – which provide images and ideas for ordering behavior; or for defining ways of thinking and believing. Or, to state it another way, there is a part of culture which is actively concerned with the establishment and defense of patterns of

belief and value. To avoid the danger of turning cultural analysis into a kind of "aestheticism," by ignoring the political, social, and historical realities which contain all people, we must understand nationalism and identity in a socio-political context.

Hence nationalism wills its identification with a common or shared culture on the people or "nation"; and this shared culture is "invented," or derived from cultural artifacts or cultural products like history, literature, or art.

As we have stated, the rise of nationalism and the search for national identity in Europe was a phenomenon of the nineteenth century, related in a way to liberal polity. According to Jürgen Habermas, bourgeois society created at the same time a public sphere of private people who came together as a public to engage in a debate over the general rules governing the relationships between the state and the interests of a basically privatized, but publicly relevant sphere of liberal capitalism.[7] Bourgeois society is defined as a public of private individuals who join in debate on issues bearing on state authority. The concept involves the notion of an élite civil society – growing out of the eighteenth-century salons and coffee houses – which institutionalizes not only a set of interests and an opposition between state and society, but also the practice of a rational–critical discourse on political matters as central to democratic polity. The idea of "public opinion," for example, came from the bourgeois public sphere's self-interpretation of its function.

As the public sphere develops and the need for public information increases, the printed word – particularly in the form of newspapers and journals – undergoes important changes. So also do cultural products like literature and history, which are associated with the middle class public sphere inasmuch as they represent a mutual understanding among citizens in their human relations. It follows that the institutionalization of a cultural public – through mediation between the critic and the reading public (literary criticism and newspapers, for instance) – can influence social or political conflicts and have a significant role in the promotion of nationalism or the definition of a national culture. This brief version or adaptation of Habermas's ideas on the transformation of the public sphere provides a suggestive framework for a study of the institutionalization of the relationship between history, culture, and political problems in the nineteenth-century debate on nationalism and national culture. In the case of Spain, the clearest examples are the Ateneo of Madrid, the Institución Libre de Enseñanza, and the Centro de Estudios Históricos.

Of more general pertinence to our understanding of how cultural artifacts come to define a nation and how they relate to polity is the development of historiography in the nineteenth century. The concept of "general history" – or the history of civilization, combining cultural history with political history – became established in nearly all European countries with the aim of providing reliable written testimony on the origins and development of a national consciousness in the context of political history (that is, the history of the people within their history). National history was no longer seen from the point of view of political absolutism, of the privileged, and of religious fanaticism, but rather from that of liberalism in which the nation's people are considered active subjects and from all that the new order stood for: the secularization of society, suffrage, and representation, the idea of progress, and the norms of the middle class, such as objectivity, justice, and collective legalized morality. The nationalist character of the genre of "general history" was defined by its treatment of the events of a people or nation from their origins, normally integrating into the "external" political history those facts related to the "internal" history of the people or nation. As an example, then, we find in the histories of Spain from then on an emphasis on the Reconquest, the *Germanías* (factions which rose up against King Carlos V in Valencia) and the *Comunidades* (factions which rose up against the same king in Castile) of the middle ages and the sixteenth century, and on other popular uprisings against the reigning authority.

For the sake of brevity, I will resort to a composite of three histories as an outline of the development of Spanish liberal historiography and of its relationship to nationalism, culture, and politics: the *Historia general de España* (A General History of Spain), published in thirty volumes between 1850 and 1867, by Modesto Lafuente, perhaps the most widely read historian in Spain throughout the last half of the nineteenth century; the work of Antonio Cánovas del Castillo on the reign of the Habsburgs and the decadence of Spain, written between 1854 and 1888; and *Historia de España y de la civilización española* (A History of Spain and Spanish Civilization) published between 1899 and 1911 by Rafael Altamira, the best Spanish historian writing around the turn of the century.[8]

In all of these works the Spanish middle ages occupy a key position. With the ascendancy of the Visigoths and their institutions and *fueros* (chartered rights) there came into being a new civilization, unified by a religious spirit, but with a legislated common law: a civilization which

was characterized by a sense of individual liberty as a sign of social progress. Thus, the medieval history of the Spanish people is symbolized by the constitutional legal codes of the *fueros* and the Cortes (Parliament) of Castile and León. We also see that the historiography under consideration gives special attention to the unification of the nation–state. To the medieval monarchs corresponds the entry of the popular element into political history (the democratic Cortes, the *fueros,* and the municipalities) and the beginning of arbitration with the aristocracy. The Catholic Monarchs are esteemed for bringing about the supposed unification of Spain, for their defense of the third estate and for cultural rebirth, although they are criticized for introducing the Inquisition into Spain. The rule of the Habsburgs is considered as the most negative aspect of Spanish national history, because of absolutism, the abolition of representative institutions, intolerance, and economic decline. Therefore, Spanish liberal historiography gives special importance to the history of the medieval municipalities and the revolt of the Castilian *comuneros,* or "communities," including the nobles, against the imperialist politics of Carlos V and his abuse of the Castilian laws.

In this context we find another aspect of nineteenth-century Spanish historiography: the history of the process of the decadence of Spain in the sixteenth and seventeenth centuries came to be considered fundamental to an understanding of Spanish nationalism. Its emphasis reaches its peak toward the turn of the twentieth century and is decisive in its contribution to the definition of the national culture that becomes institutionalized and politicized during the first half of this century. In the sixteenth century, the amortization and donation of land to the church, which was exempt from taxes, and the privileges of the Mesta (sheep owners' union) led to the stagnation and neglect of agriculture. In addition, religious fanaticism, which was permitted to become inflamed, particularly under Habsburg rule, progressively undermined the economy and the culture of the country. Imperialism, expansionism, and wars during Habsburg rule led to depopulation, poverty, idleness, and bankruptcy of the national treasury, which, when coupled with religious fanaticism and lack of unity, finally caused the decadence of Spain as a power. The result was that by the end of the sixteenth century, the administrative, political, economic, social and moral conditions of Spain, particularly in the dominant Castile, were in total decline. And the great historical institutions of the middle ages – the Cortes, the *fueros,* the municipal councils – had fallen into disuse. At the same time, the his-

tories allowed for the fact that the intellectual and literary life of the period – the Golden Age, when, as we shall see, Spanish history finds the essence of national culture – still flourished, although intellectual and cultural decadence finally came about as well. Spain did not begin to recreate a culture of the level of the rest of Europe until the Enlightenment, nor a spirit of self-decision and self-determination until the War of Independence.

Also emerging from Spanish nationalist historiography is the idea of Castile's centrality to the shaping of the Spanish nation, an idea widespread in histories written until the middle of this century (but certainly at odds with the autonomous nationalisms that emerged in Spain at the turn of the century). It was developed as follows. Castile was born affirming its personality *vis-à-vis* the kingdoms of León and Navarra, at the same time that it fought successfully against the enemy to the south, the Moors. In this way, it demonstrated an unusual vitality for a small kingdom, leading to extraordinary expansion which was characterized by the assimilation of the cultures with which it came into contact. By 1600, Castile represented some 75 percent of the territory and population of Spain.

As mentioned, Castilian culture was characterized by its assimilation of elements of the cultures with which it came into contact: the intimacy of the *mudejarismo* (style influenced by Arabic elements), the French elements of the Provençal school and chivalric poetry, and the Italian and classical influence. This process produced a literature which reflected these assimilated elements, but which progressively became more national in its form and content, availing itself, through instinct and inclination, of a decidedly popular tendency. In this way, the Castilian spirit manifested an originality in its literature which distinguished it from other cultures. We can see, for instance, how the Castilian genius renewed Galician–Portuguese poetry through the introduction of popular and realist themes and the use of a variety of metrical combinations, a development which can be traced in Spanish poetry from the *Cantigas de Santa María* (Songs of Saint Mary) of Alfonso X (thirteenth century) to the *Cancionero de Baena* (The Baena Songbook, sixteenth century). Another example of Castilian assimilation can be found in the marriage of erudition (the tradition of the *mester de clerecía*) with the satirical aspects of the Provençal school. The most notable example of this coming together is Juan Ruiz, who in his *El Libro de Buen Amor* (The Book of Good Love), besides telling in a racy tone the life-story of a priest which is

anything but edifying, paints an admirable realistic picture of the relaxed customs of the times.

According to this historiographical conceptualization, it was Castile that set the tone for Spanish history and society during the four generations of the literary and cultural Golden Age, while Catalonia and the kingdom of Valencia went through a relatively impotent period characterized by debilitating internal social struggles and the disastrous demographic consequences of the major epidemics in the fourteenth century. All of this, then, was used to explain that the apex of Spain was above all the apex of Castile, as was likewise the decadence of Spain. In the words of Ortega y Gasset – a pro-Castilian of the first order – "Castilla ha hecho a España y Castilla la ha deshecho" (Castile has made Spain and Castile has unmade it).[9]

There remains to be discussed that characteristic of Spanish liberal historiography which deals more directly with the definition of the Spanish nation, the historical collective identity. It is to be found in the pervasive influence of Francisco Giner de los Ríos's philosophy of history, derived from German thought – more specifically that of Krause – which deals with the formation and transformation of society in the context of a conceptualization of culture. It is founded not only on the concept of the formation of the Spanish nation and the reasons for its decadence, but also on the definition of a national spirit or consciousness, with distinguishing characteristics, which is revealed through the expression of the people's "fantasy" and which subsists throughout history. The reason for the study of the decadence of Spain was not only to seek its causes, but rather to discover what *could have been* in the context of the national spirit. As we know, the idea – belonging to the school of cultural relativism – that each nation possesses specific characteristics and a defined destiny, which evolve throughout history and which can only be interpreted in terms of internal norms unique to each culture, was propagated by Johann Gottfried Herder and his followers at the end of the eighteenth century and beginning of the nineteenth. Added to the Herderian notions of understanding history as no less powerful or real than nature and of the singularity of creative activity in a concrete context of space and time, we find in Giner's thought the influence of German Idealism (principally Kant, Fichte, Hegel, and Schelling) and its ideas on the philosophy of history, establishing a difference between external history and internal history, often giving more significance to internal history. The external historical event is subjected to accidents and detours which

can distort the historical progression of humanity and of the sense of national Being. The study of history, therefore, should not focus exclusively on the external historical event, but also on the internal evolution of the ideas and sentiments which are perpetuated and on the study of those factors – literary, linguistic, artistic – which express them. This way one can gain access to the intimate world of a people and arrive at a constellation of traits which define unequivocally the psychology of a people, a national spirit. It is not enough that literary criticism study the composition of the work and how it relates to canonical precepts; it has the responsibility as well to reveal and comment on the intimate historical reality manifested therein.[10]

A significant number of the canonized works that contribute to our understanding of Spanish culture – works in which a national identity is revealed and which have contributed to the creation of an "imagined community" – are related, in one way or another, to the historiography we have described. They share as a fundamental principle the idea that configurations of the world which define the "spirit of a people" are expressed in language, literature, and art. And they maintain the principle that there exists a national mentality – of Castilian origins – which has been continuous throughout the centuries.

So it is that the emergence and evolution of a nationalist historiography in Spain, which encompassed specific ideas on the relationship between history and culture – of both a political and a purely cultural nature – and which emphasized a Castilian-centered interpretation of Spanish history, engendered the conception of a national culture, providing the framework for the definition of a national identity and the creation of a "nation." Its consolidation and institutionalization are owed to several generations of extraordinary thinkers, writers, poets, painters, and literary and art critics who were absorbed by the "problem of Spain" and the Spanish way of being. They were all intellectuals whose cultural production was aggrandized, who at one time or another were active in important cultural institutions (newspapers and journals, publishing houses, universities, and research centers), and of whom several were at times politically important. In many cases it is clear that their inquiry into Spanish origins had social and political implications, in the sense that they were regenerating Spain by reviving a more promising past.

The national soul-searching in Spain at the turn of the century, was, of course, brought on by the loss of its colonies and a felt inadequacy when

faced by the modernization of the rest of Europe. It was reinforced or influenced, as well, by the European preoccupation with the scientific description and interpretation of national characters and mentalities. The defeats of the Spanish, and of the French and Italians in Sudan and Ethiopia, and the triumphs of Bismarck's Germany and Victorian England led to the diagnosis, in some quarters, of the decadence of the Latin nations and races and the superiority of the others. In any case, there is evidence that the insistence among Spanish intellectuals in this century on the existence of a national character is related to moments of social or political tension during Spain's evolution toward Europeanism: the crisis of the turn of the century, the international community's reaction to the Semana Trágica (Tragic Week) of 1909, the strike of 1917 and its aftermath which led to the dictatorship of Primo de Rivera, the Second Republic, and, finally, the dictatorship of Franco. That is, the invention of the national culture I have been describing is historical–political in inspiration.

Among the most influential contributions to the definition of the Spanish national character, of both individual and institutional origins, one finds Krausist philosophy of history; the "regenerationist" texts of Joaquín Costa, Rafael Altamira and others; the ideas of Unamuno on "intra-history," Quixoticism, and the tragic sense of life; Azorín's sketches of Spanish literature, society, and geography; Ramón Menéndez Pidal's studies on the epic and the middle ages and the school of philology founded by him; the poetry of Antonio Machado, especially *Campos de Castilla* (Fields of Castile); the "Spanish (i.e. Castilian) way of looking at things" which occupies most of Ortega y Gasset's essays on literature and art, as well as his interpretation of the history of Spain; the Spanish school of landscape painting; the work of painters like Ignacio Zuloaga and Darío de Regoyos, and the rediscovery of El Greco and Diego de Velázquez; and the publication of a new series of classical Spanish texts called the "Clásicos Castellanos" – these invented a collective national identity, by identifying a Spanish character and the forms in which it manifested itself in history.

They all shared the belief that there is a sense of unity among Spaniards, not only as a state, but as a people who, beyond local differences, have common interests, ideas, desires, and attitudes which differentiate them from the psychology of other nations. And they affirm the historical originality of Castile as the unifying force of the peninsula and the creator of its culture.

Given their conception of the history of Spain – particularly as it relates to the "internal" history and the question of decadence – and their desire to set guidelines for the regeneration of Spain, it should not be surprising that they seek the origins of the Spanish national character in the middle ages and the sixteenth century. Among the works which best express for them aspects of the Spanish mentality are the *Poema de Mío Cid* (The Poem of the Cid), *El Libro de Buen Amor*, the *Coplas por la muerte de su padre* (Verses for the Death of His Father) by Jorge Manrique, *El Romancero* (ballads), *La Celestina*, the poems of Garcilaso, *Lazarillo de Tormes*, the poetry and prose of the mystics (Santa Teresa, San Juan de la Cruz, Fray Luis de León), paintings by El Greco and Velázquez, the *Quijote*, and Lope de Vega (more specifically *Peribáñez* and *Fuenteovejuna*). The critics viewed these works as examples of what they considered to be the national character.

The characteristics of the Spanish collective identity which are propagated by the cultural artifacts I have referred to, all of which are canonized pieces of Spanish art and literature – and all of which serve to suggest that the appropriate nation–state for Spain would be essentially liberal-democratic, or even republican – can be summarized as follows. First, Spaniards are characterized by an individualism or a sense of independence which leads them to value principles of personal freedom and human dignity and freedom of conscience and thought. For this reason, Spaniards are more spontaneous than reflexive and they disdain conventionality. Because of their individuality, they are not inclined to social solidarity, except where justice is involved. This leads them, at the same time, to a strong sense of equality and fraternity. But Spanish civic-mindedness is characterized by an oscillation between benevolence and generosity, and envy. From this, the conclusion is drawn that since Spaniards do not value the work of others, Spain is a land of precursors.

Second, the Spanish people are essentially democratic in nature, enemies of absolutism of any kind, and, as we have said, respectful of justice. More than in other nationalities, liberal tones have never ceased to resonate in the history of Spain. This democratic spirit has extended from the nobility to the lowest strata of society; as expressed in literature: "a hacer que cada villano pudiese llegar a ser hidalgo" (so that every vassal can become a noble) or "el buen vasallo que no tiene buen señor" (the good vassal who does not have a good lord). On the other hand, this elevated conception of justice often manifests itself in an over-zealous fulfillment of moral codes. However, Spaniards are characterized basi-

cally by tolerance. Spanish fanaticism – or the manifestation of the predominance of form over substance – was due to a violation of the innate mentality, leading to decadence, immorality, hypocrisy and indolence.

Nevertheless, Spaniards do have a spiritual nature, dominated by a way of thinking which does not consider life the supreme good. For this reason, they think about the afterlife, place importance on reputation, and are religious in a general way. The two tendencies associated with the national religious mentality are mysticism – the contemplative knowledge of the divine, but allied with reality – which was at the root of Spanish theology in the sixteenth century, and, on the other hand, what could be called "formalism," or the Roman orthodoxy, to which the Inquisition was subject.

Above all, there abides in the Spanish character a sort of duality – immortalized by Cervantes and the Spanish playwrights of the Golden Age – which gives rise to opposed tendencies: between the spiritual and the sensual, the passionate and the skeptic, the real and the romantic. We find this in the writing of the dominant figures of early twentieth-century Spanish thought, for example, in the alliance between idealism and practicality in José Martínez Ruiz (Azorín); in Azorín's attachment to concrete reality and the melancholy which surfaces from the painful consciousness of the passing of time; in the conflict between faith and reason and the resulting heroism in Unamuno; and in the imagination of El Greco inspired through the historical reality of Castile by an authentic, but contemplative realism, akin to Castilian mysticism.

Finally, we come to the popular and realist inclination of Spaniards: a sort of carefree attitude as opposed to a formal or erudite one. Spanish aesthetics is not contrived; it is founded in popular tradition, expressing the customs and ingenuity of the times. Ortega y Gasset characterizes Spaniards as apathetic toward transcendental ideas. Unamuno says they possess a poor imagination, that they are materialists in the extreme. Spanish culture is almost impressionistic, little given to reflection and abstraction. All of this is associated with the influence on the Castilian mentality of its desolate and inhospitable landscape whose infinite expanses point up human insignificance.

Even if one believes that the definition of a collective national identity is no longer credible in a modern industrial state we must ask whether, in the case of Spain, the so-called cultural masterpieces, thought to reveal the "fantasy" or consciousness of the Spanish people, have in fact become such – that is, become canonized – as part of the invention of a national

culture which is no longer historically viable. If so, we are faced with rewriting cultural history. In addition, it is clear that Spain has been left with a sense of itself which was essentially cultural – and often ontological – in nature, in a state which is no longer centralized and which is, in fact, multi-cultural and in transition. It is, perhaps, in this context that we can best understand the Catalan Jaime Vicens Vives's socio-economic critique of the Castilian-centered interpretation of Spanish history, albeit, I must confess, from the point of view of a Catalan nationalist. His *Historia social y económica de España y América* (A Social and Economic History of Spain and America) was the first work in this century to challenge seriously the established historiography.[11] In the prologue to the second edition (1960) of his *Aproximación a la historia de España* (Towards a History of Spain), he identifies the culturalist Castilian-centered historiography – created, according to him, by personal experiences which led to a fantasized Castile – with a crisis of conscience in Spain from 1898 on, particularly as it became aware of the play of internal contradictions between Castile and Catalonia, which – Vicens Vives argues – provided the vital stimulus to and cohesion for the national state from the eighteenth century on. He goes on to say, however, that it was not necessary to study history in order to explain Spain's inability to follow the path of western civilization toward capitalism, liberalism, and rationalism and Castile's failure to make Spain a harmonious community, at ease with itself.[12]

As I mentioned at the beginning of this essay, the nationalist construct of Castile as Spain has been seriously challenged at different times since the turn of the century, either in the form of efforts at creating nationalist identities in the diverse historic regions, or in the outright rejection of a nationalist self-definition in a modern industrial state with a European and international vocation. Whatever the case, the ideas outlined in this essay are still embedded in the way many understand Spain's cultural identity.

NOTES

1. Andrés Blas Guerrero, *Nacionalismos y naciones en Europa* (Madrid: Alianza, 1994), p. 17.
2. Benedict Anderson, *Imagined Communities. Reflections on the Origin and Spread of Nationalism* (2nd edn., London: Verso, 1991).
3. Ernest Gellner, *Thought and Change* (London: Weidenfeld and Nicholson, 1964).
4. Ernest Gellner, *Nations and Nationalism* (Oxford: Basil Blackwell, 1983), pp. 53–58.
5. Ernest Renan, "Qu'est-ce qu'une nation?" (1882), pp. 889–906 in *Discours et conférences. Oeuvres complètes*, vol. I (Paris: Calmann-Lévy, 1947–1961).

6. Eric Hobsbawm, *Nations and Nationalism since 1788: Programme, Myth, Reality* (Cambridge University Press, 1990), pp. 59–60.

7. Jürgen Habermas, *The Structural Transformation of the Public Sphere. An Inquiry into a Category of Bourgeois Society.* Trans. Thomas Burger (Cambridge, MA: MIT Press, 1991), pp. 1–56.

8. Modesto Lafuente, *Historia general de España* (30 vols., Madrid: Mellado, 1850–1867); Antonio Cánovas del Castillo, *Historia de la decadencia de España desde el advenimiento de Felipe III al trono hasta la muerte de Carlos II* (1854–1888; 2nd edn., Madrid: J. Ruiz, 1910); Rafael Altamira, *Historia de España y de la civilización española* (2nd edn., Barcelona: Herederos de Juan Gili, 1899–1911).

9. José Ortega y Gasset, *España invertebrada* (Madrid: Revista de Occidente, 1921), p. 55.

10. Francisco Giner de los Ríos, *Estudios de la literatura* (2nd edn., Madrid: Suárez 1876). Also in his *Obras completas*, vol. III (Madrid: La Lectura, 1919), pp. 240–242.

11. Jaime Vicens Vives, *Historia social y económica de España y América* (2nd edn., Barcelona: Editorial Teide, 1957–1959).

12. Jaime Vicens Vives, *Aproximación a la historia de España* (2nd. edn., Barcelona: Universidad de Barcelona, 1960).

FOR FURTHER READING

Abad Nebot, F. *Literatura e historia de las mentalidades.* Madrid: Cátedra, 1987.

Aranguren, José Luis. *La cultura española y la cultura establecida.* Madrid: Taurus, 1975.

Beyrie, J. *Qu'est-ce qu'une littérature nationale? Ecriture, identité, pouvoir en Espagne.* Toulouse: Presses Universitaires du Mirail, 1994.

Calhoun, Craig (ed.). *Habermas and the Political Sphere.* Cambridge, MA: MIT Press, 1992.

Díaz, Elías. *Notas para una historia del pensamiento español actual (1939–1973).* Madrid: Cuadernos para el Diálogo, 1974.

Fox, E. Inman. *La invención de España.* Madrid: Cátedra, 1997.

López-Morillas, Juan. *El krausismo español.* Mexico: Fondo de Cultura Económica, 1956.

Smith, A. D. *National Identity.* London: Penguin, 1991.

Teich, M. and Ray Porter (eds.). *The National Question in Europe in Historical Context.* Cambridge: Cambridge University Press, 1993.

3

A cultural mapping of Catalonia

The currently healthy state of Catalan language and culture seems far removed from the pessimism expressed by the poet Gabriel Ferrater in an article entitled, from a quotation by Paul Valéry/"Paul Reboux", "Madame se meurt" ("Madame is Dying").[1] In this article, published in Castilian in 1953 during the height of Franco's power and censorship, Ferrater pronounced Catalan culture dead. According to Ferrater, the Catalan language was also in mortal danger since it was being expressed culturally – by which he meant in the printed word – only in "high" literary texts, chiefly poetry. But spoken Catalan was in everyday use, and we can say, borrowing the words of the later writer and journalist Montserrat Roig, that Ferrater expressed in this article "a fatal divorce between the life of culture and science... and the collective or 'total' life of Catalan society."[2] Time proved Ferrater wrong. In 1976, two decades after his statement, and a mere two months after General Franco's death, Roig could affirm emphatically that "Madame vit encore" ("Madame is still alive") (*ibid.*).

Roig's post-dictatorship optimism is in clear contrast to the pessimism of Ferrater, who committed suicide in 1972 and therefore was unable to see the changes in post-Franco Spain. In the post-Franco era, the hopeless divide that Ferrater saw between cultural (literary representation) and scientific life – which in Francoist Catalonia found expression exclusively in Spanish – and the everyday sphere (or "collective life" in Roig's words) in which Catalan was mostly used, came to seem perfectly negotiable. Montserrat Roig and many other representatives of Catalan culture in the years of political transition saw it as their collective task to bridge this divide. They aimed to end the cultural and scientific isolation of the Catalan language and culture in both the national and the

international context at a moment when democratic freedoms suddenly made this possible.

From 1975 on, both older and younger generations united in a spontaneous movement concerned above all with reconstructing and reconfiguring Catalan national identity. I cannot here detail the intense political and cultural effervescence of those years. Representatives of different generations, tendencies, and ideologies joined forces in a collective desire to demand the open cultural expression of Catalan identity, for so long denied and repressed under Spanish (Castilian) hegemony in general, and under Franco's dictatorship in particular.[3] Examples of this endeavor include: the critical and literary work of Maria Aurèlia Capmany, Terenci Moix, Montserrat Roig herself, Carme Riera, or Pere Gimferrer who, although formerly writing only in Castilian, started in the 1970s writing in Catalan; the songs of Raimon, Lluís Llach, Sisa, Toni Moreno or María del Mar Bonet – who all followed the path originally made at the beginning of the 1970s by Els Setze Jutges, a collective of singers to which some of them had belonged; the plays and performances of new theater groups such as Els Joglars or the Teatre Lliure; the works of Toni Catany or Joan Fontcuberta in photography; the claims of alternative performance spaces and/or advocacy of work done by marginalized groups by, for example, the Barcelonan feminist cooperative La Sal or the Front d'Alliberament Gai de Catalunya (FAGC); or the more canonical work of Xavier Rubert de Ventós, Joan Fuster, Joan Triadú, Joaquim Molas, Josep Fontana or Martí de Riquer in philosophy, linguistics, history, or art.

This dynamic collective desire found formal expression in the 1976 celebration in Barcelona of the Primer Congrès de Cultura Catalana (First Congress of Catalan Culture) in which representatives from local politics, the social sciences, and the humanities met to sketch the first outlines of the cultural politics to be followed in the next few years. Conceived as a space for multi-disciplinary reflection, the Congress presented itself as "an open, academic and popular process, with Catalan roots but sensitive to all cultural initiatives of a universal quality" (Roig, "Catalunya," p. 51; my translation). Following this premise, the Congress considered many areas of study ranging from education to the economy, from the health system to the media, from industrial production to land ownership, and from agriculture to the influence of Catalan culture abroad.

The political realignments that followed Franco's death shaped the revival of Catalan language and culture. After Franco's victory in 1939 the

Catalan Statute of Autonomy, granted in 1932 under the Second Repub-
lic, was overruled; it was reinstated in June 1977 by Adolfo Suárez, the
then prime minister of Spain, who also restored the Generalitat and
allowed its president, Josep Tarradelles, to return from exile. In this
Suárez and his Cabinet were merely responding to the age-old Catalan
demand for cultural and political independence from the central Spanish
government. After the post-Franco political changes that culminated in
the 1982 election victory for a watered-down Marxist party (PSOE) under
the leadership of Felipe González, and in view of the new European
realignments that were starting to shape at that time, Catalonia's polit-
ical aspirations as an independent nation were not seen as urgent or even
necessary. Cultural differentiation from the Spanish central state was
nevertheless another story. Immediately after Franco's death Catalonia
started to claim its space in the united Europe of the future through the
radicalization of Catalan cultural differentiation from the Castilian one.
It did so by coupling differentiation with a universalizing claim that
would allow political partnership with the Spanish central government
if needed, while at the same time giving Catalonia the possibility of
becoming an economic and cultural player in the European market.

 This need for differentiation and universalization was already clear in
the 1976 Congress, and it was also later reflected in 1983 in what is known
as the "Llei de Normalització Lingüística" (Law of Catalan Linguistic
Normalization). The law declared the official status of the Catalan lan-
guage and broadly adhered to a previous 1980 definition on "who is
Catalan," sponsored by prominent Catalan politicians and intellectuals:
"Everyone who lives and works in Catalonia and has the wish to be so and
feels tied to this land, is Catalan."[4] The motto was appropriated in 1982 by
Jordi Pujol, leader of the conservative party Convergència i Unió, and
president of the Generalitat since the first elections to the Catalan Parlia-
ment after the re-establishment of the Catalan government. The law of
linguistic normalization shared the Congress's open spirit and had the
express intention of closing the linguistic divide denounced by Ferrater
through the restoration of a Catalan identity separate from Spanish. In
one sense, the universalizing spirit of the Congress aided the process of
democratic consensus in post-dictatorship Spain and helped to ease the
ancient but still very much alive hostilities between Catalonia and central
Spanish (castellano) power. It helped establish the political viability of Cat-
alonia as a minor nation integrated into a new post-Franco Spain that had
been politically and administratively restructured as a nation–state with

multiple autonomous regions.[5] In another sense, though, the new avenues that the possibility of a united Europe offered for minor nations such as Catalonia reinforced the historical, cultural split between central (*castellano*) Spain and Catalonia while at the same time giving rise to new issues that need to be addressed.

Twenty years after the celebration of the Primer Congrès de Cultura Catalana much has changed. It is clear that Catalonia is currently experiencing the benefits of the politics of autonomy, of the law of linguistic normalization and of the various cultural and economic practices initiated in the first years of post-Franco Spain.[6] Yet at the same time, although Catalonia is relatively well established and positioned within the Spanish state, the relocation of Catalan language and culture needs to pay attention to the new global geopolitical situation of the last few years and to respond to the many issues that this configuration presents.

The universalizing of Catalan culture and identity, simply stated in the 1976 Congress in terms of an ambiguous and generalized desire for "universal cultural influence," has to confront issues then very much unforeseen. At both the national and the international level Catalonia still has the status of a "minor" language and culture. Catalan has a small number of speakers – around six million – and it is confined to a restricted geographic area with a relatively small economic capacity. As such, the global effectiveness of its political and cultural impact is clearly limited. It is therefore impossible to understand the processes of building and protecting Catalan national and cultural identity apart from the national politics of the Spanish state and the geopolitics of the economic culture imposed by the global post-industrial market.[7]

Cultural reflection centered upon Catalonia should attend to the various negotiations, resistances, and accommodations generated by the macro- and micropolitics of current economic and cultural remapping. One of the central questions presented by Catalonia's relocation is how to deal with the ways in which something so abstract and slippery as national identity and/or nationalist desire now circulates. This is particularly important because national identity is no longer used as the banner for ideological self-identity. Market forces in post-industrial Catalonia seem to require the survival of Catalonia as a "nation", determined by its capacity to supply a specific demand in the market. At present, and at least partially, Catalonia caters to the market's demand. Moreover, it not only satisfies this demand, but it also tends to maintain and even generate it. In a process that is inextricable from the demands of late

capitalist interests, "Catalan identity" may quickly become a commodity, an ideological simulacrum that can function strategically and seductively to "sell" or "negotiate" Catalan cultural capital profitably.

The synchronization between the rise of Catalan industry and global post-industrial demand reflects the route followed by western (above all European) cultural capital over the last two hundred years. If, as Fredric Jameson suggests, realism is the form of cultural representation generated or favored by capitalism in its initial stage;[8] and if modernism, as Colin MacCabe (following Jameson) says, is "the attempt, after a loss of innocence about representation, to invent forms which will ... project an interiority onto a future unmediated by any form of commodity," postmodernism is "the full entry of art into the world of commodity production."[9]

This narrative may also help to explain the current processes of cultural use and recycling of Catalan nationalism as a symbolic apparatus. The foundation of modern Catalan nationalism by the romantic/realist *Renaixença* movement coincided with the beginning of the region's industrial boom. Later, Catalan modernism (which includes *modernisme, noucentisme* and *postnoucentisme* movements) responded to the high point of Catalan industrial capital at the turn of the century. Modernism redefined in political terms the cultural proposals outlined in the *Renaixença*, setting strategies of both resistance and accommodation to the industrial class that had initially developed the national Catalan project. The popular revolts of the Setmana Tràgica (1909) (Tragic Week), the anarchist bombings of the Liceu – Barcelona's Opera House – and the foundation of the first socialist collectives, for example, all took place at the height of industrial development, and also participated in the making of modern Catalan identity.

The making of the modern Catalan national sentiment had to negotiate with central (*castellano*) Spanish politics from the *Renaixença* on. It was entangled in them, to the point that only the establishment of the Second Republic in 1931 allowed political space for the Catalan Generalitat government. Likewise, the Republic's defeat in 1939 by Franco's military force also marked the end of Catalan self-government. After the devastating interruption of Franco's dictatorship (1939–1975), Spanish cultural politics of *posfranquismo* gave room to the reconfiguration and reappropriation of Catalan nationalist cultural capital. The symbolic transmission and diffusion of Catalan nationalism brought with it a new demand: nationalists had to abandon their previous ideological

assumptions and adapt, at least partially, to the realities imposed by the circulation of post-industrial capital.

The Catalan *Renaixença*, the first expression of *catalanisme* in the modern sense, is historically located by the Catalan cultural imaginary in 1833, the year of publication of Bonaventura-Carles Aribau's "Oda a la Pàtria."[10] Its early romanticism later evolved, as did its cultural and economic capital, towards a more realist expression of national identity. Examples of this include the theater of Ángel Guimerà and Serafí Pitarra, Narcís Oller's essays, and Jacint Verdaguer's epic religious poetry.[11]

The economic development that made all this possible had its moment of splendor at the end of the century. It is the moment that fully assigns mythical literary qualities to Aribau's poem, and that, in spite of the scarcity of romantic writing in Catalan, rewrites romanticism as a turning point in the making of Catalan nationalism.[12] It is also the moment in which industry, nationalist cultural representation, and the circulation of capital were again implicated in many projects crucial for the formation of Catalan identity.[13] One of these, at the dawn of *modernisme*, was the achievement of Barcelona's urban expansion, known as the Pla Cerdà or Eixample. Another was the celebration of two International Exhibitions in Barcelona: the first Exposició Universal of 1888, and the second exposition of 1929 for which the Montjüich Exhibition Park was built.[14]

The construction of Barcelona's Eixample naturally coincided with the developments and expansions of the great modern cities, from Paris to Chicago, and with the historical moment of industrialism. The grand avenues, with their geometric and symmetrical layouts, the new tall buildings, the electric grids, and the new tramtracks served to express contemporary modernity in architectural and conceptual terms. Though the integrationist and ecological aspects of architect Ildefons Cerdà's initial plans were substantially cut back, Barcelona's urban plan still provided the modern Catalan bourgeoisie with the broad, open urban spaces demanded by the circulation of its new cultural and economic capital.

If the initial Catalan sentiment was politically diffuse, modernism ideologically shaped the *Renaixença*'s formulations with and through an intense educational platform. At the same time, while the *Renaixença* was seen by some as mostly a commercial possibility, modernism and the subsequent avant-gardes formed, simultaneously with instructional and commercial possibilities, "an area of art constitutively opposed to commerce" (MacCabe, "Preface," p. xii), and therefore with no investment in

political education. Oppositional representations in both high and popular cultural production can be seen in all fields as expressions of the conflictive aspects of the period's industrial reality.[15] The rationalism of the Pla Cerdà, for instance, was opposed by the magical and spiritual irrationalism of Antoni Gaudí's work (the Sagrada Familia church being the prime example of such functional impracticality; started in 1882 it is likely to be finished by the year 2020); the light, bourgeois frivolity of Santiago Rusiñol's paintings contrasted with the dark realism of Isidre Nonell or Apel·les Mestre; Dolors Monserdà's militant, workerist proto-feminism *La fabricanta* shared space with the popular, entertaining *petit bourgeois* theater of the versatile Rusiñol; moreover such contrasts can be found even in the same person, as in the case of the writer Caterina Albert ("Víctor Català") whose harsh and extreme realism in her novel *Solitud* (or her short stories in *Drames rurals*) contrasts with the avant-garde experimentation of her second novel, *3.000 m. Un film.*

Catalan nationalist sentiment (*catalanisme*) was strongly shaped by modernism, and especially the *noucentisme* and *postnoucentisme* movements in the 1920s and 1930s, which cashed in on the cultural and economic capital that came out of the *Renaixença*. While the *renaixentista* movement was not highly concerned with theorizing about the relations between culture and economics (and as such politics) present in the circulation of *catalanisme*, the *noucentistes* and their later representatives were very much aware of the need to do so.[16] It is useful to remember that it was not until the beginning of the century that *catalanisme* saw itself as a nationalism engaged in the theoretical and political circuits and discourses then current in Europe.[17] This explains why, for example, as Joan-Lluis Marfany says, "[Catalan] republican nationalism did not group until after 1906" although the majority of the political left continued to perceive *catalanisme* as a "conservative, religious, and reactionary movement" (*Catalanisme*, p. 385, my translation) mostly associated with the political group of La Lliga.

Noucentisme and *postnoucentisme* movements, while not necessarily conservative, religious, or reactionary, were markedly élitist and didactic. Examples include the linguistic codification of the Catalan language proposed by Pompeu Fabra, with his first Catalan dictionary out in 1932; Enric Prat de la Riba's political writings; the proto-fascism of Eugeni d'Ors whose *La ben plantada* offered an outline of the ideal new Catalan citizen (in this case the female citizen, with consequently gendered ramifications and implications); the creation of the group Acció Catalana;

the exquisiteness of Frederic Mompou's music or Josep Clarà's sculptures; the invocation of and claim for Catalonia's Greco-Roman classicism by the poet Carlos Riba and his circle (which included his wife, Clementina Arderiu, and Marià Manent). The popular sector was targeted accordingly: whether in Josep Maria de Sagarra's theater; in Josep Maria Folch i Torres's compilation of Catalan moralizing stories for children; in the creation of the Catalan Boy Scouts (*Escoltes*); in the ongoing work of the choral groups called "Cors de Clave," which had been founded at the end of the previous century and continued their program to impart Catalan national identity through music among the working class; or in the reaffirmation of the *sardana* folk dance as expression of Catalan identity (Marfany, *Catalanisme*, pp. 322–346).

The ideological, political, and pedagogic motivation of such activities contrasted with the direction taken by avant-garde movements. Generally espousing internationalism, the avant-garde often separated itself from the circulation of nationalism. In some ways, and while of course recognizing its differences, there is, paradoxically, a connection between the avant-garde desire for separation from nationalism and the fiercely internationalist politics of the anarchist groups. Curiously, we find in this alternative (and often contradictory) space some of the most well-known "Catalan" artist names. They range in an eclectic pot-pourri from Salvador Dalí and Joan Miró (and also the young Picasso) in painting, to Fructuós Gelabert in cinema. An exception would probably be the avant-garde poet J. V. Foix who always espoused his "*catalanitat*" in exile but has never been well known outside Catalan circles. On the other hand, the internationally recognized 'cellist Pau Casals, although not an avant-garde artist, always presented himself as Catalan while in exile in Puerto Rico.[18]

Such avenues, contradictory or not, were blocked by Franco's victory. The long years of the dictatorship marked a painful struggle for Catalan cultural survival. Though constantly on the verge of defeat, during the Franco years men and women worked together to keep Catalan culture alive. After the harsh repression and censorship of everything Catalan during the 1940s and 1950s, Catalan culture started to reappear in the 1960s, if still in a timid, shaky way. We can list here the work of poets such as Gabriel Ferrater or Salvador Espriú; the creation of the Catalan publishing house Edicions 62 (in 1962), and of the Catalan cultural magazine *Serra d'Or*, both of which published literature in Catalan, either by authors living in Catalonia (Josep Plà, Llorenç Villalonga), or in exile

(Mercè Rodoreda, Josep Carner, Agustí Bartra); the meetings and cultural encounters of Catalan intellectuals in the monastery of the Abadia de Montserrat (Barcelona); the periodic symbolic pilgrimages to the French-Catalan towns of Colliure or Perpignan; and the support given to Catalan culture by a journal such as *Destino* which, though published in Castilian, was of strong Catalanist sentiment.

If we think of the precarious situation of Catalan culture under the Franco regime, its present vibrancy cannot be but amazing. Still, if we accept that modernization was absolutely crucial to the task of the reconfiguration of Catalan national culture, we can therefore not evade its contemporary, post-industrial implications. Just as we cannot speak of the modern without registering, as Jameson says, "the informing presence of a range of other historically novel phenomena . . . [such as] modernization and technology . . . [and] the emergence of mass culture,"[19] so we cannot theorize about the post-modern without considering its new-technology communication systems, and its powerful effects on mass culture. The parameters that molded and propelled Catalan national identity since modernity have now been reconverted and recycled. Current media technology has been in the forefront of the attempt to reconstruct Catalan nationality and identity in recent years.

One only has to look at the most successful cultural products in Catalan in recent years to appreciate the extent to which the present post-industrial paradigm affects, indeed structures, a model of Catalan nationality that is recycled from the previous modern nationalisms. We cannot simply ignore the intimate relation that exists between the social viability of revived Catalan national identity and the global processes of commodification characteristic of our time. As much in literature as in cinema, theater or any other form of cultural interaction (music, television, design, etc.), the production, marketing, and dissemination of cultural products in Catalan or for Catalan consumption now takes into account their potential capacity for insertion into the global cultural market.[20] The channels provided by communication technology can no longer be understood as simple transmitters and disseminators of cultural works or products conceived as "representatives" or as "the voice" of Catalan identity. Nowadays, communication technology forms a structure inextricably linked to the commodity that it promotes. This is likewise the case with Catalan national identity, which is no longer a "historical essence" or "truth" ideologically appropriated. Rather, in the post-Franco era Catalan identity has become a commodity, a product

with characteristics that can be shaped, and as such quantifiable and marketable.

Thus we see a relation between, for example, cultural phenomena as apparently disparate as the decision made in the early 1980s by the then recently established Catalan television station TV3 to broadcast the US series *Dallas* in Catalan, and the performance staged for the opening of the 1992 Olympic Games in Barcelona, under the supervision of the theater group La Fura dels Baus.[21] The international praise for La Fura as much as the popular seduction of the Olympic Games, reflected in each case by high TV audience figures, proved to be functional elements in the political project to diffuse and normalize both a Catalan "essence" (Mediterranean universality in the case of La Fura's performance) and the Catalan language (in the case of *Dallas*'s dubbed transmission).

Events such as these are not without consequence. The social impact achieved by *Dallas* was one of the most important factors contributing to the normalization of the language. The series's success in promoting the popular and massive rebirth of the Catalan language contributed toward the later international presentation of Catalonia in the 1992 Olympic Games as a distinct cultural region, a minor nation located in Europe within the Spanish state. Here we also have to remember the advertising series promoting Catalonia that was printed in international magazines such as *Time* or *Newsweek* during the pre-Olympic months: "[Question]: Where is Barcelona? [Answer]: In Catalonia [instead of 'In Spain']."[22]

The success of *Dallas*, a phenomenon inseparable from its global marketing and media diffusion, ensured popular acceptance of the Catalan language, until then excluded from the major communications media. In a way the series did what had never been achieved before, what Ferrater had considered impossible: it built a (post-modern) bridge between the everyday lives of viewers and the sphere of science. But the "scientific" sphere to which Ferrater had referred in 1953 is nowadays a space occupied by the media and indistinguishable from the post-industrial market. The Catalan project of linguistic normalization and revival of national identity in part complies with and is dependent upon the new global market's demands of commodification and commercialization. It cannot escape the culture of the media to which it remains assimilated and from which it is undifferentiated. It is impossible to understand the initial impact of *Dallas* in all its complexity, nor that of other cultural products that circulate in a similar fashion, without considering this phenomenon in a global context in which politics and culture become

inextricably interlinked. Feeding off each other, both are founded and confounded in what Jameson calls an "immense dedifferentiation of the traditional levels" (*Geopolitical Aesthetic*, p. 25). Catalan cultural politics cannot escape the inevitable process of globalization. They contain, take on, produce, and reproduce the contradictions, resistances and/or accommodations of the post-industrial era, which, again in the words of Jameson, "could be thought of as an immense commodification and commercialization, the virtual completion of the process of colonization by the commodity form begun in classical capitalism" (*ibid.*). As a result it is "impossible to say whether we are here dealing any longer with the specifically political, or with the cultural, or with the social, or with the economic" (*ibid.*, 25–26).

Commercial promotion of Catalan national identity provides us again with an example of this process. On 23 April 1996 the Generalitat government placed advertisements in different languages in widely read European and US newspapers such as the *New York Times*. These publicized to their diverse international readership the Diada de Sant Jordi (23 April), probably the most symbolic of all Catalan national holidays.[23] In these advertisements language, culture, national identity, and the market are profusely "dedifferentiated," to use Jameson's term. To reach the public they target (white, middle class, of European background) with their "I am Catalan" motto and their corollary "so you could be," these paid ads follow the rigid economic lines of global advertising. If these times are definitively no longer those of the lyric, but rather those in which visual communications technology is dominant, it comes as no surprise that the former modern national identity should be reconverted, recycled, and marketed as an image commodity.

Following the success of *Dallas* it was natural that the politics of linguistic and cultural normalization begun in the post-Franco era should have fallen back onto the use of the communications media – especially television – to generate the circulation in Catalan of cultural products destined for the mass market. Catalan television, knowing the success that such series achieved in Spanish-speaking areas, broadcast other series and programs such as game shows, talk shows, and reality shows, mostly bought from US entertainment corporations. Adapted to the local culture and language, they have proved to be extremely valuable for the project of Catalan language standardization.

In literature, the most recent best-selling books also demonstrate the current dedifferentiation between market and cultural politics. This can

be seen in examples such as Maria Mercè Roca's *Secrets de família*, a novel based on the television series of the same name; *Poble nou*, based on a television script by Josep Maria Benet i Jornet; and Josep Maria Ballarín's novels on *mossèn* (priest) Tronxo. Though their subjects are quite distinct, they work as post-modern cultural artifacts. Roca's book narrates the saga of a bourgeois Catalan family in a soap opera format; *Poble nou* gives a nostalgic, super-idealized vision of life in a pre-war, working-class neighborhood of Barcelona; while Ballarín's novel presents the tribulations of a likable *mossèn* turned detective.

To the phenomenal popular success of these products we could also add examples of earlier literary best-sellers such as *Amorrada al piló*, Maria Jaén's erotic novel, or Quim Monzó's stories and short novels. If we also consider the (relatively) high circulation boasted by the Catalan daily *Avui* or the Valencian magazine *El temps*, the healthy audience figures enjoyed by TV3 and TV5 (both Catalan networks), and the many other forms of Catalan expression present in everyday life, everything now seems to point towards a moment of splendor for Catalan letters and culture. Nevertheless, it may be that the miracle of the Catalan resurrection comes at a high price. Apart from Maria Jaén's novel, whose acceptance and rejection are related to other market parameters given its erotic characteristics, we realize immediately that the majority of the works published in the last few years follow a common pattern. A subtle construction is in the making: they present a particular social and historical construct (the recycled modern nationalist values), and they target a huge middle-class audience with no strong political affiliations– although in fact the politics of no participation could be labeled as capitalist, or post-capitalist. The Catalan intelligentsia might stir uncomfortably in their seats when faced with the overwhelming popular demand for products such as *Poble nou, Secrets de família* or *Mossèn Tronxo* – the latter of which, while not written for television, provides ideal material for its commercialization through TV. However, the political and economic role that such products play in the remaking and relocation of Catalan national identity, and in the normalization of the Catalan language, greatly alleviates such discomfort.

The extraordinary revival of Catalan language and culture of the last twenty years is a phenomenon closely linked to the geopolitical repositioning of the new post-modern paradigm. This is how the Catalan revival is understood by Michael Keating in his study of the new politics of nationalism, and he also sees minority languages and cultures as a pos-

sible channel for "social integration and solidarity in the face of the market."[24] Keating sees the space of minority language as a site of resistance against global commodification and de-differentiation, and he explains the politics of linguistic standardization accordingly. For him, the definition of "who is Catalan" as all individuals who "live and work in Catalonia" (*Nations*, p. 126) is linked to the Catalan language, perceived as a political instrument of nation-building forging a common identity, integrating different ethnic communities and facilitating social communication, to sustain social solidarity across barriers of class, race, and religion (*ibid.*, pp. 135–136). Catalan cultural production is implicated with global corporate economic power. Now, at the end of the millennium, Catalonia is no longer the "poor, dirty, sad, hopeless land" described by the poet Salvador Espriú in his moving 1953 poem "Assaig de càntic en el temple." On the contrary, it seems that time has granted Catalonia Espriú's wish to escape to "the North, / where they say that people are clean, / and decent, refined, rich, free, aware and happy" ("Assaig de càntic"; Hooper's translation, *Spaniards*, p. 234). In an era when Europe has to deal with new immigrations from the east and south; when information and communications technology blur former territorial limits; and when the modern nation–states, with their origins in the last century, seem to be disappearing, the issue of "being Catalan" might take an unexpected turn since it is difficult to see how a simulacrum of the nineteenth-century bourgeois nationalist model disseminated through corporate entertainment networks, and in alliance with the corporate global market, will be integrated or understood by new immigrants. Given that Catalonia is allied with the northern countries in the North/South divide, it might prove hard to generate solidarity with the new non-Spanish, non-Catalan dispossessed populations living and working in Catalonia; this is shown by the Diada de Sant Jordi ads, with their appeal to a "white, middle-class, European" public. Reclaiming cultural partnership with the rich, northern countries, the Catalan cultural élite forgot Espriú's powerful call for solidarity:

> and here I shall remain until my death,
> for I too am wild and cowardly.
> And, what is more, I love,
> with a despairing sorrow
> this my poor,
> dirty, sad, hapless homeland.

("ASSAIG DE CÀNTIC"; Hooper's translation, *Spaniards*, p. 234)

To foster solidarity in the face of the global corporate market, a possibility might lie in rethinking Catalonia's historical hybridity, in knowing that culture and language (Catalan language, *la llengua*, a collective *llengua*) has to keep open its collective body in order to fight and survive post-national cultural construction simulacra.[25] If, as Seamus Deane says, "a culture brings itself into being by an act of cultural invention that itself depends on [an] anterior legitimating nature,"[26] this circle of invention and legitimation should now generate a force of solidarity rather than the closed and strongly suspect essentialist circuit stated in claims such as Pujol's "Catalanism is a feeling, a will to be, and from this a will to build a country" (Mercadé, *Cataluña*, p. 139; Keating, *Nations*, p. 128) – a rhetoric that too quickly spirals to an even more suspect "the majority of people who work and live in Catalonia want sooner or later to be Catalan" (Keating, *ibid.*, p. 126).

There are already examples of cultural production in the making in which Catalan language and culture work towards achieving national solidarity based on Catalanism: the popular poetry of the singer Albert Plà, committed to a politics of linguistic contamination; the early stories of Quim Monzó, which point towards the hybridity and fragmentation of the urban post-modern; Jaén's erotic writing, and Lluís Fernàndez's *L'anarquista nu* (The Naked Anarchist), which daringly open up experimental sexual transgressions; the harsh writing of Jesús Moncada or Maria Barbal, both far removed from the nostalgic complacency toward idyllic working classes pervading the market; or, finally, the works of many small alternative theater groups currently working outside the mainstream. Such efforts find an echo in the resistance to commodification long offered by some of the Catalan writers and artists who express themselves in Castilian: from the older authors Juan Marsé, Esther Tusquets, Manuel Vázquez Montalbán, and Juan and Luis Goytisolo, to the new La Cubana theater collective. If Catalan culture assumes its historical hybridity, bilingualism and diglossia, the apparently small question of their inclusion as "full" Catalan artists, as well as the bigger one of how to relocate Catalan culture *vis-à-vis* Spanish multi-cultural and multi-lingual configuration, and in the face of the widespread immigration from north Africa, eastern Europe, and the Middle East present nowadays in western Europe, have to be resolved both with and beyond the issue of language used.[27] Madame is certainly not dead. If a politics of solidarity is to be sought, it is now up to her to keep the option of a Catalan culture open to hybridity, linguistic variety, and resistance to late capitalist commodification.

NOTES

1. Gabriel Ferrater, *"Madame se meurt. . ." Insula* 95 (1953), pp. 12–13. See "Paul Reboux," *Madame se meurt! Madame est morte. Récit historique* (Paris: Flammarion, 1932).

2. Montserrat Roig, "Catalunya hacia el Congrès de Cultura," pp. 50–51 in *Triunfo 676* (10 January 1976), p. 50.

3. The Catalan struggle for independence from Spanish rule had been constant since the union of the kingdoms of Castilla–León and Aragón–Catalonia formalized by the wedding of Isabel and Fernando in the fifteenth century. In 1640 the Catalans and the Portuguese rebelled against the centralizing tendencies of Castile. While Portugal survived as an independent nation in 1665, Catalonia was defeated in 1659. The Catalans made another bid for independence at the end of the Habsburg era. During the bloody War of the Spanish Succession (1702–1713), Catalonia allied with the Austrian Habsburg against the French Bourbon dynasty. The year 1713 marked the end of Catalan hopes for an independent Catalonia. The defeat was followed by intense reprisals. The new Spanish Bourbon king, Felipe V, inflicted a heavy punishment on the Catalans (along with the Valencians and the Aragonese): physically through political assassinations and culturally through abolishing their laws and institutions. The dawn of the modern period in Europe signaled by the Treaty of Utrecht in 1714 quashed Catalan aspirations. Castilian Spain, on the other hand, burdened by imperial and spiritual issues, precariously adjusted to modern demands by trying to complete the cultural and linguistic unification of Spain initiated in the fifteenth century. An example of this Castilian hegemony is the Real Academia de la Lengua Castellana, established by Felipe V in 1713 following strong measures against the other peninsular languages, in the main against Catalan. See John Hooper, *The Spaniards* (Harmondsworth: Viking, 1986), chapter 17.

4. F. Mercadé, *Cataluña: intelectuales políticos y cuestión nacional* (Barcelona: Península, 1982), p. 153.

5. See David T. Gies, "A Country in Spain," *The Wilson Quarterly* (Winter 1994), pp. 70–76.

6. See Josep-Antón Fernández, "Becoming Normal: Cultural Production and Cultural Policy in Catalonia," pp. 342–346 in Helen Graham and Jo Labanyi (eds.), *Spanish Cultural Studies* (Oxford: Oxford University Press, 1995).

7. See Antonio Elorza, "Los nacionalismos en el estado español," pp. 149–168 in *Estudios de historia social* (Madrid: Instituto de Estudios Laborales y de la Seguridad Social, 1984); Antonio Elorza, "Some Perspectives on the Nation–State and Autonomies in Spain," pp. 332–335 in Graham and Labanyi (eds.), *Spanish Cultural Studies*; and Clare Mar-Molinero, "The Politics of Language: Spain's Minority Languages," pp. 336–342 in *ibid.*.

8. See Fredric Jameson, *Postmodernism, or the Cultural Logic of Late Capitalism* (Durham, NC: Duke University Press, 1991).

9. Colin MacCabe, "Preface," pp. ix–xvi in Fredric Jameson, *The Geopolitical Aesthetic: Cinema and Space in the World System* (Bloomington, IN: Indiana University Press, 1992); p. xii.

10. On the importance of Aribau's "Oda a la pàtria" and the role Romanticism played in the construction of modern Catalan identity, see Teresa Vilarós, *"La Renaixença:* Romanticismo y construcción nacional," *Crítica Hispánica* 18 (1996), pp. 81–89.

11. Verdaguer's famous *Canigó* is also linked to the Catholic side of Catalanist movements. A priest (*mossèn*), Verdaguer was the first to reclaim in *Canigó* the medieval monastery of the city of Ripoll as "one of the most expressive scenarios upon which to write the romantic and patriotic myths of the origins of Catalonia." See Juan José

Lahuerta, "Conversadorisme i arquitectura," *Avui. Història.* Supplement (4 January 1996), pp. 9–10. For a more detailed explanation of the links between Catholicism and Basque and Catalan modern nationalisms see Sholmo Ben-Ami, "Basque Nationalism between Archaism and Modernity," *Journal of Contemporary History* 26 (1991), pp. 493–521. For the myths of the origins of Spanish nationalisms, see Elorza, "Los nacionalismos."

12. The poet Joan Maragall was one of the leading voices in favoring romanticism as historically essential for an understanding of the Catalan nation. See for example Manuel Jorba, "La renovació i la llengua," *Avui. Història.* Supplement (4 January 1996), pp. 8–9.

13. One of these projects was the support given to the Jocs Florals, literary competitions associated with the conservative bourgeois nationalist ideology.

14. Eduardo Mendoza's *La ciudad de los prodigios* (Barcelona: Seix Barral, 1986) speaks volumes on the question of the post-modern recycling of the former modern nationalist projects. Not coincidentally, the novel – published before the Barcelona Olympics – prefigures the 1992 games in its portrayal of the Universal Exhibitions of 1888 and 1929. The importance of the 1929 Exposition is also evoked in Jaime Gil de Biedma's poem, "Barcelona ja no és bona, mi paseo solitario en primavera."

15. See Stephanie Sieburth, *Inventing High and Low: Literature, Mass Culture, and Uneven Modernity in Spain* (Durham, NC: Duke University Press, 1994).

16. Joan-Lluis Marfany, for example, states that "up to the very end of the last century, that is to say, until the birth of Catalan nationalism as such, *catalanisme* was only a movement to defend the Catalan heritage." *La cultura del catalanisme* (Barcelona: Empúries, 1995), p. 353 (my translation).

17. See Arthur Terry, "Catalan Literary *Modernisme* and *Noucentisme*: From Dissidence to Order," in Graham and Labanyi (eds.), *Spanish Cultural Studies*, pp. 55–57.

18. Joan Miró has often been considered (erroneously) a French painter in many non-Spanish art catalogues and encyclopedias. We have to remember that it was in the 1960s, well past Miró's prime, when the Catalan intelligentsia capitalized on the painter's *catalanitat*. Miró did not object. From then on, he has been appropriated as a symbol for the new Catalonia of the post-dictatorship years. It is not surprising, then, that one of his designs is being used as a logo by the Caixa de Pensions per a la Vellesa i d'Estalvis, a major Catalan bank.

19. Fredric Jameson, "Modernism and Imperialism," pp. 43–66 in Terry Eagleton, Fredric Jameson, and Edward Said (eds.), *Nationalism, Colonialism, and Literature* (Minneapolis, MN: University of Minnesota Press, 1990), p. 44.

20. Another example here would be the designs of Xavier Mariscal, which embody the post modern differentiation between art and market. On commodification, see the works of Fredric Jameson.

21. See Richard Maxwell, *The Spectacle of Democracy: Spanish Television, Nationalism, and Political Transition* (Minneapolis, MN: University of Minnesota Press, 1995), chapter 4.

22. Ignasi Arigay, "I am Catalan," *Avui* (10 April 1996), p. B1.

23. See Ignasi Arigay, "Mil llibreries s'apunten al primer Sant Jordi internacional," *Avui* (10 April 1996), p. B1.

24. Michael Keating, *Nations against the State: The New Politics of Nationalism in Quebec, Catalonia, and Scotland* (New York: St. Martin's Press, 1996), p. 221.

25. Hybridity is in fact an inescapable issue for an understanding of Catalan culture through history. In *The Spaniards* John Hooper reminds us that already in the middle

ages, "there was Ramón Lull, the multilingual Majorcan missionary who opposed the Crusades and put forward the theory that the earth was round, and Anselm Turmeda, a renegade Franciscan who converted to Islam and is regarded as a saint in North Africa" (p. 235).

26. Seamus Deane, "Introduction," pp. 3–19 in Eagleton, Jameson, and Said (eds.), *Nationalism*, p. 17.

27. After all, Catalan writers writing in Castilian such as Francesc Candel and Jaime Gil de Biedma were among the first to offer Catalonia to immigrants coming from the south of Spain. See for instance Francesc Candel, *Los otros catalanes* (Madrid: Península, 1965) and Jaime Gil de Biedma, "Barcelona ja no és bona, mi paseo solitario en primavera," in *Las personas del verbo* (Barcelona: Seix Barral, 1982), pp. 79–81.

FOR FURTHER READING

Balcells, Albert. *Catalan Nationalism: Past and Present*. Trans. Jacqueline Hall. New York: St. Martin's Press, 1996.

Cahner, M. "Identidad catalana y/o identidad española," in José Luis Abellán (ed.). *El reto europeo: Identidades culturales en el cambio de siglo*. Madrid: Editorial Trotta/Asociación de Hispanismo Filosófico, 1994.

Capmany, María Aurelia. *¿Qué diablos es Cataluña?* Madrid: Ediciones Temas de Hoy, 1990.

Díez Medrano, Juan. *Divided Nations: Class, Politics, and Nationalism in the Basque Country and Catalonia*. Ithaca, NY: Cornell University Press, 1995.

Hansen, Edward C. *Rural Catalonia under the Franco Regime: The Fate of Regional Culture since the Spanish Civil War*. Cambridge: Cambridge University Press, 1977.

Hughes, Robert. *Barcelona*. New York: Knopf, 1992.

Johnson, Hank. *Tales of Nationalism: Catalonia, 1939–1979*. New Brunswick, NJ: Rutgers University Press, 1991.

Laitin, D. "Language and the Construction of States: The Case of Catalonia in Spain," *Politics and Society* 22 (1994), pp. 5–29.

Molas, Joaquim, Manuel Jorba, and Antònmia Tayadella (eds.). *La Renaixença: Fonts per al seu estudi (1815–1877)*. Barcelona: Universidad de Barcelona and Universidad Autónoma de Barcelona, 1984.

Samso, Joan. *La cultura catalana: Ente la clandestinitat i la represa publica*. Barcelona: Publicacións de l'Abadia de Montserrat, 1994.

Sole i Sabater, Josep Maria. *Cronologia de la repressió de la llengua i la cultura catalanes (1936–1975)*. Barcelona: Curiel, 1993.

4

The Basque Country

54 The Basque Country has two of the most studied sites in modern
Spain: Mondragón and Rentería. Yet they are usually studied with very
different purposes in mind: in the case of the Mondragón Corporación
Cooperativa (MCC), the object of study is a world-famous industrial and
banking cooperative, anxiously scrutinized by business experts from
north America and Japan, much as Spaniards once admired the Altos
Hornos de Vizcaya foundries, now being dismantled. In the case of
Rentería, a radical town on the outskirts of San Sebastián – the provincial
capital of Gipuzkoa – with putrid river and matching atmosphere
caused by a Spanish government paper factory, the story bodes well for
no one. Here harried political scientists and sociologists, Spanish and
foreign, still labor, often at the behest of the Spanish government, to dis-
cover why Gipuzkoan towns like Rentería, Hernani, and Oyarzun are
still unmanageable at the end of Spain's long post-Franco Transition to
democracy.
 Indeed, not much sense can be made of the Basque Country or its
extraordinarily vibrant present-day politics and cultural ferment unless
equal weight is given to the economic success of the Mondragón Cooper-
ative – as opposed to Basque heavy industry and fisheries – and to the
incoherence of Basque nationalist politics as reflected in Rentería,
Hernani, Bilbao and San Sebastián.[1] For in the Basque Country, that is,
the provinces of Alava, Vizcaya, and Gipuzkoa, which make up the
Basque Autonomous Community (or CAV), there is both an unusual
concentration of old money and high-tech business acumen and of
radical Marxist–Leninist Basque nationalism, spearheaded by Herri
Batasuna (or HB). The latter is the coalition that *within* the new system of
Spanish political parties fronts for the Basque terrorist organization,

ETA (Euskadi ta Askatasuna), whose goal is an independent nation–state of Basque-speakers separate from both Spain and France.

Perhaps the CAV, or "Euskadi," as it is generally called, is best described today as an enigma wrapped in a double paradox. The enigma is provided, naturally enough, by the antiquity of the Basques themselves and their language, Euskara. But the difficulty lies with the enveloping paradoxes: for the first is that a terrorist organization is currently fighting for independence for what is already a semi-independent state – with its own President, Parliament, and police force – according to the Spanish constitution; and the second is that in this state of Euskadi the dominant political force is Basque nationalism, although less than half its citizens are Basque nationalists.

Whereas industrial Bilbao, the capital of Vizcaya, is still the fiefdom of the Basque Nationalist Party (PNV), in Gipuzkoa Herri Batasuna would certainly dominate if the PNV, which split apart in 1986, had not been able to turn to the Partido Socialista de Euskadi – Partido Socialista Obrero Español (PSE–PSOE – Basque Socialist Party–Spanish Socialist Workers' Party). Even so, with the violent support of ETA, HB manages to control politics in San Sebastián, even though the right recently won a surprise victory there for José María Aznar's reformed Popular Party (PP). Certainly one of the major contradictions of the democratic Transition in Spain is that a violent anti-establishment coalition like Herri Batasuna can even stand for elections, let alone dominate. Yet what concerns Basque non-nationalists even more is why both the PNV and the splinter party, Eusko Alkartasuna (EA), seem intentionally to coddle this radical Basque nationalist minority (about 10 percent of the population), allowing it to terrorize and bully the rest of the citizenry – including their own new Basque police. Because the result is to bring the entire CAV – for the problem affects all of Euskadi – to the brink of chaos, even to the point where the survival of Basque nationalism itself is threatened.

For what, in the early Transition, was a sentimental or patriotic attachment to the all but independent Basque Republic of the Civil War is fast becoming its outright rejection by over half the Basque citizens. In fact, urban and rural Basques are fast becoming disenchanted with radical *and* conservative Basque nationalist politics, since today both seem responsible for the civil disorder caused by HB's tactics of provoke and destroy. Such nationalist-associated disorder has caused the deterioration of the nostalgic communitarian ideal of a Basque "Nation," once projected beyond the Basque "State" already achieved in 1979. These

are the jagged edges of the Transition with which students of Euskadi must now deal.

Before Franco's death in 1975 it was possible, even customary, for foreigners to cross the French–Spanish border at Irún, visit lovely San Sebastián and head south for Madrid and Granada, without recognizing any distinctive signs of what is today known as Euskadi, an historically different region of Spain with – for its radical nationalists – inalienable aspirations to independence. This was because of a Francoist repression so severe that virtually all signs of sub-national identity had been erased. But this effort at the homogenization of Spain's age-old differences finally backfired, for in the late 1960s it provoked the violent reaction that today often seems close to being a matter of life and death for the new Spanish democracy.

To understand the Transition in the Basque Country one must go back in history to the Restoration of the monarchy in 1874, which laid to rest both Carlism (an arch-conservative monarchist movement) and Foralism (historical rights which granted a distinct legal and fiscal system to the Basque Provinces) and opened the Basque Country to liberalism, industrialism and Basque, instead of Spanish, nationalism. Once we have reviewed some of the salient features of modern Basque history and politics, we can proceed to examine the way Basque nationalism, in both its Christian Democratic and its radical strains, has become the driving force behind the contemporary Basque cultural resurgence.

A measure of the political ambiguity surrounding the Basque Country is symbolized by its modern lack of definition as a geo-political entity. Bordering the Bay of Biscay, it runs northeastward as far as Bayonne (France) and westward to Bilbao (Spain), and it also extends inland some 200 km. Thus, in theory its area is about 20,000 km², and it would contain roughly 2.4 million persons (90 percent of whom live on the Spanish side of the Pyrenees); it would also comprise up to seven provinces (if Navarra were included):[2] their names in Basque are Gipuzkoa, Bizkaia, Araba, Nafarroa, Zuberoa, Nafarro Behera and Lapurdi. But half of the alleged Basque territory is in France, and Spanish Navarra has little interest in belonging to the CAV. Naturally, most Basque nationalists would love to annex the neighboring foral community of Navarra, which is almost as large as the whole of the present Basque autonomous community – which comprises only Gipuzkoa (Guipúzcoa), Bizkaia (Vizcaya) and Araba (or Alava). While the actual CAV is mountainous and deceptively verdant although not particularly

fertile, the southern three-quarters of Navarra are as productively arable as the best of the Castilian *meseta*. Thus what nationalists would like to call Euskadi and Euskalherria is not only divided by the Pyrenees, the French–Spanish border, and the Cantabrian mountains, but also by the Basque language (Euskara), the wariness of the *navarros,* who have twice voted not to be Basque, and by the Basque nationalists' ambiguously exclusionary politics.

Thus, like Catalonia, Galicia, and Navarra, the CAV enjoys – if that is the word – a special relationship with the Spanish state. It also exemplifies to perfection the modern socio-political effects of Spain's problematic unification in the eighteenth and nineteenth centuries as a state and as a nation. According to Juan Linz the tensions manifest today between Spain's center and its periphery – whether in the form of President Pujol's self-serving support for the Socialists, or state counter-terrorism against Basques – are less the result of the centrifugal pull of Spain's micro-nationalisms – especially Catalonia and the Basque Country – than of Spain's historical failure to assimilate them entirely. In Linz's view, Spain exemplifies "the early creation of a state where the political, social and cultural integration of its territorial components – its nation-building – was not fully accomplished."[3]

Unfortunately in the democratic Transition the continuation of what Ortega termed Spain's chronic national "invertebration" ("lack of backbone") is now being duplicated within the historical nationalist communities. That is, the failure of nation- (as opposed to state-) building by Spain's governments – to use Linz's distinction – that caused the tensions between center and periphery in the first place can be seen replicating itself in the recent failure of the PNV-controlled Basque autonomous community to assimilate or at least tolerate its own diverse nationalist and non-nationalist elements, so that while on the larger scale of the nation–state, the Basque Country is causing the Spanish government deep distress, within the Basque autonomous community the failure of the once hegemonic PNV to convince and assimilate all its citizens has similarly created severe civic division and political ambiguity in the CAV.

This situation has arisen because, somewhat as happened fifty years earlier in Catalonia, the patrimonial control of nationalism has passed downward from the *haute bourgeoisie* to the middle and professional classes. Thus, a violent new rival protagonist has appeared to contest conservative Basque Nationalism: the radical Marxist–Leninist Movement for the Liberation of the Basque Nation (MLNV) (comprising ETA, HB,

KAS [Nationalist Socialist Coalition] and LAB [Commission of Patriotic Workers]) which once liked to compare itself with the Third World revolutionary movement in Algiers. This post-1978 competition between rival nationalist groups to hold on to or appropriate essentially the same political, ethnic, and cultural symbols explains the political turmoil but equally the cultural effervescence that characterizes Euskadi today. When the struggle for identity concerns opposing interpretations of the same nationalist symbols, differences are inevitably a mere matter of emphasis.

The background for this competition was prepared early in the Restoration when the cessation of the last Carlist War (1876) made possible the rapid industrialization of the region; but this surge in development was even easier because of an infrastructure of mines, iron works, and fisheries that dated back to pre-Roman times. Antonio Cánovas del Castillo's law of 21 July 1876 indeed put paid to Basque foral privileges. Yet the Basque industrial bourgeoisie and Basque liberals were soon working together to wrest regional fiscal autonomy from the Spanish government in the form of Conciertos Económicos.

Into the space created by the loss of Basque foral privileges and the strong sentiment attached thereto stepped Sabino Arana (1865–1903), the father of Basque nationalism. He converted an existing consciousness of ethnic and cultural difference into a political force that emphasized race, language, religion, and customs, as well as an invented historical difference and character.[4] By closely associating his nationalism with Catholicism and a rejection of an imagined Spanish domination, Sabino Arana made it difficult for liberal and conservative Basque industrialists to espouse openly his Nationalist cause. That both groups would eventually need to do so was inevitable. For what Sabino Arana's PNV would manage to do was transform completely the Basque region by providing it with a different and politically useful self-awareness and coherence. According to Juan Pablo Fusi, the salient features of this transformation of the Basque region were: (1) the assertion of its right to constitutional and legal recognition as a distinct political entity; (2) the civic education of its population through electioneering and the gradual eradication of *caciquismo* (top-down political leadership); and, finally, (3) the improvement of corrupt municipal and provincial governments with regard to efficiency and responsiveness to local needs, such that the PNV came to be viewed, in this respect, as "a renewal of the foralist spirit" (cited in García, *Nacionalismo vasco*, pp. 36–37).

Meanwhile, in the late nineteenth century, the great Basque banking, shipping, and industrial dynasties – Chávarri, Urquijo y Ussía, Aznar, and Ibarra – began to intervene directly in Restoration politics to protect their commercial and banking interests. During the late Alfonsine monarchy, members of the Vizcayan Basque *haute bourgeoisie* themselves became deputies and senators through the good offices of *caciquismo*, as in the rest of Spain. The difference, however, was that the Basque oligarchy used *caciquismo* against the central government. When universal suffrage arrived in 1890, Basque liberals also began, infrequently, to win elections. It was the Basque Socialists' advance, built on immigrant votes from the Vizcayan mines, that caused real alarm among Basque industrialists. After organizing mining strikes in Vizcaya, the Socialist Facundo Perezagua led the PSOE to its first Spanish victory by winning four seats in the Bilbao municipal elections. The Socialists also made small electoral advances in Gipuzkoa – in industrial Eibar and Deva.

Because of its neutrality, Spain – especially the big industrialists of Barcelona and Bilbao – reaped huge benefits from the First World War. Yet when the central government tried to legislate for a more equal distribution of this wealth, the Catalan and Basque oligarchies discovered the joint political power latent in their respective nationalist strategies. This brought results that were reflected in the Bilbao elections of 1917, when Mario de Arana was elected the first Nationalist mayor. Although Ramón de la Sota, son of the leading Vizcayan industrialist, was also elected President of the Vizcayan Provincial Diputación, middle-class Nationalists now began replacing the industrial aristocracy as the leaders in local politics. Indeed, in 1918 the Nationalists even decided to present candidates for election to the Cortes in Madrid. The Nationalist successes in Vizcaya displaced the Spanish-oriented Vizcayan Monarchists so that the latter considered a pact with the Socialist leader and prime minister Indalecio Prieto, in order to maintain a Spanish presence in Vizcaya against the Nationalist tide (García, *Nacionalismo vasco*, p. 47). Thus with the more liberal Nationalist Ramón de la Sota heading the Diputación and the conservative Aranista Nationalists dominant in municipal politics, Nationalist values were decisive in the creation of a largely Vizcayan, Bilbao-centered, Basque culture of the 1920s, which spread outward to Gipuzkoa and Alava.

This recently invented, and today seemingly "timeless" Basque Nationalist culture was ever a contradictory amalgam of the exotic – Catalan *art nouveau* manors in Hernani, a neo-Tudor summer palace in

San Sebastián – and the provincial – the *baserritarra* (tenant farmer) and the *arrantzale* (commercial fisherman) as heroic icons, the modernized *baserri* (family farmhouse) as a symbol of inter-class communitarianism. Still, all these modern – architectural, artistic, and imaginary – cultural markers were created to lend a spurious authority and emotional weight to the political and social designs of an ultimately upper- and middle-class Basque Nationalist intelligentsia as it worked to secure the benefits of industrial and political power from the Spanish government – whether Monarchist, Republican or Socialist – and its local representatives.

Since the modern history of the Basque Country is typically viewed as a series of ruptures with an idyllic past, such as the loss of foral privileges in 1876, the too-rapid modern industrialization and the invasion of immigrant labor for the Vizcayan mines, the Nationalists' political ideology of post-romantic nostalgia focused on the isolated farmhouse as a nuclear symbol of a lost purity. Thus the *baserri* (or *caserío*) and its culture – ironically, a last bastion of the Spanish monarchy – became the controlling icon for an "endangered" Basque difference. This is why artists were soon depicting the traditional *baserri* as a white-washed exterior and a red-tiled roof, set atop a bright green knoll – incidentally replicating the colors of the *ikuriña* or Basque National(ist) flag. Of course, the real *baserri* and its often abject inhabitants were traditionally Spanish monarchists and later Carlists, only becoming Basque Nationalists in the 1970s and 1980s. The farmhouses in which these Basque *tenant* farmers lived were rarely whitewashed and frequently so smoke-filled that humans and animals cohabited in unpleasantly fetid conditions.[5] As Imanol Agirre says of the genre painting of the Zubiaurre brothers (Ramón and Valentín), the *baserri* – as *summa* of Basque Nationalism – while perhaps not present in every picture, is the ultimate referent of all depictions of (rural) Basque life. It symbolized economic self-sufficiency, social equality, rootedness in the Basque earth, and the site where Euskera, the mothertongue and national language, was preserved, spoken, and passed on from generation to generation (Agirre, "Metáforas," pp. 145–146).

From such sentimental and ideological beginnings it was a small step to the architectural promotion of this imaginary Basque farmhouse as prototype for the first and second homes of the upper middle-class Basques. That is, the ideological connotations of the *baserri* became part of the conservative Nationalist idiom that stood opposed, according to Imanol Agirre, to both the international and the modernist styles. For the

Basque Nationalist Party eventually convinced even rural Basques to accept what Agirre calls the "retraditionalization" of their domestic architecture (*ibid.*, p. 156). Thus, an indigenous "Basque style," based on the Lapurdi variety of farmhouse, came into vogue and was promoted by Nationalist architects such as Henry O'Shea and Pedro Guimón. Even today formal echoes of this "classic" *baserri* now reduced to abstract decoration adorn the housing projects that encircle San Sebastián.

A similar story of the appropriation and instrumentalization of Nationalist symbols pertains in the case of the Basque language, remarkable for its ancient non-Indo-european origins, and precious to Hispanists because it combined with Latin to produce the Castilian language. But Euskara, unlike Catalan, had a sparse written, and virtually no secular literary, tradition, being primarily spoken in modern times by farmers and rural clergy, and rarely in the liberal urban centers of Bilbao and San Sebastián. Thus it was indeed the genuine patrimony of the farmer or recent immigrant to the city, and a vehicle for a rich oral culture. It was ironic, therefore, that Euskara, which for centuries had effectively kept Basque peasants from participating in the Castilian-speaking Spanish national culture, should become the touchstone of Basqueness.[6] Yet in the late nineteenth century Basque itself became a symbol of lost foral autonomy for writers and historians like Arturo Campión and Juan Iturralde, and for other members of the Asociación Euskara de Navarra, founded in 1877. Indeed, these writers originally coined the name Euskal Herria (Community of Basque-Speakers). Sabino Arana had avoided this designation because it excluded Basques like himself who had been deprived of their native language and must learn it. He preferred the names Vasconia, Euskeria, Bizkaia, and finally Euzkadi, for the Basque nation, which were political rather than restrictively linguistic in nature.[7]

Now we come to the repressive Franco years, years that provoked the creation of a second competing Basque nationalist identity, one which in its turn reinterpreted the Nationalist cultural symbols from a radical revolutionary perspective. The Basque government in exile, controlled by the Basque Nationalist Party, could only look on as former members of its own youth group (EGI) created ETA in 1959, at first mainly Nationalist in orientation, but then Marxist–Leninist and Nationalist. This new, radical nationalist movement (ETA), according to specialists, was the byproduct of Sabino Arana's ideology and of an indiscriminate Francoist repression.[8]

If we realize that between 1956 and 1975 martial law was declared in all of Spain four times, but also an additional seven times solely in the Basque Country, it is easier to imagine the police repression that was visited on native Basques and new immigrants alike.[9] The struggle that ensued against this military and police repression did much to forge a new popular Left Basque nationalism, which gradually began to appropriate many of the patrimonial signs of the older Basque Nationalist identity. Naturally, the new Basque nationalists struggled to revive the Basque language, since it was Franco's policy to eradicate all fundamental signs of cultural difference. Thus Euskara, which survived in the public sphere thanks to the sermons of a politically active Basque Nationalist clergy, served as the matrix for a semi-clandestine Basque-language school movement.

However, once the democratic Transition began, and the Basque Nationalist Party realized how much it had to gain by working within the extremely generous new democratic system, the extra-establishment radical Basque movement was forced to develop a distinct nationalist coloration of its own. Thus, from the fading memory of ETA's armed resistance to Franco, and from elements of Sabino Arana's original Nationalist creed, the Basque nationalists pieced together a radical nationalist identity. This featured a new anti-colonial version of Arana's virulent anti-Spain posture, and an insistence that the Basque language and the Basque nation were consubstantial, which automatically excluded the majority of the population that spoke little or no Euskara. Thus ETA and Herri Batasuna became the endogamic nucleus of a grass-roots movement that demanded – among other things – independence from both France and Spain and that articulated the unintelligible notion that present-day Euskadi was a country occupied by two foreign powers.

Unfortunately, since neither the PNV nor EA can bring themselves unequivocally to renounce the notion of independence from Spain, they cannot escape association in the minds of Basque non-nationalists with an ETA terrorism that today is also directed against the Basque Country itself – including the newly commissioned Basque police. This is why Basque nationalism, both conservative and Marxist–Leninist, has been forced to make way first before a large Socialist vote, and more recently before a significant vote for the Partido Popular, which narrowly defeated the Socialists in the national elections of 1996.

Despite the ETA violence that the Basque Country shares with the Spanish state, and its own civic disorder generated by the juvenile cadres of HB in Bilbao, San Sebastián, and Vitoria, Euskadi remains the center of

a genuine and far-reaching cultural ferment that is exceptional in Spain. Although the Basque government is reluctant to bring a greater measure of civil order to the daily lives of its constituents, nonetheless tourists and citizens enjoy international jazz and film festivals, and "Hard Protest" rock and pop musical groups like the political Negu Gorriak (formerly Kortatu) and the melodic Duncan Dhu. The new Basque cinema is outstanding, for its combination of a new thematics, original directors – Imanol Uribe, Montxo Armendáriz, Julio Medem – and excellent actors and actresses. Basque sculpture is also noteworthy and is dominated by Eduardo Chillida, Jorge de Oteiza, Agustín Ibarrola, and Andrés Nagel, all of international reputation. Yet it must also be said that the Basque government's cultural politics, as is natural, does considerably more to support Euskara-related projects than Castilian-language ones. This cultural non-support also affects Castilian-language Catalonian writers. But in Euskadi, where a Basque *cantautor* can be threatened by ETA followers for singing in Castilian, xenophobia can have tragic consequences.

Finally, together with the renown of the Mondragón Cooperative and cultural firsts like Frank Gehry's new Guggenheim Museum in Bilbao, Euskadi has enjoyed an unexpected international success in prose fiction. While there are leading Castilian-language Basque writers like Fernando Savater, and while good novels have also been written in Euskara by Ramón Saizarbitoria, Arantxa Urretavizcaya, and Ángel Lertxundi, the trajectory of Bernardo Atxaga's career summarizes to perfection the perils of present-day Basque society, precariously suspended between an ancient traditionalism and the high-tech world of the European Union.

Born Joseba Irazu Garmendia in the minute Gipuzkoan village of Asteasu, Bernardo Atxaga surprised first readers of Euskara, then Castilian, and finally, an international audience with his novel *Obabakoak* (1988), a sequence of linked stories combining reinvented Basque oral traditions with new readings of European and Near Eastern literary tales. Although Bernardo Atxaga has also written fine children's books, poetry, and song lyrics, his unexpected international success with *Obabakoak* proved that the Basque language could produce a work worthy of an Italo Calvino or a José Saramago. However, instead of continuing to surpass himself, Atxaga has since written two quite different novels – *El hombre solo* (Man Alone, 1993) and *Esos cielos* (Those Skies, 1996). Both deal with the militant sub-culture surrounding ETA, and while they have been well received in Spain and abroad, neither garnered the rave notices of his first major success. Although these novels do address the problem of ETA, Atxaga's lyrico-realistic focus so removes them from the current

civil strife in Rentería and elsewhere that he might as well be writing about the Carlist Wars. Moreover, by contrast with his profound and whimsical *Obabakoak,* his latest novels seem less, rather than more, weighted with the resistance of daily life. This suggests that Atxaga's fascinating work may be in danger of being overtaken by the disruptive daily reality of Basque civil society.

NOTES

1. I will use Nationalist with a capital "N" to refer specifically to the politics of the Basque Nationalist Party (PNV), but with a small "n" when I refer to the general attitudes and policies the former party shares with other political groups such as Eusko Alkartasuna (EA) and Herri Batasuna (HB), the ETA-supporting coalition controlled essentially by ETA–KAS (that is, Euskadi ta Askatasuna–Koordinadora Albertzale Socialista [Basque Land and Liberty–Nationalist Socialist Coalition]).

2. The area which constitutes the Basque Country is disputed; some observers include the Navarra region, others do not.

3. Juan Linz, "Early State-Building and Late Peripheral Nationalisms against the State: The Case of Spain," pp. 32–116 in Shmuel Noah Eisenstadt and Stein Rokkan (eds.), *Building States and Nations,* vol. II (Beverly Hills, CA: Sage Publications, 1973), p. 33.

4. Fernando García de Cortázar and Manuel Montero, *Historia contemporánea del País Vasco: De las Cortes de Cádiz a nuestros días* (San Sebastián: Editorial Txertoa, 1995), p. 35.

5. Imanol Agirre Arriaga, "Metáforas espaciales del imaginario vasco: Una ejemplificación antropológica del espacio como trama narrativa en el arte moderno vasco," thesis directed by Mikel Azurmendi Intxausti (Departamento de Valores y Antropología Social, Universidad de San Sebastián, 1993), p. 165.

6. See Mikel Azurmendi, *Nombrar, embrujar (Para la historia del sometimiento de la cultura oral en el País Vasco* (Irún: Alberdania, 1993).

7. Mikel Azurmendi, "Tres cuestiones de los abertzales que nos afectan a los vascos." Unpublished article. I am especially indebted to Professor Azurmendi for his comments on the present essay.

8. José Luis Granja Sainz, *El nacionalismo vasco: Un siglo de historia* (Madrid: Tecnos, 1995), p. 18.

9. Luis C. Núñez, *La sociedad vasca actual* (San Sebastián: Editorial Txertoa, 1977), p. 126.

FOR FURTHER READING

Azurmendi, Mikel. *La herida patriótica.* Madrid: Taurus, 1998.

Corcuera Atienza, Javier. *Orígenes, ideología y organización del nacionalismo vasco, 1876–1904.* Madrid: Siglo XXI, 1979.

Fusi, Juan Pablo. *El País Vasco. Pluralismo y nacionalidad.* Madrid: Alianza, 1984.

García de Cortázar, Fernando. *El nacionalismo vasco.* Madrid: Historia 16, 1991.

Juaresti, Jon. *El linaje de Aitor. La invención de la tradición vasca.* Madrid: Taurus, 1987.

 El bucle melancólico. Historias de Nacionalistas Vascos. Madrid: Espasa – Calpe, 1997.

Martínez Gorriarán, Carlos, and Imanol Agirre. *Estética de la diferencia.* Irún: Alberdania/Galeria Altxerri, 1995.

II

Culture and history

5

History, politics, and culture,
1875–1936

The so-called Restoration of 1874–1875 did not exactly restore the
situation of any former regime. Only from a sociological point of view
did it restore, and even strengthen, the rule of the "Moderado" power
block, formed in the 1840s as an amalgam of the old nobility, new land-
owners enriched by the disentailment of the church's lands, urban
developers, Catalan textile industrialists, politicians and military
upstarts. Alfonso XII's reign was a continuation of his mother's in this
sense alone. Politically, the troubles which had characterized not only the
rule of Isabel II but the whole of the first three-quarters of the nineteenth
century, reaching a climax during the 1868–1874 revolutionary period,
came to an end. What ensued was what Pérez Galdós called "los años
bobos" (the foolish years), years without events. These resulted not only
from the strongly authoritarian, almost dictatorial, hand of Antonio
Cánovas del Castillo, but also from the loss of prestige of the revolution-
aries and to the exhaustion of the people, which after so many political
upheavals welcomed the stability of the Restoration.

Cánovas's initial efforts were geared towards victory in the internal war
against the Carlists and in the colonial war in Cuba, and he was successful
in both although it took three years to conclude the latter. He then man-
aged to confine the military to their barracks, in exchange for internal
autonomy in the administration of their own affairs, *carte blanche* in rela-
tion to the remaining colonies, and a few honorary seats in the Senate. As to
his political opponents, he drew a clear line between those who were and
those who were not willing to accept the rules of the game he had estab-
lished. The former were granted freedom to associate, to publish their own
newspapers and to compete in elections, on the implicit understanding
that one day they would have access to power. The latter had to endure a

harsh repression, albeit one never comparable to the dictatorial periods the country had suffered earlier in the century. This basically applied to the Carlists and Republicans, although exceptions were made for the most moderate elements, such as the former Republican president Emilio Castelar, whose marked evolution towards conservatism made him an asset, and not a liability, for the system. The most vicious repression was reserved for the workers' organizations, considered by Cánovas not as enemies of the specific political system he had erected but as subversives of the established social order; their associations were declared illegal, their publications suspended, their leaders imprisoned and even sent to the Marianas Islands, which often amounted to death from tuberculosis.

Cánovas took all kinds of precautions before calling the first electoral contest in 1877, which was marked by restrictions in the suffrage and freedom of expression. Everything remained well under control until 1881, when Cánovas finally felt the time had arrived for a change in government. On his advice, the king appointed as prime minister Práxedes Mateo Sagasta, one of the protagonists of the 1868 revolution who had also evolved towards moderate positions and managed to rally around his recently created Liberal Union a significant group of former revolutionaries. They were in power for only two years, hardly enough time for them to do anything but remove some of the press censorship and the limits imposed on the freedom of association. Carlist and Republican newspapers were permitted, and even a new workers' organization was able to be established, the FTRE (Federación de Trabajadores de la Región Española, Federation of Workers of the Spanish Region), the direct heir of the Spanish branch of the First International, the international workers' association created in London in 1864. In spite of their revolutionary rhetoric, the FTRE leaders were fairly moderate, mainly concerned with organizing a trade-union network among Spanish workers and avoiding strikes which could be counter-productive for the embryonic organization. Their success (60,000 members in two years) exceeded what the ruling block was ready to tolerate. A strange "Black-Hand conspiracy,"[1] discovered by the Civil Guard in 1882, served as a pretext for the persecution of the whole FTRE as a criminal organization. One of the future shortcomings of the Restoration system was thus anticipated: its inability to incorporate the working classes. The FTRE disappeared after a few years of constant crisis and mutual recriminations among its leaders and some of its militants formed a meager anarchist organization, linked to terrorist groups in the following decade.

By 1885, after a brief transition government, Cánovas was again prime minister. By then, the internal problems seemed to have been overcome and the government could devote some time to foreign policy. King Alfonso XII went on a European trip where he made some gestures of friendship towards the Germans, which annoyed the French; but immediately afterwards Spain clashed with Germany over the Caroline Islands, an archipelago in the Pacific which had long been part of the Spanish empire but had been scarcely colonized by the Spaniards and was now coveted by the Germans. These rivalries and skirmishes were normal among European powers of the period, but political instability had made the Spaniards unable to compete in this field for many decades. Now, it seemed that Spanish embassies and consulates could report on national interests and colonial expansion instead of devoting all their efforts to following the movements of Don Carlos, the pretender to the throne, and Manuel Ruiz Zorrilla, the Republican conspirator.

The frailty of the new regime, in spite of this seeming strength, was made apparent when in November 1885 the young king Alfonso XII died of tuberculosis. The whole system, so laboriously built up by Cánovas over ten years, threatened to collapse. The throne was occupied by Alfonso's widow María Cristina of Habsburg, who had arrived recently in the country and lacked political experience but who carried in her womb her most important asset: the heir to the throne. Should the infant be a boy, the loyalty of the army and the stability of the monarchy itself would supposedly be much more secure than in the case of a girl, who would unavoidably evoke the weakness and military interventionism of Isabel II's reign. Cánovas quickly understood that the only way to strengthen the monarchy was to give a real opportunity to his moderate Liberal opponent, Sagasta. They reached an historic agreement, which would be christened by historians as "el pacto del Pardo" (the Pardo Pact), after the name of the palace where Alfonso XII had died.

In May 1886, when Sagasta's Liberal government was in its first months of life, the queen gave birth to a boy. He was christened Alfonso XIII and was declared king from his very first moment of life, although María Cristina would remain as regent until he reached his sixteenth birthday. However, the problems did not stop there. The child was frail and sickly, and peri-natal mortality rates were extremely high at that time. Carlists and Republicans, who had speculated for months about the possibility of having a girl on the throne, now put their hopes in Alfonso's early death. This was only one more proof of the extreme weakness of the

opposition. The truth was that the Carlists had been unable to reorganize after their military defeat of 1876, in spite of the constant conspiratorial activities of Don Carlos, and many of them had been co-opted by Cánovas into his Conservative Party through the Unión Católica led by the Marqués de Pidal. As for the Republicans, after a couple of failed conspiracies in the late 1870s, they had finally managed to convince a few garrisons to attempt a *pronunciamiento* in 1883, but it was carried out without coordination and without any chance of success. Alfonso XIII's birth lent an air of urgency to their activities and in the summer of 1886 General Villacampa raised the Republican banner once more. Amid the indifference of public opinion, he failed and Sagasta, with supreme skill, commuted his death penalty, thus avoiding the creation of Republican martyrs.

Having secured his position, Sagasta could then devote his efforts to the implementation of the ambitious program of reforms he had announced when he formed the government: religious and educational liberties, freedom of expression and association, universal male suffrage, trial by jury, military reforms, abolition of slavery in Cuba and Puerto Rico, and the codification of the civil law. In spite of considerable difficulties, throughout the following five years most of these reforms were approved, even though in many cases diluted. Only the military reforms, which included compulsory military service, faced the insuperable opposition of the privileged officer corps (supported by General Martínez Campos, who had staged the coup which restored the Bourbons in 1875), and Sagasta's minister of defense, General Cassola, had to resign.

By the end of his five-year period of government, in 1890, Sagasta felt so secure that he dared to press for the approval of the long-promised and always delayed law of universal male suffrage. One wonders about the real aim of this measure. No parliamentary monarchy at the time had such an extensive participatory system, and nobody demanded it in Spain, apart from a few former revolutionaries of 1868, who had been reduced to impotence for the last fifteen years. Sagasta could have tried the more moderate, more realistic route of a gradual widening of the franchise, but he chose to put forward "universal suffrage." Since he knew that a straightforward application of this law would be impossible to achieve – and in case he did not know, Cánovas reminded him of it while the law was under parliamentary discussion – he was cynically choosing a mere façade of modernity, which in the long run would mean a serious loss of credibility for the whole political system.

When Cánovas returned to power in 1890, the political framework

which would dominate Spanish life for the next thirty years was thus complete. If we want to summarize its traits today, we could define it as a *non-competitive oligarchical monarchy*.[2] It was not an autocratic monarchy marked by direct and arbitrary rule of the king because the citizens enjoyed limited political liberties and civil rights, while daily decisions were not taken by the monarch but rather by a restricted political élite among whom a certain degree of competition existed. Yet if we cannot compare the system to Tsarist Russia, neither can we say that it was a constitutional parliamentary monarchy similar to the British one, in spite of its apologists' claims, because universal suffrage simply did not exist, and changes in government, rather than the result of electoral results (always favorable to the ruling party), were dependent on the royal will. Furthermore, this political system was only the upper part of an administration that was formally centralized, but actually devoid of resources, which meant that the implementation of its directives required pacts with local élites. This was the origin of *caciquismo* (after the Caribbean word *cacique,* meaning an Indian chieftain, which was applied to local political bosses), a widespread phenomenon which dominated local politics. *Caciquismo*, a feature which would acquire very negative political connotations for all critics of the Restoration system, particularly after 1898, was only the logical outcome of a social reality characterized by a duality between a few urban centers, where visible major decisions were taken, and an overwhelmingly rural society; between a formally centralized administration and the real fragmentation of political power.

The fragmentation of political power did not merely encompass local differences or a gap between the cities and the countryside, both of them traditional Spanish realities. The new phenomenon was the emergence of large cities, which for the first time in the modern era rivaled Madrid for the creation of new political spaces, using old cultural differences wrapped up in the new nationalist rhetoric. In the 1880s, while Madrid was still much more a large provincial town than a European capital,[3] Barcelona was living through a hectic textile boom based on its dominion over the Cuban market, which would accumulate enough capital to transform the city into one of the most beautiful *art nouveau* milieus in Europe. Understandably, Catalan intellectuals, artists, politicians and entrepreneurs despised Madrid and considered Paris their natural pole of attraction, their model for modernity. Something similar, although slightly different, was beginning to happen in Bilbao province, in the Basque Country, where an accelerated industrial take-off that had begun

just after the end of the last Carlist War was making the city boom from 30,000 inhabitants to 100,000 in thirty years. In this case, though, even if financiers and entrepreneurs had established close links with England, the most important Basque intellectuals (Unamuno, Baroja, Maeztu) would still consider Madrid their natural center for several decades.

These new urban and industrial centers not only fostered new élites, ready to challenge the traditional Madrid rulership, but also gave rise to new political and social conflicts to which the central government had no response. This explains why, in spite of what the new universal suffrage law seemed to presage, the paramount concerns of the 1890s were not going to be those which had hitherto dominated the century – i.e., constitutional debate. On the contrary, the major themes would now be very different: labor problems, the emergence of peripheral nationalisms, new colonial insurgencies and a renewal of military interventionism.

The last decade of the century began with the workers' celebration of May Day, which aroused extraordinary fears in the traditionally hierarchical Spanish society. Confronted with the announced invasion of the streets by the proletariat, well-to-do families sought refuge in their countryside mansions, while the army took up strategic positions in the cities. Tension decreased after the first three celebrations. May Day quickly became a mere festivity, a proof of existence, and a show of strength by a new political actor, whose threat was fairly remote. Still, for a considerable section of public opinion it retained a notable degree of drama, particularly since it was linked to the important miners' strikes in Bilbao, in 1892 and 1894, and to anarchist terrorist attempts in Barcelona, in 1892–1897. It was indeed in a Bilbao invaded by Castilian-speaking immigrants where Sabino Arana felt the threat to the Basque language and culture and founded the PNV in 1894. And it was in a Barcelona shaken by industrial development and immigration where the first Catalan nationalist organizations were created: the Centre Catalá and the Lliga de Catalunya in the 1880s – born in the heat of the debate over the new Civil Code – and the Unió Catalanista in 1891, which led to the approval of the autonomist demands embodied in the *Bases de Manresa* the following year.

The Canovist monarchy faced these problems without much concern. The assassination of the prime minister and architect of the regime, Antonio Cánovas del Castillo, by the Italian anarchist Michele Angiolillo in August 1897 was met with relative calm and a surprising sense of normality, given the drama of the moment. Francisco Silvela, Cánovas's

closest aide, was appointed to succeed him at the head of the Conservative Party. At the head of the government, the succession fell to his traditional opponent Práxedes Sagasta; this was by then a routine alternation in power although this time there is no doubt that the old Liberal leader felt less enthusiastic than usual, given the dark clouds threatening the Spanish scene, mainly due to the Cuban conflict.

The Cuban War, begun in February 1895, was indeed the gravest of all immediate political problems in the 1890s. Its internal repercussions had been apparent from the very beginning, as shown by the so-called "Tenientada," a violent riot led by a group of colonial officers in Havana in protest at the criticisms published by a daily newspaper. Instead of being punished, the army pressed the government for control of the press, and this pressure led to nothing less than a ministerial crisis. The event foretold the beginnings of a new phase of military interventionism in political life. But the significance of the Cuban War, and later the Spanish–American War, was due to other circumstances, many of them of a cultural kind, which are difficult to understand from our perspective.

The loss of Cuba, Puerto Rico, the Philippines and other minor remnants of the Spanish empire in the Pacific was not such a tragedy for Spain as contemporaries believed. It is true that the Spanish armed forces – to be precise, the Spanish navy – was easily defeated by the United States, a country which, while already a mighty economic power, was not considered much of a military power at that time. But the US was at the beginning of its ascendancy to world political and military hegemony, a position it would reach less than half a century later. It is also true that the war highlighted the isolation and the lack of prestige of Spain among the world's leading powers; but Spain had become a third-rate power some eighty years before, during Fernando VII's reign, when the vast majority of the American empire had been lost. From then on, all the rhetoric about imperial grandeur was empty. What the 1898 defeat did was to expose that rhetoric for what it was.

The 1898 crisis neither provoked a severe economic recession nor put the monarchy in serious jeopardy. From an economic point of view, the textile sector was the most damaged, and then only for a few years. The loss of the Caribbean markets was compensated for by the return of capital, which quickly stabilized the peseta, helped create Spanish national banks (dominated throughout the nineteenth century by French and British capital), and played a crucial role in the modernization, electrification and diversification of Spanish industry. Neither was

there any cataclysm in the political sphere. The Spanish monarchy did not face any serious threat and in fact only eight years later, after Alfonso came of age and was married to a grand-daughter of Queen Victoria, it was more stable than at any time in the recent past. The problems faced by Alfonso XIII in the later part of his reign had nothing to do with the last years of the regency.

And yet, if there was no real crisis, there was a very acute consciousness of crisis. Contemporary Spaniards called these events "el Desastre," *the* disaster *par excellence*. There were three aspects of this disaster: from one point of view, it affected existing political institutions; from another, it concerned the ruling élites; and, finally, it had to do with the ideology or the rhetoric which legitimized the Spanish state. From the first of these points of view, the Canovist parliamentary system suffered a huge loss of prestige, particularly *caciquismo* and all the corrupt and restrictive mechanisms of electoral participation on which all the faults of the system were blamed. Joaquín Costa's well-known survey *Oligarquía y caciquismo* shows the immense detachment of the most prestigious intellectuals from the political institutions of the day.[4] From then on, all political programs would include, in one way or another, "regenerationist" proposals, a no doubt ambiguous word but one which always included a reference to the elimination of *caciquismo.* The danger of this discourse would be apparent when used by Primo de Rivera or Franco, who used *anti-caciquismo* rhetoric for the elimination of the whole liberal parliamentary system.

The second aspect of the crisis was the loss of prestige of the élites, not only the political and military élites, but also the socio-economic: the clergy, blamed for the loss of the Philippines; the aristocrats and the landowners, who had managed to exclude their offspring from the fight for the fatherland. The crisis, though, did not lead to any significant renewal in this aspect either. Silvela and Maura, products of the system, succeeded Cánovas. Sagasta himself, head of the government at the time of the 1898 War, went on presiding over governments until the moment of his death, in 1903, only to be succeeded by his immediate aide. Neither the traders and industrialists mobilized by Joaquín Costa and Basilio Paraíso for their "regenerationist" movement, nor the "angry young men" of the literary generation of 1898, more influential in relation to public opinion than any other previous intellectual group, offered themselves as a credible political alternative. They were truly concerned about the nation, but they abhorred the "state." The 1898 crisis thus opened an abyss between the political élites and public opinion but it did not produce any

political opposition able to put forward a program of reforms within an alternative strategy. The same political rulers would thus continue in power, more and more remote from public opinion, until Primo de Rivera removed them completely.

Finally, the 1898 crisis had an ideological aspect, of such an intensity that we could call it "metaphysical." The reasons for this lay in the contemporary political and cultural European context. The loss of the remaining Spanish colonies happened just when the great European powers – among which Spaniards naturally included themselves – were carving up the world, and their victories or defeats were interpreted in terms of racial and national superiority or inferiority. The meaning of these wars was utterly different from those of the eighteenth century, when autocratic monarchs forced their populations into their armies and waged wars which led to the expansion or the diminution of the king's territories. Now it was the Spanish people who had had a part of their sacred body amputated and who had staged a pathetic show of incompetence in front of the whole world. The basic tenets of the patriotic rhetoric constructed throughout the nineteenth century were thus shaken to the core. A rhetoric which mixed positive and negative qualities, in its description of the national soul or character, but which in the end led to national pride, was based on the supposed readiness of Spaniards to sacrifice their lives for their fatherland and their identity – which made them invincible, as proven at the time of the Napoleonic invasion.[5] This kind of discourse had begun to be questioned well before the end of the century, but it was after the 1898 defeat that a whole new genre of self-flagellating literature took off, creating a culture of pessimism which was epitomized by the playwright Ramón María del Valle-Inclán in his famous description of Spain as a grotesque deformation of European civilization.

Understandably, it was at this point that peripheral nationalisms, above all Catalanism, reached the stage of massive political movements. Exhausted after so many efforts to regenerate the Spanish administration, public opinion in Catalonia turned towards the construction of its own political and administrative framework (a phenomenon which, in accordance with the new rhetoric, was dressed up as a "discovery of its own identity"). But the rest of Spanish public opinion was so hurt by the Cuban War that this attitude was interpreted as an escape from a sinking ship, as a betrayal, and it aroused very negative feelings towards Catalanism, feelings which one hundred years later are not yet totally healed.

The first serious regenerationist project after 1898 was led by Antonio Maura, the politician who dominated the first decade of the twentieth century in Spain. Confronted with national decadence and failure, the Conservative leader put forward a technocratic–authoritarian program: the rebuilding of the navy, new incentives for national industry, limited administrative decentralization, reform of the suffrage towards corporatist forms instead of broadening its base, but at the same time more respect for authentic popular suffrage; and everything within a strict respect for law and order and the maintenance of traditional ties between the church and state. Maura's program left the rest of the dynastic politicians without a response. Only the new Republican generation, Alejandro Lerroux in Barcelona and Vicente Blasco Ibáñez in Valencia, were able to confront Maura, and they did so by mobilizing their constituencies – in numbers hitherto unknown in Spanish politics – using a highly emotional and even violent populist rhetoric, mainly centered around anti-clerical themes. The culmination of this new kind of populist politics was the so-called "Tragic Week" of 1909 in Barcelona, when a general strike against a recruitment drive decreed by the government in order to intensify the Moroccan War ended in a popular insurrection and the burning of about one hundred religious buildings. The harsh repression which Maura imposed after these events had unexpected consequences: a wave of protest all over Europe against the execution of the anarchist teacher and propagandist Francisco Ferrer Guardia, and the union of all the opposition, including the Liberal Party, against Maura, which convinced the king – who had little sympathy for his authoritarian prime minister – to ask him to resign. This was not the end of Maura's political career, but, prevented from heading the government by a royal veto and challenged by other leaders within the Conservative Party, he would never regain the strength he had enjoyed before 1909.

The next viable political project was led by José Canalejas, a politician who had managed to unify the Liberal Party after the deep divisions that developed following Sagasta's death. Canalejas signified almost the exact opposite to Maura within the dynastic regime: he incorporated some of the ingredients of anti-clerical rhetoric, in an effort to win popular support for his projected modernization of the administration. But very soon labor problems emerged and Canalejas made a military response to the strikes, as his French counterpart Clemenceau had recently done. This authoritarian response led to his immediate unpopularity among the left, and in the end to his assassination by another anarchist, in 1912.

This meant the disappearance of the two statesmen who, from the right and the left of the political spectrum loyal to the constitutional monarchy established in 1875, had a certain authority and credibility. Frustration mounted, in the same measure as the possibility of regenerating the system diminished.

Yet the demolition of the system created by Cánovas was not going to be easy. It would still take a long and complex crisis, developed over another ten years, until General Primo de Rivera staged his coup in 1923. During that period, the two main parties became divided among factions, irreconcilable enemies of one another, which made the development of any stable solution impossible. No ideological differences can be established among these factions, which were merely divided by personal loyalties. Not even between the Liberals and Conservatives can a clear ideological divide be established, since the Conservatives tended to favor labor legislation and a certain degree of autonomy for Catalonia, while the Liberals, following narrow short-term interests, were in favor of a reinforcement of the king's interventionism.

Confronted by the First World War (1914–1918), the great event of these years, Spain remained neutral. Public opinion was strongly divided, the *aliadófilos* favoring intervention, or at least some kind of neutrality favorable to the allies, while the *germanófilos,* who were weaker, only called for strict neutrality. Some of the most outspoken and bellicose *aliadófilos* were led not so much by ideological affinities with France and England but rather by the feeling that Spain had to overcome its isolation and irrelevance in the international arena, as well as by the need to infuse strong patriotic feelings among the Spanish masses. But all political leaders recognized that Spain was in no position to back realistically either side in the conflict.

Furthermore, neutrality proved to be very profitable for the Spanish economy. Exports boomed, and the trade balance was positive for four consecutive years, the only time in the whole modern history of Spain. The accumulation of capital permitted the creation of jobs, thus attracting the rural population to the industrial centers, but this also led to spiraling inflation (100 percent between 1914 and 1919, approximately) which hurt the populace living on fixed incomes: the social structure was radically undermined as a result. Working people resorted to unionization and a strategy of strikes, very often with success, since employers were prepared to raise salaries, knowing that the market was ready to accept higher prices. Between 1914 and 1919, nominal salaries thus grew

by 50 percent, and the levels of affiliation to workers' parties and unions also grew considerably: the PSOE went up from 14,000 to 42,000 members, the socialist union UGT, from 100,000 to 160,000, and the anarcho-syndicalist CNT, which emerged in 1915 from the clandestinity forced upon it by the struggles of the Canalejas period with no more than 25,000 members, claimed to have 700,000 in 1919.[6]

In the summer of 1917, in the middle of the war, Spain witnessed its worst political crisis in forty years. It was a particularly complex conflict, in which three processes co-existed. The first was the forming of the so-called "Juntas Militares de Defensa," a new symptom of growing military interventionism. The need to modernize the Spanish army in accordance with the requirements of modern warfare became an urgent priority as the First World War developed. The debate, repeated at least since General Cassola's failed reforms in the 1880s, focused on the promotion system, key to the selection to the highest ranks. On the one hand were the defenders of seniority, traditional in the Spanish infantry, which stood as a guarantee against political favoritism. On the other, specialized corps such as the artillery and the colonial army in Africa were in favor of promotion by merit. This debate was demagogically mixed by the leader of the Juntas de Defensa, Colonel Márquez, with the dominant regenerationist discourse. The inability of the government to subdue the Juntas provoked several crises and finally put an end to the 1916–1917 period of Liberal rule.

The second crisis of the summer of 1917 affected the parliament. Confronted with the refusal of Prime Minister Eduardo Dato to summon the Cortes, the Catalan nationalist deputies offered Barcelona as the site for an alternative assembly, conceived as a kind of constituent Cortes. Radical Republicans, the rivals of the Catalan nationalists, decided to accept the offer, and so did the Republicans and some Liberal factions. The government chose to allow the meeting, although explicitly stating that no parliamentary resolutions of value should be taken. Amid high expectations and extraordinary precautions, the meeting was held in July 1917. The few deputies who dared to attend asked only for the formation of a transitory coalition government which would call elections to the constituent Cortes.

Confusion increased that summer with the appearance of a third conflict, a general strike jointly called by the socialist UGT and the anarchist CNT in protest against the rising cost of living. The strike was so ill-timed that it was suspected to have been provoked by the government

in order to make it fail, and to defeat the two other opposition movements at the same time. The Catalanists opposed the strike, and so did the Juntas de Defensa (which had voiced an ambiguous support for the parliamentarians' assembly). Once again, the army took up the role of supreme guardian of law and order, and repressed the strike in such a vicious way that it left nearly one hundred dead. The Dato government, criticized by everybody, was forced to resign. The Liberal and the Conservative choices had been exhausted, resulting in the formation – for the first time – of a coalition government. García Prieto, a Liberal, was appointed prime minister; his government included reformist Republicans. A new hope seemed to be raised, but once again the problems the rulers had to face were different from those expected – not constitutional arrangements but a wave of labor conflicts of an intensity hitherto unknown.

The 1917 general strike had not been an isolated incident, but the signal of a new wave of social conflicts, whose origins were linked to the inflation created by the First World War. After the end of the war, the struggling spirit of Spanish workers, unionized in large numbers and well trained after four years of constant struggle against inflation, received an additional boost by news about the Soviet Revolution, which created internal tensions within workers' parties and unions. But the change in the economic situation, exacerbated by the closure of European markets to Spanish products after the war, made the employers less prone to accept their employees' demands. This situation explains the Andalusian Bolshevik Triennium (1918–1920), a wave of strikes, riots and crop-burnings, as well as the new kind of violence developed in Barcelona, where employers used professional gunmen to kill union leaders and the latter responded with "grupos de acción" which fought against employers, policemen, civil authorities, and even the high ranks of the clergy. One of the consequences of this wave of violence was the loss of power – or the physical elimination – of moderate union leaders, such as Salvador Seguí, and the takeover of the unions by the more radicalized "grupos de acción."

These problems provoked the fall of García Prieto's coalition government, which led to a political *impasse,* momentarily overcome when the king threatened to abdicate if the political factions did not reach agreement on a workable government. This was the origin of the "gobierno nacional," with Antonio Maura as prime minister, a formula which raised some hopes but was unable to last owing to the ongoing internecine wars among the factions. Two Liberal governments followed, in 1919, and

several conservative ones in 1920–1922, after which the Liberals returned for a last time in 1922–1923. Whatever their label, all of them were made up of coalitions from different factions and parties, the Conservatives always trying to include the Catalanists, and the Liberals leaning towards the moderate Republicans of the Reformist Party. In spite of constant political instability, the legislative work of this period was not negligible, as is proven by the approval of the Bank of Spain statute, the creation of the Ministry of Labor (which promoted labor regulation), the Law of Civil Servants (which protected against arbitrary firing of workers belonging to opposition parties), and major fiscal reforms. But to public eyes the image of those years was basically negative, dominated by the stereotype of inefficiency and endless political in-fighting.[7]

In the spring of 1921, when labor problems had begun to recede, the political crisis was aggravated by the assassination of Dato, the most prestigious Conservative leader after Maura and the one preferred by the king, and immediately afterwards by the news of yet another catastrophic defeat in the Moroccan War: 10,000 Spanish soldiers died of hunger and thirst near the village of Annual, surrounded by Moroccan troops. Motivated by a feeling of disaster, of incomprehensible government inefficiency, public opinion demanded the elimination of those government officials responsible for the catastrophe. A parliamentary commission of inquiry was created, and the expectations regarding its conclusions ("la cuestión de las responsabilidades") dominated the political atmosphere from then on. The seriousness of the problem reflected not only the traditional reluctance of the military to answer to any civilian authority, but also rumors according to which the king himself had taken part in the decisions leading to the military calamity.

One of the goals of General Miguel Primo de Rivera, when staging his coup in September 1923, was precisely to prevent the Cortes from hearing the conclusions of the Commission on Responsibilities. The confusing regenerationist rhetoric he used to justify his anti-constitutional intervention (the first, after fifty years of legal civilian government) and the estrangement of public opinion from the oligarchic parliamentarian regime explain his initial popularity. During the last months of 1923 and the whole of 1924, many Spaniards seemed ready to accept Primo's rule under the condition that he bring to bear some efficiency in solving the nation's most pressing problems (social struggles, the Moroccan War) and respect corporate interests. This attitude reveals the lack of a well-rooted democratic culture in Spain, in spite of long periods of constitutional

rule. But one should recall also that these were times of strong anti-liberal winds all over Europe, under the widespread seduction of the fascist and Bolshevik models.

Primo de Rivera's prestige survived for almost two years, partly because of his decision to conclude the Moroccan War in a massive military operation coordinated with the French, and partly because of his populist economic measures, which succeeded thanks to the decade's general prosperity. His success led him to think of continuing indefinitely in power, but he then revealed his limited political abilities. The single party he created, the Unión Patriótica, did not even belong to the new model of mobilizing the populace invented by Mussolini; it was just a conservative coalition, very soon dominated by the old *caciques* which Primo had sworn to eliminate. His national assembly, appointed rather than elected, was not even capable of reaching an agreement on the constitutional project they were supposed to write. By 1926–1927, Primo de Rivera had to face problems with his own military comrades, the artillery officers in open rebellion against his projected reform of the promotion system. Catalan nationalists, who had supported him at the beginning as a guarantor of social order, were now resentful of his measures forbidding the use of the Catalan language. The best-known intellectuals of the country, such as Unamuno, were sworn enemies of the dictator, and brought behind them university students making a mockery of the dictator. The last straw was the end of the economic prosperity of the 1920s, which reached a Spain heavily laden with debt from the dictator's spending habits. Sick, isolated and vilified by everybody, Primo de Rivera accepted Alfonso XIII's suggestion to abandon power in January 1930 and left the country for Paris, where he died only three months later.

Since both the parliamentarian monarchy and the military dictatorship had lost all prestige, the following year was dominated by the resurgence of the Republican option, something which only a few years earlier seemed without any future in Spain. And indeed the Republic came easily: after one year of doubts about how to restore the constitutional regime without endangering the monarchy, the Second Republic was voted in on 12 April 1931. It would be erroneous, though, to conclude that there was strong social support for the Republic, even if millions of people went on to the streets to celebrate its arrival. Furthermore, too many hopes were placed on the new regime. At least two projects of global reform, in many respects incompatible with each other, were embodied in the Republican ideal: the modernization, and above all the

laicization, of Spanish society, on the one hand; on the other, a radical redistribution of social wealth. The Republicans themselves were divided regarding the depth of the proposed reforms as well as regarding crucial aspects of the organization of the state in charge of those reforms (e.g., unitary or federal) and above all regarding adequate strategies to implement the desired changes.[8]

To the left of the Republicans there was the anarchist CNT, a very powerful organization from the point of view of the number of its members, but unstable owing to the internal power struggle between moderate trade-unionists, such as Ángel Pestaña or Juan Peiró, and the successors of the "grupos de acción" of 1917–1923, usually members of the clandestine anarchist FAI. Furthermore, the first and most dramatic measures taken by the provisional government, the labor decrees signed by Largo Caballero, were interpreted by the anarchists as intended to strengthen their traditional rival, the socialist UGT, as the only representative of the workers; thus Largo Caballero's measures not only created enemies of the Republic which could have been expected, such as rural landowners, but also unexpected ones, such as the anarchists. The FAI and other radicals took advantage of these measures to denounce the lukewarm opposition to the Republic by the reformists in charge of the CNT and launched their offensive in order to win all the key positions within the organization, something they managed to do during the summer of 1931.

Another sector which became rapidly estranged from the Republic was Catholic opinion. First of all, the monarchists and the traditional right, represented by Cardinal Segura, opposed the new regime from the very first moment (something which provoked a general burning of churches in May 1931). Later on, this opposition was joined by liberal Catholics such as Miguel Maura and Niceto Alcalá Zamora, ministers in the provisional government who resigned during the constitutional debate when their moderate proposals of separation between church and state were defeated by the Jacobin atmosphere which imposed articles such as the expulsion of the Jesuits. They both returned to the government in December – Alcalá Zamora as president of the Republic – but this problem presaged the inability of the Republic to win moderate Catholic sectors over to its point of view, especially the conservative – not necessarily pro-fascist – provincial middle classes.

The end of the first Republican biennium, dominated by the Socialist–Republican coalition, came in November 1933. In two years, the governments presided over by Manuel Azaña had managed to launch an

ambitious schooling program, had approved labor regulations comparable to the most advanced in Europe, had managed to separate church from state, and had begun the devolution of powers to some of the regions with the Catalan Statute. Their most patent failure had been agrarian reform, approved after many difficulties. But the lack of resources allotted to it and the many legal guarantees created for the landowners made it a painfully slow tool for social change. The most radical sectors of the CNT took advantage of the frustration of the peasants to organize a sequence of uprisings which provoked harsh repression by the government, and this in turn led to the loss of popularity of the Azaña government, one of the reasons which explains its electoral defeat in November of 1933.

The winners in those elections were the CEDA, a Catholic coalition led by José María Gil Robles, neither a committed Republican nor a monarchist conspirator – as his enemies depicted him – and Alejandro Lerroux's Radical Party, the only real centrist political force at that time, recognized by both industrial entrepreneurs and landowners as their voice in parliament. The immediate problem was that none of these parties had a sufficient majority to rule on their own. Alcalá Zamora, fearful of the reactions against Gil Robles, considered by many the leader-to-be of Spanish fascism, appointed Lerroux as prime minister. But Lerroux could only rule with Gil Robles's parliamentary support, and this was a source of permanent instability.

The new government devoted the first half of 1934 to dismantling the strength of the unions, particularly in the countryside. First of all, the anarchists, who were crushed after a new uprising in December of 1933, and then the FNTT, the radicalized rural branch of the socialist UGT, suffered defeat after a very tough general strike in June 1934. This emboldened the right, and Gil Robles began to put pressure on Lerroux for less conciliatory measures towards the left and to demand more direct power for the CEDA. In October of 1934, finally, Alcalá Zamora was forced to accept the inclusion of three CEDA ministers in a new Lerroux government. The left considered this equivalent to the accession of fascism to power and called a general strike, which in Spain at that time amounted to an insurrection. The gravest events occurred in Asturias, where the miners rebelled and controlled the region for two weeks, killing priests and burning churches. A vicious repression followed, in which the protagonists were the colonial troops brought from Africa for this purpose.

The Asturian insurrection was considered a prelude to the Civil War,

particularly by the right, who from then on relied only on the army as the last guarantor of the established order. The left, on the other hand, only learned from the events of October 1934 the need to be united, and steps were taken to bring the disparate Republican groups together; they then reached out to the Socialists. The Communists, following Moscow's directives, enthusiastically supported the new alignment of the left. This led to a broad coalition which came to be called the "Popular Front." Faced with the threat of a "red and separatist revolution," the right also sought a union, called "Bloque Nacional," and the new elections called for February 1936 were thus marked by polarization and constant references to the Asturian insurrection.

The winner of those elections, the Popular Front, again made the mistake of believing that they were the owners of the state and that their mission was to crush their political enemies. The moderate president of the Republic, Alcalá Zamora, was dismissed, and Manuel Azaña was elected instead, a move which relegated the most able politician of the left to an honorary position. Azaña offered the prime ministership to Indalecio Prieto, no doubt the best remaining option, but internal rivalries within the Socialist Party vetoed him. In the meantime, chaos reigned in the streets. The trade unions acted as mobilizers and substitutes for the political parties, the fascists and the youth organizations of both sides exhibited and used their weapons, and the monarchists used this chaos to convince the military to join their conspiratorial endeavors. On 18 July 1936, the military finally rebelled, a move which was not new in modern Spanish history. The novelty was the conversion of this *pronunciamiento* into a long and bloody Civil War, and the reasons for this lie probably in the international situation, the rivalry between fascism and communism, which fed both contenders with an arsenal of weapons without which the conflict would probably have been shorter. In any case, this war and the final victory of the self-denominated "national" side meant the end of a long period of liberal parliamentarian culture.[9]

NOTES

1. Clara Lida, "Agrarian Anarchism in Andalusia. Documents on *La mano negra*," *International Review of Social History* 3 (1969), pp. 315–351, and Demetrio Castro Alfín, *La mano negra* (Córdoba: Diputación de Córdoba, 1984).

2. Robert A. Dahl, *Polyarchy: Participation and Opposition* (New Haven, CT: Yale University Press, 1985).

3. Santos Juliá, David Ringrose, and Cristina Segura, *Madrid. Historia de una capital* (Madrid: Fundación Caja Madrid, 1995).

4. Joaquín Costa, *Oligarquía y caciquismo* (Madrid: Ediciones de la Revista de Trabajo, 1985).

5. José María Jover Zamora, "Carácter del nacionalismo español," *Zona Abierta* 31 (1984), pp. 1–22.

6. Javier Cuadrat, *Los orígenes de la CNT* (Madrid: Ministerio de Trabajo, 1976).

7. Luis Arranz, Mercedes Cabrera and Fernando Del Rey, "The Crisis of Parliamentarian Liberalism, 1913–1923," in José Álvarez Junco and Adrian Shubert (eds.), *Spanish History since 1808* (London: Edward Arnold, forthcoming).

8. Nigel Townson, "The Second Republic and the Radicalization of Political Life," in Álvarez Junco and Shubert (eds.), *Spanish History*.

9. Enrique Uclay, "Buscando el levantamiento plebiscitario: insurreccionalismo y elecciones," *Ayer* 20 (1995), pp. 49–80.

FOR FURTHER READING

Álvarez Junco, José. *El emperador del paralelo: Lerroux y la demagogia populista*. Madrid: Alianza, 1990.

La ideología política del anarquismo español, 1869–1910. Madrid: Siglo XXI, 1976.

Espadas Burgos, Manuel. *Alfonso XII y los orígenes de la Restauración*. Madrid: CSIC, 1975.

Jover Zamora, José María. *Política, diplomacia y humanismo popular*. Madrid: Turner, 1976.

Martínez Cuadrado, Miguel. *La burguesía conservadora, 1874–1931*. Madrid: Alianza, 1973.

Piqueras Arenas, J. A. *La revolución democrática, 1868–1874*. Madrid: Alianza, 1992.

Ringrose, David R. *Spain, Europe and the "Spanish Miracle," 1700–1900*. Cambridge: Cambridge University Press, 1996.

Shubert, Adrian. *A Social History of Modern Spain*. London and Boston, MA: Unwin Hyman, 1990.

Villacorta Baños, F. *Burguesía y cultura. Los intelectuales españoles en la sociedad liberal (1808–1931)*. Madrid: Siglo XXI, 1980.

6

History, politics, and culture, 1936–1975

The Spanish Civil War of 1936–1939 was fought along the multiple lines of cleavage – of class, ideology, and region – that had been opened by the processes of economic, social, and political modernization over the previous century. Yet despite its complex origins and internal dynamics, participants, commentators, and historians, then and since, have tended to reduce the war to a set of simple oppositions: democracy vs. fascism, Christian civilization vs. godless Communism, the working class vs. the rich, the center vs. the periphery, and so on. This dichotomizing tendency was perhaps inevitable in a war in which propaganda played such an important role, but it was also a consequence of a growing habit of mind among educated Spaniards to conceptualize their society in terms of the "two Spains." Since the early nineteenth century Spaniards had disagreed – often violently – over the desirability and direction of political and social change. The clash of social and political interests had found ideological expression in disputes over the form of the state and in contested definitions of national history and identity. In the process, many Spaniards had come to conceive of national politics as a Manichean struggle between the "true" Spain and the "anti-Spain"; at stake was the identity of the nation itself, threatened less by external rivals than by the enemy within. As they fought over the meaning of the past and the shape of the future, Spaniards became acutely aware of the role of education in maintaining or transforming the existing order – that is, they became sensitized to the link between politics and culture. At the center of the struggle to control the transmission of culture was the Catholic church, whose traditional ideological authority was magnified by its near-monopoly over the education of the middle and upper classes.

The inclination to resort to binary thinking and to cast social and

political conflict in terms of contested national identity reached its climax during the five turbulent years of the Second Republic (1931–1936). Governing during the first biennium, Republicans and Socialists sought to modernize and democratize Spanish political, economic, and cultural life in the name of the "real" nation whose voice had long been silenced by privileged élites; governing during the second biennium, the right reversed or ignored the Republican reforms, condemning them as intolerable violations of traditional national values. Not surprisingly, reform of the school system – including closure of the schools of the religious orders – provoked some of the most intense debate. Dichotomizing rhetoric about national values exacerbated political polarization, imposed a conceptual strait-jacket that limited political flexibility, and disguised the internal fissures that cut across the imaginary dyad of the two Spains. By 1936 Spaniards on each side of the rhetorical divide had come to view the other as an illegitimate usurper of the national will. The triumph of a Popular Front coalition of Republicans, Socialists, and Communists in the parliamentary elections of February 1936 set the stage for a confrontation. As the center-left prepared to resume the program of Republican reform, right-wing paramilitary groups fought in the streets with militant workers, and radicalized peasants began seizing the land on which they worked. Meanwhile, right-wing military conspirators and their civilian backers prepared to seize the state.

On 17 July 1936, the conspirators rose against the Popular Front government. The immediate purpose of the rising was to replace the government with a military dictatorship that would impose order and check the renewed threat of social reform. Involving no more than 1,000 middle-ranking and junior officers, the revolt was initially successful in only a third of the peninsular garrisons and in northern Morocco. Three days later, the failure of the coup in many of the major cities (including the two largest, Madrid and Barcelona) was guaranteed by the decision of the government to defend itself against the military rebels by arming leftist political and labor organizations. These events in turn triggered a spontaneous social revolution that spread rapidly through the areas still under Republican control.

Abandoning their hopes for an easy victory, the insurgents organized their dispersed forces for a war of conquest. An immediate obstacle was the allegiance of the air force and navy to the Republican government. Lacking the means to transport his isolated forces from northern Morocco, General Francisco Franco, the head of the African Army,

5. *España*, Civil War poster

appealed to the German and Italian governments, which responded with pilots and airplanes. Thus, foreign intervention was crucial to the outcome of events from the very first weeks of the war. It continued to play a key role thereafter, not only shaping the military conflict, but also drawing the Spanish War into the tense international climate of the 1930s.

Within a few weeks, the national territory of Spain was partitioned into two spheres of control. In the Republican zone – comprising roughly the eastern half of the peninsula plus Madrid – the Popular Front government enjoyed the support of the progressive middle class, the urban and rural working classes, and the regional governments of Catalonia and the

Basque Provinces. The rebels, who were backed by large agricultural, industrial, and commercial interests and the church, easily captured conservative Catholic agricultural regions in the north and west. Profiting from the element of surprise, they also gained an unexpected foothold in the *latifundia* provinces of Andalusia, as well as in a few industrial cities with a militant working class, such as Zaragoza and Oviedo.

As the abortive coup escalated into full-scale civil war, each side sought to legitimate itself in ideological opposition to the other by claiming to represent "the nation" under attack from internal and external foes. In the Republican zone, the defining event in this process was the spontaneous popular revolution unleashed by the military rebellion. In widespread violence directed against church property and clergy, large landowners, and rightist sympathizers, radicals assassinated anywhere from 55,000 to 80,000 "enemies of the people," including 6,800 priests, monks, and nuns, before the government managed to impose a semblance of order. More constructively, one million industrial workers and three-quarters of a million peasants took over ownership and management of the means of production, especially in areas remote from the actual fighting, like Barcelona, where representatives of the working-class parties and unions challenged the authority of both the regional and central governments. Leftist militias, in the meantime, departed for the front, where they held the line against the advancing Nationalist armies while the government struggled to reconstitute its shattered armed forces.

Behind the lines, anarcho-syndicalists, Socialists, and Communists contested the right to define and control the war and the social revolution according to their understanding of the revolutionary process and their utopian visions of the future; what they shared was a vision of the nation radically disconnected from previously existing forms of the state and society. The struggle for power during the fall and winter of 1936–1937 eroded Republican unity and prevented the government from articulating a coherent political message. To the outside world the Popular Front government claimed, quite legitimately, to be a popularly elected liberal democracy under assault from the forces of international fascism and reactionary clericalism; within the Republican zone, however, it was obliged to compete in the political and cultural arenas for recognition as the embodiment of the revolutionary working class. This competition, which was both political and cultural, undermined morale and posed insurmountable roadblocks to the formation of a coherent military strategy.

During the first months of the war, cultural initiatives by leftist parties and unions proliferated. Equating defense of the Republic with support for the revolution and defeat of the class enemy, they communicated their message to the masses through visual, "proletarian" media like poster art and the theater. Fighting to establish its authority, the government countered with its own campaign to mobilize the people through the provision of culture. The Communist minister of Public Instruction and Fine Arts, Jesús Hernández, sponsored literacy programs, cultural missions, art exhibits, and summer camps, in which the government's message of war discipline, state centralization, and a unified command were systematically imbedded. The ministry also enacted legislation establishing a state educational monopoly while expanding access to primary and secondary schooling. After mid-1937 the Communists strengthened state censorship in order to centralize further the transmission of culture and the dissemination of propaganda. But internal dissension continued to impair the unity of the Republican zone.

Communist influence in the Popular Front government was enhanced by the party's control of the military aid supplied by the Soviet Union, the only great power to respond significantly to the Republic's pleas for help. By exploiting middle-class opposition to collectivization and by arguing that the revolution threatened both the war effort and the diplomatic campaign to secure foreign aid from the capitalist democracies of the west, the Communists managed to halt and, eventually, to reverse a revolutionary process whose decentralized and democratic character was incompatible with Stalinist theory and practice. Popular revolution was thus suppressed in the name of the survival of popular democracy. Historians continue to debate whether the counter-revolutionary strategy pursued by the Communists and their moderate Socialist and Republican allies in the Popular Front government was best suited to winning the war. What is clear, however, is that the Communist ascendancy gave an important propaganda tool to the anti-Republican forces by allowing them to pose as the defenders of national integrity against a Judeo-Masonic-Marxist conspiracy bent on its destruction.

In contrast to the political disintegration in the Republican zone, the insurgents – now calling themselves "Nationalists" – rapidly centralized political, military, and cultural initiatives under the sole command of General Franco, who was named General-in-Chief and Chief of the Spanish State on 29 September 1936. The investment of all political and mili-

tary authority in a general who would brook no rivals, the imposition of military discipline on civilians and military alike, and the overriding commitment to a common objective made possible the coordination and control of the disparate groups within the Nationalist coalition.

United in opposition to the reformism of the Republic, these groups were otherwise divided by class, ideology, and political goals. The core of the Nationalists' support, outside the army officer corps itself, lay in the landowning and industrial élites who were determined to resist further erosion of their social and economic power and whose political preference was the restoration of the Alfonsine monarchy. During the Republic they had cloaked self-interest with high-minded rhetorical defense of religion, property, and national tradition in order to court the support of the conservative middle classes. The Spanish church, led by the counter-revolutionary wing of Spanish Catholicism, was also firmly in the Nationalist camp. Even further to the reactionary right was the Carlist Traditionalist Communion, whose paramilitary wing (called the "Requeté") fought not only to place the Carlist pretender on the Spanish throne, but also to restore the religious unity and political decentralization of the *ancien régime*. On the other hand, the Spanish Falange, like other European fascist parties in the interwar period, was as unrelenting in its condemnation of monarchism, conservatism, and capitalism as it was of liberalism and socialism. Even though the Falange willingly acknowledged the significance of Catholicism in the historical development of the Spanish nation, its revolutionary message of statism, imperialism, and corporativist economic modernization was viewed with deep suspicion by the anti-statist Catholic right and the monarchist agrarian élites. What held these groups together was their common opposition to the democratic reformism of the Second Republic.

With the prolongation of the war, the need for greater political organization and ideological coherence became imperative. Franco displayed great skill in balancing competing interests and in imposing a monolithic political and cultural structure that stood in dramatic counterpoint to the fragmentation in the Republican zone. In April 1937 the Generalísimo curbed competition among Falangists and Carlists for political hegemony within the Nationalist camp by forcibly fusing them into a single, quasi-fascist party, the FET y de las JONS (Traditionalist Spanish Falange and Juntas of the National–Syndicalist Offensive) under his sole leadership. With its monopoly of the political arena, the "Movement" (as it later came to be called) provided ideological definition and

political recruits for the new regime. As Franco was aware, however, the single party could not entirely eliminate the divisions within the Nationalist camp. Accordingly, after the creation of his first regular ministerial government in January 1938, Franco took care to provide cabinet representation and responsibility for each of the rival groups, or "families," among his supporters. The balance of power among these civilian factions shifted over time, depending on the domestic and international context and on Franco's determination to allow no single group to challenge his own firm grip on power.

As was befitting a military dictatorship that governed under martial law until 1948, army and naval officers played a major role in Franco's governments; during the first twenty-five years of the regime, they held nearly 40 percent of all cabinet positions. Nationalist officers were not unanimous in their political views, although they clustered at the conservative end of the political spectrum, and many initially opposed Franco's elevation to sole power. Most, however, shared Franco's hatred of democracy, communism, Freemasonry, regionalism and other "anti-national" doctrines and his faith in an authoritarian solution to the crisis of political legitimacy.

Until the collapse of the Axis powers in 1945, the Spanish Falange supplied much of the symbology, rhetoric, and organizational framework for the nascent regime. Taking shape when the prestige of international fascism was at its height, the Francoist New State defined itself as a national–syndicalist, "totalitarian," one-party state headed by the supreme leader, or Caudillo, Generalísimo Franco. The Falange controlled the Movement and, through it, the emerging national–syndicalist state bureaucracy, including the press, radio, propaganda, and censorship apparatus, the institutions of political socialization and social welfare (like the Youth Front and the women's auxiliary, the Sección Feminina), and the corporativist vertical syndicates created in 1938 to discipline the working class and the national economy. Falangist militarism and nationalism set the ideological tone of the New State during the war and immediate post-war years, when FET membership reached its peak of 932,000; public ceremonies and public spaces were dominated by its blue-shirted uniforms, parades, salutes, and oratory, which invoked the discipline, nationalism, and sacrifice of its fallen leader, José Antonio Primo de Rivera. The "fascitizing" phase of the regime was a product of Franco's dependence on the Axis powers for military and financial aid and the initial ideological incoherence among his

supporters. When these circumstantial pressures disappeared, the essentially conservative character of the Francoist regime asserted itself, to the disillusionment of the young Falangists who had taken seriously the modernizing, anti-capitalist, and anti-élitist elements in their party's original program.

Given the counter-revolutionary purpose of the Francoist dictatorship, it was not surprising that the Catholic church – or, more specifically, the integrist version of Spanish Catholicism – would ultimately determine its cultural and social values. Official Catholic support for the military rebellion emerged within weeks after the rising and the revolutionary assault on church property and personnel in the Republican zone. Leading Catholic bishops were soon referring to the war as a sacred crusade, a new Reconquest to rid the nation of atheism, communism, and other imported heresies. Military chaplains were officially attached to army units, and religious ceremonies became a salient feature of public and private life in the Nationalist zone. In an informal agreement with the primate of Spain, Cardinal Gomá, at the end of 1936, Franco promised to respect the autonomy of the Spanish church and to restore its traditional rights and privileges. The following July, the ecclesiastical hierarchy published a collective pastoral letter that endorsed the Nationalist cause as an ideological war in defense of national culture and tradition. Simultaneously, the church sought to undermine the influence of the Falange in the nascent regime. Spanish fascism, Catholic ideologues insisted, "must be supported, in its form, on an historical Catholic–traditional essence . . . Spanish fascism will be . . . the religion of religion."[1]

Seeking to shape the values and behaviors of the nation's youth, Falangists and Catholics competed strenuously to control schooling in the Nationalist zone. Franco revealed his own conservative leanings by entrusting education and cultural policy from the beginning to a succession of right-wing Catholic interest groups – first Catholic Action, then the National Catholic Association of Propagandists, and in the 1960s, the Catholic lay institute, Opus Dei. Rivals in the political arena, these Catholic groups were linked by their adherence to the counter-revolutionary political and cultural program now known as National Catholicism. National Catholic ideologues asserted that Spanish national identity and purpose had crystallized in sixteenth-century Castile with the fusion of the "Catholic ideal" and the "military monarchy." Divergence from that immutable national heritage was by definition anti-

patriotic and anti-national; thus, political liberalism and democracy, cultural pluralism, secularization, and movements for regional autonomy represented illegitimate deviations from the historical trajectory of the nation. The providential mission of the Nationalist "Crusade" was to restore the spiritual and political unity of the imperial Golden Age and thereby to rescue the nation from the humiliation and moral debasement to which it had been condemned by "bad Spaniards" and their foreign allies.

In the Nationalist zone, National Catholic efforts to "re-Christianize" and "Hispanize" Spanish schools began immediately after the July rising. Initial decrees abolished co-education, reinstated the teaching of religion and sacred history, and mandated a purge of teachers, textbooks, and school libraries to eliminate the "atheistic" and "materialistic" doctrines that had allegedly spawned the "incredulous and anarchic generations" currently running amok in the Popular Front zone. By the end of the war, up to 30 percent of the primary school teaching corps had been dismissed, transferred or demoted; those who survived the purge were subjected to retraining in the principles of National Catholicism. Despite this early attention to the ideological purification of primary schooling, however, the Francoist regime in the two decades that followed the Civil War invested little money or attention in elementary education. Neither Spain's agrarian economy nor its authoritarian social and political structures stood to gain from the creation of an educated populace.

In September 1938, secondary education was restructured along élitist, Catholic, and authoritarian lines. Over the objections of the Falange, the minister of National Education, the Catholic monarchist Pedro Sainz Rodríguez, closed "superfluous" state schools and encouraged the expansion of the private sector. By 1950 private schools – nearly all run by the religious orders – educated close to 50 percent of all students studying for the *bachillerato*. A decree of 1943 placed the National Catholic imprint on higher education as well. Capture of the major university chairs and of the research institutes in the Higher Council of Scientific Investigation (CSIC) by the Opus Dei confirmed the Catholic victory over their Falangist rivals in the cultural arena. Catholic control of schooling and intellectual production was used to inculcate an exclusionary view of national history and identity that denied legitimacy to the entire national tradition of progressive thought.

During the war the number of civilians executed by the Nationalists equaled the number of victims of the Red Terror in the Republican zone.

Having demonized their opponents as anarchic and "anti-Spanish" barbarians, the Nationalists predictably rejected Republican proposals for a peace of reconciliation at the end of the war. Instead, a Law of Political Responsibilities of February 1939 specified a long list of political crimes and applied them retroactively to October 1934. By the end of the year political prisoners officially numbered 270,719. The following year a Law for the Suppression of Masonry and Communism extended the definition of political crimes to include sympathy for doctrines that Franco and his allies deemed incompatible with national values. In the immediate post-war years, military tribunals sentenced tens of thousands of political prisoners to death; under the slogan "redemption through work," thousands more were assigned to reconstruction projects, including the massive war memorial, the Valley of the Fallen, where first José Antonio Primo de Rivera, and much later, Franco himself, were buried. Even after their release, former Republicans were denied access to military pensions, ration coupons, job permits, and the other benefits that were reserved for "good Spaniards." Little wonder that 300,000 of the nearly half million Spaniards who escaped into exile in 1939 never returned to their homeland.[2]

In the conditions of extreme scarcity that prevailed after the war, the permanent division of Spanish society into victors and vanquished affected even those who managed to escape imprisonment, death, or exile. By 1939 industrial and agricultural production had fallen 20 to 30 percent below pre-war levels, but recovery was stymied by the post-war policy of economic autarky. Predicting industrial self-sufficiency within ten years, the Francoist state sharply curtailed imports, restricted the investment of foreign capital in domestic enterprises, and subsidized capital industries like railroads, steel, chemicals, and shipbuilding through the National Institute of Industry (INI), a state-owned holding and investment company. Protected from foreign competition and unable to acquire capital, resources, and equipment at competitive prices from abroad, Spanish industries produced goods inefficiently and expensively. In the meantime, agriculture stagnated as Franco repaid his debt to the landed oligarchy with low labor and investment costs, a protected market, and high prices. A regressive tax system further exacerbated the distortions in the economy. The resulting shortages and inflation spawned a massive black market that allocated scarce resources to those with cash, extra ration coupons, and connections – commodities reserved for the victors. Unemployment and under-employment were

the fate of those defeated in the Civil War and even of many who had fought for the Nationalists, especially in the impoverished countryside. Through the vertical syndicates, the state controlled the labor market, set wages, and imposed work rules favorable to capital: strikes, independent bargaining, and walk-outs were illegal. In the immediate post-war period (1940–1945), malnutrition, low infant birth weights, and disease led to at least 200,000 excess deaths over the 1935 mortality rate. Those suffering most were least likely to receive help from the social welfare agencies controlled by the Movement because of their Republican backgrounds.

Autarky in 1940s Spain was not only economic, but also cultural. The ultimate goal of the regime was to halt and, eventually, to reverse social and cultural modernization by extirpating the sources of contamination at home and preventing their further penetration from abroad. The dictatorship aimed to re-establish traditionally "Spanish" values, social hierarchies, gender roles, and cultural norms by rigorously controlling all forms of individual or collective expression. Agencies of the state suppressed unauthorized civic activity, crushed labor protest, gave force of law to Catholic morality, regulated schools and schooling, and censored books, films, and the press. In Catalonia and the Basque Provinces, the autonomy statutes granted by the Republic were rescinded and public use of Catalan and Basque was proscribed.

The reaffirmation and institutionalization of patriarchal family structures and gender roles reinforced the repressive policies of the state. The church and the Sección Feminina shared responsibility for socializing women in the traditional virtues of piety, self-sacrifice, humility, and above all, chastity. Schools of the religious orders monopolized the education of upper- and middle-class girls; through the Social Service (a public service program theoretically mandatory for all single women between the ages of seventeen and thirty-five aspiring to paid employment), the Falange inculcated authoritarian political and cultural values. Married women were excluded by law from the labor force, ostensibly so that they might devote themselves full time to their "sacred responsibilities" as wives and mothers. But in a society where imprisonment or forced unemployment of the head of the household sentenced thousands of working-class families to desperate poverty, this law was not only hypocritical, but impossible to enforce. Equally hypocritical was the puritanical moralizing of a regime that condoned prostitution and political corruption on a large scale. Nevertheless, the attempt to isolate Span-

ish society from the outside world and to resuscitate archaic social values and behaviors was generally successful, not least because they seemed to satisfy a widespread longing for order and authority among the Spanish middle classes.

The economic independence sought by Franco was compromised by the financial obligations the Nationalists had contracted during the Civil War with their chief allies, Italy and Germany. Hitler, in particular, insisted on full repayment, primarily through mining concessions awarded to German companies. Franco further repaid his debt by subscribing to the Anti-Comintern Pact and withdrawing from the League of Nations shortly after the end of the Civil War, although he maintained neutrality at the outbreak of the world war a few months later. With the fall of France in June 1940, however, the dictator saw an opportunity to bargain with Germany for Spanish entry into the war and thereby to realize the "imperial" ambitions of his military and Falangist supporters. But Franco's price for active belligerence – expansion of Spain's territorial holdings in north Africa and military support for the conquest of Gibraltar – was too steep for Hitler, who proved unwilling to alienate Vichy France in exchange for an ally of dubious military value. After the Nazi invasion of the Soviet Union in June 1941, Franco sent the "Blue Division" of military and Falangist volunteers to fight at the orders of the German army at Leningrad and agreed to provide German war industries with Spanish workers. Hitler still rejected the terms that Franco set for full belligerence, and with the defeat of the German armies at Stalingrad the next winter, the moment for Spanish intervention passed. Franco later boasted of his skill in keeping Spain out of the Second World War, but it would be truer to say that only his excessive demands and notorious caution spared the nation further suffering.

From mid-1942 onward, Franco began to modify his diplomacy, if not his sympathies, a shift encouraged by the growing discontent of civilian and military monarchists angered by his refusal to relinquish power to the heir to the throne, Don Juan de Borbón. Still convinced that democracy was the root of all Spain's political and social ills, Franco nevertheless began to hedge his bets against an Allied victory by providing his dictatorship with pseudo-constitutional window dressing. A law of July 1942 proclaimed Spain to be an "organic democracy" whose "natural" corporate groupings were to be represented in a Cortes composed of deputies appointed by Franco and the Movement. Subsequent legislation reaffirmed Franco's sole and unlimited authority by defining the Cortes

as "neither a consultative body nor a parliament but the highest organ of participation in the work of the state." After the Allied victory in 1945, Franco issued the "*Fuero* of the Spaniards," a heavily qualified bill of rights that explicitly excluded the right to attack Spain's "spiritual, national, and social unity." Resolution of the monarchical question was delayed until 1947, when Franco disappointed both Carlist and Alfonsine partisans by declaring Spain to be a "monarchy without a monarch," reserving to himself for life the titles of head of state, head of the government, and head of the Movement. Franco also retained the right to appoint his royal successor and to revoke the appointment should the designated candidate subsequently fail to adhere to the "fundamental principles" of the state. This provision, which breached the historic rules of dynastic succession and also the principle of popular sovereignty, was condemned by both exiled pretenders to the throne.

Although Franco's deferral of the monarchist question pleased the anti-monarchist Falange, it did not signify the Movement's victory over its rivals within the Francoist coalition. On the contrary, simultaneously with this superficial approximation to constitutionality, the fascist elements in Francoist political culture were allowed to wither away and the most zealous Falangists sidelined. In compensation, the regime strengthened its Catholic identity by providing for ecclesiastical representation in state institutions, extending church privileges and subsidies, and enforcing church teaching on educational and social issues. The reward for this courtship was the 1953 Concordat with the Vatican, which lent international legitimization to the Francoist dictatorship.

Although the façade of constitutionality did not deceive the victorious Allies, neither were they moved to dislodge General Franco after the war, preferring a reasonably stable dictatorship to a potentially chaotic situation susceptible to a Communist take-over. They thus took refuge in the principle of self-determination, declaring that only Spaniards themselves could effect a change of regime. Hoping to isolate and weaken the dictator, the Allies recalled ambassadors, excluded Spain from the United Nations, and disqualified the regime from receiving aid under the Marshall Plan. International ostracism played into Franco's hands, however, by arousing a xenophobic nationalism among Spaniards, who accepted Franco's defiant claim that Spain's diplomatic isolation was but the latest instance of foreign incomprehension of cherished national traditions. In the meantime, Franco moved to strengthen ties with sympathetic authoritarian regimes in Latin America under the banner of

"Hispanidad," an essentialist doctrine that proclaimed the cultural and religious unity of the Hispanic peoples in the Old World and the New. Celebration of Spain's spiritual legacy in the Americas also served, however inadequately, as compensation for the regime's inability to satisfy the imperialist longings of its nationalist supporters.

Ultimately, the Franco regime owed its survival to mounting Cold War tensions. Boasting of his crusade against Spanish communism during the Civil War, Franco posed as the "sentry of the West," holding the line against Red encroachment in the heartland of Christian civilization. Diplomatic recognition was restored in 1950; three years later, Spain signed a bilateral agreement with the United States that authorized the construction of three American air bases and a naval base in exchange for military aid to modernize Spain's antiquated armed forces and economic aid to stimulate growth in an economy still hobbled by the regime's autarkic policies.

Significant economic liberalization, however, did not begin until the late 1950s, when technocrats affiliated with Opus Dei gained control over key ministries in the cabinet. Fearing that rising social conflict might destroy the dictatorship and the traditional Catholic culture it guaranteed, the Opus ministers advocated controlled economic modernization that would raise living standards without raising expectations for political change. Between 1957 and 1964 they stabilized the *peseta*, lifted import restrictions and limits on foreign investment, authorized collective bargaining (within the official syndicalist structure), and laid the groundwork for rationalized state economic investment and planning. Belatedly discovering the importance of "human capital," they sponsored the expansion and modernization of the state educational system at all levels. With these reforms in place, the stage was set for the "Spanish miracle." The rapid economic growth of 1960–1973, when Spain's GDP rose at an average annual rate of 7.2 percent, transformed Spain's agrarian economy into an industrial one. By 1975 only 29 percent of the active population earned their living in agriculture, 70 percent of the population lived in cities, and per capita income had risen from $300 to $2,246 a year.

To be sure, economic development and prosperity were not evenly distributed. Wages were still lower and the working week longer than in the rest of Europe. Hindered by lack of capital and inefficient land tenure patterns, agriculture continued to stagnate, although the chronic unemployment of landless peasants in the *latifundia* regions of Andalusia

was finally resolved through massive emigration to western Europe and to urban centers in northern Spain. Uncompetitive Spanish industries proved unable to generate investment capital through foreign trade, but the trade gap was offset by emigrant remittances, foreign capital investment, and tourism, the biggest growth industry of the decade. Illiteracy was essentially eradicated by 1970, but access to secondary and higher education still differed widely by class and place of residence.

The increase in living standards was accompanied by the emergence of a mass consumer culture whose principal commodities were television, film, and football. By promoting a "culture of evasion" and the pursuit of consumer durables, the regime sought to distract the public and to forestall demands for greater political and cultural freedom. It also encouraged political demobilization by abandoning the dichotomizing triumphalist rhetoric of the post-war years. Where once the dictatorship had divided the nation into "true" and "false" Spaniards, it now adopted communitarian rhetoric that emphasized "twenty-five years of peace," national unity, progress, and prosperity. In support of the regime's (unsuccessful) application to the Common Market, it also toned down the National Catholic celebration of Spain's "difference" from her European neighbors (although echoes survived in the advertising campaign aimed at promoting tourism). Altogether, the official stance of the dictatorship from the 1960s onward was to emphasize Spain's modernity, unity, and stability and to legitimate itself to both Spaniards and foreigners as the creator and guarantor of these virtues. Ironically, this reconceptualization of national identity may well have served to convince Spaniards of their capacity to make a peaceful transition to democracy after the dictator's death.

Contrary to the predictions of the Opus technocrats, however, rising material well-being subverted the Francoist "peace" by exposing the political and cultural gulf that still separated Spain from her European neighbors. In 1962 a wave of strike activity, led by clandestine "Workers' Commissions" organized by the Spanish Communist Party, inaugurated what would soon become a protracted struggle by the Spanish working class to win the right to independent collective bargaining. Continuing abridgment of academic and cultural freedom provoked student unrest and nourished an alternative culture of protest and contestation. In Catalonia and the Basque Provinces, demands for linguistic, cultural, and political self-determination resurfaced. Meanwhile, the liberal edicts of Vatican II, the appointment of a new generation of bishops, the emer-

gence of a Christian Democratic tendency among former regime supporters, and the activism of young priests encouraged the church hierarchy to put some distance between itself and the dictatorship.

Reflecting internal tensions within the governing coalition (divided into immobilists and liberalizers), the regime responded schizophrenically to this growing ferment. Repression of political dissent continued – most vigorously, in Euskadi, where relentless pursuit of the Basque nationalist terrorist organization, ETA, created a receptive climate for the emergence of a more broadly based Basque nationalist movement. On the other hand, the regime made minor concessions intended to appease mounting demands for liberalization. In 1967 an "Organic Law" expanded the Cortes to include popularly elected "heads of household" and approved the expression of "legitimate contrasts of opinion" (although not the formation of political parties). Shortly thereafter, new laws extended freedom of worship, authorized linguistic and cultural expression in peninsular languages other than Castilian, and relaxed state censorship. Predictably, these concessions only clarified the absence of real political self-determination and thus heightened, rather than diminished, the tensions in Spanish society. Disunity among opposition forces precluded any serious assault on the dictatorship, but their principled refusal to accept the legitimacy of the regime's wan reformist gestures helped to define a real democratic alternative for the future.

As Franco advanced in age (he turned seventy in 1962), the question of how to guarantee the continuity of the regime acquired new urgency. The succession to the throne was settled in 1969, when the Cortes endorsed Franco's choice, Juan Carlos, the eldest son of the legitimate heir, Don Juan. Educated in Spain under the watchful eye of the Caudillo since age ten, Juan Carlos swore allegiance to Franco and the Movement in July 1969, thus disappointing the liberal supporters of his father, as well as Carlists and anti-monarchist Falangists. The official selection of Juan Carlos represented a victory for Admiral Luis Carrero Blanco, the vice-president of the government and an opponent of liberalization, and for the Opus technocrats, who were indifferent, when not hostile, to political reformism. The political ascendancy of Carrero marked an end to the timid liberalization measures of the mid-1960s and a return to a hard-line policy on labor and student unrest, press censorship, and Basque terrorism. But the spirit of criticism had spread too widely to permit an easy return to the "peace" of the 1940s and 1950s. By late 1973 Carrero, who had been named prime minister that June, was attempting to reopen a

limited dialogue about the future of the regime when he was assassinated by an ETA commando unit.

With Carrero Blanco died the hopes of the "continuists" who favored a moderate evolution of the regime towards greater freedom and political participation. Carrero's successors veered erratically between conciliation of the increasingly confident and vocal opposition and repression intended to appease the "bunker" of die-hard Franco loyalists. Yet repression, aimed with special ferocity at Basque nationalism, only provoked further terrorism and strengthened the opposition's claim that only a complete break with the dictatorship would restore civil peace. Franco, weakened by phlebitis in 1974 and in severe decline from mid-1975 onward, resisted to the end any meaningful democratization of the state. Shortly before his death on 20 November 1975, he wrote a final testament to the Spanish people, in which he insisted that his only personal enemies were those who were also the "enemies of Spain." Franco's revival of the rhetoric of the two Spains merely revealed how isolated the dictator had become from a society that had changed radically since the Civil War and the Nationalist victory of forty years earlier. In spite of – not because of – the Francoist dictatorship, broad segments of Spanish society in 1975 were eager to accept the rules of democratic political life, including acceptance of the principle of a loyal opposition and of honest disagreement about political means and ends. Within two years of Franco's death, King Juan Carlos I and his prime minister Adolfo Suárez negotiated the transition to a stable constitutional monarchy, in which political pluralism, representative democracy, and cultural freedom are fundamental political values.

NOTES

1. José Penmartín Sanjuán, ¿Qué es 'lo nuevo'?: Consideraciones sobre el momento español del presente (2nd edn., Santander: Aldus, 1938), pp. 69, 63.
2. Estimates of the number of civilians executed by the Nationalist forces during and after the Civil War vary widely. Using the calculations of the pro-Franco military historians, Ramón and Jesús Salas Larrazábal, Payne has estimated Nationalist executions at 70,000–72,000 from 1936 to 1950. Other historians have placed the figures as high as 200,000. Stanley G. Payne, The Franco Regime, 1936–1975 (Madison: University of Wisconsin Press, 1987), pp. 209–228.

FOR FURTHER READING

Abella, Rafael. La vida cotidiana en España bajo el régimen de Franco. Barcelona: Editorial Arcos Vergara, 1984.
Alpert, Michael. A New International History of the Spanish Civil War. Basingstoke: Macmillan, 1994.

Boyd, Carolyn P. *Historia Patria: Politics, History, and National Identity in Spain, 1875–1975*. Princeton, N. J.: Princeton University Press, 1997.

Carr, Raymond. *The Civil War in Spain*. London: Weidenfeld and Nicolson, 1986.

Carr, Raymond and Juan Pablo Fusi. *Spain: Dictatorship to Democracy*. 2nd edn. London: George Allen and Unwin, 1981.

Ellwood, Sheelagh. *Spanish Fascism in the Franco Era: Falange Española de las JONS, 1936–76*. London: Macmillan, 1987.

Esenwein, George and Adrian Shubert. *Spain at War: The Spanish Civil War in Context, 1931–1939*. New York: Longman, 1995.

Jackson, Gabriel. *The Spanish Republic and the Civil War, 1931–1939*. Princeton, NJ: Princeton University Press, 1965.

Lannon, Frances. *Persecution, Privilege, and Prophecy: The Catholic Church in Spain, 1875–1975*. New York: Oxford University Press, 1987.

Nash, Mary. *Defying Male Civilization: Women in the Spanish Civil War*. Denver, CO: Arden Press, 1995.

Payne, Stanley G. *The Franco Regime, 1936–1975*. Madison: University of Wisconsin Press, 1987

Preston, Paul. *Franco: A Biography*. New York: Harper Collins, 1993.

The Spanish Civil War, 1936–39. London: Weidenfeld and Nicolson, 1986.

Shubert, Adrian. *A Social History of Modern Spain*. London and Boston, MA: Unwin Hyman, 1990.

Thomas, Hugh. *The Spanish Civil War*. 2nd edn. New York: Harper and Row, 1977.

7

History, politics, and culture, 1975–1996

104 A few months after Franco's death, many observers feared "that Spain may well revert, in the not too distant future, to the pattern or the path it had entered in the thirties, a pattern of extreme and polarized pluralism," an experiment in democracy which had been "chaotic and far too brief."[1] In general, these observers continued to see Spanish society as torn by conflict – in keeping with the myth of the two Spains – as well as prone to violence and the extermination of the adversary. Even though the level of political violence in Spain since 1875 had been significantly lower than in other European countries, the dramatic experience of the Civil War had contributed to this image of backwardness, lack of civic culture, extremism, passion and cruelty. "Spain for some time to come needs to live under an authoritarian regime," wrote Gerald Brenan in 1950, when he perceived the belief that parliamentary democracy could be an alternative to Franco to be a "very dangerous illusion."[2] Twenty years after that, no one was sure how Spaniards would react to Franco's death and many feared that they might simply revert to old, violent habits.

They did not. In a very short space of time, and without having had the opportunity to benefit from the experiences of other nations in their transitions to democracy from authoritarian regimes, Spain very peacefully dismantled the institutions of the Franco dictatorship and put new democratic institutions into their place, with a democratic constitution, within a process which at first caused great surprise, and then led to much analysis. Among these analyses, there was the theory – expounded by those who, not having witnessed a full-scale revolution, felt that Spanish democracy had been "handed down" – that out of fear of a return to a civil war, Spaniards had accepted the Franco regime, with different trap-

pings, and that even now, Spain was living not in a democracy but in post-Francoism.[3] This theory held that Francoism and its values were so firmly ingrained in the Spanish political culture that Spaniards cynically had ended up adapting themselves to the lesser evil of being led towards democracy by the same political class that had been behind the dictatorial regime.

None of those contradictory visions – of an outbreak of violence and of fear of freedom – had taken into account the profound change that had come over Spanish political culture after 1956, when the first generation of university intellectuals who had not participated in the war first made their mark on public life. Nor did they take into account the impact of the mobilization of a new industrial working class after 1962. The massive movement away from rural areas, emigration, the end of autarky, the opening up of the country, the gradual integration into the international market, the flow of capital and the influx of money from abroad – the implantation, in short, of a capitalist market economy – brought about, from the beginning of the 1960s, a profound change in society as well as significant modifications in the composition, habits and speech patterns of the middle and working classes. The working classes entered the factories and underwent a rapid transformation, while the middle classes became technicians and managers within a market economy that was growing rapidly.

The shift towards democratic values of the working class was linked to new union activity which combined the negotiation of labor contracts with the negotiated resolution of collective conflicts via strikes called by clandestine organizations operating from within the official unions. From their position in favor of the struggle for better working conditions under a dictatorial regime, working-class leaders incorporated within their demands the idea of solidarity with other workers on the questions of strikes, freedom of union affiliation and political democracy.[4] The union became an instrument of recovery and for making certain demands for certain freedoms and ceased to be perceived as a fermenter of revolution, as had been the case until the Civil War. During the 1950s and 1960s, the middle classes had also undergone a very significant change in attitude, as reflected in the fact that many children of the victors in the Civil War had publicly come out in favor of democracy and against the regime, alongside many children of the defeated. The deep divide within the middle class – caused by religious and ideological differences – became even more pronounced within the new idea of

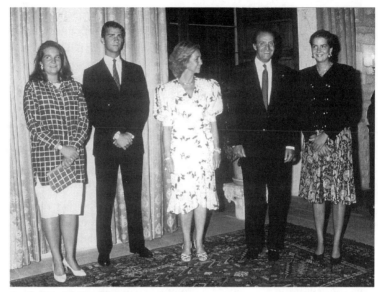

6. The Spanish Royal Family

national reconciliation, above and beyond victory or defeat in the Civil War. This idea centered around the notion of recovering democracy as the only possible system under which Spaniards could live with one another.

By the end of this process, during the final years of the Franco regime, the vast majority of Spaniards saw it as normal that the political future of the country should be similar to the present of other European countries. New generations which had not participated in the war, which had emigrated to European countries in search of work, or which had gone *en masse* to university and then on to post-graduate work in Europe and the United States, could not conceive of a future which was not similar to their neighbors', with whom they had great historical links and with whom they were now beginning to have greater commercial and cultural exchanges. The idea of securing liberties similar to those enjoyed in other European countries was always closely linked to the notion of stability. Professionals, company managers, and workers were the social group amongst whom democratic values were most firmly ingrained and for whom the notion of the existence of parties was widespread. But with the exception of university students, the growing middle classes had never been moved to mass mobilization against the regime, as had been the case against Alfonso XIII. The working classes, in spite of the increase in

the number of strikes called, never followed the call for a "peaceful, political general strike," so often made from the ranks of the clandestine Spanish Communist Party. People began to prefer democracy as a political value – as long as it did not mean generalized disorder.

The majority of the population, although ready to alter the values it had held during the first two decades after the Civil War, was still not willing to place political freedom and democracy above everything else. The years of economic development had seen the emergence of a sector of society – between a quarter and a third of the population – which was under the age of thirty-five, resident in urban areas, more educated, more tolerant, democratic, and pluralist. At the same time, there had been a significant reduction in those who completely identified with the regime, no more than 15 percent of the population, among members of the middle and lower middle class who were over the age of thirty. But although it is true that the values of peace, order, and stability declined as the first preference of Spaniards (from 71 to 46 percent between 1966 and 1976) and that justice, freedom, and democracy as positive values rose from 20 to 40 percent during that same period, it is also true that the level of distrust and lack of interest as far as politics was concerned was very high, while there was a greater interest in and priority for private matters over collective tasks: the level of active involvement and interest in politics was still very low. Hence the reason for the ambiguity in political sentiments: the aspiration for freedom existed alongside the desire to maintain stability. A survey carried out at the end of 1976 showed that the only issue on which over 90 percent of Spaniards were agreed was that "Spaniards desired a situation of general harmony" and that "the best way to secure freedom of expression was through order" (*El País*, 8 December 1976).

If the great changes in society and attitude of the previous fifteen years served as a firm base for a peaceful transition from dictatorship to democracy, the strategy adopted by the political élite was going to be crucial to the final result. The Franco regime had been sustained on a coalition of political groups which had begun to suffer serious internal conflicts in 1969, when Prince Juan Carlos was designated as the future king of Spain and Franco's successor. Upon Franco's death in 1975 there were serious differences among those bent on maintaining an authoritarian regime, something exceptional within Europe, and those who wished for the introduction of reforms geared towards opening the regime to more moderate sectors of the opposition. From the end of that year, both

sectors sought to use the king for their own ends, with the former inclined towards the continuity of the Franco regime through him, believing that he should be faithful to its ideals. The latter were bent on making him the motor of change. At the beginning the king appeared to be in favor of the former, and a guarantor of the continuity of the regime, although he did seek to appease the reformists: the first president of the government of his monarchy was the same person who had been the last president of the dictatorial era, Carlos Arias Navarro. Yet he had had to accept three distinguished reformists as ministers of Foreign Affairs, the Interior, and Justice respectively, in the persons of José María de Areilza, Manuel Fraga, and Antonio Garrigues.

In the opposition, the different groups and parties formed around the Communist Party, in a Democratic Junta, and around the Socialist Party, in a Plataforma de Convergencia Democrática, which pushed for a break with the regime that would lead to true democracy. In its earliest stages, the democratic break-up implied the formation of a provisional government which would have to call general elections within a year of its constitution. It therefore demanded the immediate legalization of all political parties, the restoration of the fundamental rights of meeting and association, and the return to Spain of political exiles with full amnesty. In March 1976, the Junta and the Plataforma signed an agreement which gave birth to one single organization, Coordinación Democrática, which also called for those minimum conditions in order to mark the break with the past regime, although it slightly toned down the concept of "provisional government," which sounded too revolutionary, and adopted instead the term "a government of a broad democratic consensus." The opposition parties adopted a strategy of negotiating with the government regarding the conditions of the break while they were calling for massive public mobilization for amnesty and democracy.

Neither continuists nor reformists managed to secure the support of the vast majority of the population, no doubt because neither side had taken into account the profound change that had come over Spanish political culture in recent years. The continuists confused passive adaptation to the dictatorship with active support for the regime because of its economic efficiency and because of the access to the products of the new consumer society on the part of a significant portion of the working and middle classes. They thought that by allowing a minimum amount of openness and by installing a kind of "handed down" democracy, they could remain in power forever. Those in favor of a complete break with

the past had not realized, when they called for massive mobilization, that if the political horizon of the majority of the population was democracy and Europe, the way to get there could not be by veering from the path of order and stability. Some still dreamt of a repetition of the massive popular mobilization of the kind that had dethroned Alfonso XIII in 1931.

So, with the year 1976 passing by, neither tendency managed to achieve its aims. One side was frustrated by the uncompromising sector of the regime, the other by its own intrinsic weaknesses. The king therefore intervened personally at the beginning of June, when he declared before the United States Congress his desire to achieve full democracy and said that Carlos Arias's government had been "an unmitigated disaster" (El País, 3 June 1976).[5] A few weeks later, when the hopes for democratic change met with the opposition of the Movement, the king called on Arias to resign, and on 3 July 1976, via the mechanisms allowed him by Francoist laws, he appointed Adolfo Suárez, former general secretary of the Movement, as the new president of the government.

With that appointment – which was initially received with great surprise by the opposition and public opinion alike – began the decisive phase of the crisis between the Francoist regime and the beginning of democracy. The new government very quickly presented its program, in which for the first time it recognized popular sovereignty. It also promised a broad amnesty, announced its intention to call a referendum on a Law of Political Reform and promised to call general elections before 30 June of the following year. With such a declaration a new project towards political transition began, aimed at achieving democracy without breaking with the existing legal framework. The government was to present to the Francoist institutions a text which, if approved by those institutions, was going to bring about the end of those very institutions.

In the months that followed, Adolfo Suárez negotiated the transition process with those sectors of the Francoist regime which had been opposed to the first reforms and, after securing the neutrality of the armed forces, got the Cortes to approve the Law of Political Reform, which envisaged general elections and the election of the Cortes by universal suffrage. The vote in favor given by the Francoist Cortes was the stepping stone towards the democratic process which had been initiated by Suárez with the full support of the king, since that vote was the guarantee of the legality of the referendum which had been called to ratify the law. In spite of a feeble abstentionist campaign instigated by the

opposition, the referendum was a success for the government which, from then on, felt legitimately able to negotiate – with a commission made up of representatives from the major opposition groups – the political measures which, within six months, were going to lead to Spain's first free general elections for forty-one years.

The opposition accepted the new ground opened by the referendum and demanded neither the formation of a provisional government nor an ample democratic consensus. Nor did it question the legitimacy of Suárez's government. After January 1977, opposition interest centered around the questions regarding procedure, election law, demand for the legalization of all political parties without prior government approval, and the dissolution of the political and repressive institutions of the Franco regime, such as the Tribunal de Orden Público (Public Order), the Movement, and the Trade Union Organization. The granting of amnesty and the legalization of the Communist Party – after the gruesome murder of lawyers representing the communist group in their office in 1977 – was a significant step towards the legitimization of the electoral process, as well as of the subsequent general elections, in which all the parties participated freely.

The results of the first general elections of the new democratic era, held on 15 June 1977, confirmed the moderate tendencies of the electorate and revealed that the old conflicts which had led to the failures of the attempts at democracy in Spain were not very much present in the Spanish psyche. The religious conflict had more or less blown over and there was no longer any debate as to the form the state should take: the king, who had been appointed by Franco as his successor, had managed to earn new democratic legitimacy for the monarchy as an institution, an institution which was now unlikely to be questioned. There only remained the ever-present tensions between the nationalists and the central state, as well as the doubts as to the efficiency and effectiveness of the new system for a society that had lived for forty years under an authoritarian regime.

Yet apart from confirming its moderate tendencies, the electorate also drastically reduced the number of parties and forced them into a policy of pact and negotiation: no party secured an absolute majority, though the two main forces, the Socialist Party and the Unión de Centro Democrático (UCD), did achieve 70 per cent of the seats between them. The fact that the parties at the extreme ends of the political spectrum achieved very poor results, and that the nationalists failed to secure majorities in their own regions, forced all the parties to maintain a policy of consensus in order to

approve a constitution acceptable to all. Economic crisis also pushed everyone in the same direction. This state of affairs resulted in the Pactos de Moncloa, which approved an economic policy aimed at regenerating the economy, the control of salary increases, and the elaboration of a constitution. Only the Basque Nationalists refused to take part in these talks.

Accompanying the Transition in those years, as its base and fundamental linchpin, was a rapid transformation in Spaniards' values and political attitudes. The elections of June 1977 saw the triumph of parties close to the center, on the left as well as on the right, and the small extremist groups on either side disappeared from the political map. The most significant feature was the relative youth of the leaders of the parties that triumphed: Adolfo Suárez and Felipe González, as well as the king, belonged to a generation of Spaniards that represented a break with the past and were of an age which meant that they could have no direct link with the Civil War.[6] Alianza Popular (AP), a party formed by Manuel Fraga with the relics of Francoism, the Communist Party (PCE), led by Santiago Carrillo, a well-known communist leader from the Civil War, and the Partido Socialista Español (PSE), led by "the old professor," Enrique Tierno Galván, all failed miserably. The election results were a breath of fresh air: freedom blew across the whole of Spanish society.

This climate of freedom allowed, in the short space of a few months, for the consolidation of democracy as "the central value of the political universe of the vast majority of Spaniards."[7] Those who are nostalgic for the Franco days or for any other form of authoritarianism have represented, since 1977, a very small and insignificant minority. The very rapid growth in the appreciation of democratic values gave rise, as a natural consequence of the Transition, to the suppression of censorship in artistic circles – which had been in force since the end of the war – and the recovery of the freedom of the press, which had disappeared after Franco's victory. In that new climate, almost everything seemed possible, from the making and exhibition of pornographic films to the birth of a newspaper of the quality of *El País*. In fact, the Transition was experienced and perceived as an explosion of freedom after forty years during which any form of cultural expression had had to go before a board of censors. This does not mean that during the Franco era Spain was a cultural desert. In fact, in the 1950s and 1960s there was a significant increase of production in the field of the plastic arts, a renewal in Spanish poetry and prose, and some of the most outstanding films in the history of the Spanish cinema were made.

The difference was that what had previously been the reserve of a few had now become "an explosion of pluralism."[8] The Ministry of Culture (previously the Ministry of Information), which had had the mission of presenting a tourist image of Spain, now recognized the pluralist character of Spanish culture, though this was not translated into any clearly defined new policy. Still, it was during the Transition that "the National Orchestra, the Youth Orchestra, the National Center of Dramatic Arts and the Classical Theater Company became unusually powerful forces."[9]

In addition, during those years of the Transition, certain outstanding figures of the "Generation of 1927" were still very active, and lent added impulse, vitality and dynamism to the situation. Some of them started to receive universal acclaim, as was the case of the poet Vicente Aleixandre (Nobel Prize for Literature, 1977); others returned to Spain after a long exile, as did the communist poet of the Republic, Rafael Alberti, who was made a senator in the first post-Franco Cortes. In this way the Spain of 1977 was able to identify itself with Spanish culture's so-called Silver Age (the Generation of 1927), and to prove that it had "been impossible to cut Spain off from the modern world."[10] Alongside these figures, others who had participated in the war or had experienced it as children felt the need to project their vision towards the past in an exercise of memory that encompassed the cinema, literature, and personal memory. In this sense it is completely false to say that the Transition was built around a kind of collective forgetting of the Civil War. Quite the opposite: the memories of Dionisio Ridruejo or Pedro Laín Entralgo, the novels of Juan Benet or Camilo José Cela, the theater of Antonio Buero Vallejo or the cinema of José Luis Borau and Carlos Saura were full of constant references to the Civil War and the years immediately after it, evoking memories of a time that many Spaniards had not experienced directly, but the effects of which they had suffered for a long time.[11]

However, a feeling of disenchantment soon followed this climate of new-found freedom, of preference for democratic values, for the presence of the past within the collective memory. This feeling of "disenchantment" was blown out of all proportion by the media. The end of Francoism was not followed by the best of all possible worlds, but by a political system under siege from many strong enemies. First of all, the governing party, the UCD, underwent a process of fragmentation and eventual disintegration after the proclamation of the constitution and the general elections which followed. Adolfo Suárez resigned as prime minister in January 1981, casting a long shadow of doubt and uncertainty over all

those who saw his televised address in which he announced his resignation or those who read it in the press: Spanish democracy once again appeared to be weak and fragile. In fact, a few weeks later, on 23 February, there was an attempted military coup, which again exposed the fragility of the country's democratic institutions. The king's rapid intervention together with the massive popular demonstration in favor of democracy provided the kind of political impulse necessary for the coup leaders to be tried and sentenced, though this was not enough to restore internal unity to the UCD. The governing party steadily disintegrated into small, insignificant, splinter groups, effectively digging its own grave, and was unable to put an end to the period of instability that had begun after the approval of the constitution. Suárez's successor, Leopoldo Calvo Sotelo, who was unable to command the support of his party, and whose own parliamentary group often stood in the way of his political initiatives, had no choice but to call elections for October 1982.

Thanks to the air of renewal they lent to the Spanish political scene and the mixture of radicalism announced in their program – as well as the pragmatic moderation they showed during the first stages of the Transition – the Spanish Socialist Party managed to win almost 30 percent of the votes in the first general elections held in June 1977. After this they became the second biggest political force in the country, only four percentage points behind the UCD. Those results put them way ahead of the Communists, who – some sociologists had predicted – would receive a level of support similar to that of their Italian counterparts at the end of the Second World War. From then on, the success the party began to enjoy seemed to open the door to immediate access to government. By the beginning of 1979, membership had increased tenfold, from an original figure of less than 2,000 in 1974. As the organization grew, Felipe González also grew in political stature and soon became the leader who would guarantee unity and internal discipline, tenets upon which the new ideology of moderate reformism was built, and which was symbolized by the removal of all references to Marxism and by the shelving of any project aimed at a gradual transition to socialism. After 1979 the Socialists began to use a new language in which the key words were no longer "working class," "democratic socialism," or "Federal Republic," but "modernization," "Europeanization," "democratic consolidation," and "the strong internal unity of Spain." They saw themselves as replacements for the bourgeoisie, ready, willing and capable of carrying out the task of transforming the country into a modern democracy.

With this new identity, they went to the polls in October 1982, a very delicate moment in the then still young and fragile new democracy. The memory of the recently aborted military coup, the disintegration of the ruling party, the series of crises into which the Communists had been plunged, and the widespread need to reaffirm the democratic will of the majority of Spaniards, gave those elections a dimension which went far beyond the ritual exercise of a simple democratic right. The level of participation was the highest ever recorded. From the 17.9 million votes cast in 1979, the figure rose to 20.9 million, of which the PSOE got 10.12 million, 4.6 million more than in 1979. In addition to reinforcing its image as a party with broad appeal, the PSOE won a comfortable parliamentary majority, with the AP finishing a very distant second. Although the Alianza had increased its share from 1.06 to 5.47 million votes, the PSOE was still some fifteen percentage points ahead.

The triumph of the socialists, the failure of the UCD, the relative success of the AP, the decline of the Communist Party, and the confirmation of the strength of the nationalists in Catalonia and the Basque Country all led to a crucial change in the party system. The previous "imperfect" two-party system gave way to a dominant-party system, with more than ten percentage points separating the first and second parties. To round off this overwhelming triumph, the regional elections of May 1983 brought a Socialist majority to all the regional parliaments, with the exception of Cantabria and the Balearic Islands. The Socialists now governed in Andalusia, Asturias, Aragón, the Canary Islands, Castilla La Mancha, Castilla-León, Valencia, Extremadura, Murcia and La Rioja.

This success could be attributed as much to the break-up of the UCD and the crisis of the Communists as to Socialist unity built around a strong and popular leader with a coherent electoral program. Of all the promises made, which were presented under the general banner of change, the ones that really captured the imagination of the electorate were the fight against unemployment – the Socialists promised to create some 800,000 new jobs – as well as their undertaking to call a referendum on Spain's continued membership of NATO. They talked of modernizing the country's production sector, helping small and medium-sized firms, combating tax fraud and giving new impetus to public enterprises. They also spoke in glowing terms of a more just society, with reforms in health, the social security system and education. The Socialists made a firm pledge to reform the civil service and to improve public services, and

spoke of greater autonomy in foreign policy. They presented themselves as a party willing not only to develop the classical policies of social democracy – growth and redistribution – but also to consolidate democracy and tackle the as-yet unfinished tasks of the creation of a more competitive economy, political decentralization and the modernization of the armed forces. And along with these general changes came a moral message: they were going to be the bearers of a new political ethic, of a project of moral regeneration for state and society.

Four years after coming to power, things could not have been better for the government. The worst of the economic crisis was over and a period of great activity and expansion, characterized by an annual rate of growth of 4 percent until 1991, was about to begin. The unemployment situation had also improved and there were no conflicts with the financial and business world, which was kindly disposed towards a government that had tackled the crisis with rigor and seriousness of purpose; and the specter of military coups seemed to have disappeared forever, with the army now completely subjected to civil power. The church had ceased to be a problem and the nationalists had found new and valid grounds for their political demands, though Basque terrorism continued to be a serious problem. Spain was now in the European Community, which was the fulfilment of the impossible dream of liberals and the enlightened alike. It was therefore hardly surprising that the Socialists repeated their success in the 1986 elections, though with far fewer votes. In contrast to the crises that social-democratic parties in northern Europe were going through and the increasing difficulties of their southern counterparts, the PSOE stood out as the only Socialist party in Europe with an absolute majority, ready and able to start another four-year term.

The stability which characterized the Spanish political scene after 1982 allowed the government to develop policies which stood in contradiction with its electoral program – without losing the support of the electorate. Thus, the NATO referendum was accepted as the price for Spain's entry into the European Economic Community as a full-fledged member, from 1 January 1986. The policy of economic readjustment and the confrontation with the unions were understood as the necessary base from which the accelerated growth of the late 1980s would later take place. Most of all, the not inconsiderable rise in taxes was taken as a necessary condition for the Spanish state to climb out from its historically impoverished condition and cover, in the short space of a few years, the ground which had hitherto separated it from the welfare states that

existed in Europe. Public spending rose from 25 percent to 49 percent of GDP in ten years. In general – and in spite of the growing discontent which was manifested in a general strike in December 1988 – the "pro-found disquiet" which had characterized the Spanish political scene from the end of 1979 to October 1982 was followed by a lengthy period of political exuberance, which continued until the end of 1989.[12] The PSOE, apart from being the dominant party, enjoyed throughout this period a prolonged "state of grace" which was reflected in the increasingly posi-tive view of the political situation and in the widespread sensation that democracy had overcome serious obstacles and had now reached a level of stability that was a guarantee against previous dangers.

This exuberance accounted for the fact that a feeling of tranquillity and security was now added to the air of freedom that had been blowing over the country since the beginning of the Transition. The cultural manifestations of the 1980s were a very good reflection of this: from the explosion of modern cultural expression – the so-called *movida* – which came to be associated with night life in the cities, to the proliferation of young novelists whose work was published and well received across Europe. Foreign policy, which was strongly orientated towards full and meaningful participation in the institutions of the European Union, gave rise to a certain thirst for modernism, an overriding interest in showing the rest of the world that Spaniards were perfectly modern – meaning that they were, finally, European. On the other hand, the consolidation of the system of regional governments, with the appear-ance of élites with a solid power base in the autonomous communities, produced a strong thrust towards local and regional (or national, in the case of Catalonia and the Basque Country) values, and this was released in what was commonly called "the recovery of identity," which had suppos-edly been lost during the long years of dictatorship and as a result of the process of social change which had taken place in the 1960s. The cultural institutions of each region and nationality received substantial govern-ment funding and the use of the Catalan, Galician, and Euskara lan-guages was consolidated and extended, thanks to the aid received from the regional governments in those areas. The increase in the number of universities was also a consequence of the emergence of local and regional power élites, to such an extent that today there is hardly a Span-ish province that does not have a university.

Between a European identity and other local and ethnic entities, the government's cultural policy was geared towards favoring the national –

the Spanish – by establishing or increasing awards and national prizes in the fields of literature, history, painting, music, etc., and also towards giving the country a significant cultural infrastructure, through the existence of institutions such as auditoriums and public libraries, which belonged to the state but were run by regional authorities. To these could be added the so-called "cultural centers" in virtually every town and municipality. With this policy, Madrid, as the capital of the Spanish state, Barcelona, which hosted the 1992 Olympics, and Seville, where the World Fair was held in 1992 to commemorate the five hundredth anniversary of the discovery of America, were the regional capitals that benefited most from this policy of investment and infrastructure. But things were not limited to only those three cities: from the beginning of the Transition, and especially in the late 1980s, when economic recovery took place, a significant number of auditoriums, museums, art exhibition centers and theaters have sprung up in Spain, allowing virtually every citizen access to culture.

It would, however, be an error to use the expression "socialist culture" to describe what has taken place in the cultural world of Spain since 1982; national awards have gone to artists and creators of very diverse ideologies, literary creation has been unhampered by ideological compromise, and historians have begun to have access to new sources in order to delve into the past as they saw fit. It is true that the Socialist government gave far more money to culture, but in 1982, with a society of such varied and pluralistic tastes, it would have been impossible to attempt any kind of revitalization of any official culture.

When the World Fair and the Olympic Games – the two major events that were used to present an image of modernization to the rest of the world – were over, a new era of frustration and bleak perspectives began. In December 1990 the deputy prime minister and real power broker of the PSOE, Alfonso Guerra, was forced to resign from the government as well as the party executive, after allegations of illegal financing. The rapid economic growth after 1986, which went hand in hand with easy money for speculators and adventurers, the continued domination of one party in power, the extraordinary rise in the level of public spending and heavy state investment in massive infrastructural works, the virtual lack of control mechanisms prior to the approval of major expenditure from the Ministry of Finance, political decentralization and the increase in expenditure from local and regional sources – coupled with rising costs of support for political parties – all brought about widespread corruption

that neither the government nor the PSOE seemed particularly anxious to curb.

A new economic recession was beginning, with an increase in unemployment which reached a record 24 percent. In spite of all this, the Socialists won the June 1993 general elections again, thanks mainly to Felipe González's leadership. This time, however, the margin of victory was not large enough to secure an absolute majority in the Cortes. There was also the risk of an internal break-up of the party, given the division between the "guerristas" (named after Alfonso Guerra) and the so-called "renewers." So, with a minority government and the party divided, the government now had to face the worst ever corruption scandals of the new democratic era, scandals which rocked institutions as important as the Bank of Spain and the Civil Guard. Even more serious was the reopening of the case of the government's illegal war against ETA, with accusations made against prominent politicians by two policemen who had already been condemned for their participation in the criminal activity of the police-sponsored clandestine anti-terrorist group GAL. These policemen started to point accusing fingers at their superiors, and in December 1994 the judge handling the case sent to prison the former Civil Governor of Vizcaya and the General Director for Security in the Ministry of the Interior during the Socialist government. Two months later, the same judge ordered the imprisonment of the ex-Secretary of State for Security and the general secretary of the Socialist Party in Vizcaya. News of those arrests had not yet died down when the bodies of two ETA militants, kidnapped by GAL in 1983, were discovered and identified in Alicante.

Almost at the same time, two leading figures in the business and financial world who had risen to prominence in the 1980s and who were extremely well connected with the political establishment in Madrid and Barcelona – Mario Conde, ex-president of the major bank Banesto, and Catalan businessman Javier de la Rosa – were also brought before the courts for tax fraud and embezzlement and subsequently sent to prison. What followed was an unmitigated disaster for the government. After those scandals came the affair of the papers allegedly removed from the CESID intelligence service, which could implicate well-known politicians in the creation and activities of GAL. These papers were put into public circulation through a network controlled by businessmen and politicians who had been arrested. The revelation that they contained significant references to telephone bugging and eavesdropping on political figures led to the resignation of two ministers close to Felipe

González: Deputy Prime Minister Narcís Serra, Minister of Defense at the time when the eavesdropping and recordings allegedly took place, and his successor, Julián García Vargas.

In the face of such a scandal, Jordi Pujol, president of the regional government of Catalonia, withdrew his parliamentary support for the government. Felipe González had no choice but to bring forward the general elections, which were called for 3 March 1996. Although the Spanish presidency of the European Union had been a success, and in spite of the economic recovery which was beginning, all forecasts pointed to a heavy Socialist defeat and to the Partido Popular (the former Alianza Popular) being able, for the first time, to form a government on its own, without having to seek parliamentary support. But the forecasts were proved wrong. With 9.4 million votes and 141 seats in parliament, the PSOE came a very close second to the PP, who only got 9.7 million and 156 seats, leaving them some way short of an absolute majority. It was sufficient to seek parliamentary support from the Basque and Catalan nationalists, who decided to lend the PP such support after lengthy negotiations from which they secured significant fiscal concessions.

This marked the end of a long period of "light and dark." During this period, democracy in Spain had been firmly consolidated and the specter of military intervention obliterated; Spain had opened its market to the international world and had become fully integrated, culturally and politically, into the European Union; it had experienced great economic growth, but had been unable to resolve its major problem – unemployment – which, at times, reached alarming proportions; it had satisfied the demands for autonomy of its different regions and nationalities, but had not resolved the problem of Basque terrorism; and it had modernized much of its infrastructure and many of its customs, but had not been able to rid itself of that strange mixture of cliques and family interests which, as in so many Latin countries, runs deep in the fabric of the political culture.

NOTES

1. Giovanni Sartori, *Parties and Party Systems* (New York: Cambridge University Press, 1976), p. 155.

2. Gerald Brenan, *The Face of Spain* (London: Turnstile Press, 1950), p. xvi.

3. Jo Labanyi, "Postmodernism and the Problem of Cultural Identity," pp. 396–406 in Helen Graham and Jo Labanyi (eds.), *Spanish Cultural Studies* (Oxford: Oxford University Press, 1995), p. 396.

4. José M. Maravall, *El desarrollo económico y la clase obrera* (Barcelona: Ariel, 1970), pp. 130–143.

5. See Charles T. Powell, *El piloto del cambio* (Barcelona: Planeta, 1991), pp. 168–175.

6. Cyrus L. Sulzberger, "Los comicios, dominados por tres hombres jóvenes," *El País*, 18 June 1977.

7. Jorge Benedicto, "La cultura política de los españoles. Un balance de casi dos décadas," *A Distancia* (primavera 1995), pp. 113–116.

8. Rafael López Pintor, "Continuidades y discontinuidades en las actitudes de los españoles," pp. 41–62 in Francisco López Casero, Walter Bernecker and Peter Waldmann (eds.), *El precio de la modernización* (Frankfurt am Main: Vervuet Verlag, 1994), p. 41.

9. Juan Pablo Fusi, "La cultura de la transición," *Revista de Occidente* 122–123 (1991), pp. 37–64, here p. 43.

10. Raymond Carr and Juan Pablo Fusi, *Spain: Dictatorship to Democracy* (2nd edn., London: George Allen and Unwin, 1981), p. 11.

11. See José Carlos Mainer, "Cultura," pp. 329–349 in Manuel Tuñón de Lara (ed.), *Historia de España*, vol. x (Barcelona: Labor, 1985).

12. José Ignacio Wert, "Sobre cultura política: legitimidad, desafección y malestar," pp. 113–151 in Javier Tussell, Emilio Lamo de Espinosa and Rafael Pardo (eds.), *España entre dos siglos* (Madrid: Alianza, 1996), p. 122.

FOR FURTHER READING

Aguero, Felipe. *Soldiers, Civilians, and Democracy: Post-Franco Spain in Comparative Perspective*. Baltimore, MD: Johns Hopkins University Press, 1995.

Alonso Zaldívar, Carlos. *España, fin de siglo*. Madrid: Alianza, 1992.

Arago, E. Ramón. *Spain: Democracy Regained*. 2nd edn. Boulder, CO: Westview Press, 1995.

Gunther, Richard. *Spanish Public Policy: From Dictatorship to Democracy*. Madrid: Instituto Juan March de Estudios e Investigaciones, 1996.

Juliá, Santos. *Los socialistas en la política española, 1879–1982*. Madrid: Taurus, 1997.

Lakauskas, Arvid John. *Regulating Finance: The Political Economy of Spanish Financial Policy from Franco to Democracy*. Ann Arbor, MI: University of Michigan Press, 1997.

Pérez Díaz, Víctor. *The Return of Civil Society: The Emergence of Democratic Spain*. Cambridge, MA: Harvard University Press, 1993.

Culture and prose

8

Narrative in culture, 1868–1936

Modernization arrived late and fitfully in Spain. Democratic 123
government, secular philosophy, industrialization, urbanization, and
social reform for women and the working classes only began to have a
major role in Spanish life after the September Revolution of 1868. It is no
coincidence that at the same time as Spain undertook social and ideolog-
ical modernization, Spanish fiction picked up the thread it had dropped
after the major accomplishments of the picaresque genre and *Don Quijote*
in the late sixteenth and early seventeenth centuries. The novel, a genre
whose form and length equipped it to reflect multiple social phenomena,
accompanied Spain on its belated journey into the modern era, recording
it, critiquing it, and helping to shape it.

Standing out among the novelists who chronicled the rapid changes
in Spanish social and political life after the ill-fated "Revolution" are
Juan Valera, José María Pereda, Pedro Antonio de Alarcón, Benito Pérez
Galdós, Emilia Pardo Bazán, Leopoldo Alas ("Clarín"), Armando Palacio
Valdés, and Vicente Blasco Ibáñez. Their ideological positions are widely
divergent, and in many ways their novelistic production of the period fol-
lowing the 1868 Revolution represents a national forum on the issues –
the position of the bourgeoisie (the third estate) and the working classes
vis-à-vis public policy and decision-making, the role of the church (espe-
cially the clergy) in public and private life, and women's place in society –
foregrounded during the brief revolutionary period (1868–1875). Euro-
pean philosophical rationalism, which finally made a mark on Spanish
thought through Julián Sanz del Río (a follower of the German philoso-
pher Karl Christian Friedrich Krause) from the 1860s onward, had im-
portant consequences for educational reform, especially in the founding
of the Asociación para la Enseñanza de la Mujer (Association for the

Instruction of Women, 1870) and the Institución Libre de Enseñanza (Institute of Independent Education, 1876).

The techniques of literary realism – attention to details of social custom and appearances – that the Spanish novelists were learning from Dickens, Balzac, and Flaubert, among others, perfectly suited the airing of these concerns. More wide-spread education for both sexes coalesced with the mercantilism of the age to promote a "commerce of the book" that favored increased novelistic production. According to Jean-François Botrel, there were more than 2,000 novelists in Spain in the nineteenth century. Many authors enhanced sales by writing serial novels, and the installment format had a hand in shaping the length of works and their plots. As Stephanie Sieburth and Alicia Andreu have demonstrated, there was a certain tension between popular and "high" literary forms in Benito Pérez Galdós's novels. The schism between popular and élite fiction became even more unbridgeable in the early twentieth century.

Many novels written after the Revolution enter into a dialogue with one another about social issues, some taking a more conservative position, others a more liberal one. A salient example of these "dialogues" is Juan Valera's *Pepita Jiménez* (1874) and Benito Pérez Galdós's *Doña Perfecta* (1876). *Pepita Jiménez* is a love story in which Luis, a naive candidate for the priesthood, unwittingly reveals in a series of letters to his priest-uncle his love for Pepita, a beautiful young widow who is sought in marriage by Luis's father. The potentially serious conflicts inherent in this situation are happily resolved with the young man's abandoning his pretensions to the priesthood to marry the widow, all of which the father, the uncle, and society at large accept quite amiably. Galdós projects a much gloomier view of rural Spanish life in *Doña Perfecta* in which local political interests and the church unite to impede the marriage of Doña Perfecta's daughter to a young man with modern secular and scientific ideas.

Pedro Antonio de Alarcón also casts an ironic eye on Spanish society in his classic novel *El sombrero de tres picos* (The Three-Cornered Hat, 1874). Set in the early nineteenth century when French cultural and political forms dominated Spain, its lighthearted "bed trick" plot is actually an acerbic commentary on decaying Spanish political traditions that continued to plague Spanish modernity, even at the end of the century. The Spanish realist novel, which got off to a good start during the six years of the "Revolution," settled into its maturity during the more reactionary Restoration period (1875–1902). Perhaps the conservatism (especially the increased role given the church in public life) and the political corruption

(*caciquismo* and falsified elections) that characterized the Restoration sharpened the need for narrative irony. The Restoration was a period of relative political peace, during which the bourgeois economy and cultural hegemony grew apace; readership of the novel, the bourgeois genre *par excellence*, increased concomitantly. Since the Restoration system of government did not allow for participation of the new workers' alliances, which were given the right to form syndicates in 1887, there was growing disaffection and militant action in that sector. A few feminists, such as Concepción Arenal and Emilia Pardo Bazán, were also beginning to take public stands on women's rights.

The vast novelistic *œuvre* of Benito Pérez Galdós offers the most complete vision of the social upheavals of the last third of the nineteenth century. Galdós contemplated his century from both a contemporary (thirty-one novels, some in multiple volumes) and a historical perspective (*Episodios nacionales* [National Episodes] comprising forty-six novels in five series). As the only major novelist of the Spanish nineteenth century to live most of his life in the capital city of Madrid and to use it as the setting for many of his contemporary novels, he was perhaps in the best position to portray the effects of industrialization and urbanization on Spanish society. Galdós learned his craft in the heat of the September Revolution; his first novel *La Fontana de Oro* (The Gold Fountain Café), which centers on clandestine political activity, was published in 1870. In *La de Bringas* (That Bringas Woman, 1884) Galdós takes a retrospective look at the September Revolution from inside Isabel II's court. Narrated from the perspective of one of Rosalía de Bringas's lovers, it is a highly ironic view of the new middle class whose pretensions outstrip its means.

Galdós is one of the few novelists of the Restoration period to make lower-class characters a focus of his narratives. In *Fortunata y Jacinta* (1886–1887), also set in Madrid and arguably his best novel, he creates many memorable characters, foremost among them Fortunata, a woman of the people, and Jacinta of the well-off middle class. These two women are pitted against one another for the affections of Jacinta's husband, Juanito Santa Cruz, the donjuanesque son of a wealthy merchant. Although Fortunata ultimately dies, she triumphs as the fecund mother of two children by Juanito, while the bourgeois wife remains barren. In *Misericordia* (Mercy, 1897) Galdós focuses on relations between the pretentious but impoverished middle class and the underclass of homeless beggars whose misery supports the idle classes. *Misericordia* questions scientific reality in a way that we do not usually associate with

nineteenth-century realism, prophesying twentieth-century novelistic forms that eschew realistic narrative techniques and faith in scientific materialism.

Interestingly, many of Galdós's novels center on female characters (as do those of other nineteenth-century Spanish novelists), although the view of women they project is not particularly feminist. As Lou Charnon-Deutsch has pointed out, female characters in nineteenth-century Spanish novels by men are almost invariably constructed through the male gaze. And Catherine Jagoe observes that Galdós's female characters are "ambiguous angels," who struggle with and often succumb to the prevailing ideology of domesticity. If the feminist movement was much less developed in Spain than it was in England and the United States, Spanish writers were certainly aware of women as a potential social force that needed to be conceptualized, portrayed, and restrained.

One finds a conservative backlash in novelists such as José María Pereda and Armando Palacio Valdés. Although delightful to read thanks to the many fine details of regional life they include in their narratives, both writers find ways of curtailing the independent spirit of their female characters. Pereda's *Sotileza* (1884–1885) paints a lively picture of Santander's fishing industry around the figure of Sotileza, whose affections are sought by three men – one above her station in life, another of her class, and a lower-class down and outer. The narrative maneuvers her into a position in which she must choose the member of her own social class. Armando Palacio Valdés's *Marta y María* (1883), set during the last Carlist War of the 1870s, portrays two sisters, whose names reflect their divergent characters and the two socially acceptable options for women – marriage or the convent.

Emilia Pardo Bazán, who formally introduced Zola's naturalism (the effects of hereditary and social determinism) into Spanish intellectual debates with her essays *La cuestión palpitante* (The Burning Question, 1883), offers a more pessimistic view of life in the rural provinces of Spain during the Restoration period than either Pereda or Palacio Valdés. Even though her major novels *Los pazos de Ulloa* (The Ulloa Estate, 1886) and *La madre naturaleza* (Mother Nature, 1887) modify Zola's naturalism with a spiritual dimension that undercuts its determinism, the rural landed classes are depicted as brutal, politically manipulative, and manipulated. They form a core of decay that undermines any attempt to modernize Spanish life. In depicting the plight of women in traditional Spanish society, Pardo Bazán introduces melodramatic and Gothic elements into

her realistic/naturalistic narratives, which makes her an important "fore-mother" to twentieth-century women novelists such as Carmen de Burgos, Concha Espina, and Carmen Laforet.

Clarín's is perhaps the best portrayal of the complex workings of the Restoration political system. Like Pardo Bazán's narratives, *La Regenta* (1884), which is set in Vetusta (a thinly disguised Oviedo, capital of Asturias; the word itself means "ancient" in Spanish), draws on French naturalism for some of its techniques, especially certain scenes that focus on the grotesque. Vetusta is ruled by a loose coalition of clergymen, the most prominent nobleman, and the local political boss (*cacique*). The tension between these forces is played out as a contest for the affections (sexual favors) of the city's most beautiful woman, the regent's wife Ana Ozores. Ana's psychology is brilliantly developed; she is a sensitive woman who has never had any real love in her life (her parents left her an orphan at a young age, and she married a much older man in order not to be a burden to her relatives). As the *cacique* and the most powerful clergy-man (Ana's confessor) vie for her attention, Clarín manages to fill a large canvas full of memorable characters who make up the social, political, and economic structures of this typical Restoration city. Clarín's ironic view of the paradoxes of Restoration "democracy," achieved primarily through an exceptionally deft free indirect style, is unparalleled in Spanish literature.

The only Spanish novelist to take a revolutionary position *vis-à-vis* the plight of the working classes was Vicente Blasco Ibáñez, who employed a less spiritual version of French naturalism than Clarín and Emilia Pardo Bazán. His novels *La barraca* (The Cottage, 1898) and *Cañas y barro* (Reeds and Mud, 1902), for example, sympathetically depict the harsh lives of rural workers in Valencian agricultural areas. His prose and narrative techniques are straightforward, although the plots of these works are contrived to make one wonder if the working classes are not sometimes their own worst enemies. One of the innovations of Blasco's novels is the mass protagonist, which reappears later in novels of social thesis in the 1930s and 1950s by writers such as Ramón Sender and Camilo José Cela.

Blasco Ibáñez's novelistic production overlaps chronologically with that of a new group of writers – often called the "Generation of '98" – that began to write in the 1890s and whose mature works appeared in the first and second decades of the twentieth century. Ramón del Valle-Inclán, Miguel de Unamuno, Ángel Ganivet, Pío Baroja, and José Martínez Ruiz ("Azorín") coincided with Blasco and his predecessors Galdós, Clarín, and

Pardo Bazán in their desire to reform Spanish social and political structures. Rather than mirroring Spanish society through ironic realism, however, their fictions look inward – inward to a Spanish "soul" and inward to the interior consciousness of a central (usually male) character. Their protagonists' identities are constructed within a clashing set of philosophies that entered Spain through the door opened by Krausism and the ideologies informing the workers' movements – socialism, anarchism, and Marxism. Nietzsche's iconoclastic views of bourgeois society and Christianity had also reached Spain by the 1890s.

If modernization was slow to take root in Spanish soil, artistic modernism, which was largely a critique of modernization, came earlier to Spain than to other European countries, where it is usually considered a phenomenon that arose between the two world wars. Spanish narrative modernism or the inward turn that marked Spanish fiction from the year 1902 forward can in part be attributed to the disillusionment intellectuals experienced over the possibility that the new ideas entering Spain might have any real impact on the quality of social and political life. This disillusionment was exacerbated by Spain's loss of her last colonies (Cuba and the Philippines) in 1898 in a very brief war with the United States, an upstart nation across the Atlantic.

Early twentieth-century fiction (especially that by canonized male authors) abandoned the realistic techniques that characterized the novel of the 1870s to the 1890s and found innovative ways of conveying a more subjective reality. These narrative innovations often include long passages of a philosophical nature that makes them more appropriate for an educated audience. The division between popular and élite fiction that had begun to assert itself in the nineteenth century became more prevalent after 1900. Miguel de Unamuno invented a new genre he called the *nivola*, which should center on dialogue, according to the character who is writing one of these works in Unamuno's novel *Niebla* (Mist, 1914). *Niebla* challenges novelistic realism in yet another way by having the main character visit and carry on a conversation with Unamuno himself; the two argue over who has control of the character's life and whether or not he is at liberty to commit suicide. Unamuno marked this new narrative path in 1902 with *Amor y pedagogía* (Love and Pedagogy), which avoided external descriptions in favor of exploring internal *Angst*. It concentrates on the philosophical and artistic struggles of the characters, who attempt to find their way in a world in which neither rigid scientific principles nor traditional religious faith can structure human life. These existential pre-

occupations form the heart of Unamuno's subsequent narratives – *Abel Sánchez* (1917), *La tía Tula* (Aunt Tula, 1921), *San Manuel Bueno, mártir* (St. Manuel Bueno, Martyr, 1931).

While the "real" world of social and political difficulties all but disappeared in Unamuno's fiction, Ramón del Valle-Inclán and Pío Baroja reinvented it artistically by filtering it through a narrative consciousness they constructed with unusual literary techniques. Valle-Inclán's *Sonata de otoño* (Autumn Sonata, 1902), *Sonata de estío* (Summer Sonata, 1903), *Sonata de primavera* (Spring Sonata, 1904) and *Sonata de invierno* (Winter Sonata, 1905) are the memoirs of the fictitious Marqués de Bradomín, a Galician aristocrat whose life spans much of the turbulent Spanish nineteenth century. Although he lived during times that provided opportunities for heroic action (the Carlist Wars), he devoted himself primarily to seducing women. The novels incorporate a pastiche of Romantic tropes, stylistic features from Latin American *modernismo*, and naturalist and decadent touches in their scathing portrait of Spain's persistent medieval social forms. Valle-Inclán continued his stylized critique of Spanish politics and society in his highly original *esperpentos*, a form of narrative that parodies and distorts society by holding up a concave mirror to it and exaggerating its flaws. *Tirano Banderas* (1926) and *El ruedo ibérico* (The Iberian Circuit, 1927, 1928, 1932) are fine examples of narrative *esperpentos* (the *esperpento* form, which has much in common with Expressionism, also made successful theater).

Pío Baroja likewise strayed from realist techniques by filtering panoramic views of a variety of Spanish social strata through an individual consciousness. In *Camino de perfección* (The Way of Perfection, 1902) Fernando Ossorio, who is a failed medical student and desultory artist, travels about Spain in search of his own identity. In the course of his travels, he encounters the brutal effects of Spain's social backwardness and political and religious hypocrisy. *El árbol de la ciencia* (The Tree of Science, 1911) is an even more pessimistic view of both Spanish urban and provincial life which forms the backdrop to Andrés Hurtado's struggle to find his way in a country whose modernity is more of a promise than a reality. Many of Baroja's novels combine elements of popular adventure fiction with highly intellectual conversations on philosophical topics.

Azorín entered into a dialogue with Baroja's *Camino de perfección* in his novel *La voluntad* (Willpower, 1902). Baroja ended his novel with his protagonist happily married and living in a rural district of Valencia. Azorín mocks this ending by having his protagonist Antonio Azorín, whose life

is very similar to that of Fernando Ossorio's, also settle into bourgeois marriage in a small town. Antonio's marriage, however, has reduced him to a hen-pecked wimp who has left all his intellectual pursuits behind. Azorín continued his parody of Spanish provincial life in *Doña Inés* (1925). Here an independent female protagonist runs afoul of traditional social forces in the provincial city of Segovia. After she is seen kissing a younger man in the cathedral, she is so ostracized that she departs for Argentina where she founds a school for orphans.

In contrast to the large number of female protagonists in the novel of the late nineteenth century, *Doña Inés* is one of the few novels with a female protagonist to be written by a male novelist between 1900 and 1936. Women writers (who are much less well known) follow more in the footsteps of the nineteenth-century realists and naturalists, both in focusing on women characters and in their narrative techniques. Not having been privy to the university education and the intellectual circles that brought the male members of their generation in contact with the philosophical ideas they incorporated into their fiction, women writers wrote from their own more domestic experiences, and often (out of economic necessity) for more popular outlets. Carmen de Burgos, for example, published a number of short novels in popular series such as *La novela corta* (The Short Novel) and *Los contemporáneos* (Contemporary Authors). Her novelettes not only focus on women characters, but, as a feminist, she incorporated new possibilities for women's lives into her stories. In *La flor de la playa* (Beach Flower, 1920), for example, a working-class girl takes a vacation with her fiancé. During their month together in Portugal, they both realize that marriage to each other would be tedious, and they part ways when they return to Spain, where she continues her independent life as a seamstress. Concha Espina's *La esfinge maragata* (The Maragatan Sphinx, 1914) also foregrounds the travails of working women, here in a rural setting. Although marriage is ultimately the solution for the protagonist Mariflor, she arrives at the decision independently and for altruistic reasons; her wedding to a wealthy cousin solves her family's financial problems. The novel masterfully portrays the difficult lives of women in a poor agricultural region of Spain where all the able-bodied men have gone to the New World to make the living they cannot in Spain.

Gabriel Miró and Ramón Pérez de Ayala mirror Spain's contemporary political ills, especially the lingering conflict between those who wish for a more modern, secular Spain and those who want to maintain the country's traditional forms, by setting their major novels in the late nine-

teenth century. Miró's *Nuestro Padre San Daniel* (Our Father St. Daniel, 1921) and *El obispo leproso* (The Leprous Bishop, 1926) capture the flavor of Restoration Spain through a series of characters – clergy, landed gentry, and businessmen – who represent either a liberal or a conservative attitude towards modernization. The building of a railway between the provincial city and Madrid is a symbol in these novels of the inevitable modernization and the social disturbances it causes. Pérez de Ayala's *Belarmino y Apolonio* (1921) is likewise set in the late nineteenth century and also deals with the political influence of the clergy and the landed gentry. While the society they portray is similar to that in Clarín's *La Regenta*, Miró and Pérez de Ayala's novelistic techniques are more akin to those of their European contemporaries – Modernists like Marcel Proust, James Joyce, Virginia Woolf, and Thomas Mann – who employed intricate stylistic and structural methods to capture the way human consciousness filters time, space, and sensation through memory.

If women characters recede into the background in novels by men after the turn of the century, they reappear in vanguard novels such as those of Benjamín Jarnés, Ramón Gómez de la Serna, and Pedro Salinas, but more as an "obscure object of desire" than as the subjective focus of the narrative. Vanguard narrative reflects the influence of surrealism's interest in the subconscious and possibly that movement's ambivalence towards the new more public roles that women were assuming in Europe after the First World War. (Spain was still behind Europe in terms of its social and economic modernization, but the workers' movements had achieved cohesiveness, and feminism had more activists. Both of these movements rapidly gained ground during the short-lived Second Republic [1931–1939].) The avant-garde novel, which takes many of its aesthetic cues from cinema's emphasis on surface images, has a more playful approach to human subjectivity than modernist stream of consciousness. Because vanguard aesthetics postulate art as superior to life, women are one more *objet d'art* to be imaginatively transformed by the writer. In Benjamín Jarnés's *El convidado de piedra* (The Stone Guest, 1928, 1934) a young seminarian is much more preoccupied with the clandestine photographs of women he illicitly sneaks into the seminary than with the formal religious studies he is supposedly undertaking. Pedro Salinas's *Víspera del gozo* (Prelude to Pleasure, 1926) is a series of vignettes in which a protagonist imagines a woman of his acquaintance whom he expects to see in the near future. When the woman arrives, she is entirely different from the mental image he had formed of her. Both Jarnés and Salinas employ clever lan-

guage combinations to evince the central character's consciousness. Their verbal play is very like the *greguerías* (short ingenious sayings that combine metaphor and humor in highly original ways) invented by Gómez de la Serna and incorporated into his novels *El secreto del acueducto* (The Secret of the Aqueduct, 1922) and *El novelista* (The Novelist, 1923), among others.

Women novelists of the 1920s and 1930s (the height of the vanguard period) mostly avoid the clever word-games of the male writers to concentrate on more realistic renderings of the painful process by which women were making social progress. For example, Margarita Nelken, one of the most outspoken feminists of the era, portrayed a "new woman" (a woman who lives alone and works to support herself) in *La trampa del arenal* (The Sandtrap, 1923). In *La indomable* (The Untameable Woman, 1926), Federica Montseny, a feminist and anarchist, depicted the difficulty a woman political activist can have in achieving a well-balanced life that includes both political activity and a male companion. *Estación. Ida y vuelta* (Round Trip, 1930), Rosa Chacel's one novel written before the Civil War (1936–1939), combines vanguardist linguistic virtuosity with serious concerns about family responsibility.

Ramón Sender and Francisco Ayala, two male novelists whose careers began in Spain during the 1920s and 1930s, also found ways to combine the linguistic and structural innovations associated with vanguardism with the socio-political tensions that led to the Spanish Civil War in 1936 (for example, Sender's *Siete domingos rojos* [Seven Red Sundays, 1932] and Ayala's *Cazador en el alba* [Hunter at Dawn, 1930]). Both writers participated in the war on the Republican side, and like Rosa Chacel continued their novelistic careers in the New World when the Republicans lost the war in 1939. The accelerated modernization of social and political forms that Spain experienced in the 1930s under the Republic was essentially frozen until the death of Francisco Franco in 1975, but the rebirth of narrative that accompanied and chronicled modernization in Spain from 1868 to 1936 did not end with the Republic; it lived on in "exile" writing both inside and outside Spain.

FOR FURTHER READING

Aldaraca, Bridget. *El ángel del hogar. Galdós and the Ideology of Domesticity in Spain.* Chapel Hill: North Carolina Studies in the Romance Languages and Literatures, 1991.

Andreu, Alicia. *Galdós y la literatura popular.* Madrid: Sociedad General Española de Librería, 1982.

Botrel, Jean-François. *Libros, prensa y lectura en la España del siglo XIX.* Madrid: Pirámide, 1993.

Charnon-Deutsch, Lou. *Gender and Representation: Women in Spanish Realist Fiction.* Amsterdam: John Benjamins, 1990.

Eoff, Sherman. *The Modern Spanish Novel. Comparative Essays Examining the Philosophical Impact of Science on Fiction.* New York: New York University Press, 1961.

Gilman, Stephen. *Galdós and the Art of the European Novel: 1867–1887.* Princeton, NJ: Princeton University Press, 1981.

Gullón, Germán. *El narrador en la novela del siglo xix.* Madrid: Taurus, 1976.

Jagoe, Catherine. *Ambiguous Angels: Gender in the Novels of Galdós.* Berkeley and Los Angeles, CA: University of California Press, 1994.

Johnson, Roberta. *Crossfire: Philosophy and the Novel in Spain, 1900–1934.* Lexington, KY: University Press of Kentucky, 1993.

Montesinos, José F. *Introducción a una historia de la novela en España en el siglo xix.* Madrid: Castalia, 1955.

Pérez Firmat, Gustavo. *Idle Fictions: The Hispanic Vanguard Novel 1926–1934.* Durham, NC: Duke University Press, 1982.

Pérez Gutiérrez, Francisco. *El problema religioso en la generación de 1868 (Valera, Alarcón, Pereda, Pérez Galdós, "Clarín," Pardo Bazán).* Madrid: Taurus, 1975.

Pino, José M. del. *Montajes y fragmentos: Una aproximación a la narrativa española de vanguardia.* Amsterdam: Rodopi, 1995.

Sieburth, Stephanie. *Inventing High and Low: Literature, Mass Culture, and Uneven Modernity in Spain.* Durham, NC: Duke University Press, 1994.

Spires, Robert C. *Transparent Simulacra: Spanish Fiction 1902–1926.* Columbia, MO: University of Missouri Press, 1988.

9

Narrative in culture, 1936–1975

134 The Spanish Civil War and Franco's dictatorship were pervasive in the cultural life of Spain from the start of the armed conflict on 18 July 1936 until the Generalísimo's death on 20 November 1975. With a country divided into two irreconcilable factions, most individuals had to choose a side, willingly or not, and their private plans or desires seldom coincided with the events that engulfed them. Any cultural object, be it a novel, a movie, or a daily column in a newspaper, was scrutinized for its political impact by special governmental, political, and religious organizations which existed solely to multiply the rules that creators and producers had to obey and to reinforce the limits of transgression. If one takes into account this restricted field of operations and its consequences, the narrative of this period reveals itself as daring, experimental, and accomplished.

A novel that appeared in the first year of the war, *Cinematógrafo* (1936) by Andrés Carranque de Ríos, is a reminder that several creative strains in Spanish culture were drastically interrupted by the insurrection. Carranque, besides being a writer, was an actor in several movies who sympathized with anarchism. He draws a funny and scathing portrait of the primitive Spanish film industry. His main characters are exploited, frustrated by poverty and physical limitations, but manage to see beyond their private suffering and to act for the larger social and political good. Carranque's novel presents a contrast to the dreamy and utopian novels published in the anarchist series *La novela ideal* (The Ideal Novel) and *La novela libre* (The Free Novel) that for thirteen years, until interrupted by the war, churned out almost 600 titles with runs of between 10,000 and 50,000 copies. But for Carranque as well as for the pulp novelists, the better future was an alternative to the present. What would prevail

within Spain, instead, would be the position presented in such novels as Agustín de Foxá's *Madrid de corte a checa* (Madrid: From Court to Clandestine Prison, 1938), which describes the transition between the old regime and the Second Republic as one that precipitates the elegant and civilized Madrid, ruled by decadent but amiable aristocrats and intellectuals, into the violence, terror, and chaos of a city dominated by the rabble. Foxá proceeds by presenting effectively a vast array of characters, painting them with a language that is reminiscent of Valle-Inclán's sensuous and distorting impressionism, but there is no confusion as to his conservative point of view, which makes several of his pages jarring for most of today's readers. To expect a dispassionate and balanced representation of a partisan reality, though, is to hope for a distanced translation and a filtered view: Foxá, instead, speaks from a world where culture is also part of a national catastrophe.

The war that broke out on 18 July 1936, after tensions that went back at least half a century, took precedence over purely artistic goals and determined the issues. On the Republican side the main thrust was to write a literature that was understandable to the peasants and workers who supported the government, while conveying hope and placing the local struggle in the context of the great revolutionary traditions. Still, the best narrative about the war would develop during the next decades, slowly emerging as oral narratives, memoirs, and novels, published both within Spain and in exile. These books and narratives are still part of a devastating conflict, fought now in the terrain of interpretation. The creative and critical literature of this period must be read, therefore, with an imagination trained to notice the ideological slant of authors and the many allusions that evaded censorship, some intended by the authors, others invented by readers' active and creative mistrust. These readers knew that the films, novels, and newspapers that told them stories about Spain contained a hint of silenced lines, either nipped prudently by authors before making their work public, or excised by censorship. In these circumstances a removed glove concealed the impossible revelation of a naked body, and a truncated paragraph suggested more the work of the censor than the lack of skill of the author.

Yet one must not imagine two neatly divided and opposing forces. Within each faction there were conflicting ideologies, goals, and expectations, as is remembered ironically in a short story by Max Aub, "La verdadera historia de la muerte de Francisco Franco" (The True Story of the Death of Francisco Franco). The main character is a Mexican waiter who

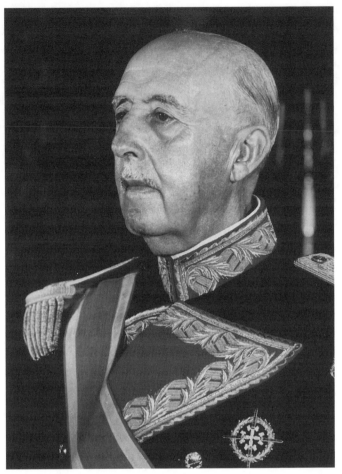

7. Francisco Franco

sees with distress that his serene café in Mexico City is invaded by Spanish exiles discussing loudly and interminably among themselves about the reasons why they lost the war. He pins his hopes on the death of Franco, but it only brings a new flood of contentious debaters. Splintering into numerous groups and ideological strife was not restricted to the defeated and exiled. One of the most successful novels of the post-war period in telling the story of the combatants from the Nationalist point of view was Rafael García Serrano's *La fiel infantería* (The Faithful Infantry). It received the 1943 "José Antonio Primo de Rivera" National Prize for Literature and was published by the Editora Nacional, but it displeased the archbishop

of Toledo, who objected to the crude language of the novel, to the lack of piety of the Nationalist soldiers it presented, and to scenes at a cabaret and a house of prostitution. The novel was removed from all bookstores and was published again only in 1973, with a virulent prologue by the author that is one of the best available documents on the pernicious effects of censorship. *Javier Mariño,* a novel by Gonzalo Torrente Ballester, suffered a similar fate and was prohibited fifteen days after it was published by the Editora Nacional in 1943, in spite of the fact that Torrente had altered his original manuscript to please the censors. In the first manuscript of the novel the protagonist, Javier Mariño, is in Paris during the critical year of 1936 and fails to respond to the call to arms. Instead, he emigrates to America, leaving behind his French lover, a communist sympathizer, who commits suicide. After consulting with a friendly censor, who warned him that his cynical portrayal could never be published, Torrente produced a sanitized version that made it to press. He had Javier Mariño experience a conversion into an activist, returning to fight in Spain, while his lover converted to Catholicism. His arrogant protagonist, a passionate intellectual, speaks with echoes of the Falangist leader José Antonio Primo de Rivera, whose articles and speeches Torrente had anthologized and published with a laudatory prologue in 1942. There are few better examples of how story lines were warped and toned down to access the marketplace and reach the reading public. *Javier Mariño,* with its discursive and essayistic rhetoric, must be read in the context of José Antonio's vibrant and often melodramatic harangues and Franco's own speeches, both being among the most prevalent and discussed texts of the 1940s. Franco himself tried his hand at the novel, using the pseudonym of Jaime de Andrade, with *Raza* (Race, 1942). It had previously been the script for a movie that was part of the *cine cruzada,* or the continuation of the "crusade" on the screen with numerous films celebrating the justice and heroism of the Nationalists. On a different front of the religious crusade, a text of meditations of slight originality but of a fervent and simple piety was of great importance: it garnered more readers than most novels of the period. Published first as *Consideraciones espirituales* (Spiritual Thoughts) in 1934, it was expanded and renamed *Camino* (The Way) for a second edition, by the founder of the Opus Dei, Josemaría Escrivá de Balaguer. At his death, the Opus Dei had expanded to five continents and counted around 60,000 members, usually from influential sectors of society. *Camino* has to be considered one of the most significant literary works of the decade, regardless of its artistic merit or its dubious

ideology. As of March 1996, some 298 editions have been published, and almost 4 million copies in forty-one languages have been sold, making it the clear bestseller of the period. To separate the novels of the 1940s from their political and religious context misses the dramatic struggle with dogma, amnesia, indoctrination, and prudery from which they emerged.

The stage had been set by a progressive politicization of art and literature during the 1930s and by the creation of institutions on both sides of the Civil War to channel cultural production into propaganda machines, as can be seen in the numerous memoirs and autobiographies about this period. Some examples are María Teresa León's *Memoria de la melancolía* (Memory of Melancholy, 1970) and Rafael Alberti's *La arboleda perdida* (The Lost Grove, vol. I, 1959) which tell poignantly about the cultural splendor of the Spain of the early 1930s, the excitement and suffering of the war, the attempts to preserve the cultural patrimony from destruction, the programs to reach the common soldier with books, plays, and recitals, and the pain of exile. On the other side of the conflict, Dionisio Ridruejo has recorded in *Casi una memoria* (Almost a Memoir, 1976) his participation in the Nationalist cultural battle during the war and his progressive disenchantment with the dogmatism and insularity of the post-war period.

The long first decade after the war – roughly from 1939 to 1954 – is dominated for those writers who remained within Spain by the reality of the dictatorship, censorship, and poor economic conditions. Existentialism offered a way to rise to the challenge of bleak conditions and give meaning to individual moments of decision. This philosophy was known in Spain in spite of the opposition of the church to Unamuno's continued influence and to that of Jean-Paul Sartre, which culminated with the incorporation of Sartre's works into the Index of forbidden books in October 1948. Camilo José Cela's *La familia de Pascual Duarte* (The Family of Pascual Duarte, 1942), often compared to Albert Camus's *L'Etranger* of the same year, is one of the best known novels of the 1940s. A description of its gruesome narrative line and complex structure cannot do justice to the originality of its language that offers a wide register from evocative lyricism to abrupt coarseness. Pascual commits several crimes, but the crime for which he is finally condemned to death is not presented in the text. It can, nevertheless, be reconstructed as the collaboration of Pascual in the murder of a rich man in town at the start of the war. Pascual's narration is not lineal; it jumps back and forth in time as the events in his life are skillfully presented to reduce his own responsibility. He seems to go through

life in a daze and to have no other recourse than violence. His narration is followed by two closing statements, one from a priest and one by a member of the Civil Guard. *Pascual Duarte* is a triumph of ambiguity: does it suggest that the peasants who rose against their ancestral masters were incapable of control and brutal to the extent of killing their own mother in a rash of Oedipal frenzy? Or does it stress the conditions of marginality, ignorance, and poverty that could lead a man to resort to violence as the only way out from relentless exploitation? The novel was first celebrated and then briefly prohibited. Eventually the solution that the cultural establishment found to assimilate the unavoidable success of a novel that presented such a grim portrait of the situation of poor peasants in the Spain preceding the Civil War – a situation that had only deteriorated in the 1940s with the massive destruction and displacement occasioned by the armed struggle – was to invent a category, *tremendismo,* that explained it away as a literary style that deformed reality, dwelling preferentially on the ugly and shocking. It was a matter of writing, not a social reality.

A second unflattering portrait soon followed. The Nadal yearly prize was instituted in Barcelona in 1944 by the weekly *Destino,* published in the Nationalist zone since 1937. Its director since 1939 was the novelist Ignacio Agustí, whose *Mariona Rebull* (1944) and *El viudo Rius* (The Widower Rius, 1944), both notable and still worthwhile reading, are a celebration of the enterprising spirit of the Catalan bourgeoisie, seen by Agustí as endangered by the rumble of foreign ideologies and the demands of ungrateful workers. The resurgence of the economy in Barcelona after the war without a doubt was due in large part to the business acumen that Agustí magnified nostalgically in his novels. It is in the Catalonia of the 1940s that books become again prime commodities, successfully marketed in Spain and Latin America. The Nadal prize was a commercial ploy that initiated a flood of similar awards whose seriousness can be debated, but that have significantly helped the careers of many novelists. The novel that received the first Nadal in 1944 was Carmen Laforet's *Nada* (Nothing), a stinging portrayal of family life in one household in Barcelona. As in the case of *Pascual Duarte,* this novel flew in the face of the official discourse in which the family was the revered nurturing unit and the model that inspired government itself. When Andrea, a young woman, arrives in the house of her relatives in Barcelona to study at the university, she is confronted with a group of individuals – her grandmother, her aunt, and two uncles, one of them married – who are locked into a sordid antagonism fueled by past events that go back to

the war period. The persistence of memory, the return of the repressed, and the obsessive nature of passion were appropriate topics for the mid-1940s. Told by Andrea with disarming immediacy and autobiographical intimacy, her encounter with these forces and her survival can be read today also as a novel about growing up as a woman at a time in which most of society was still controlled by men.

The 1950s brought a greater sense of community and openness. In the early part of the decade, the outstanding novel is Cela's *La colmena* (The Beehive), published in 1951 in Buenos Aires. It was begun around 1946 and, with its action set in the early 1940s in Madrid, it still contains much of the bitterness and isolation frequently found in novels of that period. While hunger, sex, power, and bare survival are the driving forces of the 296 characters that fleetingly appear during the six days the novel describes, the corrosive narrator does reveal that in spite of the cocooned insignificance of the characters, they are nevertheless connected by the circulation of money, a network of urban interaction, and a system of news reporting that eventually touches the lives of most of them. In a country with its economic infrastructure devastated by war and suffering the consequences of the isolation brought about by the Second World War, where the executions of the defeated between 1939 and 1943 numbered close to 40,000, plus a quarter of a million imprisoned, many of them to die in jail, Cela's beehive has reason enough to be bleak. Yet the novel does not only look back in despair: it prefigures most of the important novels of the 1950s and early 1960s, in which the protagonist is plural, on the verge of solidarity, and generally seen with cinematic objectivity.

A week of Italian neo-realist films shown in Madrid in 1951 at the Institute of Italian Cultures had an immediate effect not only on young directors but also on writers. Many saw or heard about Antonioni's *Chronicle of Love* (1950), De Sica's *Bicycle Thief* (1948) and *Miracle in Milan* (1951), and Rossellini's *Open City* (1945) and *Paisa* (1946). Rafael Sánchez Ferlosio, who knew this cinematic tradition well from having spent some years in Italy, follows the neo-realist principle of portraying collective aspects of normal everyday life with unknown actors. *El Jarama* (The River Jarama, 1956) presents groups of people – none of them a powerful social figure, except a judge who appears towards the end – on a Sunday summer outing to the shores of the Jarama river. There is among them a muted consciousness that this river was the scene of bloody fighting during the war, and an occasional encounter with two *guardias civiles* close to a ceme-

tery serves as a reminder that the freedom in those days is limited. A drowning interrupts the merriment, stressing the forgotten significance of death by the example of one woman known to them, evident at last to these youths too young to remember the battles of the Jarama. But what energizes the book is the language of the young friends, criss-crossing the page with humor and creativity. At a time in which the official newscasts and the obligatory newsreels shown in all theaters before the featured film used a tired and inflated language to describe the triumphs of official policy – acceptance of Spain by the international community in 1953 following the signing of the accords with the Vatican and a military treaty with the United States, the inauguration of new roads and dams, hunting and fishing exploits of the Generalísimo – some novelists, such as Sánchez Ferlosio, countered with novels that were at the same time tough looks at the flimsy social fabric and displays also of the vitality of the new generation's language. Chief among these novelists who combine a preoccupation with the social with the creativity of language is Ignacio Aldecoa, whose novels depicting the daily lives of Civil Guard soldiers (*El fulgor y la sangre,* Resplendence and Blood, 1954), gypsies (*Con el viento solano,* With the Hot Easterly Wind, 1956), and fishermen (*Gran sol,* Great Sun, 1957), stand among the masterpieces of the 1950s.

The 1950s also made possible a broader look at the Civil War. José María Gironella's *Los cipreses creen en Dios* (Cypress Trees Believe in God, 1953) presents an inclusive portrayal of the events that preceded it, using a flat journalistic style and the alternation of episodes dedicated to characters representing different factions. The privileged point of view is conceded to the adolescent Ignacio Alvear in Girona, whose brother César becomes a priest and dies a martyr – censorship would not have allowed anything else – while communists and anarchists are traced less sympathetically. Yet this extensive and very popular historical novel – followed by *Un millón de muertos* (A Million Dead, 1961) and *Ha estallado la paz* (Peace Has Broken Out, 1966) – was a milestone in the representation of the war.

From the work of the exiled writers abroad very little appeared directly in Spain itself – even if a book about exile literature by Marra-López was published in Madrid in 1963[1] – but they were influential in the way in which the Spanish Civil War came to be perceived. The victors of the military conflict eventually lost the image war. Notable among the many books produced in exile are the series of novels and short stories by Max Aub comprising his *El laberinto mágico* (The

Magic Labyrinth), with the first three novels published between 1943 and 1945 in Mexico. Arturo Barea's trilogy *La forja de un rebelde* (The Forge of a Rebel) was published in Buenos Aires in 1951. Ramón Sender's *Mosén Millán* (1953, later published in 1960 as *Requiem por un campesino español*, Requiem for a Spanish Peasant) is unforgettable as it portrays one of the thousands of summary executions in the early stages of the war.

Some of the novels of the 1950s and early 1960s carry a documentary with a message, but they are nevertheless effective, uneasily occupying the space that newspapers and television dared not enter. Outstanding are Jesús López Pacheco's *Central eléctrica* (Powerhouse, 1958), Antonio Ferres's *La piqueta* (The Pickaxe, 1959), Armando López Salinas's *La mina* (The Mine, 1960), and Alfonso Grosso's *La zanja* (The Ditch, 1961). These novels are examples of well-meaning anthropological reporting in a situation of internal colonialism, but the lack of questioning about the place of the observer seems outdated today. Only Juan Goytisolo consistently introduced in his early novels, short stories, and trip narratives a measure of self-doubt that showed awareness of the difficulty of speaking for others, especially in *La chanca* (The Chanca, 1962). In fact, intellectuals who wanted to be the vanguard of the proletariat found that the proletariat was moving on its own, partly owing to the experience of working in Europe and partly owing to the infusion of tourism into the small towns of the Spanish Mediterranean. Another aspect of this internal migration, the development of coastal resorts by affluent professionals from Barcelona and Madrid, is seen in Juan García Hortelano's *Tormenta de verano* (Summer Storm, 1962), a novel where a dead body discovered naked on a beach, numerous disjointed conversations, and much aimless driving along the coast build a world that the owners of the neat villas exploit for their own pleasure but view with bored detachment.

Relatively well-to-do intellectuals who attempted to bridge the class divide had to contend with conservatives who called them traitors to their class, with their own skepticism as to the value of their efforts, and with their own narcissism. Juan Goytisolo in *Señas de identidad* (Marks of Identity, 1966) examines critically these allegiances to class, attachments to culture, and the selective memory of a family and of a whole country, and proposes a daring rejection of these ties, in the knowledge that there is a heavy price to pay for this rebellion. But the strongest attack came in a memorable novel by Juan Marsé, *Últimas tardes con Teresa* (The Last Afternoons with Theresa, 1966), where rich university students from Barcelona are seen unsympathetically as playing the revolutionary for

the thrill of transgression and the need for ethical satisfaction, without renouncing any of their privileges. Class and the unsure task of the intellectual are minutely analyzed, and with great depth and brilliance, in Luis Goytisolo's *Recuento* (Inventory, 1973), published in Mexico to avoid censorship.

The topic of social relations was treated less stridently by a series of writers that created superb novels by building a novelistic world that was content with presenting glimpses of lives without grand stories to tell or major ideological points to prove. A masterpiece of the period is Luis Fernández Santos's *Los bravos* (The Brave, 1954), a portrait of a small town in the province of León shown through the eyes of a newly arrived doctor. The suffocating interdependence of the villagers' stagnant and lonely lives is presented in a series of brief descriptions – a sick woman, a confidence man, a truck driver – connected by money, sex, gossip, and power. While the doctor, who replaces the old town chieftain by buying his house and taking his lover, does represent some progress, there is scant hope for the future. The open road and the city offer in *Los bravos* the allure the rural town, with its archaic economy, cannot provide. Carmen Martín Gaite's *Entre visillos* (Between the Blinds, 1958) is also masterful for its insightful but open-ended and undogmatic presentation of a girl growing up in Salamanca under the guidance of a peculiar German teacher. Another master of this understated creation of a local world is Miguel Delibes, whose novels affirm the dignity of the marginal, the forgotten, and everyday provincial life. Among the greatest novels of this period are his *Diario de un cazador* (A Hunter's Diary, 1955) and *La hoja roja* (Red Leaf, 1959), written with a unique understanding of his characters and their humble lives and less dated today than his also notable *Cinco horas con Mario* (Five Hours with Mario, 1966). Perhaps this is also the place from where the novels and short stories of Mercè Rodoreda find their extraordinary power, concerned as they are with the fabric of daily life and its experience, more than with general statements. Her novel *La plaça del Diamant* (Diamant Plaza, 1962) tells the story of Natalia, and follows her life in Barcelona through two marriages and the war. This is a novel of admirable craft and its devastating analysis of gender relations is both moving and convincing.

The publication late in 1961 of *Tiempo de silencio* (Time of Silence) by Luis Martín-Santos marks a turning point. The story line itself is not strikingly original and even owes much to Pío Baroja: a young researcher falls from grace when he gets involved in an abortion in the shanty

towns and is later entangled with the granddaughter of the owner of the guest house where he lives in Madrid. Martín-Santos's originality can be found in the dazzling freedom of his narrator, who makes of every sentence an occasion for irony, intertextual play, parody, essayistic forays, and reading between the lines. Similarly, in Juan Benet's *Volverás a Región* (You'll Return to Región, 1967) sentences branch out in a world in which no reflection is free of emotion or passes by without attracting a comparison that elevates it to an instance of the general human condition. Benet's enigmatic novel starts out on the day of the arrival in a town of a woman where a burnt-out doctor takes care of a mentally troubled boy. In the minute reconstruction of a backwater region where the Civil War embroiled the prominent families in webs of complicity and treason Benet echoes Faulkner's Yoknapatawpha County, and his conception of memory owes much to the French philosopher Henri Bergson, yet he is a writer not only of originality but also of a sustained depth that flows in sentences of singular beauty and complexity. The difficulty of reconstructing the past, of leaving behind old passions, of solving the mysteries of love, of uncovering the ultimate roots of power were appropriate for the post-war era, but are not limited to it. Benet returned to Región in other novels, even publishing a detailed map of his imaginary territory but, in spite of being an engineer by profession, he left enough contradictory information and gaps to keep the effect of a historical world perceived through the fallible eyes of a human observer. Benet was also an accomplished author of short stories. "Syllabus," contained in *5 narraciones y 2 fábulas* (5 Narrations and 2 Fables, 1972), portrays the travails of a university professor who after retirement at last can teach with the freedom he had always dreamed of, and starts out by delivering awe-inspiring lectures, under the private sponsorship of a financial institution, to the acclaim of his mesmerized audience, until he is confronted with his own projected super-ego in the figure of an indolent and silent foreign student who makes his confidence crumble. This short story uncannily anticipates by a few years the euphoria of political freedom and the disenchantment with the discovery of deeply rooted and persistent layers of social and private repression that immediately followed the period we study here.

What made these novels possible in which language, intelligence, and playfulness prevailed, coupled with a determinedly serious purpose? To those novels mentioned above, one should add Juan Goytisolo's *Reivindicación del conde don Julián* (Revindication of Count Julian, 1970) and *Juan sin*

tierra (Juan the Landless, 1975), and Juan Marsé's *Si te dicen que caí* (The Fallen, 1973). In all of these novels language occupies the space of freedom, but contaminated by inherited myths, half-truths, and relentless propaganda. As the armed struggle of the *maquis* in the 1940s faded away into the past, and the collective uprisings promised repeatedly in the 1950s failed to materialize, and as the material conditions of life improved in Spain, these writers focused on the insidious, persistent, and subtle domination of unexamined speech, images, and symbols. Their extremely complex novels bring to a close a period that was first dominated by the urgency to describe the reality of need and suffering against triumphalist official proclamations; a period followed by a willingness to contemplate the social and the possibility of filling in the gap left by censored and co-opted media; and ending when the regime began to deteriorate but still left behind the cadaver of its memories, indoctrination, and monuments. Later writers would have the privilege of writing in a democracy, supported by a prosperous economy, and in the context of a post-modern society. In order to judge adequately the writers active between 1936 and 1975, scarcity, censorship, dictatorship, and the modernist desire for progress and social justice must always be kept in mind.

There are a number of novels that exemplify categories that have become almost invisible because they do not fit the grand narrative that criticism has established for these years. They are not representative nor part of a well-defined group, neither timely nor politically correct. Some of these are Miguel de Villalonga's *Miss Giacomini (Ocho días en la vida provinciana)* (Miss Giacomini: Eight Days of Provincial Life, 1941) in which he gets away with making fun of the authorities and newspapers in a small town that is visited by a starlet during Holy Week; Azorín's *El enfermo* (The Sick Man, 1943), a remnant of the lyrical novel of the 1930s, but charged with the frustration of an intellectual for whom contemplation has become suspect as a form of paralysis; the fanciful novels by Elisabeth Mulder de Daumer, such as *Preludio a la muerte* (Prelude to Death, 1946), which offer next to unusually elegant, rich, and well-traveled characters, important insights into the ideals of Spanish women and their possibilities of self-fashioning; Wenceslao Fernández Flórez's *El bosque animado* (The Animated Forest, 1943), a playful collection of related narratives of the countryside in Galicia; Rafael Sánchez Ferlosio's *Industrias y andanzas de Alfanhuí* (Alfanhuí's Inventions and Travels, 1951), the imaginative growing-up story of the apprentice to a naturalist who teaches him,

among other startling and mysterious things, how to color the leaves of a tree; Camilo José Cela's *Mrs. Caldwell habla con su hijo* (Mrs. Caldwell Talks with Her Son, 1953) which shows the fragmented and passionate interior monologue of a mother with her dead child, an exploration of one flow of conscience, couched in surrealist lyricism, at a time when the tide was turning towards the external and collective; or José Luis Castillo Puche's *El vengador* (The Avenger, 1956), a stark meditation on the revenge exacted by the victors on the defeated after the war. The list could be made much longer, but its function is only to show that Spanish culture was rich and varied enough to produce notable texts that do not fit well within the mainstream.

NOTES

1. See José R. Marra-López, *Narrativa española fuera de España, 1939–1961* (Madrid: Guadarrama, 1963).

FOR FURTHER READING

Abellán, Manuel. *Censura y creación literaria en España (1939–1976)*. Madrid: Península, 1980.

Brown, Joan L. *Women Writers of Contemporary Spain: Exiles in the Homeland*. Newark, NJ: University of Delaware Press, 1991.

Fraser, Ronald. *Blood of Spain: An Oral History of the Spanish Civil War*. New York: Pantheon Books, 1979.

Herzberger, David K. *Narrating the Past. Fiction and Historiography in Postwar Spain*. Durham, NC and London: Duke University Press, 1995.

Jordan, Barry. *Writing and Politics in Franco's Spain*. London and New York: Routledge, 1990.

Labanyi, Jo. *Myth and History in the Contemporary Spanish Novel*. Cambridge: Cambridge University Press, 1989.

Mangini, Shirley. *Memories of Resistance: Women's Voices from the Spanish Civil War*. New Haven, CT and London: Yale University Press, 1995.

Pope, Randolph D. *Novela de emergencia: España, 1939–1954*. Madrid: SGEL, 1984.

Sobejano, Gonzalo. *Novela española de nuestro tiempo (en busca del pueblo perdido)*. 2nd edn. Madrid: Prensa Española, 1975.

Thomas, Gareth. *The Novel of the Spanish Civil War (1936–1975)*. Cambridge: Cambridge University Press, 1990.

Ugarte, Michael. *Shifting Ground: Spanish Civil War Exile Literature*. Durham, NC and London: Duke University Press, 1989.

Vázquez de Parga, Salvador. *Los comics del franquismo*. Barcelona: Planeta, 1980.

10

Narrative in culture, 1975–1996

The main impact on the Spanish publishing industry of the shift from dictatorship to democracy has been the creation of a literary scene led by market forces. The Franco regime, in its attempt to control cultural production through censorship, forced the publishing industry, like the other media, into an at least obliquely political role. The only publishers which could be said to cater to the market were those which, like Planeta, co-existed happily with the regime. However, the market was largely construed by them as a passive entity that would consume what it was given. Opposition publishers, notably Carlos Barral, tended to act as good-intentioned cultural mandarins decreeing what the public ought to want. Consequently they failed to reach the masses, except with the 1960s Latin American fictional "boom," whose exhaustion by the early 1970s drove publishers to invent "the new Spanish novel" by commissioning a body of highly intellectual, largely unreadable novels by young writers. This élitist approach to the reading public meant that fictional trends, in each of the successive cultural phases of the Franco period, were relatively homogenous. The most obvious change brought by democracy has been a massive diversification of literary production, hugely extending the public's range of choice. In the initial Transition years, following the abolition of censorship by the January 1977 amendment to the 1976 Law of Political Reform, this diversification was itself largely imposed by publishers eager to issue the public with previously banned literary works, chiefly foreign, and a flood of books on national history. This over-production, plus the 1982 Latin American debt crisis causing the collapse of the Latin American export market, forced publishers to face the realities of a market economy, promoted from that same year by the newly elected PSOE government.

The result in the period 1982–1986 was a process of concentration and globalization, as in the publishing world elsewhere. Large editorial houses in Spain took over smaller ones both in Spain and in Latin America; some in turn were themselves taken over by foreign concerns (Germany's Bertelsmann or Italy's Mondadori groups, for example).[1] Since this restructuring, the publishing industry has boomed. By 1987 Spain occupied fourth place in world book production (Acín, *Narrativa*, p. 107), and the annual number of new titles has continued to rise, by 1993 reaching 40,221 (*Cambio16*, 1 April 1995, p. 70). The creation of large publishing groups has permitted aggressive marketing: in 1983, Planeta's advertising budget was 15 million *pesetas*, placing it in the top thirty national companies in terms of advertising expenditure, with Plaza y Janés close behind (Acín, *Narrativa*, p. 117). Books are increasingly marketed through department stores, supermarkets, drugstores, newspaper stands, and book clubs, as well as bookshops. Yet the latter have blossomed, noticeably in previously poorly provided provincial capitals, benefiting from an enlarged student population. Symptomatic of the new "lifestyle" approach to marketing culture is the successful five-floor book and record store FNAC, which opened in 1994 off Madrid's Gran Vía, complete with café and auditorium for book signings, talks, and concerts. Bookshop displays, bestseller lists, cultural supplements in the press, TV chat shows, TV or film versions of novels, and literary fairs have all added to this marketing hype, which undercuts diversification by encouraging standardization: the same bestsellers are reviewed and displayed everywhere; bookshop shelving tends to be arranged according to standard genres (historical novel, thriller, sci-fi, fantasy, erotica).

Although half the population reads no books at all (*Cambio16*, 1 April 1995, pp. 70–71), this commercialization means that novels are selling. Of the many literary magazines created in the early 1980s, often funded by local government or banks, several have survived the current recession. And although more foreign fiction continues to be translated than in the English-speaking world, Spanish novelists are now the major sellers. The PSOE government of 1982–1996 has been criticized for promoting culture as a consumer spectacle but, in subsidizing tours and translations of Spanish writers, it made a growing number known abroad. The Ministry of Culture has offered grants for literary creation since 1980. It is probably true that the proliferation of literary prizes (over 300 in Catalonia alone) serves mainly to promote the sponsors: whether regional or municipal authorities, banks, or publishers as with the massive Planeta

prize whose overt aim is to increase sales by generating scandal (Planeta has been accused of fixing juries and pre-determining the winners). Still, the Premio de la Crítica and Premio Nacional de Narrativa have rewarded genuine talent; in 1989 the Premio Nacional de Literatura was first awarded to a novel in Basque (Bernardo Atxaga's *Obabakoak*) and in 1995 to one in Catalan (Carme Riera's *Dins el darrer blau*, Beyond the Final Blue). The proliferation of local publishing with regional autonomy may have created a "minifundismo editorial" (editorial fiefdom: Acín, *Narrativa*, p. 134) which risks provincialism, but it has also launched major writers: Antonio Muñoz Molina was first published by Granada's Diputación Provincial.

To deplore this cultural promotion is to forget that the novel owes its pre-eminence as a genre to the commercialization of publishing in the nineteenth century. One must remember that the diminished selection of titles available before democracy was a far more damaging manipulation of the public than the present over-production. Behind current complaints about the commodification of culture there lies, one suspects, a fear of mass culture. José Carlos Mainer has argued that the most significant cultural feature of post-1975 Spain has been "the establishment of a new contract between the Spanish novel and its readers":[2] novelists now write for the public. Indeed, a major feature of contemporary Spanish fiction is its blurring of the old divide between élite and mass culture. Although the cultural mandarinism of the Franco era did produce more major novelists than those which emerged in the first decade of the capitalist free-for-all, worries about declining standards have been contradicted by the emergence since the mid-1980s of some outstanding new writers, of all ages. One of them, Antonio Muñoz Molina, has been elected to the Real Academia Española, alongside the Peruvian Mario Vargas Llosa, in an attempt to renovate the literary establishment. In the post-1975 period generational classification breaks down, for new authors who have grown up, or even been born, after Franco's death coincide with writers who started publishing in the 1950s or, in the case of returning Republican exiles, the 1930s. Perhaps even more encouraging than the emergence since 1992 of a number of young authors born between 1967 (Ray Loriga) and 1982 (Violeta Hernando) has been the publication since 1975 of some outstanding first novels or short-story collections by writers in their forties or fifties: Esther Tusquets (first novel 1978), Juan Eduardo Zúñiga (first book of stories 1980), Josefina Aldecoa (first novel 1984), Luis Landero (first novel 1989). In this essay I

shall range across writers of different ages and literary generations, concentrating on an analysis of significant fictional trends.

If returning exiles, like Rosa Chacel in *Barrio de maravillas* (Neighborhood of Wonders, 1976), have tended to focus on their pre-war Spanish experiences, the majority of post-1975 writers are resolutely cosmopolitan. Many have lived abroad, mostly in Britain or the US. As a result, in a major cultural shift, English-language models have replaced French ones. Several novelists are literary translators, mostly from English. Characters in contemporary Spanish novels now travel the globe, from Oxford (Javier Marías, *Todas las almas* [All Souls, 1989, filmed by Querejeta]) to India (Soledad Puértolas, *Queda la noche* [Still the Night, 1989]). Juan Goytisolo, living in Morocco and Paris, has of course set his novels abroad since 1970. Several writers, asserting their cosmopolitan credentials, have set their first novels in the United States with exclusively American characters: Javier Marías, *Los dominios del lobo* (The Domain of the Wolf, 1971); Soledad Puértolas, *El bandido doblemente armado* (Two-Armed Bandit, 1980); Violeta Hernando, *Muertos o algo mejor* (Dead or Something Better, 1996). While most writers live in Madrid, which since the late 1970s/early 1980s *movida* has replaced Barcelona as the cultural networking center, a large number are from the provinces. Although the contemporary novel is predominantly urban, provincial towns figure alongside Madrid and Barcelona. Indeed, a significant feature of much of the new fiction in the minority languages has been its cosmopolitanism, opting for post-modern playfulness as in Lluís Fernàndez's camp romp *El anarquista desnudo* (The Naked Anarchist, Catalan *L'anarquista nu* [1978]), Bernardo Atxaga's Basque *Obabakoak* (1988), or Suso de Toro's novels in Galician (*Polaroyd* [1986], *Land Rover* [1988], *Tic-Tac* [1994]).

It has become fashionable to describe contemporary Spanish culture as post-modernist. Accelerated development, replacing historical linearity with simultaneity, has created an apocalyptic sense of the "end of history," exacerbated, as capitalism has moved into its post-industrial phase, by the collapse of the liberal belief in material progress and, crucial in Spain, of the Marxist dream of a more just future. In fiction, this has produced a tendency towards narcissistic self-reflexivity in the double form of metafiction and introversion. The historical irony whereby Spain's achievement of democracy, after four decades of largely Marxist opposition struggle, coincided with the demise of international communism, causing the near annihilation of the Spanish Communist Party after its legalization in 1977, produced in many former opposition writers

a terminal sense of futility. There are parallels with the cynicism felt by some 1940s fascist intellectuals on Franco's purging of the Falange's radical elements on the victory of the Nationalists. Thus, a similar conversion of history into self-reflexive, eternally repeating playfulness is found in the post-1975 fiction of the former Falangist Torrente Ballester – the notion of apocalypse is foregrounded in the title of his *Fragmentos de apocalipsis* (Fragments of Apocalypse, 1977) – and of the former communist activist Luis Goytisolo: notably, his *Antagonía* tetralogy (1972–1981) and *Estatua con palomas* (Statue with Pigeons, 1992). In the latter's recent *Mzungo* (1996), about European adventurers in Africa, history is literally converted into virtual reality by the novel's publication with accompanying CD-ROM. This joins hands with the cynical reduction of history (the Civil War) to eternal repetition in *Mazurca para dos muertos* (Mazurka for Two Dead Men, 1983), the only major post-1975 novel of Camilo José Cela, another ex-Nationalist, awarded the Nobel Prize for Literature in 1989. The case of Juan Goytisolo is more complex. Both he and his brother Luis have rewritten Marx's biography as post-modern pastiche, in *La saga de los Marx* (The Marx Saga, 1993) and *Investigaciones y conjeturas de Claudio Mendoza* (The Investigations and Conjectures of Claudio Mendoza, 1985) respectively. But the post-modern self-reflexivity of Juan Goytisolo's fiction since 1970, intensified in his post-1975 works *Makbara* (1980), *Paisajes después de la batalla* (Landscapes after the Battle, 1982) and *Las virtudes del pájaro solitario* (Virtues of a Solitary Bird, 1988) to the point that they are as much essay as apocalyptic sci-fi fantasy, is used to make powerful statements about material issues such as racial discrimination and AIDS. Of all the opposition novelists who started writing in the 1950s, those who have blossomed most since 1975 are Juan Goytisolo and Carmen Martín Gaite: a homosexual writer and a woman writer whose concern with sexual politics gives them a continued relevance in a post-modern world where political parties, particularly given the corruption scandals of the PSOE in its last years of government, are discredited.

The work of the New Novelists promoted from around 1972 is equally self-reflexive in its extreme intellectualism and pretentiously erudite intertextual references, influenced by the French New Novel and structuralism, with plot and historical reference virtually disappearing to leave nothing but language about language, as in Javier Marías's *El monarca del tiempo* (The Monarch of Time, 1978) and *El siglo* (The Century, 1983): a trend culminating in Julián Ríos's *Larva* (1983) which attempts to rewrite *Finnegan's Wake*. The only New Novelists to have produced interesting

work in the last decade are those – Marías, Vicente Molina Foix – whose first novels combined this French-inspired intellectual élitism with the equally self-reflexive pastiche of English-language mass cultural forms (horror story, thriller, adventure story, and above all Hollywood), anticipating what in the 1980s would become a dominant trend. Vicente Molina Foix's best novel *La quincena soviética* (Soviet Fortnight, 1988), exploring the contradictions between Marxist commitment and sexual liberation experienced by late 1960s student activists, represents political activism as the donning of a series of disguises/costumes, suggesting that Marxist disillusionment is the subtext to the post-modern playfulness of his other works. The New Novelists' aggressive refusal of political commitment has been justified by Marías, now Spain's best known writer, on the grounds that, with democracy, political activity can be pursued through political channels, ending the subordination of the novelesque to "extraneous" factors (*Cambio16*, 1 April 1995, p. 69). His own smoothly crafted novels, notably *Corazón tan blanco* (Heart so White, 1993), exemplify this emphasis on the "purely novelesque," with a strong debt to the detective tradition, in which history becomes a pretext for a story and indeed is shown to be just "stories." The characters in Marías's fiction are often writers or booksellers. Similarly, the slick thrillers of Antonio Muñoz Molina (*El invierno en Lisboa* [Winter in Lisbon, 1987, filmed by Zorrilla], *Beltenebros* [1989, filmed by Miró]) are inhabited by literal or figurative performers, with constant references to the hardboiled thriller and jazz as relayed through *film noir*. Indeed, the number of contemporary Spanish novels about writers, filmmakers, or performers is threatening to become tiresome.

The fondness for cinematic references, reflecting the contemporary replacement of print by the visual image, reinforces the stress on surface at the expense of depth. The last decade has seen a vogue for historical fiction, but with history frequently converted into exotic pastiche. The clever self-conscious historical thrillers of Arturo Pérez-Reverte, several turned into films, have earned him the title "the Spanish Umberto Eco" and the highest advance paid to a Spanish writer by a US publisher (Harvill) for his recent *La piel del tambor* (The Drumskin, 1995). Terenci Moix's best-selling novels about Cleopatra and her daughter (*No digas que fue un sueño* [Don't Tell Me It Was a Dream, 1986], *El sueño de Alejandría* [Dream of Alexandria, 1988]) or Pauline Bonaparte (*Venus Bonaparte* [1994]) turn history into camp spectacle. A similar exoticizing tendency is found in Paloma Díaz-Mas's pastiche reworkings of past cultural forms – chivalric romance in *El rapto del Santo Grial* (The Capture of the Holy Grail, 1984),

the picaresque through to 1940s songs and comics in *El sueño de Venecia* (Dream of Venice, 1992) – which nevertheless explore gender and racial issues.

In fact, a number of writers have used the pastiche of mass cultural forms to make serious statements about history. Eduardo Mendoza's *La verdad sobre el caso Savolta* (The Truth About the Savolta Case, 1975, filmed by Drove) returns to the early twentieth-century tradition of anarchist serialized fiction, exposing capitalist villainy in Barcelona in that period. However, his *La ciudad de los prodigios* (City of Marvels, 1986), framed by the two Barcelona Universal Exhibitions of 1888 and 1929, tends to turn history into post-modernist spectacle. The loyal Communist Manuel Vázquez Montalbán has self-consciously used the thriller format in his Pepe Carvalho series – notably, *Asesinato en el Comité Central* (Murder on the Central Committee, 1981, filmed by Aranda) where Carvalho attends a seminar on detective fiction – to expose corruption in high places. His historical thriller *Galíndez* (1990) investigates the true story of the murder of a leading member of the Basque Government in Exile through the self-reflexive narration of its investigation by a historian. However, his *Auto-biografía del general Franco* (Autobiography of General Franco, 1992), narrating the writing of a fake autobiography of Franco, while reminding us that all history is a textual fabrication, comes close to reducing history to a literary joke, as does the parodic autobiography of a former Francoist in Juan Marsé's *La muchacha de las bragas de oro* (The Girl with the Golden Panties, 1978, filmed by Aranda). Marsé is at his best when reworking elements of the thriller and melodrama, via Hollywood, to convey working-class suffering and repression in the 1940s, as in *Un día volveré* (One Day I Shall Return, 1982) and his earlier *Si te dicen que caí* (The Fallen, 1973, filmed by Aranda) released in Spain only in 1976 whereupon it was confiscated, subsequently becoming a bestseller. Marsé's delight in popular cultural forms, and his post-modern emphasis on identity as performance, can be seen in retrospect to have anticipated later trends.

The main advantage of popular fiction is its capacity to involve readers emotionally. Perhaps the most successful reworkings are those which avoid pastiche, using the *folletín*'s episodic structure and coincidences to express a post-modern view of the discontinuity and irrationality of history, as in Lluís-Anton Baulenas's *Nombres en la arena* (Names in the Sand, Catalan *Noms a la sorra* [1996]) which takes its female protagonist on an erratic journey through the Spanish Civil War, Salazar's Portugal, colonial Angola and the 1974 Portuguese Revolution; what she learns is

that all political convictions have to be abandoned and the only certainty is love. Curiously, something similar occurs with the references to youth culture (rock songs and cult movies) in the novels of the massively promoted "Generación X": Ray Loriga, *Lo peor de todo* (The Worst of All, 1992), *Héroes* (1993), *Caídos del cielo* (Fallen from Heaven, 1995); José Ángel Mañas, *Historias del Kronen* (Stories of the Kronen Bar, 1994, filmed by Armendáriz), *Mensaka* (1995); Violeta Hernando, *Muertos o algo mejor* (1996). In their construction of an apocalyptic post-industrial world dominated by sex and violence, mass culture is the only thing taken seriously. Despite their nihilism – strongest in the "dirty realism" of Mañas, whose *Historias del Kronen*, centered on a Madrid café, reads like a 1990s rewrite of Cela's *La colmena* (The Hive) – there is considerable poetry in the references to road movies in *Caídos del cielo* or the quotations from rock lyrics in *Muertos o algo mejor*. Indeed, some of the cultural references are to the 1960s when a better world seemed possible. And although all the love stories end in violent death, there is a tenderness and longing for love beneath the bravado, particularly in Violeta Hernando's work where love, sometimes between two women, is realized albeit briefly. Another good first novel, Gabriela Bustelo's *Veo veo* (I Spy With My Little Eye, 1996), is a pastiche thriller, sending up a post-*movida* Madrid where the stress on media hype turns being into representation; consequently, the heroine cannot tell whether her accidental shooting of the one man she loved was real or faked – but the love is real.

This romantic affirmation of love as the only value in a post-political world is one manifestation of a not always positive concentration on the personal. The last two decades have seen the emergence of autobiography as a major genre in Spain, pioneered by the publisher Carlos Barral's *Años de penitencia* (Years of Penitence, 1977) and *Los años sin excusa* (Years with No Excuse, 1978). Juan Goytisolo's magnificent *Coto vedado* (Forbidden Territory, 1985) and *En los reinos de Taifa* (In the Kingdoms of Taifa, 1986) chart his "coming out" as a homosexual in a particularly urgent example of the need to make the private public, illustrated more frivolously by Terenci Moix's *El peso de la paja* (A Wanker's Tale, 2 vols. to date, 1990–1993). Luis Goytisolo's *Antagonía* reworks autobiographical material, as does Antonio Muñoz Molina's *Ardor guerrero* (Warrior Spirit, 1995) and Soledad Puértolas's *Recuerdos de otra persona* (Memoirs of Someone Else, 1996). This new interest in the private seems the key to the success of Marías's novels, whose microscopic psychological analysis, like that of much British fiction, exists in a social void. First-person narration and free indirect style

are noticeably frequent, from the abstract stream-of-consciousness of the late 1970s New Novels, which claimed Juan Benet as their antecedent, to the alienated "Generación X," passing through a plethora of titles by almost every writer about loneliness, withdrawal, and the breakdown of relationships. The monotonous frequency with which jacket blurbs proclaim such subject-matter as the novel's selling point – Juan José Millás's *El desorden de tu nombre* (The Disorder of Your Name, 1988), *La soledad era esto* (That Was Loneliness, 1990) and *Volver a casa* (Coming Home, 1990) have now been packaged together as a "Trilogy of Loneliness" – makes it clear that Spain's formerly strong family ties are now in crisis, though one wonders whether this aestheticization of neurosis or "Prozac poetics" is not something of a literary fashion.[3]

In writers over forty the stress is logically on middle-age crisis, usually accompanied by marital breakdown, often attributed to egotism resulting from the loss of former anti-Franco political solidarity as the male characters become successful figures under late capitalist democracy, as in Millás's *La soledad era esto* (1990), José María Guelbenzu's *La tierra prometida* (The Promised Land, 1991), or Esther Tusquets's *Para no volver* (Never to Return, 1985) prefaced with Darío's lines "Youth, divine treasure, / gone never to return." Contradicting this mythologization of the past, recognized by Tusquets, the younger Olga Guirao (*Mi querido Sebastián* [My Beloved Sebastian, 1992], *Adversarios admirables* [Admirable Adversaries, 1996]) has returned to the Franco period to show how its repressive gender codes made many marriages a disaster. In the youth-culture writers of the "Generación X," the stress is on the breakdown of relations with parents, plus the inability, in a world where sex is everywhere, to form lasting sexual attachments: the streetwise heroes of Loriga's *Héroes* and *Caídos del cielo* are virgins. Oedipal traumas occur in works by writers of all ages: son infantilized by devouring mother in Javier Tomeo's *Amado monstruo* (Beloved Monster, 1985); daughters traumatized by but attracted to wayward fathers in Adelaida García Morales's *El sur* (The South, published 1985 after Erice's film) or Luisa Castro's *La fiebre amarilla* (Yellow Fever, 1994). Failure of communication is the hallmark of García Morales's and Tomeo's work generally; the latter, first publishing in 1967, became popular only after 1979 with his Kafkaesque fictions, several in the form of one-sided dialogues. Indeed, García Morales's and Tomeo's characters seem to prefer to relate to others through the imagination and language, like the hero of Belén Gopegui's *La escala de los mapas* (The Scale of Maps, 1993) who rejects the offer of love for a purely

textual existence. The horror stories of Cristina Fernández Cubas – her first books *Mi hermana Elba* (My Sister Elba, 1980) and *Los altillos de Brumal* (The Attic, 1983) remain her best – dramatize a similar fear of invasion by the other.

This failure, or fear, of relationship frequently leads to a solipsistic narcissism. The hero of Álvaro Durán's *A la intemperie* (Exposed to the Elements) walls himself up in an empty house known as "el Bunker"; that of Loriga's *Héroes* locks himself in his room with his hi-fi and TV. The films referred to by the "Generación X" are seen not in the cinema but on TV or video, reflecting intensified isolation. The heroine of Bustelo's *Veo veo*, like that of Millás's *La soledad era esto*, contracts a private eye to report her own movements back to her. This solipsistic introversion seems particularly chronic in male writers, especially young ones: Mañas's *Mensaka* and Pedro Maestre's *Matando dinosaurios con tirachinas* (Killing Dinosaurs with a Catapult, 1996) depict depressive unemployed heroes on drugs or drink, incapable of helping their working girlfriends with the housework. And although homosexuality is no longer a taboo subject, homosexual characters still tend to be depicted as doomed to tragedy or loneliness, as in the apocalyptic science fiction of Eduardo Haro Ibars, which engages with AIDS, or Rafael Chirbes's *Mimoun* (1988) and *En la lucha final* (In the Final Struggle, 1991). Álvaro Pombo makes brilliant use of stream-of-consciousness, in the best modernist tradition, to explore the awkwardness of adolescent relationships in particular, but his homosexual characters mostly remain loners (*Relatos sobre la falta de sustancia* [Tales of Insubstantiality, 1977]), die (*El parecido* [The Resemblance, 1979]), or betray (*El héroe de las mansardas de Mansard* [The Hero of the Big House, 1983]) or kill (*El metro de platino iradiado* [Measure of Iridescent Platinum, 1990]) their love-objects. Even Fernàndez's outrageously funny *L'anarquista nu* ends with a suicide, while the "happy end" of Guirao's *Mi querido Sebastián* consists in the repressed homosexual hero's narcissistic incest with his mirror-image daughter. In a heartening exception, Ferran Torrent's *Gracias por la propina* (Thanks for the Favor, Catalan *Graciès per la propina* [1994]) ends with its boy protagonist engineering the "normalization" of relations between his uncle and his male lover.

The repeated emphasis on male maladjustment in male-authored fiction contrasts with the more positive depiction of female characters in novels by women. It is, of course, traditional for women novelists to depict intimate emotions and use first-person narration. Yet their female characters, although equally suffering from loneliness, generally transcend it: whether through writing (as in Tusquets's stream-of-consciousness

novels, Rosa Montero's *La función Delta* [The Delta Function, 1981], or indeed Millás's male-authored *La soledad era esto*) or through female–female relations. One notes, however, that when the latter are sexual – as in Tusquets's trilogy *El mismo mar de todos los veranos* (The Same Sea as Every Summer, 1978), *El amor es un juego solitario* (Love is a Solitary Game, 1979) and *Varada tras el último naufragio* (Grounded by the Last Shipwreck, 1980) – they end tragically. Supportive relations between women are central to Montserrat Roig's novels of the Transition period; in Martín Gaite's *Nubosidad variable* (Variably Cloudy, 1992), two former girlhood friends overcome their mid-life crises by addressing autobiographical texts to each other. In *Nasmiya* (1996), the usually gloomy García Morales tackles the risky subject of polygamy among Spanish converts to Islam, as her first-person narrator learns to grow through her relationship with her husband's young second wife. A number of novels treat mother–daughter relations, raised in Tusquets's *El mismo mar de todos los veranos* and Millás's *La soledad era esto* but highlighted in Roig's works, Josefina Aldecoa's magnificent sequel novels *Historia de una maestra* (Story of a Schoolteacher, 1990) and *Mujeres de negro* (Women in Black, 1994), and Martín Gaite's *Lo raro es vivir* (Living is the Strange Thing, 1996), perhaps her best to date. In Martín Gaite's *La Reina de las Nieves* (The Snowqueen, 1994), the healing encounter is between illegitimate son and mother. Laura Freixas's anthology of female-authored stories *Madres e hijas* (Mothers and Daughters, 1996) has been a major bestseller. There are now almost as many female as male writers in bookshop displays, though Colección Femenino Lumen, to my knowledge, remains the only all-female-writer series, and Madrid's Librería de Mujeres stocks fiction by women and men. The number of male writers now choosing to write about women is significant: in 1995, Antonio Gala's *Más allá del jardín (Una mujer en busca de sí misma)* (Beyond the Garden: A Woman in Search of Herself), Terenci Moix's *Mujercísimas* (Real Women), José María Guelbenzu's *El sentimiento* (Feeling, about the relationship between two women) and José Merino's *Las visiones de Lucrecia* (Lucretia's Visions, about the sixteenth-century visionary Lucrecia de León); Álvaro Pombo's latest novel (1996) is titled *Donde las mujeres* (Where Women Go). Pombo's previous *Telepena de Celia Cecilia Villalobo* (Chatshow Sorrows of Celia Cecilia Villalobo, 1995), frivolous title apart, ends with the life-renewing encounter between an older and younger woman. Spanish women writers universally reject the notion of "women's writing," not wanting to be sidelined in a female ghetto. But this is clearly no ghetto if male writers now feel that, to keep control of the market, they need to write about women.

The only woman novelist to have attempted to construct a tradition of Spanish women's writing is Martín Gaite in her essays *Desde la ventana* (Looking out of the Window, 1987). The heroine of Tusquets's *Para no volver*, while refusing the patriarchal bias of her male Freudian psycho-analyst, returns to him at the end. In the bestselling *Malena es un nombre de tango* (Malena is a Name from a Tango, 1994, filmed by Herrero), which has established Almudena Grandes as a major writer, the female protagonist is driven by hatred for her sister and her mother, but draws inspiration not only from her maternal grandfather, who refused traditional morality, but also from her paternal grandmother, embodying the liberated woman of the Spanish Republic. Grandes's novel bravely rejects a "politically correct" feminist line, asserting the need for women to face the dangerous aspects of sexuality rather than sanitize it; something that, curiously, her shocking first novel, *Las edades de Lulú* (The Ages of Lulu, 1989, filmed by Bigas Luna), an attempt at writing female pornography, came close to doing by ending with its heroine rescued from the perils of sado-masochism by her husband and tucked up in bed in baby clothes. Grandes also rejects first-person introspective narration for a third-person chronological account clearly situated in history, appropriating for women the *Bildungsroman* genre, which some have said cannot have a female protagonist since it consists in charting the character's insertion into the public sphere. At the end of the novel, Malena, having shown herself capable of taking social risks by associating with Bulgarian immigrants, teams up sexually with a psychiatrist who rejects psychoanalysis and works with criminals, whom he invites into his home: the "happy end" involves relationship with the outside world. Even Martín Gaite's novels of female development tend to limit themselves to an inner journey, using fairy stories rather than history as a framework, despite the references to Francoist repression in her metafictional *El cuarto de atrás* (The Back Room, 1978) and her historical essays on sexual mores. Fairy stories and mythology also structure the woman-centered novels of Tusquets and of Carmen Gómez Ojea.

A number of women writers, following the current vogue for "biografías noveladas" with female subjects, have opted for historical fiction in the form of stylized costume drama (the title story of Ana María Moix's *Las virtudes peligrosas* [Dangerous Virtues, 1985]) or exoticism (Ángeles de Irisarri's *Toda, reina de Navarra* [Toda, Queen of Navarre, 1991] and *Ermessenda, condesa de Barcelona* [Ermessenda, Countess of Barcelona, 1994]). Carme Riera's *Dins el darrer blau* (1994) tackles the suffering of the

Majorcan crypto-Jews burnt at the stake in the late seventeenth century, but reduces a religious and political drama largely to the personal. However, Moix's *Vals negro* (Black Waltz, 1994), about Sissi, Empress of Austria (subject of a Spanish TV series and a 1995 "biografía novelada" by Ángeles Caso), gives her heroine a historical understanding lacking in her emperor husband; while the protagonist of Lourdes Ortiz's *Urraca* (1991) is a wily politician who expresses herself through interior monologue. The use by women writers of a supposedly feminine first-person narration can lock their characters in an inner world. This is a problem in Montserrat Roig's Catalan trilogy *Ramona, adiós* (*Ramona, adéu* [Goodbye, Ramona, 1972]), *Tiempo de cerezas* (*El temps de les cireres* [Time of Cherries, 1977]) and *La hora violeta* (*L'hora violeta* [The Violet Hour, 1980]). The most explicitly feminist Spanish writer, Roig insists on her female characters' relationship to history, but her preference for first-person narration or free-indirect-style stream-of-consciousness dooms them to be history's victims rather than its agents; significantly, the story of her most active female character Kati is told in the third person. A perfect balance is found in Aldecoa's *Historia de una maestra* and *Mujeres de negro*, which trace the journey of first mother, then daughter through 1920s rural Spain, Equatorial Guinea, the Second Republic and Civil War, exile in Mexico, and the daughter's return to 1950s Madrid, using the autobiographical first person to engage with history through memory, but constructing a simple chronological narrative that looks outwards rather than indulging in introspection.

It has become common to criticize contemporary Spain for historical amnesia, particularly with the PSOE government's marketing of Spain as a youthful, modern nation, epitomized by the 1992 celebrations. But this is not borne out by the novel. Although the current vogue for historical fiction frequently takes the form of escapist pastiche, an increasing number of writers have engaged with the repressive legacy of the Civil War. Apart from the novels by Marsé, Vázquez Montalbán, Roig and Aldecoa mentioned above (Cela's *Mazurca* is more caricature than exploration of history), Benet's *Saúl ante Samuel* (Saul before Samuel, 1980) and admittedly disappointing *Herrumbrosas lanzas* (Rusty Lances) series (1985–1986) examine the psychological wounds of war, interior monologue here recreating a solipsism enforced by history: an important difference from the New Novelists who claimed Benet as master. Juan Eduardo Zúñiga's stories *Largo noviembre de Madrid* (Long Madrid November, 1980) and *La tierra será un paraíso* (There Will be Paradise on Earth, 1989),

benefiting from his lifelong dedication to Russian literature as translator and critic, subtly use stream-of-consciousness to evoke wartime and post-war bewilderment. Antonio Muñoz Molina's first novel *Beatus Ille* (1986) uses the detective format to expose his student investigator to the buried past of Republican sexual and cultural euphoria and Francoist repression; however, in a post-modern twist, the protagonist's historical investigation turns out to be a literary text written by the man whose supposed death he is investigating. Muñoz Molina's *El jinete polaco* (The Polish Rider, 1991) also returns to the past, with an international interpreter in New York reconstructing from a series of photographs the local history of his home town (a fictionalized Úbeda, Muñoz Molina's own hometown), taking the Civil War as starting-point. The final twist here, far from turning history into a literary imposture, grounds it in a sense of commitment to personal roots and community since the enigma's solution lies in the protagonist's family; the novel ends with him returning home, overcoming the betrayals of history by reinserting himself into tradition. Memory is equally central to the work of Julio Llamazares, whose last novel *Escenas de cine mudo* (Scenes from Silent Cinema, 1994), like *El jinete polaco*, reconstructs the past from a series of snapshots, in this case of the author's childhood. If post-modernism converts history into isolated snapshots, Llamazares takes a series of isolated snapshots and reconverts them back into history, making this "silent cinema" speak. Here, autobiographical narrative is an expression of personal commitment to history and community: Llamazares looks at himself in the photos to recapture not his inner self but what the boy in the photos is looking at. Thus history becomes a landscape: Llamazares's work, including his travel book *El río del olvido* (The River of Oblivion, 1990), is crucial for its recovery of a forgotten rural Spain. But Llamazares's landscapes are saturated with history in the form of personal memories: in *Luna de lobos* (Wolf Moon, 1985, filmed by Sánchez Valdés), those of the 1940s rural guerrillas hiding in the Cantabrian mountains; in *La lluvia amarilla* (The Yellow Rain, 1988), those of the sole surviving inhabitant of a Pyrenean village abandoned through migration to the city. In both novels, interior monologue is used to bear witness to history, and to overcome isolation by inserting the individual's voice into the collective memory.

Bernardo Atxaga's last two novels are also notable for their return to history and to community, in contrast to the metafictional games of *Obabakoak* where the Basque frame of reference is minimal. Both *El hombre solo* (*Gizona bere barkardadean* [The Lone Man, 1993]) and *Esos cielos* (Past Hori-

zons, 1996, no Basque original mentioned) engage with the difficult subject of ETA, with protagonists who are former ETA activists who no longer believe in ETA's goals but feel a continuing personal loyalty to their former co-activists. Both novels use third-person narration interspersed with stream-of-consciousness but particularly with dialogue, for they are about interpersonal relations; indeed, the stream-of-consciousness takes the form of dialogue with the voices of others inside one's head. The protagonist of *El hombre solo* is a loner because of difficult relations with history, not because of personal maladjustment, and sacrifices himself feeling that one has to remain attached to the past, even if it does not make sense. The inclusion of a Polish football team and interpreter raises the subject of the demise of Marxism, replaced by capitalist desire for personal gain. The novel's message – that it is the unimportant things that matter and bind one to others – makes it a major reflection on where Marxism went wrong and why we still need community.

This same importance of the ordinary and of community is found in the novels of Luis Landero, despite their post-modern concern with identity as a fictional construct. The dotty characters of *Juegos de la edad tardía* (Games of Later Life, 1989) and *Caballeros de fortuna* (Gentlemen of Fortune, 1994) redeem their banality by creating imaginary worlds, which bring them into relationship with each other: the first novel clearly reworks *Don Quixote*. A number of novels, including *Caballeros de fortuna*, contain touching idiot characters, highlighting this interest in the seemingly insignificant; in Loriga's cynical *Lo peor de todo*, the only emotional bond is the protagonist's protectiveness towards his idiot brother, the subject also of Atxaga's *Dos hermanos* (Two Brothers, 1995). The banal characters inhabiting Pombo's works (notably, his first book *Relatos sobre la falta de sustancia* [1977]) are depicted with enormous tenderness. His masterwork *El metro de platino iradiado* (1990) uses modernist stream-of-consciousness not to explore the ironic discrepancies between different characters' viewpoints, as in modernism, but to bind them together through their relationships to the central character María, the measure ("metro") which gives them definition. Like Mrs. Ramsay in Virginia Woolf's *To the Lighthouse*, María represents wholeness and integrity, contrasting with the alienation and selfishness of most of the other characters, male and female. The novel's philosophical slant (Iris Murdoch is mentioned) explores the question of what is the difference between "sencillez" (simplicity in the sense of integrity) and "simplicidad" or even "simpleza" (simplicity in the sense of the ordinary or banal). In her

admirable simplicity, which includes intelligence, María is one of the most brilliantly drawn characters in Spanish literature. After the tragedy caused by her maladjusted homosexual brother, she leaves home to be on her own like many recent heroines, but returns because, as she simply puts it, she loves them all. This outward-going love is not stereotypical female self-sacrifice, for the same sense of responsibility towards others is exemplified by her son and by the homosexual dandy who becomes her ally at the end. The novel's unfashionable reflections on St. Francis of Assisi as the prototype of this caring simplicity, which crosses genders, contrast strikingly with the contorted introversion of so much Spanish fiction since 1975. In this return since the mid 1980s to simplicity and community, contemporary Spanish writers have established a genuine contract with their readers.

NOTES

1. Enrique Bustamante and Ramón Zallo (eds.), *Las industrias culturales en España* (Madrid: Akal, 1988), pp. 207–215. See also Ramón Acín, *Narrativa o consumo literario (1975–1987)* (Zaragoza: Universidad de Zaragoza, 1990), pp. 80, 97, 106, 113–114.
2. José Carlos Mainer, "Encuesta: Diez años de novela en España, 1976–1985," *Insula* 464/465 (July–August 1985), p. 10.
3. Eloy Fernández Porta, "Poéticas del Prozac: Tres líneas en la novela española de los noventa," *Quimera* 145 (1996), pp. 35–37; here p. 35.

FOR FURTHER READING

Alonso, Santos. *La novela en la transición (1976–1981)*. Madrid: Libros Dante, 1983.
Amell, Samuel (ed.). *The Contemporary Spanish Novel: An Annotated, Critical Bibliography, 1936–1994*. New York and London: Greenwood Press, 1996.
Buckley, Ramón. *La doble transición: política y literatura en la España de los años setenta*. Madrid: Siglo XXI, 1996.
Christie, Ruth, Judith Drinkwater and John Macklin. *The Scripted Self: Textual Identities in Contemporary Spanish Narrative*. Warminster: Aris and Phillips, 1996.
Davies, Catherine. *Contemporary Feminist Fiction in Spain: The Work of Montserrat Roig and Rosa Montero*. Oxford: Berg, 1994.
Manteiga, Roberto C., Carolyn Galerstein and Kathleen McNerney (eds.). *Feminine Concerns in Contemporary Spanish Fiction by Women*. Potomac, MD: Scripta Humanistica, 1988.
Navajas, Gonzalo. *Teoría y práctica de la novela española posmoderna*. Barcelona: Ediciones del Mall, 1987.
Nichols, Geraldine C. *Des/cifrar la diferencia: narrativa femenina de la España contemporánea*. Madrid: Siglo XXI, 1992.
Ordóñez, Elizabeth. *Voices of Their Own: Contemporary Spanish Narrative by Women*. Lewisburg, PA: Bucknell University Press, 1991.
Vilanova, Antonio. *Novela y sociedad en la España de la posguerra*. Barcelona: Lumen, 1995.

11

Culture and the essay in modern Spain

The essay is an essentially rhetorical genre, in which the author need not defend his or her views in a rigorously logical manner, nor justify conclusions with formal disciplinary support. Rather, the essayist gives a personal, reasonable, informed opinion on subjects of common and usually immediate interest, to a literate public. As such it is a literary form particularly suited to the dissemination of ideas, controversy, and the critique of ideology. There are a variety of types of essays (historical, philosophical, topical) and related subgenres and modes (treatise, newspaper article, autobiography, meditation, confession). It is best to think of the essay not as a predetermined form but rather as a variable model of communication between writer and public that reflects the expressive needs and particular ideological agenda of the author and which, depending on literary quality and degree of intellectual richness, complexity and sophistication, may transcend its immediate purpose and achieve the status of a classic. Thus, to achieve persuasive effects Spain's major Enlightenment figure, Benito Jerónimo Feijoo, relies on a balanced, parallel, antithetical sentence structure consonant with his belief in harmonious, universal reason; Mariano José de Larra, a disillusioned Romantic, infuses the genre of *costumbrismo* (the study of local customs) with personal despair and a satiric, grotesque vision of public apathy and political ineptitude. In the twentieth century two giants of the essay offer a contrast of styles. Miguel de Unamuno, unable to resolve his conflict between reason and faith, shocks the reader with outrageous existential paradoxes; José Ortega y Gasset, in cultivating a cosmopolitan, elegant, yet colloquial style, makes complex philosophical issues accessible to the general educated public.

The birth of the modern Spanish essay is generally identified with the

Teatro crítico universal (Universal Theater of Criticism, 1726–1740) of Feijoo, who like his French and British predecessors – Montaigne and Bacon respectively – represents a stage in the history of European culture in which the intellectual begins to show considerable confidence in his own voice and feels sufficiently independent from established authority to express a personal view of the world. All theories philosophical and scientific, as well as popular opinions, are subjected by Feijoo to the test of experience and placed before the tribunal of Reason. With the critical spirit of Feijoo, as with the enlightened policies of his sovereigns Fernando VI and Carlos III, Spanish culture showed unequivocal signs that it was willing to assimilate the import of experimental science and philosophical novelty without renouncing its religious identity. This reasonable, moderate program was dashed in 1814 by the retrograde policies of Fernando VII. Consequently the nineteenth and early twentieth centuries saw – as they did in the rest of Europe, and in varying degrees and modes – the ideological struggle between the forces of tradition and modernity.

Feijoo has been rightly characterized as a champion of critical inquiry, a publicist for the scientific method and an unflinching foe of ignorance, complacency, and superstition – intellectual qualities evident in a number of eminent essayists who followed the progressive ideals of the Benedictine monk. In his zeal to question authority and educate his readers in the ways of modernity, Feijoo inaugurates the argumentative, polemical essay with both pedagogical and emancipatory aims, a critical tradition that has prevailed in Spanish cultural discourse to this day. Feijoo's environment and audience consisted of a homogeneous society sustained by monarchy, nobility and the church, whereas essayists of the following century represented an emerging bourgeois society based on the ideals of national sovereignty, representative government, and a series of liberal policies locked in a struggle with the interests of absolutism and reaction. A number of essayists throughout the nineteenth and twentieth centuries – notably Larra, the Krausists Julián Sanz del Río and Francisco Giner de los Ríos, Joaquín Costa, the Generation of 1898 and Ortega y Gasset – heeded Feijoo's critical and pedagogical imperative. With persistence and verve they exhorted Spaniards to undertake intense cultural self-scrutiny and encouraged a variety of social reforms and educational programs aimed at national regeneration and cultural parity with Europe. In very broad terms, the prescriptions ranged from militant modernization or *europeización* (secular culture, democratic institutions,

importance of educational reform and scientific research, and attention to concrete economic problems) to a recovery of Spain's imperial glory along with a restoration of counter-reformation Catholicism. A strict division between tradition and modernity, however, is not possible in many writers, as the following pages will show.

With the pioneering example of Feijoo in mind, we may approach the central, most controversial and long-debated issue in Spanish culture: the so-called "Problem of Spain." Implicit in this topic is the quest for a Spanish identity born of a conflict between tradition and modernity and the theme of Spain's relation to Europe, known as the project of *europeización*. But if Spain is geographically and formally already a part of Europe why, one may wonder, should there be a sustained effort to make it *European*? Even those who recognize that Spain is indeed in Europe believe that somewhere in the course of their history Spaniards have opted for a way of life distinct from the rest of Europe. This so-called Spanish eccentricity has been traced to at least two sources; the first speaks of a unique feature of Spanish civilization, the second of an erroneous historical choice. There is one line of thought, characterized by Ángel Ganivet's *Idearium español* (Spanish Idearium, 1897), Miguel de Unamuno's "Sobre la europeización" ("On Europeanization," 1906) and Américo Castro's *La realidad histórica de España* (Spanish Historical Reality, 1948), which despite substantial differences among its proponents, points to a markedly oriental (semitic) identity in Spanish civilization. (Unamuno, identifying the Moorish element, simply called it "African.") As a consequence, according to this view, Spain has generally eschewed the rational and pragmatic approach to reality and shown a predilection for imaginative and religious solutions to life's problems. Another explanation for Spain's "difference" from the rest of Europe is the prolonged, obstinate implementation of an anachronistic historical project, to wit, the counter-reformation, which in defiance of modernity chose to ignore a new European political reality and enforced an inflexible, closed notion of Catholic universalism. The consequences of this policy for the nation's economic, political, and cultural development were hardly favorable, plunging the country into decadence and backwardness. Thus for the next 300 years Spain's marginalized existence was attributed to a stifling of intellectual curiosity and freedom of inquiry, a less than successful, short-lived experiment with liberal–democratic institutions, a lack of state support for progressive economic planning, and church control of education. It therefore became a principal tenet of *europeizantes*

such as Larra, Costa, and Ortega to replace this mentality with secular values and scientific training. Others of a more traditional temperament, Marcelino Menéndez y Pelayo for example, looked to the Renaissance for models of national regeneration and praised the more open, tolerant policies of Carlos V, and the humanist Catholicism of Luis Vives and Fray Luis de León. In our own day, Pedro Laín Entralgo has up-dated this line of thought.

Among the opposing views discussed above, one finds subtle differences, changes in point of view over time and, as in the case of Unamuno and Ramiro de Maeztu, even dramatic reversals. Thus, the young Unamuno briefly fell under the spell of positivism and Marxist socialism and in *En torno al casticismo* (On Spanish Purism, 1895) conceived the Spain/Europe opposition in terms of a gradual fusion of the local and the universal, in which authentic Spanish tradition (*casticismo*) eventually blends with European values and ultimately with the aspirations of humanity. But in 1897 a religious crisis led Unamuno to seek inspiration in a faith he was never able to recover fully and to proclaim the authenticity and superiority of mysticism, "Africanism" and the Quixotic ideal over the European rationalist heritage. Likewise Maeztu, an anarchist and ardent *europeizante* in his youth, embraced a reactionary form of traditionalism that on the eve of the Spanish Civil War cost him his life. Our understanding of the Spain/Europe opposition is further complicated by a number of paradoxical examples of which two will suffice: the religious existentialist and traditionalist Unamuno defends the "Africanist" position with the knowledge and argumentative skills of a consummate European rationalist, while the scientist and *europeizante* Gregorio Marañón is at the same time a staunch defender of the so-called authentic Spanish identity or *casticismo*. All the above attitudes have been dramatized in lapidary statements such as "The tomb of El Cid should be locked away with seven keys" (Costa); "Let *them* (Europeans) invent!" (Unamuno); "Europe is Science" and "My God, what is Spain?" (Ortega y Gasset).

The fullest, most sustained expression of these attitudes, which looked simultaneously to Europe and Spain's past, is exemplified in the writings of the Generations of 1898 and 1914. As Fox has rightly noted, the Generation of '98 was the first group of intellectuals consciously aware of their cultural mission to "regenerate" their country (*Ideología*, p. 18). Unamuno, Antonio Machado, Pío Baroja, José Martínez Ruiz (Azorín) and Maeztu – to name only those who cultivated the essay – responding

to Spain's defeat by the United States and the subsequent loss of her remaining colonies, offered a variety of diagnoses and remedies to a demoralized nation steeped in the corruption of Restoration politics and bogged down by ineffectual institutions. The Generation of 1898 inherited Larra's romantic disillusionment in the face of political ineptitude and general hypocrisy, the Krausist call for a morally aware, tolerant and civic-minded individual, and the regenerationist insistence on practical solutions to economic and educational problems. It should be noted that although the Generation's concerns centered around the historical and cultural role of Castile, some of the root causes of economic backwardness were to be found in the agrarian problems of Andalusia. Also to be kept in mind is the contribution of Catalan essayists, whose ideology, often antagonistic to Castilian cultural and political hegemony, reflects regional and even nationalistic aspirations. Yet the best known modern Catalan essayist, Eugenio D'Ors, transcended strictly local cultural interests by writing in Catalan, Spanish, and French on a number of artistic and philosophical issues.

The role of nationalism is particularly important at the turn of the century. In fact, the Generation of 1898 may be considered the first to embody fully nationalistic aspirations in a political and cultural sense. When Fernando VII dashed liberal hopes for national sovereignty and imposed an absolutist and retrograde traditionalism, progressive intellectuals turned to European – particularly German – models of nationhood and cultural identity. These romantic, idealist models (Herder, Fichte, Schelling, and Krause) inspired writers such as Giner de los Ríos and subsequently the Generation of 1898 to articulate a national Spanish spirit or character (Herder's *Volksgeist*) embodied in the language and art of the people. Thus nationalism was both a progressive–liberal way of understanding the history of Spain and a traditionalist interpretation of its culture, which affirmed an intra-historical, subterranean, permanent identity unique to the Spanish people. Ganivet and Unamuno assimilated, each in his own way, this type of traditionalism.

Unamuno, arguably Spain's most gifted, versatile and profound modern writer, cannot be easily categorized. His exaltation of passion and arbitrariness, his diatribes against logic, scientism, materialism and modernization do not exclude respect for a genuine love of science and scientific inquiry. Yet in spite of his many contradictions, Unamuno remains the great myth-maker of Spanish personalism, idealism and spirituality – as manifest in his *Vida de Don Quijote y Sancho* (Life of Don

Quixote and Sancho, 1905), a work consistent with a general hostility to purely secular values based on the utopian ideals of scientific progress.

If Unamuno, the patriarch of the Generation of 1898, opposed the assertive form of *europeización*, the leading figure of the Generation of 1914, Ortega y Gasset, embraced it. Whereas Unamuno saw in Don Quixote the Hispanic knight of faith, Ortega emphasized the importance of the author Cervantes, whose critical, ironic vision held the key to the Spanish enigma. The young Ortega of *Meditaciones del Quijote* (Meditations on the Quixote, 1914) saw Spanish culture in a pre-scientific stage of development, bound to a pre-theoretical, sensuous conception of reality. This so-called Mediterranean disposition, he averred, can only yield an impressionistic, superficial culture based on appearances. For genuine culture to exist Spanish thought needs to cultivate the concept – the supreme organ of knowledge and the royal road to modernization – and appropriate the rigor, precision and discipline of the sciences. Ortega's enthusiasm for the primacy of science ceded gradually to a broader and more flexible idea of life and culture, exemplified in the philosophy of vital and historical reason. In essays such as *El tema de nuestro tiempo* (The Main Theme of Our Times, 1923) and *Historia como sistema* (History as System, 1941) all scientific disciplines, public institutions, and political systems become subservient to human life in its concrete and circumstantial reality. Thus from a naive faith in science and the benefits of *europeización*, Ortega moved to a critique of the European rationalist tradition and of the limited and ambiguous cultural values it engendered. *La rebelión de las masas* (The Revolt of the Masses, 1930), the author's most famous work, continued to explore the impact of modernity (specifically, the emergence of an impersonal, homogeneous society impervious to a sense of history and cultural values) on the phenomenon of the mass-man. Finally, no mention of Ortega can be complete without reference to his journal *Revista de Occidente* (1923), clearly the most ambitious and sustained effort to bring the best of European culture to the attention of the Spanish public.

Gregorio Marañón may well be the man of science who best represents Ortega's cultural ideal. A trained physician and specialist in endocrinology, Marañón was highly competent in psychology, historiography, and art criticism. His essays, infused with liberal principles, champion the causes of government support for research, pedagogical reform, and women's rights.

The Civil War of 1936–1939 brutally disrupted a veritable silver age in

Spanish letters, sending many prominent intellectuals into exile. Following the Nationalist victory of General Franco all intellectual and artistic activity was subjected to the whims of political and religious censorship. For nearly fifteen years the peninsular essayists revived yet once again the by now Byzantine topic of "The Problem of Spain" in a sterile but acrimonious polemic between militant neo-traditionalists, who wished to extirpate the last vestiges of a liberal, secular, and heterodox "anti-Spain," and intellectuals of Falangist and/or liberal Catholic filiation, who slowly and cautiously attempted to return to some degree of cultural normalcy. The latter group, mainly Laín Entralgo, José Luis Aranguren and Julián Marías, affirmed Spain's essentially religious identity but entered a critical and creative dialogue with the Spanish secular and heterodox tradition and with most of European philosophy. Laín Entralgo's Christian humanism assimilated the import of existentialism and contemporary psycho-biological theory into his studies of hope, the nature of the "other," and of the human body. *La espera y la esperanza* (Waiting and Hoping, 1956) and *Teoría y realidad del otro* (Theory and Reality of the Other, 1961) are representative samples of Laín's thought. Aranguren, a liberal Catholic activist and moralist, invited official scorn and sanctions when he examined the Protestant way of life and Marxist theory with impartiality. In 1965 he was removed from his position as Professor of Ethics at the University of Madrid for his efforts (along with other professors) to liberalize academic life. Aranguren trained and inspired a number of currently active philosophers. Worthy of attention are his *Protestantismo y catolicismo como formas de existencia* (Protestantism and Catholicism as Forms of Existence, 1952), *El marxismo como moral* (Marxism as a Moral Code, 1968) and *Human Communication* (1969). Marías, a loyal disciple of Ortega, developed his own version of the master's concept of vital and historical reason. He also penned essays of historical interpretation such as *La España posible en tiempos de Carlos III* (The Spain that Might Have Been in the Time of Charles III, 1963) and *Una España inteligible* (An Intelligible Spain, 1985). In this last work he defended Spain's historical project of maintaining her Catholic identity.

Perhaps the most radical, dramatic turn for the essay during the Franco years was the work of Enrique Tierno Galván, professor of political science, a prominent opposition figure, and after Franco's death the beloved mayor of Madrid. Tierno considered the question of Spanish identity a subject totally devoid of interest and value, created by intellectuals unwilling to face social realities. Tierno evolved from neo-

positivism to Marxism, eschewing the preoccupations with metaphysics, transcendence, personalism, and existentialism so prevalent among his contemporaries. In essays such as *Diderot como pretexto* (Diderot as Pretext, 1965) and *¿Qué es ser agnóstico?* (What Does Being an Agnostic Mean?, 1975) Tierno attacks every premise of liberal humanism and proposes scientific engineering of society based on the principles of utility, efficiency and material well-being. He relies on the aphorism for the exposition of his theories and on provocative antitheses and definitions for the critique of culture.

Among the exiles the novelist and sociologist Francisco Ayala expanded and refined Ortega's analysis of mass society and nationalism in essays both formal and informal. *Razón del mundo* (Reason of the World, 1944) and *Tecnología y libertad* (Technology and Freedom, 1958) both warn of the threat to culture and individual freedom from propaganda, demagoguery, the leveling of standards, and the displacement of spiritual values by purely utilitarian concerns. Ayala stresses the need for new institutions and forms of government to accommodate the complexity of post-modern society. Spain's Renaissance spirit of humanism and ecumenism as well as Ortega's proposals for European unity are not alien to Ayala's ideals. His informed lucidity and stylistic gifts may still be savored in Madrid's daily press. Another exiled disciple of Ortega, María Zambrano, fused philosophy and poetry into an essay form of considerable lyrical force and conceptual subtlety inspired, in her own words, by the metaphor of the heart.

After the death of Franco in 1975 and with the advent of democracy, Spanish society gradually became assimilated to the European community. As a result the themes of national identity and Europeanization lost their ontological and metaphysical dimensions and acquired a more functional character, so that the notions of tradition and modernity became not fixed oppositions but rather flexible categories by which to evaluate Spanish culture. The essay of the post-Franco years, exemplified by Eugenio Trías, *El artista y la ciudad* (The Artist and the City, 1976), Fernando Savater, *Panfleto contra el Todo* (Pamphlet Against Everything, 1982), Eduardo Subirats, *La crisis de las vanguardias y la cultura moderna* (The Crisis of the Vanguard and Modern Culture, 1985) and Xavier Rubert de Ventos, *El laberinto de la hispanidad* (The Labyrinth of Spanishness, 1987), represents both a synthesis and transcendence of the antagonistic positions – Christian humanism and Marxist socialism – that defined the previous generation of thinkers. Their essays defend the integrity of the concrete,

empirical subject in the face of any system – philosophical or political – that threatens to absorb or subordinate the individual to any abstract entity, be it the State, Utopia, or the General Will. They have retained the Enlightenment ideals of a rational, free, creative, protean individual committed to universalist principles of co-existence, but they have also attempted to purge this rationality of its purely instrumental, dehumanizing features and approach all theories and social programs with skepticism and ironic detachment. Of the post-Franco essayist, some have achieved notable popular success. Savater has not only engaged the perennial problems of philosophy but is a frequent contributor to the daily press on a variety of social, political and artistic issues. His Voltairean wit, boldness (he has written on terrorism in the Basque region with uncommon frankness and fearlessness) and accessibility account for his continuing popularity.

There are a few contemporary essayists not easy to classify, but of considerable importance. In the past ten years the cultural essays of the prize-winning novelist José Jiménez-Lozano bring together three lines of historical and literary themes in modern Spanish letters: landscape (Castile), the spiritual heritage embodied in art and architecture, and the contribution of Jews and Moslems to peninsular culture. *Guía espiritual de Castilla* (A Spiritual Guide to Castile, 1984) is representative of Jiménez-Lozano's best efforts. There is also the mordant, witty, incisive cultural critiques of Rafael Sánchez Ferlosio, whose meditations in *Vendrán más años malos y nos harán más ciegos* (More Bad Years Will Come and They Will Make Us Blinder, 1993) is a miscellany of aphorisms, poems, and adages. Of the more recent voices we should mention the devastating attacks against the shortcomings of the Socialist government by Gabriel Albiac in the daily newspaper *El Mundo*. Albiac has also written a bold, startling psychoanalysis of love and death in *Caja de muñecas* (Box of Dolls, 1995). Reminiscent of Norman O. Brown's influential *Life Against Death*, Albiac's essay fuses poetic and visionary elements with psychoanalytic theory to offer a provocative revision of Freud's notions of the female body as object of male fantasy. The poet Carlos Piera takes literary criticism to new heights of subtlety and refinement in *Contrariedades del sujeto* (Contradictions of the Subject, 1993). Also worthy of mention is Enrique Lynch, whose *El merodeador* (The Marauder, 1990) bridges the fields of philosophy, rhetoric, and literature with insight, agility and grace, and Rafael Argullol, author of *El héroe y el único* (The Hero and the Unmatched, 1982), a highly gifted interpreter of the European romantic tradition and its

impact on modern culture. Finally, there are a number of professional philosophers who occasionally bring to bear the insights of their discipline on a variety of cultural issues in the form of the essay. Javier Muguerza, an expert on Kant and moral philosophy, for some time has illuminated contemporary social problems, of which *Sobre la perplejidad* (On Perplexity, 1991) is a good example. Carlos Thiebaut, a thinker whose work also follows in the spirit of the Enlightenment, has radically revised the notion of identity in our post-modern era in *Historia del nombrar* (A History of Naming, 1990).

The essay continues to provide a rich and varied field of cultural discourse in a Spain that can now boast of having arrived where her artists and intellectuals have long sought so fervently to be – integrally in Europe.

FOR FURTHER READING

Aullón de Haro, Pedro. *Los géneros didácticos y ensayísticos del siglo XVIII*. Madrid: Taurus, 1987.

Ayala, Francisco. *El escritor en su siglo*. Madrid: Alianza Tres, 1990.

Bretz, Mary Lee. *Voices, Silences and Echoes: A Theory of the Essay and the Critical Reception of Naturalism in Spain*. London: Tamesis, 1992.

Díaz, Elías. *Pensamiento español 1939–1975*. Madrid: Cuadernos para el diálogo, 1975.

Fox, E. Inman. *Ideología y política en las letras de fin de siglo: 1898*. Madrid: Espasa-Calpe, 1988.

Gómez Martínez, José Luis. *Teoría del ensayo*. México: Universidad Nacional Autónoma, 1992.

Mermall, Thomas. *The Rhetoric of Humanism: Spanish Culture after Ortega y Gasset*. New York: Bilingual Press, 1976.

RICHARD A. CARDWELL

Poetry and culture, 1868–1936

The period 1868 to 1936 was witness to a political and social strug-
gle between left and right and the inability of politicians to create a viable
democratic system which would respond to the demands of all the people
and the diverse regions of Spain. The history of the poetic developments
in the same period is also one of a confrontation between a traditionalist
and Catholic outlook and one that is progressive, impatient of aesthetic
strictures, profoundly skeptical, and élitist. The former seeks a consensus
from above, the second is subversive of the consensus and offers its own
intellectual aesthetic agenda from the margins. The first is undynamic,
reactionary, resistant to change. The second is dissident, deconstructive
of the status quo and anxious for new aesthetic goals, profoundly trans-
gressive in its engagement with the taboos of Catholic Restoration
society: cultural diversity, individuality, sexuality and sensuality, non-
rational states of mind, aesthetic subversion and inversion. The contrast
is a striking one manifest in two statements. First, Gaspar Núñez de
Arce's *Gritos de combate* (Combat Cries, 1875) which affirms that "the
century demands that poetry should be reason in song, and it asks of the
poet not only elegance of form . . . and the ecstasies of thought . . . but also
grandeur of ideas and the teachings of reason which . . . fortify the will."
Second, Gustavo Adolfo Bécquer's reflections in his "Introducción sin-
fónica" (*c.* 1868) that "my muse conceives and gives birth in the mysteri-
ous sanctuary of my head, peopling it with innumerable creations, to
which neither my activity nor all the years which remain to me will be
sufficient to give form." In the former, despite skepticism, there remains
a faith in poetic meaning and word, and in the relationship of poet and
public. In the second, Bécquer not only excludes the real world but
despairs of giving utterance even to his own thoughts. As Bécquer noted

in his review of Augusto Ferrán's *La soledad* (Solitude, 1861), poetry is not made of statements nor ideas but a mysterious creative process beyond the control of reason or conscious thought. These two views of poetry emerged in the same moment of ideological and political crisis and were products of it. They represent the line of cleavage of the modern age, the two discourses which would seek supremacy until the struggle was resolved by the political and Nationalist victory of 1939.

The years between 1867 and 1874 were ones of instability and social and political turmoil. The Glorious Revolution of September 1868 had been preceded by the collapse of the stabilizing Liberal Union and a naval *pronunciamiento*. The post-revolutionary period saw a caretaker government, an attempt at a constitutional monarchy, the Cuban War, a Carlist uprising, a Republic, the Cantonalist experiment and the restoration of the Bourbon monarchy. The poetry of the decades which followed *la Gloriosa* bears witness to a program that hoped to harmonize the traditions of the past with the progressive ideals of liberal thought. Yet, at the same time, as the poetry of Núñez de Arce and others demonstrates, that desire was bedeviled by doubts, political, social and, above all, spiritual. The crisis was a metaphysical one raised in its modern form in Spain in the 1830s.[1] While the immediate post-romantic period attempted to contain and to neutralize the corrosive effects of skepticism and doubt, it is clear from the frequent references in the mid-century to unease and uncertainty that many writers still remained unreconciled to theological arguments or erudite orthodoxy. The 1870s saw, then, an attempt to reconcile tradition and progress while still beset with uncertainties. The post-romantic search to define and restructure the nation through literature, led by Manuel José Quintana, whose work remained popular during the late century, gave way gradually to the search for unity and harmony in politics. The increasingly large bourgeois electorate (universal male suffrage was enacted in 1890) was terrified of revolution from below and supported the status quo in politics. This attitude was expressed through a civic literature. Dissidence was marginalized, social codes were reaffirmed, moral and aesthetic ideals were institutionalized. Poetry, in effect, formed a discourse of power and taste; it became the voice of the ruling classes. Art was identified with life, poetry mirrored the aspirations and ideals of the bourgeois ruling class. It was, as Palenque has powerfully argued, a realist poetry which fused art and life.[2] Second, the poetry of the Restoration was also a discourse of power in that it only permitted that which reflected the hegemony of the ruling class, its poetic

language making impermissible the dissident voices of the margins save only in a few cases: regionalist poetry and Galician and Catalan poetry. Poetry was considered to be "high" culture as against "mass" or "popular" culture. Both left and right sought the naturalization of popular poetic forms, especially the *cantar* and the *balada*, notably by Ferrán, Bécquer, Antonio de Trueba, Ventura Ruiz Aguilera, and Melchor de Palau. For traditionalist and progressive alike the *pueblo* and its culture were employed to bolster political and intellectual ideals. For the right, popular culture was domesticated to incorporate the rural masses into the process of rebuilding the nation and in the expression of a national ideal of "tradition" and *costumbrismo* (the "picturesque"). For the intellectual left, the *pueblo* served as evidence of an apparently radical but paradoxically conservative outlook. It was the locus of an unchanging tradition which revealed the essential spirit of the nation which would serve in its turn as a nucleus for reconstruction and spiritual regeneration. A cultural model was created in which ideology and art went hand in hand. Poetry had to be civic, moral, idealistic, express the aspirations of a ruling group. Poetry, argued the conservative Palau in 1889, had its creator, its reader and its theme. The reader, of *buen gusto* (good taste), would respond to author and subject matter, would become a complicit arbiter of taste. Classical poets were esteemed and others (Góngora, for example) were deemed "ridiculously extravagant," an attitude which persisted until his rehabilitation in the 1920s. The effect was to create a consensual community, the author addressing an implied reader and expressing a common set of assumptions. The anthologies of Juan Valera and Marcelino Menéndez Pelayo offered a list of canonical and "classical" poets acceptable to the taste and the discourses of the time. Poetry also became increasingly accessible to its middle-class public, especially its female readership. Much of the poetry of this period – be it sentimental (José Selgas, Antonio Arnao), philosophizing (Ramón de Campoamor), idealizing (Gabriel García Tassara, Manuel José Quintana), civic (Núñez de Arce) or celebrating scientific progress (Palau, Joaquín María Bartrina) – was designed to promote the education of its readership and, especially, the inculcation of family values and feminine virtues. Selgas's *La primavera* (Springtime, 1850) and *El estío* (Summer, 1853) and Arnao's *Himnos y quejas* (Hymns and Complaints, 1851) combine sentimentality and poetics, and, particularly, celebrate women in terms of flowers which marks the presence of a male discourse of power which both promotes bourgeois virtues through a female readership but also seeks to control it, to

marginalize women as flowers: fragrant, beautiful, and silent. This program of ideals, morals, and social norms was controlled by patronage. The salons of the *nouveaux riches* (who were very often linked by marriage to the old nobility and the new aristocracy created by Isabel II) were centers of taste, the locus of poetry recitals. These fashionable *tertulias* were widely reported in the press,[3] and poets sought to make their reputations in such venues. Antonio Fernández Grilo, favorite and confidant of the deposed Isabel and one of the most popular poets of the age, is a case in point. Ricardo Calvo, the actor, read the poems of Núñez de Arce in the poet's presence in the Madrid theaters to packed audiences. *Juegos Florales* (poetic competitions) were a feature of even the smallest towns, and winners gained public acclaim. The verses of popular poets appeared in reviews and newspapers, even anarchist and working-class journals, and subsequently were issued in volume form. Poetry was disseminated by oral and written means to large sections of an increasingly literate middle class and the poet became a national figure with huge prestige. Núñez de Arce's *La última lamentación de Lord Byron* (Lord Byron's Last Lamentation, 1879), for example, boasted twenty-nine editions by 1890 and the poet became a minister. Campoamor's sentimental *doloras* found huge favor among his female readership and made him wealthy. Grilo was welcomed at Isabel II's court in Paris and Alfonso XII's court in Madrid and was granted a state pension. Poetry became a form of exchange; the public received reassurance that their ideals were safe, the poet gained fame and fortune. Reviews – *El Seminario Pintoresco, El Museo de las Familias, La Ilustración Española y Americana* – single sheets, *cuadernillos* (five-sheet gatherings), collected works, all functioned to provide the necessary outlook, moral, social, aesthetic, and spiritual that would, in its turn, supply the confidence the Restoration so sorely needed.

Yet, for all the superficial confidence, there were dissenting voices, conscious and unconscious, that were, eventually and fatally, to undermine the consensus. The seeds of the aesthetic revolution to come lay in part in the overuse and increasingly mediocre rendition by minor poets of the restricted number of subjects of their more able colleagues. Salvador Rueda's *El ritmo* (Rhythm, 1894) attacked the general lack of culture in a public which applauded the mediocre verses which filled the market place in the 1880s. Distinguishing between a "público docto" (who desired a poetic evolution) and a "público vulgar" (who understood nothing) he proposed metric experimentation and new themes, especially those involving color, beauty, and exotic effects. However, Rueda's

realism, his moralizing and his belief in a providential scheme of things which combined Catholic teaching and the monads of Leibniz meant that he never became the revolutionary he claimed himself to be even though he expresses an explicit, at times perverse, sexual sensuality. Another poet of light, music, and color in poetry but now combined with skepticism is Manuel Reina, who became a senator and civil governor. His review, *La Diana*, which published translations of French and German lyrics, and a succession of volumes of poetry between 1877 and 1907 brought new aesthetic ideas, notably the combination of the worship of art ("I kneel before all types of Beauty") with unbelief and the association of sensual pleasures with skepticism. In this Reina was a precursor of the decadence in Spain. He is the first to evoke the *poète maudit* well before the acculturation of French models in the late 1890s. Like the decadents, Reina proclaims the supremacy of Beauty as a metaphysical absolute and the role of the poet as supreme prophet and victim of his own art. Reina's plastic and musical poetry was to have a profound effect upon Rubén Darío and the younger poets in Spain (Francisco Villaespesa, Juan Ramón Jiménez, Arturo Reyes, Salvador Rueda). For all the experiments of Rueda and Reina, however, they were never able to capitalize completely on their timid dissent. Their appearance in the conservative *La Ilustración* is a measure of the ready accommodation of their novel experiments to public taste yet, at the same time, a portent of what was to come.

The seeds of a more powerful revolution had been sown in the heart of *la Gloriosa* itself. In 1871, a year after Bécquer's death, the first edition of the *Rimas* was published in which appeared a poem whose aesthetic was subsequently to inaugurate real poetic experimentation. In "Yo sé un himno gigante y extraño" (I know a strange and giant hymn) Bécquer combines an Orphic vision with displaced theology and mysticism expressed in a prosaic tone so typical of the realist aesthetic. But Bécquer does not express the confidence of his peers. "Yo sé" (I know) quickly becomes "si pudiera" (if I could). He recognizes that he cannot render thoughts, feelings and insights into adequate language, cannot control "el rebelde y mezquino idioma" (rebellious and inadequate language). The poem is addressed to an absent interlocutor, and represents a failed communication and the breakdown of language itself. It is a poem of non-referentiality. While echoing the disillusion, skepticism and loss of faith of his romantic forebear, José de Espronceda, and his contemporary, Núñez de Arce, Bécquer's loss is more profound. In his *Introducción sinfónica* Bécquer contrasts the ferment of his imagination with his lack of

powers to give it expression. In so doing he focuses on two aspects of the aesthetic process which were to provide the dynamics for the revolution in poetry at the end of the century and beyond. Yet Bécquer, though the most radical, was not a solitary voice. With the apparent triumph of reason and science, critics seriously began to discuss whether the lyric could survive. The debates of Campoamor with Valera and Núñez de Arce with Clarín suggest that poets of the time felt that aesthetics were at a point of exhaustion. The theoretical pronouncements of Campoamor (rather than the verses themselves) also indicate the lines of cleavage which were soon to occur. In his *Poética* and *El Ideísmo* of 1883, Campoamor argued that natural language and "una poesía interior" (the inner thoughts poetry strives to express) were the proper basis for a modern aesthetic. When poetry acts as music awakening in the reader unexpected and inexpressible ideas, he wrote, then beauty will come from within. He emphasizes intuition, poetic visionary experience, spiritual sensitivity, the transcendental, refinement in expression, plain language, and popular art. Much of this reformulates Bécquer's ideals and echoes the aesthetics of European symbolism. It also breaks with the timid and narrow range of poetic themes cultivated by other Restoration poets who tended to overlook the intellectual and imaginative side of the lyric, fettered as they were by a tradition of rationalism, anti-speculation, anti-intellectualism and anti-individuality. The new aesthetic formed a threat to the discourse of power of the consensus. Bécquer's "desire for an impossible ideal of perfection" (ethics) which might be found in the imagination (aesthetics) – "this other world which I carry in my head" – is very much in tune with the thrust of Krausist thought of the 1880s and anticipates the very basis of the literature of the new century and beyond.

After the Republican experiment of 1873 we find assertions of regional difference. In Andalusia there is a marked aesthetic and intellectual reaction to the collapse of republicanism which turns to popular tradition and experimentation; in Murcia the verses of Vicente Medin express in simple, dialectal language the suffering of the oppressed and the poet, and in Galicia there emerged one of the most singular poetic voices of the Restoration period, that of Rosalía de Castro. Her Galician verses express nationalistic concerns – identity, oppression, emigration, exploitation, homesickness – as well as personal obsessions that can be linked with the continuing romantic spiritual crisis. Her adaptation of folksong, metrical experiments, and subdued tone anticipate the revolution to come. In her last collection, *En las orillas del Sar* (On the Shores of the Sar River, 1884,

written in Castilian), she returns to a meditation on existence and the collapse of religious faith, her homeland, children, family, and feminine concerns. Along with the earlier verses of Carolina Coronado, Rosalía also introduces a feminist voice. Her sincerity and self-probing anticipate the work of the symbolists who were to emerge in 1903.

In this period of slow change, two poets, Ricardo Gil and Francisco de Icaza, had begun the process of stylistic and thematic experiment which was to introduce symbolist aesthetics in Spain. They are romantic in their dislike of modern industrial progress and in the evocation of a time of unspoilt innocence and childhood faith. Still, their reaction is not of metaphysical protest, rather a flight into the imagination. Their expression is one of understatement in an unadorned language (contrasting with Rueda and Reina). Their poetic domain is the world of reverie, dream, and the inner world of the spirit. From this comes the exploration of the inner self, emotions and feelings in tune with contemporary developments in medicine and psychopathology and which would soon be employed by the establishment to counter the inward search and marginalize it as derangement. "Mi memoria clasifica" (My memory classifies), wrote Bécquer, and memory is used to give access to an unfragmented world of ideals. They can be expressed only through the search for the adequate word. Ethics and aesthetics come together.

The poetry of the turn of the century (1898–1900) – Villaespesa, José Sánchez Rodríguez, Manuel Paso, Juan Ramón Jiménez, Rubén Darío (briefly) – presents all these aspects of exoticism, color, and musicality along with the more restrained wistfulness of Bécquer and his heirs. This dissident poetry was short-lived and only continued in minor poets. The main thrust of Spanish symbolism came in 1902–1903 with Manuel Machado's *Alma* (Soul), the *Soledades* (Solitudes) of Antonio Machado and *Arias tristes* (Mournful Arias) of Jiménez. Their poetry, deeply shaped by Krausist ideals, seeks to probe recalled experiences as a means to self-knowledge as Antonio Machado explained in *Soledades* (1903): "y podrás conocerte, recordando / del pasado soñar los turbios lienzos" (and you can know yourself in the recall of the blurred canvases of past dreams). States of mind are suggested through evoked planes and indirect language, myth, metaphor and allusion, suggested absences. The new poetry was for a cultivated minority although Jiménez, Antonio Machado and Ramón Pérez de Ayala believed that art could bring about a spiritual regeneration of the nation. Inevitably, a poetry of self-analysis, of profound spiritual anguish and the exaltation of beauty and the ideal

in art over orthodox belief received a hostile reception from the "gente vieja" (old guard). The young progressives' campaign against materialism, hypocrisy, and philistinism was waged in ephemeral reviews which sought to create a serious reading public and informed critical taste. Cosmopolitan rather than nationalistic, breaking the taboos on subject matter, especially the inner life and sexual desire, they broke decisively with the past. For the most part Andalusian, they acculturated their own tradition with the gains of the European (principally French) symbolist decadence. They sought the "alma" (soul) of the past and of their related inner selves, their ideas shaped by the Krausist Institución Libre de Enseñanza, to regenerate the spiritual lives of their fellows. They absorbed the militant doctrines of Nietzsche and of evolution as a means to create a dynamic and revolutionary art. These ideas serve to create the first part of the avant-garde movement in Spain and inform the atmosphere of the Residencia de Estudiantes, the hothouse of intellectual endeavor between 1916 and 1936.

Miguel de Unamuno is a lone voice in his antagonism to the early cultivation of artifice and sensuality. His response in Poesías (1907) was to create poetic equivalents of philosophical ideas in forthright verses. His familiar themes of the hunger for immortality and questions of faith, however, lack the subtlety and allusive appeal of Spanish symbolism.

The poetry of the new century was one of constant change. The verses of Jiménez are a case in point. By 1912 he had abandoned symbolism and the decadence to embark on a quest for "el nombre exacto de las cosas" (the exact name of things) in creating his dynamic "Obra en marcha" (Ongoing Work) which would give substance to the visible world and make of the poet a god.

Jiménez finally turned to a metonymic style seeking in symbols of decay and death the truly eternal essence within temporality, creating a paradox in which anguish becomes exultant affirmation. Art triumphs over life. Antonio Machado abandoned the symbolist frames and spaces (gardens, patios, mirrors, pictures) after 1907 and confronted his own personal and national obsessions in the landscape and history of Castile. In both poets memory and the inner self are used as points of access to a transcendental reality and a nucleus of ideas around which some form of national and personal reconstruction might be organized. Jiménez's relationship with José Ortega y Gasset in the Residencia de Estudiantes and the creation of the Liga de Educación Política in 1914 was the culmination of the intellectual response of the late Krausists in the attempt to

respiritualize the nation through art. The growing antagonism of Machado, Jiménez, and Unamuno to the poets of the 1920s is an indicator of their apparent shift away from human concerns and spiritual relevance. Ortega's sharp comments on "perspectivism" relate to the introduction in 1909 of Italian and French avant-garde ideas by Ramón Gómez de la Serna. The former's *La deshumanización del arte* (The Dehumanization of Art) of 1925 identifies the culmination of a process where art and life are seen as distinct. Symbolist language began to give way to more novel experimentation: intuition, self-reflexiveness, subversion of artistic immunity, breaking of frames and limits, juxtaposition, fragmentation, lack of transition, collage, intertextual reference, discontinuity, the pursuit of "pure" poetry.

The new poets manifested a strongly ludic tone, in which we witness the continuation of the romantic crisis. When words become games rather than functions of rational signs, we find a pointer to the absurdity of life. Yet by contrast with the early avant-garde poets (the *ultraístas*) Jiménez's *Diario de un poeta recién casado* (Diary of a Newly-Wed Poet, 1916) deals with profound spiritual concerns. He also increasingly sought pure expression which contrasted with his rejection of other European avant-garde styles: futurism, dada, surrealism. In many ways the search by the Chilean poet, Vicente Huidobro, for a poetry from which every vestige of representation or reference had been eliminated (*creacionismo*) ran parallel to the god-like enterprise of Jiménez to name things so that they would transcend mortality, although far less successfully. Increasingly poetry ceased to be mimetic and representational, rather it presented hermeneutical insights. Emphasis moved from the symbolic or metaphorical to the search for images which contain the poetic experience. Bécquer's search for the adequate word had come nearer its conclusion.

By the early 1920s a new generation of principally Andalusian poets, initially influenced by Machado and Jiménez, had begun to create an art which could bridge the gulf between avant-garde élitism and popular tradition. Their increasingly difficult poetic language is inspired also by Góngora, and the tercentenary of his death in 1927 offered a rallying point. The renewed emphasis on the metaphor and its importance in poetic expression can be discerned in Rafael Alberti's *Homenaje a don Luis de Góngora y Argote* (Homage to Luis de Góngora y Argote); his *Soledad tercera* (Third Solitude), published with the very Gongorine *Cal y canto* (Stone and Mortar) and García Lorca's lectures on "La imagen poética de don Luis de Góngora" (The Poetic Imagination of Luis de Góngora) and

on "Imaginación, inspiración, evasión" (Imagination, Inspiration, Evasion). In these works the two writers set out the new aesthetic of the metaphor and demonstrate the underlying ludic tone of their verbal gamesmanship. The voice of romantic despair is still to be heard in the ludic tone, the disillusion with progress, and behind the images of tortured bodies and fragmentation. The new poetic language is also highly literary, one of intertextual allusion, myth, children's games, songs, vulgar expressions often employed as masks to hide personal obsessions. The juxtaposition of high and low styles is a challenge to aesthetic hierarchies and a threat to the hegemony of the Spanish Royal Academy of Letters. Luis Cernuda's *Perfil del aire* (Profile of the Air, 1927), Federico García Lorca's *Romancero gitano* (Gypsy Ballads, 1928) and Rafael Alberti's *Cal y canto* (1929) comment more daringly on themes that the finisecular poets had first broached: the inner self, sexuality (hetero- and homosexual), passion, anti-social attitudes, violence, social protest. In powerful images and personal symbols they convey private impressions which are highly suggestive but are far from arbitrary or accidental. The most revolutionary collections were written under the impact of surrealism though rarely do they convey uncontrolled or automatic responses to powerful emotions, preferring the tradition of inner exploration. They also express a sense of alienation from bourgeois capitalism and, in the case of García Lorca's *Poeta en Nueva York* (Poet in New York, 1929–1930), offer a denunciation of modern society's denial of life-enhancing ideals and its oppression of the weak and helpless. His often impenetrable verses stand in contrast to the greater control of Alberti's *Sobre los ángeles* (Concerning the Angels, 1929) and the disciplined and honest assessment of self, family, and society in Cernuda's *Un río, un amor* (One River, One Love) and *Los placeres prohibidos* (Forbidden Pleasures, 1929–1931). These works, along with the verses of Emilio Prados and Manuel Altolaguirre, for all the modern dress, are romantic in their expression of anger and inner emptiness, in the exaltation of personal and sexual freedom and in the collision of ideals and reality. What is new is the extension of the limits of symbolic language. With the increasing politicization of the intellectuals and the collapse of the dictatorship of Primo de Rivera, their work becomes overtly political, especially in the case of Alberti. Exceptions are Jorge Guillén, Pedro Salinas and Vicente Aleixandre. In many ways the first two poets may be linked to the tradition of Platonic idealism expressed by Jiménez. While Salinas begins with the typical preoccupations of *ultraísmo* – speed, the city, the cinema – in a ludic tone

which matches the growing despair of Alberti's *Cal y canto*, the main body of his work after 1930 (*La voz a ti debida* [My Voice I Owe to You, 1933] and *Razón de amor* [Reason of Love, 1936]) refines the symbolist quest to transmute reality into a mysterious and tenuous impression, one beyond the confines of language. Guillén, by contrast, expresses more intellectually, in a distilled and "pure" poetry, a celebration of the joy of living and the beauty of the here and now. His first version of *Cántico* (Canticle, 1928), like much of Jiménez's verse at this time, strives to lay bare the structure, physical and ideal, of the world before him. Aleixandre's *Pasión de la tierra* (Passion of the Earth, 1929–1935) and *Espadas como labios* (Swords Like Lips, 1932) mix elements of romanticism and French symbolism and complete the subversion of the revolution begun in the 1890s in his fragmentation of language and perception as well as in his focus on the body (generally the female body), on desire, erotic passion, and experience. All these poets, save Guillén, rebel against the dominant capitalist culture, raise questions concerning human responsibility (ethics) and uphold their belief in the autonomy of the poetic act and the supremacy of poetic language over rational ideas and traditional assumptions concerning artistic communication (aesthetics).

As the looming political crisis and social divisions of the 1930s made their work increasingly committed or impossible, it was inevitable that their voices would be silenced in Spain following the Nationalist victory of 1939. García Lorca was dead, and most of the rest were in exile. After the war both old and new generations turned to religious themes and formal exercises in pastoral and amorous poetry. The new régime, like the Restoration, encouraged a poetry of realism, of consensus, and classical poetic values. Spain had returned, for a moment, to a poetry of controlled prosaic testimony and pale imitations of the classical masters.

NOTES

1. See Donald L. Shaw, *A Literary History of Spain: The Nineteenth Century* (London: Ernest Benn, 1972).
2. See Marta Palenque, *El poeta y el burgués (Poeta y público 1850–1900)* (Seville: Ediciones Alfar, 1990).
3. *La Ilustración Española y Americana* is one typical example, as Marta Palenque records. *Gusto poético y difusión literaria en el realismo español* (Seville: Ediciones Alfar, 1990).

FOR FURTHER READING

Brown, G. G. *A Literary History of Spain: The Twentieth Century*. London: Ernest Benn, 1972.

Cardwell, Richard A. *Juan R. Jiménez: The Modernist Apprenticeship (1895–1900)*. Berlin: Colloquium Verlag, 1977.

Ciplijauskaité, Biruté. *El poeta y la poesía*. Madrid: Insula, 1966.

García de la Concha, Víctor. *El surrealismo*. Madrid: Taurus, 1982.

Gullón, Ricardo. *Una poética para Antonio Machado*. Madrid: Gredos, 1970.

Mainer, José Carlos. *Historia y crítica de la literatura española, vol. VI/1, Modernismo y 98. Primer suplemento*. Barcelona: Grijalbo-Mondadori, 1994.

Morris, C. B. *A Generation of Spanish Poets*. Cambridge: Cambridge University Press, 1969. *Surrealism in Spain*. Cambridge: Cambridge University Press, 1972.

Morris, C. B. (ed.). *The Surrealist Adventure in Spain*. Ottawa: Dovehouse, 1991.

Sánchez Vidal, A. *Historia y crítica de la literatura española, vol. VII/1, Epoca contemporánea: 1914–1939. Primer suplemento*. Barcelona: Grijalbo-Mondadori, 1995.

Urrutia, Jorge. *Poesía española del siglo XIX*. Madrid: Cátedra, 1995.

Zavala, Iris M. *Historia y crítica de la literatura española, vol. V/1, Primer suplemento*. Barcelona: Grijalbo-Mondadori, 1994.

ANDREW P. DEBICKI

13

Poetry and culture, 1936–1975

The cultural and social conditions underlying Spanish poetry during the Civil War really originated in the early 1930s. The strained economic circumstances motivated by the world depression, as well as the increasing political ferment in Spain that culminated in the advent of the Republic in 1931, and in the ever-greater polarization between the right and the left from then until the war, led writers and readers to focus on social rather than aesthetic issues. In this climate, the search for timeless meanings which had typified the poetry of the 1920s now seemed irresponsible and escapist.[1] The quest for "pure poetry" as well as the linguistic experimentation of vanguard writing were soon left behind, and many poets, including prominent members of prior generations, sought a poetry relevant to the times. This led to works more expressive and emotive on the one hand, and more concerned with social issues on the other. The exact nature of any social "commitment" varied greatly, from a general awareness of social circumstances to an advocacy of specific political and social positions. Still, the bonds between literature and social issues grew tighter (Cano, *Poesía*, p. 96).

Shortly before the advent of the Civil War, the new poetics had become obvious in several events and publications. The Chilean Pablo Neruda, who arrived in Spain in 1934 as consul of his country, collected a number of Spanish poets around the magazine *Caballo Verde para la Poesía* (Green Horse for Poetry, 1935). Combining surrealist imagery with a stress on material reality and a desire to open poetic expression to everyday language and to social concerns, the poets gathered around Neruda created a new direction for verse. It is best represented in the mid to late 1930s by Miguel Hernández, who left behind the stylized imagery of his first book and composed anguished emotive verse; by Rafael Alberti, who used sur-

realistic techniques to portray nightmare images of a Madrid in decay, and later composed poems that directly praised the Soviet revolution and advocated social upheaval; and by the work of several new poets such as Carmen Conde, Germán Bleiberg, and Gabriel Celaya. Meanwhile Federico García Lorca was writing poetic plays that reflected the problems of Spanish social codes, while organizing a traveling troupe to take theater beyond the cities.

A whole strand of Spanish poetry of the mid to late 1930s highlighted personal experiences and emotive attitudes in verse. Bleiberg, Celaya, Leopoldo Panero, and Luis Rosales published books of love poetry that echoed Renaissance verse and seemed to continue some of the writing of the 1920s. Yet their specific referents, their emphasis on personal responses, and the subjectivity that underlay many of them marked a turn away from the earlier quest for a universal aestheticism, parallel but different from that of social verse.

The outbreak of the war in 1936 intensified the social and political currents in poetry. On the Republican side, Hernández and Alberti, among others, wrote patriotic verse praising their side and dramatizing the need to redress social ills. Much of this work was composed for oral recitation and morale-building; there was a systematic effort to collect inspirational *romances* (ballads) and publish them for the Republican troops.[2] Some of this poetry strikes us as dated propaganda, while some, especially works that reflect the suffering and anguish of the combatants, remains readable today.

Poetry was also written and published on the Nationalist side. José María Pemán's "Poema de la Bestia y el Ángel" (Poem of the Beast and the Angel) was a long allegorical defense of conservative values. Several anthologies and a number of individual books also took up the Nationalist cause. All in all, the climate of a bitter civil war which polarized the whole country focused poetic production on morale building and partisan message, and away from what had been a main tenet of modern writing, the embodiment and preservation of complex experiences in verbal form. Meanwhile, the war gradually destroyed and scattered the nucleus of poets who had led Spanish poetry in the 1920s and early 1930s: Juan Ramón Jiménez, Jorge Guillén and Pedro Salinas went, in exile, to the United States, Alberti to Argentina, and several others to Mexico; Antonio Machado died in France, García Lorca was assassinated, and Hernández died in jail.

As the war ended and the Nationalists emerged victorious, the social

NUEVE NOVISIMOS
POETAS ESPAÑOLES

J. M. CASTELLET

BARRAL EDITORES

BARCELONA

1970

8. Title page, *Nueve novísimos poetas españoles*, ed. J. M. Castellet

and political climate was not conducive to poetic creativity. Partisan ideological concerns, underpinned by censorship, dominated all writing. The prohibition on publishing or importing the work of many poets, including García Lorca, Neruda, and the Peruvian César Vallejo, kept a whole generation from reading major Spanish and western poets.

Given all that, it was remarkable that any valuable poetry appeared soon after the war. The magazine *Escorial*, founded in 1940, besides publishing some nationalistic, morale-building verse, did manage to open its pages to several kinds of writing, as did others (García de la Concha, *Poesía*, I, pp. 313–339). The magazine *Garcilaso* (1943–1946) and the work of poets grouped around it (led by José García Nieto) marked an effort to

restore and reinterpret Renaissance love poet Garcilaso de la Vega; these poets published some elegant verse, with nostalgic evocations and gentle feelings of love, picking up, to a degree, the subjective poetic vein of the 1930s. Sonnets abounded.

From today's perspective, one can accept this verse as a commendable if limited effort to recapture literary values. In the Spanish climate of the post-Civil War, however, it struck many as escapist and irrelevant, and was soon left behind as existential and social concerns became dominant. By 1945, a number of voices were rejecting the goals of the *garcilacistas*. The magazine *Espadaña*, started in 1944 in the provincial city of León with rather contradictory statements of poetics, soon became an outlet for poets who wished to highlight contemporary problems. Pointedly attacking the twin tyrannies of the sonnet and of political repression, these writers, led by Victoriano Cremer and Eugenio de Nora, started a current of existential and social poetry that would dominate Spanish verse for the next decade or more, until the late 1950s. A series of other magazines, some of short duration, picked up these currents.

The existential current is represented in works by both older and younger authors. Dámaso Alonso, a well-known poet and critic of the 1920s and 1930s, shocked the public in 1944 with *Hijos de la ira* (Sons of Anger), a collection of poems in free verse whose protagonist questions the meaning of his existence, using colloquial language and a variety of rhetorical and narrative techniques. His dominant metaphor of Madrid as a city populated by living cadavers, and of his own life as a form of death, reflects both an anguished attitude to the times and a protest against his circumstances, personal and social. Another older poet who remained in Spain, Vicente Aleixandre, also expressed his sense of loss and alienation in *Sombra del paraíso* (Shadow of Paradise, 1944). And the younger Blas de Otero used echoes of Spanish mystic poetry to construct an irreverent questioning of God and life's meanings. Techniques adopted from earlier surrealist writing, combined with the ideas of French existentialism, were used by these and other authors to convey a sense of dismay and anguish in the face of the disintegrated society which surrounded them.

Some other authors composed "testimonial" verse that did not fit in this anguished vein, but constituted a parallel effort to embody and convey personal feelings. José Hierro, perhaps the best new poet in Spain at this time, used very specific and personal referents to convey a sense of loss and disintegration in the face of time. Luis Rosales, whose subjective

love poetry gained notice in the 1930s, published in 1949 *La casa encendida* (The Well-Lit House), an emotive representation of a family reflected in its physical surroundings.

More overtly social poetry is represented by later books of Blas de Otero, in which protests against the status quo combined with an appeal to solidarity with the oppressed; by the everyday language verse of Gabriel Celaya, Ángela Figuera, Cremer, and Nora; and, later, by some more subtle works of younger writers such as Ángel González, Gloria Fuertes, and Eladio Cabanero.

By the mid-1950s, a new poetics had become dominant on the Spanish literary scene. The value of poetry as communication of personal responses, larger human concerns, and social issues was widely accepted. Also taken for granted was the need to make poetry accessible to the everyday reader. The critic Carlos Bousoño indicated a major stylistic shift in which everyday language, emphasis on collective rather than individual concerns, narrative techniques, and irony used for serious purposes replaced the more lyric, imagistic, and individualized styles of prior poetry.[3] The quantity of poetry published in magazines and short-run series was very large, though quality varied widely.

It may at first seem puzzling that poetry, of all genres, should become so dominated by the expression of social concern and protest. Yet there are reasons for it. One should keep in mind, first of all, the long Spanish tradition of poetry as the means to convey feelings and responses to oppressive circumstances and social injustices. (One thinks of the longing for peace by Fray Luis de León in the sixteenth century, the bitter satire of Francisco de Quevedo in the seventeenth, the romantic protests of the Duke of Rivas and José Zorrilla in the nineteenth.) In another vein, poetry was the genre least likely to draw the veto of the censors in the 1940s and 1950s. A play that might be seen on stage, an essay that could be read widely, or even a novel published in many copies would attract careful scrutiny from the censors, leading frequently to rejection. A volume of poetry or a small magazine, less widely distributed and considered more personal, had a better chance of slipping by. In addition, and as Ángel González has pointed out, censors were not adept at understanding the implications of irony and satire and González's outrageous parody of a "franquista" speech emerged unscathed.[4] Poetry became, therefore, the protest genre of choice in the Spain of the period.

In this climate, verse that was not easily accessible did not command much attention, although it did appear in places. In the late 1940s, a

group of poets in the city of Córdoba in southern Spain started a maga-
zine, named after the 1920s poet Jorge Guillén's book *Cántico* (Canticle)
and aimed at furthering a more pure form of poetic expression. They
remained marginal until their work gained some attention in the 1960s.
Likewise, several vanguardist strands, including a group that called itself
postistas and several writers influenced by surrealism, did not gain much
attention. Somewhat paradoxically, the magazine *Postismo* was immedi-
ately shut down by the censors in 1945. Experimental and vanguard
writing was quickly deemed subversive by the censors, perhaps more
easily than subtle satire or generalized social protest.

In the late 1950s significant changes were occurring in Spanish society,
and were accompanied by changes in poetry. Spain gradually became
much more open to European and world currents, joining the United
Nations in 1956. A series of governments committed to technological
progress took over from the preceding Falangists and military leaders,
and led the country to significant economic development. Such develop-
ment brought with it a growing foreign presence, largely from the
United States. This presence and the growing tourist industry helped
introduce foreign cultural phenomena, and above all popular movies
and music. The impact of these changes was intensified by the growth of
population centers (especially Madrid and Barcelona) and of the indus-
trial middle class.

Meanwhile censorship was significantly relaxed, most noticeably
under new laws of the press instituted in 1966. Foreign literature, classic
and current, highbrow and lowbrow, as well as works by previously cen-
sored Spanish and émigré writers, became more readily available. New
magazines and poetry series appeared, increasing publication outlets.

A number of new poets became visible and published important verse
between the mid 1950s and the late 1960s. Born between 1924 and 1939,
they had experienced the Civil War as children, as victims rather than
protagonists. They lived their adolescence in a time of limited cultural
horizons, though several expanded them later through foreign resi-
dence. Their formative years were influenced by the rigidity and
hypocrisy of the first post-Civil War decades.

As they reached adulthood and expanded their cultural horizons,
these poets sought new ways of dealing with their experiences and
responses. At the same time, they became aware of the limitations and
simplifications of the preceding era and of its poetry. While accepting the
need to write clearly and building on the tradition of realistic verse that

preceded them, they sought to use language more artfully, and through it to produce work of greater subtlety and originality. Their vision of social and political issues, while for the most part liberal and anti-regime, was more skeptical and nuanced than that of their parents and mentors.

This generation also initiated a major shift in views about the nature of poetry, introducing what might be called the beginning of a post-modern attitude. Its members saw the poem not as a stable object whose meaning remained fixed forever, but as a text whose meanings changed and unfolded in time. José Ángel Valente offered a definition of the poem as "conocimiento haciéndose" (knowledge becoming).[5] He and contemporaries like Ángel González, Francisco Brines, Jaime Gil de Biedma, and Claudio Rodríguez saw the writing of poetry as a gradual process of discovery, not as the writing down of previously established meanings.[6] This change in attitude mirrored a similar shift in poetics that had been occurring in the United States, Britain, and France for some time, but that had not previously affected Spain. One could suggest that the stress on poetry as a social weapon in the 1940s and early 1950s had actually preserved the old view of the literary work as a repository for stable meanings, and delayed, in Spain, the shift in poetics that was taking place elsewhere in the west and that then reached Spain by 1960 or so.

The new poets who emerged in the 1950s published very original and important works. Valente began by authoring several books between 1955 and 1963 in which specific personal experiences gradually point to larger patterns of life, mainly the passage of time. In the latter 1960s, his poetry made greater use of intertexts and allusions, while further exploring the passage of time and the issue of creativity. Brines and Gil de Biedma likewise built their poems on reminiscences and specific experiences, but always pointed to larger themes. And González continually explored tensions between illusion and disillusion in a number of books published between 1956 and 1967, ranging in subject from personal love to social circumstances to the nature of poetry itself. Throughout their work, all of these poets found new ways of giving greater originality and poetic value to the ordinary language and referential mode that had become the accepted form of poetic expression in post-Civil War Spanish verse.

Claudio Rodríguez, perhaps the most original poet of the time, developed in isolation from the social currents of the 1940s and 1950s. Raised in

the Castilian countryside and educated on Renaissance and Golden Age poetry, Rodríguez published extraordinarily sensitive nature poems with neo-mystic echoes. Like Valente, Brines, and González, however, he is exceptionally skillful at evoking a concrete scene or event, and then drawing from it a larger vision and meaning.

One other "new" poet deserves special mention: Gloria Fuertes. Though somewhat older (born in 1918), Fuertes published most of her work after the mid-1950s, and revealed an extraordinary ability to impart new meaning to the commonplace. Her ironic re-castings of common expressions, love declarations, daily events and catastrophes, and social situations, as well as her way of constructing poems in unusual forms of writing (telegrams, file cards, letters, prayers), constitute an exceptionally creative way of transforming the ordinary. Although Fuertes was not always given due credit by the later women poets who would gain prominence in the 1980s, her work shows a feminist cast and an undermining of conventions that presages their accomplishments.

One should not forget poetry written in the late 1950s and the 1960s by older authors. Blas de Otero continued publishing important works, and portrayed a more complex vision of social and personal issues. José Hierro, in the *Libro de las alucinaciones* (Book of Hallucinations, 1966), explored diverse perspectives on human experience, while continuing to stress the theme of time. Meanwhile, books, old and new, written by Spanish poets in exile became available to Spanish readers, who could now see the poetry of their country in a fuller context, while also being able to read the works of major foreign authors.

It is important to remember that by the mid to late 1960s, Spain, and specifically Barcelona, had become a publishing center for the whole Hispanic world. The publishing house Seix Barral, directed by Carlos Barral, a prominent poet and man of letters, made its name by discovering the principal authors of the Spanish American "boom," beginning the interest in "magic realism" that would make Spanish American writing known throughout the world. Thanks to its proximity to France and its economic success, the city of Barcelona was at this time the most dynamic and culturally open place in Spain, in contrast to the more bureaucratic Madrid.

Social changes intensified in Spain as the 1960s wore on and gave way to the next decade.[7] Economic development and increased opening to western European and United States currents introduced the popular culture represented by movies, fashion magazines, rock music, and pulp

fiction. Young people were exposed to the mythic premises of these genres, the mood of sensory gratification, and the fantasies of sexual freedom represented by tourists on Spain's beaches (the *suecas* [Swedes] became a myth of Spanish conversation and movies). The new popular culture, and the thirst for contemporaneity among Spain's youth, evoked contradictory responses among poets. Popular culture, on the one hand, furnished materials for new forms of expression, and became linked with the search for a less conventional and authoritarian discourse. On the other hand, it represented a target against which some authors reacted as they strove for a higher art.

The new social circumstances also modified the way in which new poetic forms and movements gained ascendancy. Polemical essays and anthologies, often presented in publicity-seeking readings, had significant impact on the reading public. (The poetry publisher Hiperión even started keeping track of "poetry best sellers.") Thus José María Castellet, an established critic, created a major stir in 1970 with his publication of an anthology of new poets called *Nueve novísimos poetas españoles* (Nine Innovative Spanish Poets). All of the poets included, and several other important ones who gained visibility shortly thereafter, coincided in their search for a more contemporary, more artful, and more language-oriented poetry, which would bring Spanish letters into the mainstream of European culture and leave behind the limitations of social poetry (limitations which were already being overcome by older poets, though this was not recognized by the younger ones). Several poets of this generation, and most notably Pere Gimferrer, elected to do most of their writing in Catalan, which had been banned by the Franco regime. This marked an attention to non-Castilian language poetry which would increase in later decades, and lead to a flourishing of Catalan and Galician writing.

In some ways, these "newest" poets differed widely from each other. Their political beliefs ranged from the conservatist élitism of Guillermo Carnero to the socialism of Pere Gimferrer. But they came together in their desire to renew language.

The most important members of this generation built their poems on webs of literary intertexts and allusions. As Guillermo Carnero indicated, they tended to base their works on artistic and literary, rather than anecdotal, reality. Carnero explicitly suggested, in fact, that what we read is often more interesting and a better basis for writing than what happens in our everyday world.[8] His own first books of poetry used references to

art and literature as vehicles for embodying a paradoxical struggle for permanence against the limitations of time and death. Gimferrer's poetry combined artistic echoes and personal reminiscences to create emotive experiences, while reflecting, as did Carnero's, on the poetic process itself. Meanwhile Antonio Martínez Sarrión used more contemporary allusions and more references to popular culture, and juxtaposed disparate elements in irrational ways that recalled the surrealists; and Leopoldo María Panero combined shocking imagery with references to popular movies and cartoons. Meanwhile, several older poets also showed evidence of the shift in sensibility that I have been noting. Ángel González's poetry became self-conscious and metapoetical after 1970; Blas de Otero published texts created by *collages* of other authors' lines; Valente's new books turned even more overtly intertextual.

In some ways, one could argue that the *novísimos* (and some poets of the prior generation) were more truly revolutionary in their works and poetics than the social poets of the 1940s and 1950s. In making us see the poem as process rather than just product, and meaning as unfolding and unstable, they undermined the notion of text as stable message – a notion which had been shared by both the pro-Franco poets and their social opponents. They left behind the direct vocabulary and the tendency to messages that had previously characterized both pro- and anti-regime writing.

The social changes which I have been describing in the late 1960s and early 1970s would intensify dramatically after the death of Francisco Franco in 1975. Almost overnight, Spain would change from a traditional society to a wildly open one. Poetry would obviously reflect these changes, as will be evident in the next essay. But one can also think of poetry as actually *anticipating* some of them. The verbal play, the irrationality and shock effects, and the mixture of literary and popular culture in the work of the *novísimos* point ahead to the post-Franco society of Madrid, as does the post-modern poetic of the text as unstable and subject to changes in meaning. This brings to mind John Brushwood's hypothesis, according to which writers intuit forthcoming social change and reflect it in their works before it occurs in the political realm.[9] This hypothesis might be particularly applicable to Spain around 1970: aware of the aesthetic developments throughout the western world, observant of social changes occurring in Spain, and knowing that the end of the Franco era had to be near, sensitive poets could make their work reflect the future rather than the past.

NOTES

1. Juan Cano Ballesta, *La poesía española entre pureza y revolución (1930–1936)* (Madrid: Gredos, 1972), pp. 94–112.

2. Víctor García de la Concha, *La poesía española de 1935 a 1975*, 2 vols. (Madrid: Cátedra, 1987), vol. I, pp. 122 ff.

3. Carlos Bousoño, "Poesía contemporánea y poesía postcontemporánea (1961)," in *Teoría de la expresión poética*, 2 vols. (5th edn., Madrid: Gredos, 1970), vol. II, pp. 277–319.

4. Ángel González, "Introducción," pp. 13–24 in *Poemas* (Madrid: Cátedra, 1980), p. 19.

5. Pedro Provencio (ed.), *Poéticas españolas contemporáneas* (Madrid: Hiperión, 1988), vol. I, p. 98.

6. Andrew P. Debicki, *Poetry of Discovery: The Spanish Generation of 1956–1971* (Lexington, KY: University Press of Kentucky, 1982), pp. 6–14.

7. For details, see Manuel Vázquez Montalbán, *Crónica sentimental de España* (Barcelona: Lumen, 1971).

8. Guillermo Carnero, "Culturalism and the 'New' Poetry," *Studies in Twentieth-Century Literature* 16 (1992), pp. 93–96.

9. John S. Brushwood, *Narrative Innovation and Political Change in Mexico* (New York: Peter Lang, 1989), pp. 57–95.

FOR FURTHER READING

Castellet, José María (ed.). *Nueve novísimos poetas españoles*. Barcelona: Barral, 1970.

Debicki, Andrew P. *Spanish Poetry of the Twentieth Century: Modernity and Beyond*. Lexington, KY: University Press of Kentucky, 1994.

Francini, Graziella. *La generación poética de 1936*. Milan: Vita e Pensiero, 1990.

López de Castro, Armando. *Poetas españoles del siglo XX*. León: Universidad de León, 1996.

Mahew, Jonathan. *The Poetics of Self-Consciousness: Twentieth-Century Spanish Poetry*. Lewisburg, PA: Bucknell University Press, 1994.

Perez, Janet. *Modern and Contemporary Spanish Women Poets*. New York: Twayne Publishers, 1996.

Wilcox, John C. *Women Poets of Spain, 1960–1990: Toward a Gynocentric Vision*. Urbana: University of Illinois Press, 1997.

14

Poetry and culture, 1975–1996

198 The twenty-odd years following the death of Franco – although they have seen the deaths of such central figures to poetic writing as Jorge Guillén, María Zambrano and, from another tradition, Gabriel Celaya – have been ones of extraordinary vitality for poetry.[1] Developments have been particularly swift and multi-directional not just because of poetry's continuing ability to act as the prism for change through language and as the catalyst for intense new ways of participating in culture, but also because of a confluence of the following processes: the opening out of poetry to a wide range of cultural and theoretical perspectives from beyond the immediate Spanish contexts; the development of new poetic languages to express desire, sexual, and gendered identity; the publication of new works in new voices from earlier established poets (José Ángel Valente and Francisco Brines chief among them); an especially acute sensitivity to the creative possibilities offered by reworkings of poetic traditions in contexts of radical novelty; an increasingly sophisticated and enliveningly partisan apparatus of critics, prizes, and autonomous regional authorities needing to remake their cultures; a growth in prestigious and successful collections and poetry lists (in Madrid Adonais, Visor and Hiperión; Renacimiento in Seville; El Bardo and, lately, Tusquets in Barcelona); considerable numbers of collections and periodicals devoted to poetry, more than one thousand volumes of verse published a year, and an audience avid if not for poetry to read in print then certainly for poetry read out in performance and recital.

An inescapable part of the transactions and jostlings for position which have characterized these years is a proliferation of categories, labels, and shifting attempts at definition. So full and varied is the cultural production in verse and poetic language that some of the dead

husks of terminology need to be noted before the poems are studied. In the Spanish cultural establishment – in journals, cultural supplements, introductions to anthologies, in the classroom, in *tertulias*, and in publishers' promotional literature – the talk is of generations (as ever), and two in particular: that of the 1950s as a continuing, enriching presence and that of the 1970s as a point of departure for new and contrary directions. It is also of *novísimos* (publishing from the mid-1960s to the mid-1970s) and *posnovísimos* (mid-1970s to the early 1980s), both names coming to refer to much more than just the few poets at first associated with them; *poesía de la experiencia* (poetry of experience) (bridging the entire period, but with new impulse in the late 1980s and early 1990s); *nueva poesía social* (the new social poetry) associated with strands of poetry of experience and at times spoken of in terms of a new realism (this has sporadic outbreaks, but a more consistent line in Basque culture: see, for example, the poems by Jon Juaristi in García-Posada (ed.), *Nueva poesía*, pp. 101–109); *neopurismo* (new pure poetry) following the tightly controlled, intellectual celebratory mode of Jorge Guillén and *poesía del silencio* (poetry of silence), formally similar but without the celebratory aspects (minority approaches these, but practiced by some of the more prestigious poets throughout the period); *la tradición clásica* (a new classicism), again a strain running throughout the period, but central to certain influential types of poetry of the late 1980s and early 1990s.[2]

Alternative categorizations and an awareness of the open-endedness of these new poetic enterprises are also in evidence however. Luis Antonio de Villena, attempting to delineate the *posnovísimos*, soon has to point out they had no sense of themselves as a group, had various rather than one dominant aesthetic, and formed an "open, plural generation."[3] Similarly Luis Jiménez Martos, introducing the Adonais collection's anthology for 1969 to 1989, speaks of a "journey through plurality."[4] The chosen poets of the Adonais collection form an interesting if somewhat mixed counter-culture when set against the publishers listed above. Adonais has a strong tradition of publication of women poets which predates considerably the sudden interest of bigger publishing houses in Spain and the arrival of liberal feminist-inspired editions by Torremozas and others: the anthology includes – and therefore reminds us that there are whole Adonais collections out by these poets – Blanca Andreu, Pureza Canelo, Julia Castillo (all winners of significant literary prizes), Dionisia García, Clara Janés, and Acacia Uceta, among other significant women. Also the Adonais enterprise takes a stand in the name of the sort of poetry

that many intelligent people would prefer to read and would consider proper to the genre, a stand against poetic careerism through self-insertion into tendencies and movements. Decadentism, aestheticism, *culturalismo* (the sometimes deliberately extreme cultivation of highbrow intertextuality), and indifference to social issues have been cited, the introduction notes, "since the 1960s" as the defining characteristics of contemporary poetry but one of the aspects of the poems here is the alliance of aesthetic concerns with "human," or social, ones; in the selection "grand motifs" persist – love (as a unifying, stabilizing element), death, creativity as transcendence, God, landscape, the struggle with the self, memory, deep emotion, and personal crisis (Jiménez Martos (ed.), *Antología*, pp. 10–11). In a similar vein Julia Barella's 1987 selection of Andalusian, Basque, Castilian, Catalan, and Galician poems[5] bears out her suggestion (but then perhaps it would, such are anthologies and anthologists) that the poetry of the 1980s is as wide-ranging in its fields of reference as it was in the 1970s but now combines this characteristic with "a certain classicism and serenity" (*Después de la modernidad*, pp. 9–10) and the perpetuation of literary traditions where the predominant features are melancholy, anguish, nostalgia, despair, and disillusionment. This said, there is also a poetry which faces the world with vitality, irony, and fun and which has faith in "traditional human virtues" (*ibid.*, p. 10).

The following, inevitably partial account of the poetry of this period aims to interweave the formalized categories with some of the more open descriptive approaches outlined above; it begins, in fact, with poems written in radical defiance of reality and very much against traditional virtues.

By 1975, just as an era was about to open out in which new formations of social and political discourse would gain enormous urgency and momentum, poetry had perversely become famous in Spain for a radical refusal to engage with contemporary politics and serious social issues. In part this was a reaction to a perceived pre-eminence of socially committed poetry in the 1960s as well as to the lasting echoes of the existentialist–religious poetry of the 1940s and 1950s; in part it was an artistic rebellion against a rapidly encroaching value system based on productivity and material gain. The radical modernizing style of some of the contributors to an, at first, obscure anthology, José María Castellet's *Nueve novísimos poetas españoles* (loosely, Nine Innovative Spanish Poets) (1970), had gained prominence, and the term *novísimos* had struck a chord (despite persuasively dissenting voices such as those of the left-wing

poets of the Equipo Claraboya in *Teoría y poemas*, 1971: see Palomero (ed.), *Poetas*, p. 14). What was so innovative was the mix of ingredients in this poetry: aestheticism, decadentism, the use of formal strategies taken from surrealism and comics, pastiches of style from the academic to the journalistic, references to cinema, posters, and television. Although this seems to suggest a certain rooted and streetwise quality in these poems, their knowing excursions into mass culture look mostly away from contemporary, modern Spain; and poems of the late 1970s by Villena or Antonio Colinas are, for all their sensuality and adventurousness, extremely bookish (see the selections in García Moral and Pereda (eds.), *Joven poesía*, pp. 228–236 and 386–403). An important part of the modernizing project of this poetry is a reclamation and reintegration of literary traditions of the immediate European and north American past as well as the distant past of the Mediterranean: the density and variety of reference, enrobed in transgressive eroticism and perverse or subtle desires as it frequently is, becomes its own radical statement of otherness, new despite its sources, and liberating despite its élitism.

It should also be noted, though, that in the Castellet anthology, as well as in others of the early 1970s,[6] there is evidence of a powerful continuation of an older and extremely restrained style of self-reflexive poetic writing in Spanish. Two of the Castellet poets, Guillermo Carnero and Pere Gimferrer could – despite the odd wry reference to the modern world – scarcely be further from the teeming realities of Spain in transition in this sense. Carnero in a famous poem, "Meditación de la pecera" (Meditations on a Goldfish Bowl), in *El azar objetivo* (Objective Chance, 1975) considers with dry sharp humor some problems of physics and philosophy prompted by watching the movement of goldfish. Gimferrer remains concerned, in some of the most intense and traditionally "poetic" writing of the period, with questions of the self and its construction in relation to beauty, form, and the apprehension of reality (see, as an example of the final development of this mode, the extract from *Apariciones y otros poemas* of 1982, in Palomero (ed.), *Poetas*, pp. 305–306).

In another direction José María Álvarez, with flair, elegance, and a strong nose for philistinism, kept a very considerable distance from what most people were going through in the Transition and the early years of government by PSOE as well as from certain forms of literary humbug and cultural classification (take for instance his remark "I have always said that Castellet's *Antología* was a list of people who used to go out for meals together").[7] Amplified re-editions of his *Museo de cera* (Wax

Museum), commenced in 1960, and *El botín del mundo* (Worldly Plunder, 1994), have managed to keep alive powerful motifs of *culturalismo*, in an eclectic exaltation of poetry, jazz, Hollywood, Hölderlin, historic Italy, sex and famous lives. "Príncipe de tinieblas" (Prince of Shadows) is dated 1977 (all Álvarez's poems bear dates to mark out poetry as a record of radical alternative personal history) and bears the epigraph "*¡Maldición! ¡Estamos rodeados!*" (Curses! We are surrounded!) languorously attributed to "algún libro" (a book). It evokes:

> El limpio cielo
> Del Sur El calor de una copa
> mientras escucho a Mozart
> Las telas de Velázquez o Rousseau
> estas playas en calma que contemplo
> . . .
> Paisajes rostros libros

(The clear sky / Of the South The warmth of a glass in my hand / as I listen to Mozart / Canvases by Velázquez or Rousseau / these calm shores I contemplate / . . . / Landscapes faces books).[8] These words "Paisajes rostros libros" could be appropriately recycled, in the spirit of the *novísimos,* as an epigraph for many a poem of the late 1970s in the then new style of only sometimes mock defiance of reality.

The exotic sources and language of the poetry associated with the name *novísimos* and its atmosphere of novelty, aesthetic, and experiential adventure encouraged a new openness in writing about sexual desire in poetry in Spanish. The earlier advances in this direction by García Lorca, Cernuda, and Aleixandre had had no consistent following in the 1950s and 1960s (nor, in the circumstances in Spain, could they have done). By the 1980s, however, alongside conventional heterosexual erotic writing by male poets, a counter-tradition had emerged of writing by women about their own bodies and about their desires for men's bodies (this latter backed by a wealth of openly homoerotic poetry by Villena). Clara Janés, in *Eros* (1981), has constant recourse to the substance and feeling of her own body, in language that owes much to the new *culturalismo*; sex with a young man reveals for the first time "cavidades melosas en la carnosa pulpa / suavemente entreabierta / . . . / la belleza de un glande" (honeyed cavities smoothly opened / in the fleshy core / . . . / the beauty of a glans) (in Palomero (ed.), *Poetas*, p. 107). Ana Rossetti, in *Indicios vehementes* (Vehement Signs, 1985) has men deliciously compromised and

Almudena Guzmán, in *Usted* (You), rewrites both poetry of experience and sexual power relations (see Rossetti's "Chico Wrangler" [Wrangler Guy] and "La anunciación del ángel" [The Annunciation of the Angel] and selections from *Usted* in García-Posada (ed.), *Nueva poesía*, pp. 84, 85 and 234–236).

These radical envisionings of the body and its desires aside, the concept *cuerpo* (body) also has quite a different resonance through much of the period we are concerned with as a cipher for pure poetry. Valente's later work powerfully uses the body to encode both an insistent sense of loss and an exacerbated joy. The poems of *El fulgor* (Radiance) (1984) are a dialogue with the body, a body which is variously the poet's own (in poem XIV), or the body of words (XXVI), or that of a desired or once desired other (in Poems XIII or IV).[9] In *Al dios del lugar* (To The God of This Place, 1989) "body" signifies the many forms of god, of art, science, and writing. In a poem dedicated to the painter Antoni Tàpies, the "Cuerpo volcado / sobre sombra" (Body thrown / athwart shadow) represents what is written about (a painting) and writing itself (*Material memoria*, A Material Memory, p. 208); poetry is "Línea o modulación, apenas / trazo, tentativa del cuerpo, envite / oscuro / del ángel" (Line or modulation, scarce / trace, the body's attempt, the dark / invitation / from the angel) (*ibid.*, p. 197). The radical beauty of Valente's writing of this period is that "Poetry not only is not communication, it is, before anything else or long before it can aspire to be communication, rather the lack of it" (in the essay "Cómo se pinta un dragón" [How To Paint a Dragon] *ibid*, p. 11). Similarly austere but exciting in his devotion to unknowability and ineffability is Jaime Siles in *Columnae* (poems written between 1982 and 1985) where, in "Palimpsesto," a poem ends in "sones, signos, emblemas / de sí mismos, lenguaje, / negación: el poema" (sounds, signs, emblems / of themselves, language, / negation: the poem).[10] There are a number of collections of the late 1970s and early 1980s in which this more cerebral and minimalist line is followed (for example, the poems of Álvaro Valverde, in García-Posada (ed.), *Nueva poesía*, pp. 194–198). Jorge Guillén's *Cántico*, Mallarmé, Valéry, Ungaretti also have their influence, with both celebratory and vitalist poetry in the manner of Guillén and a more skeptical writing being apparent (*ibid.*, pp. 22–24). Julia Castillo interestingly combines the intellectual and the sensual, a poetics of silence and a form of poetry of experience in *Selva* (Forest, 1983) (reproduced in part in Villena, *Posnovísimos*, pp. 71–72) and in *Tarde* (Afternoon, 1981) there is a commitment of heart and mind to the faithful representation of a "rumor" (a murmur)

which is both natural (the sound of a bee in a silent afternoon) and literary apprehension (the sound of a word forming in the mind and taking flight and form) (*ibid.*, pp. 70–71).

In an interesting counterpoint to the general rumbustiousness of Spanish cultural and social life in this period of change, then, as well as to the intricate and many-charactered neo-realist plots of some of the most successful contemporary Spanish novels, there is a notable strain of poetry of quiet, leisured, if sometimes desperate reflection. The subject – and I mean to begin with poems by men – draws attention to himself in the place of writing particularly to offer a simple point of reference which intensifies by contrast the complexities of ideas and emotions, or which seduces the reader by making him or her envious or in awe of that quiet and serious place. The most noticed voices of the earlier part of this period, the late 1970s, are so furiously outward-looking that it is easy to overlook this meditative strain (as much part of the late-1980s poetry of experience as plain speaking). Thus while Antonio Martínez Sarrión constructs 1970s poems around references to Bob Dylan, Pink Floyd and Mozart, Palm Beach, Salamanca and Mars, *crème de menthe*, blackberry juice, and hemlock (García Moral and Pereda (eds.), *Joven poesía*, pp. 77–92) in the same years Jesús Munárriz, although by no means a closed-in poet, is writing "en defensa de lo que se ha perdido, / de la paz verdadera, del sosiego, / de la palabra limpia . . . y del silencio" (in defense of what is lost, / of true peace, inner calm, / of the clean-cut word . . . of silence) (*ibid.*, p. 101), or nurturing a neo-romantic lyricism as "un perfume tardío / de agua estancada, musgo y hojas secas / llega hasta mi ventana. / el otoño adereza el festín de la muerte" (a belated scent / of stagnant water, moss, dry leaves / reaches my window. / autumn putting the last touches to the feast of death) (*ibid.*, 104).

The sharply elegiac poetry of Francisco Brines, a poet of the Generation of the 1950s who remains enormously influential with younger poets like Felipe Benítez Reyes, is frequently structured around such a place of calm. In "Contra la pérdida del mundo" (Against the Loss of the World) an allegorical moment of intense spirituality and sensuality unfolds in the domestic space: "qué juntos hoy el mundo y yo, / y las sombras piadosas de esta sala / ungiéndome la carne con su aceite" (how close we are today the world and I, / and the merciful shadows in this room / anointing my flesh with their oil); at the end of the poem a lamp is lit on the poet's desk to ward off nothingness and death.[11] Or, in "Madrid, julio 1992," "Vuelve la hora feliz. Y es que no hay nada / sino la luz que cae en la ciudad / antes

de irse la tarde, / el silencio en la casa y, sin pasado / ni tampoco futuro, yo" (The moment of happiness returns. And yet there is nothing / but the light falling on the city / before the evening moves on, / silence in the house and, without past / or future either, me here) (*La última costa*, p. 77).

The trajectory of poet and academic Jenaro Talens reveals some interesting variations on the reflective mode. He moves away, as the 1980s progress, from a highly conceptual and formalized writing influenced in part by French theory, towards low-key and ironic meditations on the relationship of poetry to daily life. A kind of refined matter-of-factness in recounting and a polished ordinariness of situation in Talens underlies an attempt, in which others are engaged also, to demystify poetry and poetic vision. Poet and words are enmeshed in the objective rather than the subjective: as Talens has it, "el aire que azota mi rostro no medita / ni esos rostros que miro son otra cosa diferente de unos rostros que miro" (the wind which stings my face doesn't meditate / nor are those faces I observe anything other than faces I observe) ("Salmo dominical" [Sunday Psalm] in García Moral and Pereda (eds.), *Joven poesía*, pp. 285–287).

Reacting against *culturalismo* and in parallel with certain forms of the poetry of solitude, there is a marked tendency in writing of the mid- to late 1980s to place emphasis on everyday experience, emotion, perception, and intelligibility: the setting is usually urban and contemporary.[12] Such features (albeit familiar from writing in other genres and of earlier periods too) are cornerstones of the new *poesía de la experiencia*. It exploits the elegant matter-of-factness touched upon above, and makes (sometimes problematically old-fashioned) use of easily recognizable meters and stanzaic forms. The Granadine poet Luis García Montero underlines the importance for poetry's survival of "protagonists [who are] not heroes but ordinary people ['personas normales'] representing ordinary people's capacity to feel things."[13] One key strategy of this poetry is a dramatization of the speaking subject so that the *yo* who speaks in the verse, no matter how intimately and directly, is never quite the same as the *yo* who feels the emotion or experiences the events (one much admired and often emulated model here is the poetry of Jaime Gil de Biedma). In Villena's poetry, as part of its *culturalismo*, the speaker is often an exemplary historical or fictional figure. In García Montero, particularly in *Habitaciones separadas* (Separate Rooms, 1994), there is an intriguingly underplayed city-dwelling protagonist who recounts tricky moments in his personal life or muses on the city around him (see the selection in García-Posada (ed.), *Nueva poesía*, pp. 176–182). This figure is

to be found in similar tones and guises in poems by Roger Wolfe and José Mesa Toré (see "Café y cigarillos" [Coffee and Cigarettes] and "Tren de vuelta" [The Last Train Back], *ibid.*, pp. 220, 241–242).

One problem here for many readers – and it arises in relation to the enormously successful anecdotal and wry poetry of Luis Alberto de Cuenca too – is that the ordinary people and ordinary experiences invoked by García Montero look very much like men and men's experiences only, with the roaming access to street and bar, free time, quiet smokes and late night adventures – attractive though they indeed are, and enlivening to the body of poetry – feeling, if not élitist, at least not open to everybody.

Dionisia García's *Diario abierto* (Open Diary, 1990) and *Las palabras lo saben* (Words Know, 1992) (as too some of her earlier poems) offer a domestic and settled, though far from domesticated or restricted, alternative poetry of experience where serene, sad clarity comes onto the page from scenes of washing the dishes, sitting at a table, rummaging in a wardrobe, savoring the quiet when all the family has left the house.[14] In her erotic poetry Ana Rossetti's walks through the city more than reclaim it for women's desires (as in "Chico Wrangler," in García-Posada (ed.), *Nueva poesía*, p. 84), while her later poems of lost love make the four walls of home a place of intense experience where "la soledad tantea, / se desliza por el empapelado" (loneliness feels its way, / creeping across the wallpaper) as police or ambulance sirens "moan" in the streets outside (*ibid.*, p. 57).

Closer to the heart than much poetry of experience written by men is the poetry of Luis Alberto de Cuenca, for all that it is elegant, witty, literary, and formally restrained in its fragmentary chronicling of a sentimental education in modern Madrid. In with *film noir*-like scenarios, classical mythology, and children's stories, a knowledge of streets and underpasses, and a repertoire of old poetic forms, are sudden intense poems of love and self-surrender. Cuenca uses city life and sentiment to mingle the modernizing and the classicizing urges in a new, urbane and cleaner-cut form of the innovatory *culturalismo* which, in productive tension with the temptations of quiet reflection and the pull of experience, has informed these twenty or so years of poetry in Spain.

NOTES

1. Many of the poems discussed are included in three standard anthologies: Concepción García Moral and Rosa María Pereda (eds.), *Joven poesía española. Antología* (Madrid: Cátedra, 1979); Mari Pepa Palomero (ed.), *Poetas de los 70: Antología de la poesía española contemporánea* (Madrid: Hiperión, 1987); Miguel García-Posada (ed.), *La nueva poesía (1975–1992)* (Barcelona: Crítica, 1996).

2. Luis Antonio de Villena (ed.), *Fin de siglo (El sesgo clásico en la última poesía española). Antología* (Madrid: Visor, 1992), pp. 9–34.

3. Luis Antonio de Villena (ed.), *Posnovísimos* (Madrid: Visor, 1986), p. 17.

4. Luis Jiménez Martos (ed.), *Antología general de Adonais (1969–1989)* (Madrid: Ediciones RIALP, 1989), p. 10.

5. Juliá Barella (ed.), *Después de la modernidad: poesía española en sus lenguas literarias* (Barcelona: Anthropos, 1987).

6. For a brief description of significant anthologies see Palomero (ed.), *Poetas,* pp. 11–17; also pp. 451–455 for a chart of anthologized poets in the period 1967–1982.

7. José María Álvarez, *Al sur de Macao (Memorias)* (Valencia: Pre-Textos, 1996), p. 191.

8. José María Álvarez, *Museo de cera* (Madrid: Visor, 1993), 3rd edn., p. 22.

9. José Ángel Valente, *Material memoria (1979–1989)* (Madrid: Alianza, 1992), pp. 162, 174, 161, 152.

10. Jaime Siles, *Poesía 1969–1990* (Madrid: Visor, 1992), p. 189.

11. Francisco Brines, *La última costa* (The Final Shore) (Barcelona: Tusquets, 1995). See also the powerful *El otoño de las rosas* (The Autumn of the Roses) (Seville: Renacimiento, 1987).

12. Jaime Siles, "Ultimísima poesía española escrita en castellano: Rasgos distintivos de un discurso en proceso y ensayo de una posible sistematización," pp. 7–32 in *La poesía nueva en el mundo hispánico* (Madrid: Visor, 1994), p. 16.

13. Pedro Provencio, "Las últimas tendencias de la lírica española," *Cuadernos Hispanoamericanos* 531 (1994), p. 41.

14. Dionisia García, *Tiempos del cantar (Poesía 1976–1993)* (Barcelona: Los Libros de la Frontera, 1995), pp. 267–288.

FOR FURTHER READING

Buenaventura, Ramón (ed.). *Las diosas blancas. Antología de la joven poesía escrita por mujeres.* 2nd edn. Madrid: Hiperión, 1986.

Castellet, José María (ed.). *Nueve novísimos poetas españoles.* Barcelona: Barral, 1970.

Ciplijauskaité, Biruté (ed.). *Novísimos, postnovísimos, clásicos: La poesía de los 80 en España.* Madrid: Orígenes, 1990.

Debicki, Andrew P. "New Poetics, New Works, New Approaches: Recent Spanish Poetry," *Siglo xx / Twentieth Century* 8 (1990/1991), pp. 41–53.

Geist, Anthony. "Poesía, democracia, posmodernidad: España, 1975–1990," pp. 143–150 in José Monleón (ed.). *Del franquismo a la posmodernidad. Cultura española 1975–1990.* Torrejón de Ardoz: Akal, 1995.

Rubio, Fanny and José Luis Falco (eds.). *Poesía española contemporánea (1939–1980).* Madrid: Alhambra, 1981.

Ugalde, Sharon (ed.). *Conversaciones y poemas: la nueva poesía femenina española en castellano.* Madrid: Siglo XXI, 1991.

Villanueva, Darío *et al. Los nuevos nombres: 1975–1990.* Vol. ix of Francisco Rico (ed.). *Historia y crítica de la literatura española.* Barcelona: Editorial Crítica, 1992.

Culture and theater

15

Theater and culture, 1868–1936

The Revolution of 1868 marked the beginning of a cultural process that by 1936 left Spain torn into warring camps. The period that began with revolution and ended in Civil War was punctuated by the short-lived First Republic (1874–1875), the restoration of the Bourbon Monarchy (1875), a disastrous war with the United States (1898), a coup d'etat by General Primo de Rivera (1923) and the proclamation of the Second Republic (1931). No wonder that in 1897 the novelist and playwright Pérez Galdós wrote of living in a time of "confusión evolutiva" (evolving confusion) and underscored the "rapidez con que se transforman ahora nuestros gustos" (the rapidity with which our tastes are now being transformed).[1] What was the role of the theater in such tumultuous times? Poised at the center of social and intellectual life in urban centers and enjoying a popularity that no other art form could rival until the advent of film, the stage served as a point of mediation between tradition and modernity, high culture and mass culture, Spain and the rest of Europe.

In the second half of the nineteenth century, tradition in Spanish theater meant a discourse that enunciated themes as venerable as Calderón: honor, adultery, the clash between spiritual ideals and materialistic ambition, love thwarted by hostile clans, the sanctity of family. The locus of these themes was what Peter Brooks has called the "moral occult" of melodrama, the "domain of operative spiritual values which is both indicated within and masked by the surface of reality."[2] Behind the correct verse and good taste of the *alta comedia* – drawing-room melodramas that survived into the 1870s – powerful forces were clashing, allowing audiences to feel the surge of controversy and polemic that characterized the times. Thus in Adelardo López de Ayala's *Consuelo* (1878) a failed marriage was the pretext to dramatize "the battle between good

and evil, conscience and duty, man and the angels" according to a contemporary critic. At stake was a woman's ambition to rise in the social hierarchy by means of marriage. Choosing a financial speculator over an honorable suitor, Consuelo articulated what has been called "the money culture of the 1870s."[3] Punished for her ambition, Consuelo embodied the clash between an entrenched aristocracy and an ambitious class bent on using money to attain power.

López de Ayala, like other masters of the *alta comedia* (Tomás Rodríguez Rubí, Ventura de la Vega and Manuel Tamayo y Baus), represented contemporary reality as an attack upon sacred institutions – the family, spiritual ideals, Christian orthodoxy – by forces of degeneration whose agents were commonly libertines, financial brokers and the egotistical promoters of positivist materialism. Class mobility made possible by quick financial gain was a special threat. The view was decidedly from within the upper classes, whose privileges and power were defended by means of beautifully crafted moral examples. In plays like *Consuelo* contemporary society was compressed into the closed space of an elegant drawing room. The resulting pressure made of each scene a symbolic battle of values whose tension was intensified by being contained in measured verse and reasonable dialogue.

It took little to increase the pressure in such dramas to the point of explosion – the special *métier* of José de Echegaray, Eugenio Sellès, Leopoldo Cano and Ángel Guimerà, masters of Neo-romantic drama that dominated the upper-class stage in the 1870s and 1880s. Beneath the hyperbole, antithesis and violent stage effects of Echegaray's *El gran Galeoto* (The Gossipmonger, 1881) or Sellès's *El nudo gordiano* (The Gordian Knot, 1878), the conflicts of class and ideology were so magnified that parody was only a step away.[4] Nevertheless, the art of Echegaray and Sellès included criticism of the very class that paid to see itself rendered larger than life on stage. Both of the plays just mentioned indicted the audience, whose cynicism became the force that drove the young lovers to adultery in *Galeoto,* and whose false idealism prevented the divorce that would "cut the Gordian knot" in Sellès's drama.

Under the sway of naturalism, some playwrights wished to equate the forces clashing on stage with specific social and political issues posed by modernization. As Galdós noted, playgoers once content with symbolic renderings of society's problems now demanded a "reproducción de la vida" (reproduction of life) on stage.[5] In this context, Joaquín Dicenta's *Juan José* (1895) represented both a warning and a compromise. A play that

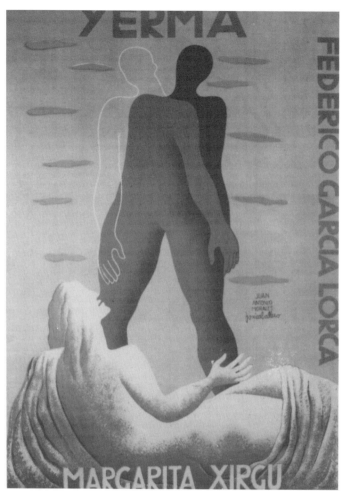

9. Poster for García Lorca's *Yerma*

became emblematic of socialist ideology – later it was performed on May Day throughout Spain – its tavern setting and popular language laid bare the injustice felt by working-class Spaniards during the Restoration. Its dramatic structure, however, conformed to the melodramatic code that located tension in sentiment rather than in class conflict. Evoking the play's première, José Deleito y Piñuela wrote that *Juan José* impressed all sectors of public opinion, being as popular with "illiterates" as with Madrid's learned classes.[6]

The reformist plays of Enrique Gaspar and Benito Pérez Galdós

responded more forcefully to this shift in taste. Praised by the lucid Catalan critic José Yxart[7] for their realism, works like Gaspar's *Las personas decentes* (Decent People, 1890) brought an Ibsenian spirit of observation and analysis to the Spanish stage. Thus the "decent people" evoked by Gaspar were criticized for leading lives in which decency all too often masked acts of infamy. Similarly, the "reality" announced in the title of Galdós's *Realidad* (1892) was that Spanish husbands, when confronted with an adulterous wife, pardoned more often than they murdered the offending spouse. Yxart readily identified the source of this theatrical mode in France and spoke of its underlying incompatibility with the rules of decorum in Spanish society (*Arte escénico*, p. 146). As the stage edged toward a frank depiction of manners *(verismo),* it was thus caught in the crossfire between Spanish nationalists and "Europeanists": realism on the stage was suspect because of its foreign origins. Not until the 1920s, when Valle-Inclán turned to Fernando de Rojas, Goya and the picaresque in creating his satiric farces was this issue put to rest.

Challenging the high drama of the élite theaters, a form of low comedy arose in the decade of the 1870s and came to dominate the commercial stage until the First World War: the *género chico* – one-act plays based on lower-class urban life – found an avid audience in the urban masses who flocked to theaters to see farces in one-hour sessions. The invention of hourly sessions brought the price of entertainment down while it created a market for short plays. Thus arose a theatrical industry whose dynamism drove the stage for half a century. In the 1870s Madrid had seventeen theaters devoted to hourly sessions, and in 1909, 377 of 411 plays premièred in the capital were of the one-act variety.

The essence of the *género chico* was the *sainete,* a colorful depiction of working-class types whose dress, language, and trades became emblems of Restoration Madrid. The formulaic depiction of these stock characters – laborers, street vendors, housewives, tavern owners, etc. – shifted interest from plot and moral conflict to brilliant word play and festive music which often accompanied the action. Masterpieces of the genre include *La verbena de la Paloma* (The Paloma Summer Festival, 1894) by Tomás Bretón (libretto by Ricardo de la Vega) and *La revoltosa* (The Prankster, 1897) by Ruperto Chapí (libretto by J. López Silva and Carlos Fernández Shaw). Miguel de Unamuno denounced the genre in 1896 for its falsification of genuinely popular culture[8] – he saw the beginnings of mass entertainment and despised it – a view shared by Serge Salaün who detects a "cultural pact" in the genial depiction of the lower classes by

bourgeois playwrights.[9] Humor, music, and sentimentalism combined, he argues, to further an ideology that favored militarism, patriotic nationalism, standard gender roles, and uncritical common sense. The *sainetes* of Enrique García Álvarez, Carlos Arniches and the Álvarez Quintero brothers provide examples of fictional worlds that hid Spain's pressing problems beneath a seductive, festive mask.

The dynamism of this festive theater produced, nevertheless, a number of forms that today convey a sense of Spain's ambiguous response to modernization. The multiple session format allowed for programs to evolve rapidly as conditions and tastes changed. Thus, political reviews found a place on the bill as did parodies of high drama during the Restoration. Silent films were incorporated by 1905, European operettas were adapted after 1908, and erotic music-hall performances – the so-called *género ínfimo* – also found a niche. In the 1920s a lavish form of musical review (based on Parisian models) became the center-piece of commercial theater, competing successfully with the often nationalistic musical comedy known as *zarzuela*. In short, festive performance mediated between a nostalgic reprise of traditional Spain and the modern forms of entertainment that gained mass appeal throughout Europe after the turn of the century. Thus, in the 1920s it was common for stock characters from the traditional *sainete* to be whisked off to foreign capitals in elaborately staged fantasies that dazzled with techniques imported from Paris, as in *Todo el año es carnaval o Momo es un carcamal* (Carnival All Year, or Momo is a Decrepit Bum, 1927) by Joaquín Vela and Ramón Moreno, with music by Ernesto Rosillo.

To Jacinto Benavente belonged the distinction of forging a new theatrical language suited to the passage from one century to another. Denounced by Pérez de Ayala as "justamente lo antiteatral, lo opuesto al arte dramatico" (anti-theatrical, the very opposite of dramatic art),[10] Benavente's plays from the 1890s systematically deconstructed the stage language of melodrama, substituting irony for passion, witty conversation for verse and a Nietzschean disdain of society for benighted wishes to reform it. One critic claimed that Benavente was perfectly suited to understand everything, "porque no cree en nada" (because he believes in nothing).[11] Credited with bringing about "la más grande revolución dramática que han conocido nuestras letras" (the greatest dramatic revolution in Spanish letters),[12] the author of *Los intereses creados* (The Bonds of Interest, 1907) and *Señora ama* (Mrs. Landlady, 1908) set a standard of theater that only García Lorca, in the 1930s, was able to match: his

plays enjoyed both commercial success and literary acclaim by contemporary critics.

Benavente's sardonic dissection of Spain's upper classes in works like *La comida de las fieras* (The Dinner of the Beasts, 1897) was in keeping with the critical mood that surrounded the disastrous war with the United States in 1898. The post-war crisis intensified attacks on traditional institutions, and the stage was not exempt. Socialists and anarchists were quick to call for plays that would deal with workers' concerns, and for a time authors like Ignasi Iglesias, Felip Cortiella and José Fola Igurbide found an audience for plays, in Catalan or Spanish, whose aim was to make of the stage a window upon social reality. As in *Joventut* (Youth, 1901) by Iglesias, the existence of two separate societies – workers and their bourgeois employers – was commonly dramatized through a "natural" couple spanning class divisions whose marriage society would not tolerate. In Ángel Guimerà's *Terra baixa* (Lowlands, 1897) the injustice inherent in this social and economic system was denounced when a shepherd kills an oligarchic "wolf" who preys upon his wife. Less metaphoric were plays like Jaime Firmat Noguera's *Gente de fábrica* (People from the Factory, 1914) that celebrated the dignity of work and the proletariat's spirit of comradeship while protesting its victimization by corrupt factory managers.

The soul searching that followed the war of 1898 also prompted a resurgence of nationalist feeling given expression in verse plays upon historical themes set in Spain's imperial age. Termed "poetic theater" at the time, plays like Valle-Inclán's *Cuento de abril* (April Story, 1909) and Eduardo Marquina's *En Flandes se ha puesto el sol* (The Sun Has Set in Flanders, 1910) provided a panorama in which the topics of national decadence and regeneration were taken up in rich, *modernista* verse. In this lyrical current Jesús Rubio Jiménez discerns a turning away from realism in an avatar of symbolist aesthetics that would lead to avant-garde experiments with spectacle in the 1920s.[13] Not to be discounted is the possibility that the return to national models (Lope, Calderón, Zorrilla, etc.) was a response to France's cultural hegemony during the Restoration. Salaün reminds us, however, that Spanish playwrights did not simply imitate foreign authors and staging methods but adapted them with "extrema flexibilidad y receptividad" (extreme flexibility and receptivity) to their own purposes.[14]

By 1924, two years after Benavente was awarded the Nobel Prize, his "manner" was beginning to seem outdated, and not by chance there arose a consensus that Spain's theater had entered a period of crisis. Voices on

all sides demanded reform and accused playwrights and impresarios of betraying the theater's social and/or artistic mission by turning it into a venal – and boring – industry.[15] Jacinto Grau's *El señor de Pigmalión* (Mr. Pigmalion, 1921) exemplified the issue: its prologue was a bitter attack upon "industrialized theater" while its late première in Madrid (1928) followed upon productions abroad in ambients more receptive to avant-garde experiments. The play dramatizes the rebellion of fictional characters against their creator, and carries echoes of Pirandello's *Six Characters in Search of an Author*, written the same year. A series of articles on "El trascendental problema del teatro" (The Transcendental Problem of the Theater) by Ricardo Baeza appeared in the Madrid daily *El Sol* from 19 October 1926 to 22 January 1927 and called for state intervention to halt the theater's deterioration. While awaiting a new Benavente who could alter stage conventions to mirror the new visage of Spain, the country's intellectual élite thus experimented with fresh forms while waging a campaign to revitalize the stage – a pattern that recalls the self-criticism of bourgeois art that typified the avant-garde according to Peter Bürger.[16] For its part, the commercial stage dramatized – and exhibited – the impact upon traditional culture by such novelties as bobbed hair, short skirts, Freudian ideas, and silent films.

The years between the First World War and the outbreak of civil war in 1936 saw a number of attempts to modernize the Spanish stage in response to the obvious disparity between pre-war stage conventions and post-war social conditions. One route lay in adapting innovations developed abroad – "Pirandellism," surrealism, Piscator's "political theater" – and, indeed, the Spanish stage opened itself enthusiastically to foreign influences: Lenormand, Pirandello, Kaiser, O'Neill, Cocteau, Andreev and others were staged in both art circles and on the commercial stage. Foreign companies – the Pitoeffs for example – brought modern European texts and lighting effects to Madrid and Barcelona while inexpensive weekly collections sold in kiosks (*La Farsa, El Teatro Moderno, La Novela Teatral*) and journals like the *Revista de Occidente* made translations available. As a result, the European stage became increasingly the point of reference for critics. For the same reason, an innovative director like Cipriano de Rivas Cherif, following in the footsteps of Adrià Gual, suddenly had room to work: his collaboration with the talented actress Margarita Xirgu in Madrid's Teatro Español between 1931 and 1935 marks a high point in repertory, new staging techniques and acting.

In this context of experimentation, the plays of Ramón del Valle-

Inclán found an avid albeit select readership. Though never performed during his lifetime, his *esperpentos* were praised as native examples of avant-garde theater with clear links to expressionism. Valle-Inclán said repeatedly that Goya invented the *esperpento,* but in *Luces de bohemia* (Bohemian Lights, 1920/1924) the blind poet Max Estrella supplied a definition that invoked tragedy as well as grotesque distortion: "The tragic sense of Spanish life can best be rendered by an aesthetic of systematic deformation . . . My current aesthetic consists of transforming classical norms with the mathematical exactness of a concave mirror." Likewise, Unamuno's bare dialogues on the tortured divisions within the modern self, as in *El otro* (The Other, 1926), harkened back to Calderón's *autos sacramentales* while simultaneously echoing Pirandello's favorite themes. Both authors thus joined opportunely Spain's tradition with Europe's theatrical avant-garde.

The commercial stage had its own idea of renewal. The stakes were high, for film and other popular forms of entertainment were attracting audiences that before had filled the theaters. In the early 1920s the appeal of the stage was still paramount: in Madrid, an average of 200 plays were premièred each season, with more than 1,000 performances per month distributed between twenty-odd theaters.[17] Nevertheless, beginning in 1923 attendance began to diminish, theaters closed or were converted to cinemas, and appeals to the government for relief went unheeded. The consequence was an adjustment in the repertory: serious comedy and drama were pushed to the margin as musical spectacles, the cabaret and the *cuplé* (popular music-hall songs) choreographed according to Parisian models found a powerful audience in the urban *petite bourgeoisie.* This was the audience that paid to see Mademoiselle Wiard and her "artistic nudes" in Madrid's El Lido cabaret and eagerly attended erotic revues like *Noche loca* (Crazy Night) by Joaquín Vela and José Campúa, with music by Francisco Alonso, a "modern revue in the French style" that triumphed in 1927. It also provided Pedro Muñoz Seca and his collaborator Pedro Pérez Fernández with hit after hit, season after season, to the disgust of serious critics. It was this audience that Valle-Inclán scorned and that García Lorca determined to educate once he had gained sufficient authority to command its respect.

Mass entertainment thus invaded the stage in the 1920s, bringing with it a feverish display of modernity's dazzling, external signs. Occasionally the currents of high and low theater fused, offering a brilliant mix of tradition and modernity – José Martínez Ruiz caught such a moment in *Old Spain* (1926) – but most often they followed parallel

courses. Nevertheless, the points at which the old and the new mingled on stage best defined the direction Spain's theater was taking when civil war broke out in the summer of 1936.

The most important point of convergence involved forms that emphasized the grotesque, a code whose presence in popular farce and German expressionism did not go unnoticed. Two commercially successful playwrights, Carlos Arniches and Pedro Muñoz Seca, developed subgenres that emphasized extreme distortion of plot and language: the *farsa trágica*, in which Arniches captured the Spaniards' "despicable callousness toward love, justice, moral beauty and the elevation of the spirit" (Pérez de Ayala, *Las máscaras*, I, p. 33), and the spasmodic *astrakán*, Muñoz Seca's caricature of a theatrical caricature[18] in which he exaggerated the conventions of the immensely popular *juguete cómico*, a comic genre that joined Spanish farce and French vaudeville. Meanwhile, Valle-Inclán developed a grotesque form of tragedy he dubbed the *esperpento* (based, as seen above, on "systematic deformation"), and García Lorca experimented with violent burlesque in avant-garde farces like *Amor de don Perlimplín con Belisa en su jardín* (Don Perlimplín's Love of Belisa in Her Garden, 1933). Common to these forms was a flight from stage realism toward distortions that expressed a grotesque vision of society. Like Pirandello, Ghelderode and Kaiser, Spanish playwrights found in the grotesque a language ideally suited to convey the horror lurking behind modernity's cult of progress.

A second convergence may be seen in playwrights who achieved box-office "hits" with texts praised for their literary merits. García Lorca proved that poetry and tragedy need not preclude popular appeal in *Bodas de sangre* (Blood Wedding, 1933), his first commercial triumph. In this light, García Lorca may be seen as Benavente's heir and successor: *Bodas de sangre* could not help but remind critics of Benavente's *La malquerida* (The Illbeloved, 1913). Both plays followed the conventions of the rural drama,[19] but more significantly, both raised the level of theatrical discourse to literary heights while returning sizeable profits. Other playwrights and directors provided evidence that commerce and sophisticated art could mingle: Gregorio Martínez Sierra's "Art Theater" in the Teatro Eslava (1917–1925) introduced modern staging techniques to bourgeois audiences who paid to see lavish productions of Shakespeare, Ibsen and Shaw; Ricardo Baeza took his reformist ideals on tour with Irene López Heredia's company, whose repertory was decidedly modern and European; and the youthful Valentín Andrés Álvarez found financial success in *¡Tararí!* (1929), a comic farce acclaimed as avant-garde by the critics.

A third tendency that joined popular and refined tastes was the development, under the Second Republic, of a National Theater whose goals included the spread of culture to remote areas devoid of modern notions and conveniences. In 1931 the Ministry of Education created the Misiones Pedagógicas, a project that included a Teatro del Pueblo (Theater of the People) directed by Alejandro Casona and a puppet troupe organized by Rafael Dieste. A year later García Lorca and Eduardo Ugarte founded a company composed of university students, La Barraca, which with state funding took classic Spanish plays to towns in rural areas. Inspired by socialist ideology, these experiments wedded popular with literary culture while they circumvented urban-based forms of modern mass entertainment.

The course of Spanish theater from the Revolution of 1868 to the outbreak of civil war in 1936 was thus fed by a variety of competing currents. Enduring national traditions, foreign imports, true popular forms, political melodramas, avant-garde experiments, small art theaters, modern hybrids that appealed to the urban masses – all found a place in the rich theatrical life of the period. The very success of the commercial theater often seemed an impediment to its renewal, but, on the whole, Spain's singularly syncretic stage served as a faithful mirror of the country's struggle with modernization and with itself. Ingeniously adept at combining foreign with national forms, Spanish playwrights entertained their audiences, at times abjectly, but also showed how cruel, grotesque, and absurd their countrymen appeared when put on stage. Rarely has the theater been so richly involved with a society that paid dearly to see itself both praised and reviled.

NOTES

1. Benito Pérez Galdós, "La sociedad presente como material novelable," *Discursos leídos ante la Real Academia Española* (Madrid: Tip. de la Viuda e Hijos de Tello, 1897), p. 13.
2. Peter Brooks, *The Melodramatic Imagination* (New York: Columbia University Press, 1985), p. 5.
3. See David T. Gies, *The Theatre in Nineteenth-century Spain* (Cambridge: Cambridge University Press, 1994), p. 255.
4. Indeed, both plays inspired parodies, *Galeotito* by Francisco Flores García and *El nudo corredizo* by Enrique González Bedma. See Gies, *The Theatre*, pp. 335–336.
5. Benito Pérez Galdós, *Nuestro teatro*. Alberto Ghiraldo (ed.) (Madrid: Renacimiento, 1923), p. 158.
6. José Deleito y Piñuela, *Estampas del Madrid teatral fin de siglo* (Madrid: Editorial Saturnino Calleja, 1946), p. 209.
7. José Yxart, *El arte escénico en España* (Barcelona: Imprenta de la Vanguardia, 1894).

8. Miguel de Unamuno, "La regeneración del teatro español," in *Obras completas*, vol. I (Madrid: Escelicer, 1966).

9. Serge Salaün, "El 'género chico' o los mecanismos de un pacto cultural," pp. 251–261 in Equipo de Investigación sobre el Teatro Español (eds.), *El teatro menor en España a partir del siglo XVI* (Madrid: CSIC, 1983).

10. Ramón Pérez de Ayala, *Las máscaras* (Madrid: Editorial Saturnino Calleja, 1919), vol. I, p. 154.

11. Manuel Bueno, *Teatro español contemporáneo* (Madrid: Biblioteca Renacimiento, 1909), p. 130.

12. Manuel Machado, *Un año de teatro* (Madrid: Biblioteca Nueva, 1917), p. 85.

13. Jesús Rubio Jiménez, *El teatro poético en España. Del modernismo a las vanguardias* (Murcia: Universidad de Murcia, 1993), pp. 36–57.

14. Serge Salaün, "Las *Comedias bárbaras*. Teatralidad utópica y necesaria," pp. 21–41 in Jean-Marie Lavaud (ed.), *Lire Valle-Inclán. Les Comédies barbares* (Dijon: Université de Bourgogne, 1996), p. 26.

15. Dru Dougherty, "Talía convulsa: La crisis teatral de los años veinte," pp. 85–157 in *Dos ensayos sobre teatro español de los veinte* (Universidad de Murcia, 1984).

16. Peter Bürger, *Theory of the Avant-garde*. Trans. Michael Shaw (Minneapolis, MN: University of Minnesota Press, 1984), pp. 20–27.

17. Dru Dougherty and María Francisca Vilches, *La escena madrileña entre 1918 y 1926: análisis y documentación* (Madrid: Fundamentos, 1990), pp. 13–22, 141–144.

18. Francisco Ruiz Ramón, *Historia del teatro español. Siglo XX* (4th edn., Madrid: Cátedra, 1980), p. 58.

19. Valle-Inclán's *Divinas palabras* also reworked the subgenre and was finally staged in 1933 with little success. The interest shown in the rural drama by these and other outstanding European playwrights (notably Synge and D'Annunzio) is a reminder that European society was still predominantly rural well into the 1930s.

FOR FURTHER READING

Cansinos-Assens, Rafael. "Un concepto de teatro." *Los temas literarios y su interpretación*. Madrid: Editorial Palomeque, n.d.

Espín Templado, María Pilar. *El teatro por horas en Madrid (1870–1910)*. Madrid: CSIC, 1995.

Fernández Cifuentes, Luis. *García Lorca y el teatro: La norma y la diferencia*. Zaragoza: Universidad de Zaragoza, 1986.

Fuentes, Víctor. "Por un teatro nacional-popular," in *La marcha al pueblo en las letras españolas, 1917–1936*. Madrid: Ediciones de la Torre, 1980, pp. 119–144.

Lyon, John. *The Theatre of Valle-Inclán*. Cambridge: Cambridge University Press, 1983.

Nieva de la Paz, Pilar. *Autoras dramáticas españolas entre 1918 y 1936*. Madrid: CSIC, 1993.

Pérez Minik, Domingo. *Debates sobre el teatro español contemporáneo*. Santa Cruz de Tenerife: Goya Ediciones, 1953.

Rubio Jiménez, Jesús. *Ideología y teatro en España: 1890–1900*. Zaragoza: Libros Pórtico/Universidad de Zaragoza, 1982.

Santos Deulofeu, Elena. "Fafner o la ópera en Madrid de 1918 a 1925," in Dru Dougherty and María Francisca Vilches (eds.), *El teatro en España entre la tradición y la vanguardia*. Madrid: CSIC/Fundación García Lorca/Tabacalera, SA, 1992, pp. 53–65.

16

Theater and culture, 1936–1996

Theater is more than a literary genre. The written dramatic text might be viewed in parallel with narrative or poetry, but theater encompasses performance and the practical considerations of bringing that performance to an audience. Theater is also potentially more subversive than literary works intended to be read in private; thus it has frequently been subject to greater suspicion, censorship, and repression. On the other hand, theater may be more directly open to international currents; acting companies may tour abroad, and works staged at home may come from other nations and periods. The study that follows is not limited to playwrights but rather examines various facets of stage history in post-war Spain.

The Spanish Civil War is considered a point of rupture in national culture. In the case of theater, Spain lost hundreds of playwrights, directors, and actors through death or exile: García Lorca was assassinated in the early weeks of the war; Alejandro Casona wrote most of his major plays in Argentina; Cipriano de Rivas Cherif headed an acting company in Mexico; Margarita Xirgu directed theaters and acting schools in Argentina, Chile, and Uruguay. As the victorious Francoists established their national theater, suspect dramatic texts, too, were banished: the works of García Lorca, Ramón María del Valle-Inclán, and others disappeared for decades. Still, the rupture was by no means total. As César Oliva explains, prior to 12 April 1939, there was leftist theater, rightist theater, and a wide area in between without overt political bias; with the war's end, only rightist theater was allowed, but there was no decline in theatrical activity.[1]

The forms that activity took in the early post-war years were predictable. Pervasive attitudes toward art in all post-revolutionary periods are

the "rejection of complexity, the desire to create exemplary myths, censorship, and . . . a fear of art's capacity to subvert."[2] Even without official censorship, play selection would have been guided by audience preference for light entertainment. As Spaniards tried to forget the war's devastation, they flocked to musical revues and to revivals of comedies by Pedro Muñoz Seca or Serafín and Joaquín Álvarez Quintero. At least some spectators, and certainly the regime in power, likewise sought a reaffirmation of Spanish history and values. Francoist historiography is shaped by national myth. Accordingly, the stage turned to plays by Eduardo Marquina and José María Pemán that exalted the grandeur of Spain's past and an essentialist notion of the nation's Castilian and Catholic identity. One may deplore the intellectual content of works staged through the mid-1940s, but one should not be surprised by it.

In the initial flurry of activity, the Teatro Español and the María Guerrero in Madrid were converted into national theaters; these showcases eventually made the artistic director the central force on the Spanish stage. The national playhouses featured Shakespeare, seventeenth-century Spanish Golden Age drama, and other prestigious texts that were considered above reproach. Works like Lope de Vega's politically charged *Fuenteovejuna* (1619) and Sophocles's classical *Antigone* could invite radical stagings that foregrounded their revolutionary potential; in the early Francoist period, they were mounted conventionally. During his 1942–1952 term at the helm of the Teatro Español, Cayetano Luca de Tena directed fifty-four large-cast productions, including thirty-four classical works. Although his stagings of Shakespeare have been praised for their psychological depth,[3] Oliva points out that with so many productions and so little time for rehearsal, the classics had to be handled as "museum pieces" (*El teatro*, p. 77).

Many new Spanish plays of the 1940s were also less than innovative. Jacinto Benavente, who readily made peace with the victors, premièred thirty formulaic bourgeois comedies of manners. The decade was dominated as well by the improbable but immensely popular melodramas of the prolific Adolfo Torrado. Benavente's early masterpieces are still revived in Spain and abroad; Torrado's works vanished even before his death in 1958. Over time, theater criticism became polarized and liberal commentators began to reject rightist theater in favor of socially committed works. These liberals adopted the adjective *benaventino* to describe well-made plays that end with scenes of reconciliation, and they labeled "escapist" much of the theater of the 1940s and 1950s. When Casona

returned from exile in the early 1960s, they declared that his plays, too, were "escapist," and added *casoniano* to the list of negative qualifiers. Audiences in Spain and abroad, however, enthusiastically applauded Casona's poeticized portrayal of death in *La dama del alba* (The Lady of the Dawn, 1944) and his idealistic representation of theatricalized life in *Los árboles mueren de pie* (Trees Die Standing, 1949).

According to George Szanto, all theater is implicitly political and may be divided into three categories of propaganda: agitation, integration, and dialectical propaganda. During a period of crisis, agitation propaganda is common in the arts.[4] Hollywood movies during the Second World War urged support of the American cause against the dreaded enemy; similarly, both sides during the Spanish Civil War made use of agitprop. But when José Monleón writes of *Treinta años de teatro de la derecha* (Thirty Years of Theater on the Right), he is not describing thirty years of pro-Franco theater.[5] Rightist theater in post-war Spain, like most plays of wide appeal anywhere, was essentially integration propaganda: works that, by neither advocating change nor questioning the social circumstance, tend to reinforce the status quo. Agitprop urges the spectator to take action. Dialectical propaganda, by revealing perspectives that might previously have been invisible, urges the spectator to think. The Franco-era catchphrase, "No pasa nada" (nothing's happening), captures well the essence of integration propaganda, which leaves the spectator satisfied that there are no pending problems. Because theater is polycentric and polysemous, however, plays that are innocuous entertainment for some viewers may prove thought-provoking to others; the line between integration and dialectical propaganda may blur.

A major and enduring current of new theater in the first decades after the war was metatheatrical comedy. Enrique Jardiel Poncela and Miguel Mihura invented outlandish, imaginative plots and dialogue that anticipated the theater of the absurd. Jardiel's *Eloisa está debajo de un almendro* (Eloise is under an Almond Tree, 1940) and Mihura's *Tres sombreros de copa* (Three Top Hats, written 1932; staged 1952) have become part of Spanish repertory. Although these playwrights initially received rave reviews, their later works evoked strong criticism, on a par with that leveled at Víctor Ruiz Iriarte and José López Rubio, whose comedies, reminiscent of Pirandello, Evreinov, and Anouilh, in Spain were considered the epitome of escapist fare. Their mild satires of theatricalized life made no direct references to the socio-historical context and, following a longstanding

tendency of Spanish comedy, tended to reinforce traditional moral values. On the other hand, these post-war comedies did reveal the ideology of the moment by mirroring their middle-class audiences; spectators, who like the characters within the dramatic world, wished to substitute fantasy for harsh truth. López Rubio's *Celos del aire* (In August We Play the Pyrenees, 1950) may be seen as a clever metatheatrical farce that ends in a scene of marital reconciliation, or, alternatively, as a subtle indictment of prevalent hypocrisy.

Integration propaganda is by no means limited to escapist comedy. *La muralla* (The Wall, 1954), by Joaquín Calvo Sotelo, is the prototype of a dominant trend from the 1950s and 1960s: psychological dramas of moralistic bent, ranging in their staging from conventional realism to the imaginative use of time or expressionistic techniques associated with Miller. The enormously popular *La muralla* dealt openly with the Civil War and even admitted that victors had committed crimes, yet it is not explicitly political theater. After considering several endings, Calvo Sotelo chose one that allowed the guilt-ridden protagonist to confess before dying, thus guaranteeing his spiritual salvation, while yet allowing his self-serving family to keep the wealth that he had wrongfully acquired. The victim never appears on stage and may easily be forgotten by spectators who are satisfied by the closed ending.

Socially committed theater that would serve as a dialectical antidote to rightist integration propaganda erupted on the post-war stage with *Historia de una escalera* (Story of a Stairway, 1949), by Antonio Buero Vallejo. In representing the lives of three generations of working-class families trapped in the same wretched situation, Buero led the way for authors of social protest. In the early 1950s, Alfonso Sastre, José Martín Recuerda, José María Rodríguez Méndez, and Lauro Olmo, reflecting as well the influence of Italian neo-realist cinema, began to probe contemporary problems. *Historia de una escalera* announced the rebirth of Spanish theater; this first production of Buero Vallejo, contemporary Spain's foremost proponent of tragedy, is considered the theatrical counterpart to Cela's *La familia de Pascual Duarte*.

With *Un soñador para un pueblo* (A Dreamer for a People, 1958), Buero led the way for politically committed historical drama that subverted official historiography. In the same Hegelian and Marxist vein as Brecht's *Mother Courage* and Miller's *The Crucible,* Buero revealed "the continuity of an ongoing historical process that culminates in the spectators' own epoch."[6] Buero's masterpiece, *El sueño de la razón* (The Sleep

of Reason, 1970), focuses on the conflict between an aging, liberal Goya and a despotic Fernando VII, but Franco-era spectators, who had developed a keen ability to read subtexts, readily understood that the nineteenth-century repression depicted on stage was repeated in their real world. *El sueño de la razón* also epitomizes Buero Vallejo's original approach to psychological expressionism, a technique equivalent to stream-of-consciousness in the novel which forces spectators to enter the protagonist's mind. The elderly painter is deaf; when Goya is on stage, the only sounds, besides his speaking voice, are those of his imagination. The metaphorical potential in historical drama allowed playwrights to outwit Franco-era censors, but interest in history plays has not waned under democracy; its many practitioners include the realists cited above, Antonio Gala, Jaime Salom, Domingo Miras, and others. Although both historical and explicitly political drama are generally absent from mainstream American theater, they remain central to the Spanish stage. Central, too, is psychological expressionism and other strategies that require spectators to use their imagination and thereby enter the dramatic world. By contrast, the dominant realistic/naturalistic mode of the American stage allows spectators to remain relatively passive.

Official censorship in post-war Spain was closely allied with the Catholic Church and thus upheld moral values and prohibited references to such subjects as abortion, homosexuality, and divorce. It precluded advocating Marxism or criticizing either the Franco regime or Francoist historiography. Censorship varied over time, however, and there was a major relaxing of standards in the early 1960s. Unthinkable in the previous decades were landmark works like Olmo's *La camisa* (The Shirt, 1962), which foregrounded the economic plight of shanty town dwellers; Gala's *Los verdes campos del Edén* (The Green Fields of Eden, 1963), a poetic vision of the homeless, juxtaposed with biting caricatures of those in power; and Martín Recuerda's *Las salvajes en Puente San Gil* (The Savages in Puente San Gil, 1963), a revelation of the morally depraved, seamy underside of provincial respectability and sexual repression. Gala's play premièred at the María Guerrero under the direction of José Luis Alonso. Martín Recuerda's play proved that censorship had, in fact, eased more rapidly for theater than for cinema; its popular film version, starring Adolfo Marsillach, softened his criticism and superimposed a typical romance with happy ending.

Official censorship was not to be abolished for another fifteen years,

and at times it was applied with rigor. Its continued existence does not necessarily mean that all playwrights avoided difficult subjects or wrote inferior works. Metaphorical dramas may transcend their socio-historical context while direct political reference may soon become dated. Buero's *El sueño de la razón* has been well received in several European countries and the United States despite the loss of a subtext relating to Francoist repression.

Even without censorship, commercial theater responds to audience interests. Middle-class American playgoers prefer musical comedies and light entertainment; serious drama is the exception on Broadway. Observers in post-war Spain identified four distinct, but overlapping audiences: a large, middle-class audience that favored comedies; a more select, but still bourgeois audience that supported such works of serious intent as Buero's tragedies and Gala's tragicomedies; an intellectual minority that supported experimental groups; and a popular audience that favored musical revues. Anyone who thought that freedom of expression in democratic Spain would eliminate this pattern was disappointed. Box-office pressure continues to divert innovative authors to the path of formulaic bourgeois comedy. In the 1960s and 1970s, the dominant playwright was the prolific Alfonso Paso. The equally prolific Juan José Alonso Millán holds sway in the 1980s and 1990s, as author, director, and impresario. For the period 1982–1994, among Spanish authors Alonso Millán headed the Madrid billboard for number of performances (4,740), attendance (847,194) and box office receipts (817,778,028 *pesetas*); with twenty productions, he was second only to García Lorca (with twenty-five).

In the early 1970s, two of the most successful serious playwrights of the Spanish stage were Gala and Ana Diosdado. Gala typically writes metaphorical tragicomedies; despite sparkling surface humor, his protagonists are usually disillusioned in their search for freedom and love. *Los buenos días perdidos* (The Bells of Orleans, 1972), like much of Diosdado's theater as well, criticizes contemporary consumer society. His *Anillos para una dama* (Rings for a Lady, 1973) is a feminist debunking of the patriarchal Cid myth. With *Olvida los tambores* (Forget the Drums, 1970) and *Usted también podrá disfrutar de ella* (Yours for the Asking, 1973), Diosdado emerged as the major woman playwright of the post-war period. Her theater is marked by impeccable craftsmanship and a desire to break down the divisive us/them mentality. Into the 1990s, Gala and Diosdado continue among the most staged Spanish playwrights.

Ostensibly as a complement to the commercial stage, in the late 1940s the Franco regime created the Teatro de Cámara y Ensayo, an experimental, chamber theater. Its function was to bring to an interested audience avant-garde works that, because of "theme, high cost, or other difficulties" were not suitable for mainstream theaters.[7] With no playhouses of their own, the experimental groups used official theaters. They received financial assistance but worked under severe regulations: no ticket sales and perhaps only one performance. Along with university student theaters, they served as an escape valve for stage censorship; but even if their audiences were restricted and the danger they implied thus limited, they were still subject to oversight. Alfonso Sastre's existentialist *Escuadra hacia la muerte* (The Condemned Squad, 1953) was closed by the censors after the third performance because of its perceived antimilitarism. Valle-Inclán's *Los cuernos de don Friolera* (Don Friolera's Horns, 1925) was performed in 1958 by the Teatro Universitario de Madrid, under the direction of Alonso Millán; believing the satire would be less offensive to military honor with the horns removed, the censor shortened the title to *Don Friolera*. The culminating event in Teatro de Cámara history was the enormously influential staging in 1968 of Peter Weiss's *Marat-Sade*, whose innovative stage techniques and shocking content marked a new moment in contemporary theatrical history. Directed by Marsillach, who also headed the talented cast, it was limited to three nights but nevertheless figures among the most memorable productions of contemporary Spanish stage history.

A major factor in the renovation of the post-war stage was the gradual introduction of controversial foreign authors. Sastre, Paso, and others involved in experimental theater in the late 1940s proposed a Theater of Social Protest that would include works by such writers as Miller, Sartre, and Brecht. Oliva reports that by 1953 Miller and other Anglo-American playwrights were being produced even in provincial centers (*El teatro*, p. 79). French Boulevard comedies were freely staged on the commercial stage, but the French playwrights who were to have a significant impact on Spanish authors – Anouilh, Camus, Ionesco, Beckett, Sartre, and Genet – were initially restricted to the Teatro Nacional de Cámara y Ensayo. Sartre, considered atheist and communist, was banned until 1967, two years after the curtain of silence was lifted on Brecht. The fact that Brecht's plays were prohibited did not mean they were unknown. Not only were the German originals and Argentine and French translations widely read in theater circles in

Spain, but in the 1950s some Spanish theater people traveled abroad to see the Berliner Ensemble perform.

The easing of censorship in the early 1960s allowed the return to mainstream theater of works by García Lorca and Valle-Inclán, along with key foreign plays. Directors of stature like Alonso, who headed the María Guerrero 1962–1974; José Tamayo, who established the Bellas Artes theater in Madrid in 1961; and Ricard Salvat, who founded the Adria Gual School of Dramatic Art in Barcelona in 1960, lent their prestige to the endeavor. At the end of the decade, Argentine–French director Víctor García and Catalan actress Nuria Espert combined their talents to create a series of brilliantly daring productions of Genet's *Las criadas* (The Maids), García Lorca's *Yerma* and Valle-Inclán's *Divinas palabras* (Divine Words) that toured internationally for years. Three other, interconnected efforts at revitalization also date from the 1960s: underground drama, theater festivals, and the independent theater movement.

Underground drama was the name given by George Wellwarth to a group of anti-realistic political allegories and absurdist farces that won prizes at festivals, were published and studied abroad, but were generally banned from the Franco-era stage.[8] Wellwarth proclaimed futile the attempt to suppress these authors: "Their works … will inevitably be recognized as the continuation of the great theatrical tradition of Spain" (*Spanish Underground Drama*, p. 160). His prophecy proved overly optimistic; only an exceptional production – like *Las hermanas de Búfalo Bill* (Buffalo Bill's Sisters, 1975), a satire of the end of the Franco era by Manuel Martínez Mediero, and *Ejercicios para equilibristas* (Exercises for Tightrope Walkers), short plays by Luis Matilla creatively staged in 1980 by the National Drama Center (CDN) – has attracted audiences. Even the creation in 1984 of a National Center for New Tendencies of the Stage has done little to interest Spanish audiences in non-traditional theater. Fernando Arrabal, who has resided in France since the mid-1950s, and Francisco Nieva, who also lived in France for years before establishing himself as Spain's foremost set designer, are wildly imaginative, transgressive, anti-realistic playwrights who have transcended this limitation, but they were not part of the underground movement.

The annual Sitges Theater Festival from its start in 1967 was the key place for underground playwrights (relabeled "new authors" in democratic Spain) to interact with experimental troupes. Twenty years later the importance of Sitges had diminished, and other festivals came to play a central role in theater activity in Spain, providing a showcase for both

foreign and national groups: Madrid's spring and autumn festivals, Almagro and Mérida for classical theater, Valladolid and Granada for avant-garde, Cádiz for Latin American participation.[9]

The independent movement was both an outgrowth of and a reaction to restricted chamber and university theater. Consisting of a wide range of young groups, it rejected government support and control. In the last decade of the Franco regime, groups like Los Goliardos and Tábano were an important vehicle for expressing discontent; the former's corrosive stagings of Arrabal's *Ceremonia por un negro asesinado* (Ceremony for an Assassinated Black, 1966) and Brecht's *La boda de los pequeños burgueses* (A Petty Bourgeois Wedding, 1970, 1973) and the latter's satirical *Castañuela 70* (1970) rank among the memorable productions of contemporary stage history. *Castañuela 70* set the pattern in various ways; it was given multiple stagings in a large, privately owned theater, with ticket sales to the public; rather than a dramatic text by an identified author, it was collective spectacle. In Spain, as in France after the student revolt of 1968, the individual author was temporarily pushed aside by collective creativity and, in the case of Catalan groups, the text itself was partially replaced by mime. Troupes like Tábano, La Cuadra de Sevilla, and Els Joglars were considered anti-Franco political activists. At home their productions were sometimes closed by the censors, but they performed to acclaim in international festivals and were enthusiastically welcomed by audiences of Spanish expatriates abroad.

Largely itinerant at first, some independent groups established small, permanent playhouses, where they premièred new or controversial texts. In Madrid they survived into the early years of democracy; from their ranks emerged two of the important playwrights of post-Franco Spain: José Luis Alonso de Santos and Fermín Cabal. In Seville, La Cuadra, founded by Salvador Tavora in 1971, continues as a major theatrical force; dynamic, highly visual spectacles combining music and dance, like *Andalucía amarga* (Bitter Andalusia, 1979) and *Las bacantes* (The Bacchae, 1987) – a Greek tragedy choreographed to flamenco rhythms – play to full houses nationally and internationally. There are also creative theater groups in the Basque Country and in Galicia, but it is in Catalonia where the most enduring legacy of the independent movement is found.

Although Madrid has traditionally been Spain's theater capital, today Barcelona is home to a number of internationally acclaimed troupes and resident companies. Els Joglars, founded in 1962 by Albert Boadella, heads a list of innovative groups that includes Els Comediants, Tricicle, La Fura

dels Baus, and many others. The Francoist prohibition against the use of Catalan on stage was removed in 1946; the emphasis on mime is therefore an artistic choice, not a reaction to linguistic censorship. The foregrounding of movement over text facilitates access to audiences everywhere; Els Joglars's polemical, anti-Catholic *Teledeum* (1983) has been performed before more than 250,000 spectators in Spain, New York City, and several European countries. The circus-like comedic performances of Tricicle are dependent upon their actors' tireless gymnastic skills. La Fura dels Baus, which exploits Artaudian shock effects, rivals the popularity of rock concerts with younger spectators. At the other end of the spectrum, the prestigious Lliure Theater, founded in 1976 by Lluís Pasqual and Fabia Puigserver, has specialized in an international repertory of classical and contemporary drama, performed in Catalan. Pasqual's success at the Lliure led to his appointments as director of the CDN (1983–1989) and, since 1990, of the Paris-based Théâtre de l'Europe. The opposite path was followed by fellow Catalan Josep Maria Flotats, who achieved fame as an actor on the French stage and then, in 1985, returned to Barcelona to assume direction of the government-subsidized Poliorama Theater.

The final years of the Franco regime witnessed increasing stage freedom, but certain topics remained taboo. In his record-breaking hit, *La casa de las Chivas* (The House of the Jezebels, Barcelona 1968, Madrid 1969), Salom was able to describe conditions behind the Republican lines in the Civil War; nevertheless, the drama's focus is primarily psychological and moral. Only with the advent of democracy has the political strife been foregrounded in such texts as *Las bicicletas son para el verano* (Bikes are for Summer, 1982), by noted film actor Fernando Fernán-Gómez and *¡Ay Carmela!* (1987), by the Catalan author José Sanchis Sinisterra. *Las bicicletas* also makes reference to the retroactive repeal of Republican divorce laws. Salom's 1976 *La piel del limón* (Bitter Lemon) presents an impassioned plea for divorce reform, told from the perspective of a man torn between his love for "the other woman" and his love for his daughter. The protagonist's inner conflict is revealed expressionistically by having both of these female roles played by the same actress, who removes her clothing in full view of the audience while changing character.

The elimination of previous restrictions on nudity, sexual material and erotic, colloquial language brought an immediate and predictable result: a wave of "infantile, inconsequential plays."[10] During the period of Transition, nudity became virtually obligatory. Partial female nudity was imposed on Gala's *¿Por qué corres, Ulises?* (What Makes You Run, Ulysses?,

1975) over the author's protests. On the other hand, Nieva's *La carroza de plomo candente* (The Carriage of White-Hot Lead, 1976), a "black ritual" whose satire focuses on an impotent king, artistically incorporated full nudity. Pornographic reviews proliferated, and there was a vogue in cross-gender casting. The initial turmoil has subsided, but the Spanish stage today, like the films of Pedro Almodóvar, is less puritanical than mainstream counterparts in France or the United States and may deal with themes like homosexuality and drugs more openly. The long-running comedy hit of the 1985 and 1986 seasons, Alonso de Santos's *Bajarse al moro* (Going down to Marrakesh), is a rapid-fire portrayal of young people rebelling against hypocritical, middle-class morality; their language is colloquial and their activities include smuggling hash. When the American translation was staged in Kansas City in 1992, there were protests because of the subject matter and verbal references to bodily orifices.

There are no longer official sanctions against freedom of expression in Spain, but in the first years of Transition the taboo against attacking the military lingered on. Thus Boadella and his actors were judged by a military tribunal and imprisoned after Els Joglars dared perform *La torna* (Change, 1977). Individuals also harbored pro-Franco feelings, giving rise not only to a short-lived agitprop theater of the extreme right but also to death threats sent to Buero Vallejo when his *La doble historia del doctor Valmy* (The Double Case History of Doctor Valmy, written 1964) premièred in 1976. This Pirandellian tragedy posited that anyone who denied the existence of political torture was mentally ill.

The Transition brought a wave of long-prohibited plays. Martín Recuerda's exuberant "Spanish Fiesta," *Las arrecogías del Beaterio de Santa María Egipcíaca* (The Inmates of the Convent of Saint Mary Egyptian), achieved notable commercial success in 1977. This history play dealing with the nineteenth-century martyr, Mariana de Pineda, simultaneously made a plea for amnesty of political prisoners in the present. Rodríguez Méndez's *Bodas que fueron famosas del Pingajo y la Fandanga* (Famous Nuptials of Pingajo and Fandanga) triumphantly inaugurated the 1978–1979 season of the newly established CDN. Set in a poor neighborhood of Madrid in 1898, it satirizes the military while portraying a picturesque group of rogues.

At first, the CDN actively promoted living Spanish authors. Catalan playwright Josep M. Benet i Jornet was introduced to Madrid audiences in 1980 through a creative, cinematographic staging by film director Josefina Molina; the text, *Motín de brujas* (The Witches' Revolt), deals with

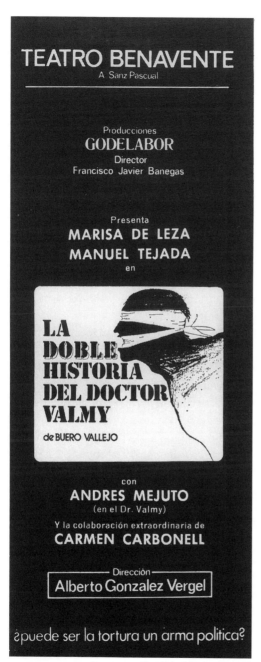

10. Program cover for Buero Vallejo's *La doble historia del Dr. Valmy*

the oppressive lives of a crew of cleaning women. A visually dazzling version of Cervantes's *Los baños de Argel* (The Baths of Algiers), written, directed and designed by Nieva, won for him the 1979 National Theater Prize; it was followed in 1982 by his *Coronada y el toro* (Coronada and the Bull), a satire of traditional machismo. Also produced in 1982 were Alonso de Santos's expressionistic, quasi-autobiographical *Album de familia* (- Family Album) and Cabal's *¡Vade retro!* (Get Thee behind Me!), a humorous, verbal battle between two priests of different generations. Under the directorship of Pasqual and José Carlos Plaza, the national theater subsequently shifted its emphasis to García Lorca, Valle-Inclán, and international repertory. Plaza, who revealed his talent for fluid, cinematographic stagings with *Las bicicletas son para el verano,* in 1991 staged a brilliant, marathon production of Valle-Inclán's epic trilogy *Comedias bárbaras* (Barbaric Comedies), thus consolidating not only Valle-Inclán's reputation but also the central role of the artistic director. On the other hand, in 1990–1991 the CDN did not stage a single living Spanish writer. Some authors, like Nieva, Alonso de Santos, and Diosdado, responded by forming their own companies.

Despite growing difficulties, in the 1980s and 1990s a number of contemporary works have succeeded on the commercial stage. Cabal firmly established his reputation in 1983 with *¡Esta noche gran velada!* (Big Match Tonight), a tragicomedy about the boxing world that owes much to American films; one of the characteristics of recent theater in Spain, both in terms of scripts and of staging, is its intertextuality with movies. Sastre achieved a long-awaited triumph in 1985 with Gerardo Malla's hyperrealistic staging of *La taberna fantástica* (The Fantastic Tavern, written 1966), a tragicomedy reflecting the lives of the marginalized underclass. Diosdado's *Los ochenta son nuestros* (The Eighties Are Ours), a play that focuses on young people's search for self-identity and rejects prejudice based on class and sexual orientation, proved a box-office hit for two seasons, starting in 1988. That same year, Gala's musical *Carmen Carmen* (written 1975), directed by Plaza, started an equally long run; a debunking of the patriarchal values of honor, power, religion, and fame, the musical starred the ever-popular Concha Velasco. Velasco's contribution to the success of *Carmen Carmen,* along with that of Rafael Álvarez, "El Brujo," to Sastre's play and Amparo Larrañaga to Diosdado's, highlights the increasing importance of big name actors to the success of commercial productions.

The only younger author to rival the box-office records of Alonso

Millán is María Manuela Reina. Although Reina's bourgeois dramas dealing with dysfunctional families and taboo sexual relationships have attracted the attention of American scholars, they verge on soap-opera melodrama and have not readily traveled outside Spanish-language theater. The woman writer who has achieved greatest international attention is Paloma Pedrero; her works have been staged in the United Kingdom, France, Brazil, Portugal, and the United States.

Pedrero's most-staged plays are intimate dramas, dealing with personal relationships and featuring two-actor casts: *La llamada de Lauren* (Lauren's Call, 1985) and *El color de agosto* (The Color of August, 1988). At least since 1984, when Marsha Norman's *'night Mother* was a smash hit in Madrid, two-character plays have been in vogue. Sebastián Junyent rivaled that triumph with his Lope de Vega Prize winner, *Hay que deshacer la casa* (Packing up the Past, 1984). Salom's *Una hora sin televisión* (An Hour Without Television, 1987) toured for more than four years and 2,000 performances. Sanchis Sinisterra's meta-theatrical *¡Ay, Carmela!*, centering on a couple of itinerant performers during the Civil War, relied on the versatility of actor-director José Luis Gómez and popular film actress Verónica Forqué for its success.

Finding both the commercial and national stages largely closed to them, younger directors, actors, and authors in Madrid have created a series of alternative theaters. Their small auditoriums, located in popular neighborhoods, often operate in conjunction with theater schools or cafés. These younger authors tend toward realistic, well-made plays that emphasize colloquial language and cultural situations with which younger audiences can relate. While their names do not figure on the lists of box-office hits, Ernesto Caballero and the Catalan Sergi Belbel were represented by nine and seven productions, respectively, during the 1982–1994 period in Madrid.

Theater in Spain, as elsewhere, is perpetually in crisis. Over the decades it has nevertheless survived the advent of movies, television, and video. The commercial Madrid stage – Spain's equivalent to Broadway or the Parisian Boulevard – has no doubt lost ground in recent years, but government-subsidized theaters, both in the capital and in the autonomous regions, continue to stage high-quality productions, and throughout the country there are creative professional, semi-professional and amateur groups who keep theater alive, often on minimal budgets. The true story of the contemporary Spanish stage goes well beyond Madrid and the subjects treated here.

NOTES

1. César Oliva, *El teatro desde 1936* (Madrid: Alhambra, 1989), pp. 67–69.
2. A. P. Foulkes, *Literature and Propaganda* (London and New York: Methuen, 1983), p. 13.
3. Manuel Díez Crespo, "El teatro clásico universal en los escenarios de España," pp. 23–26 in Enrique de la Hoz (ed.), *Panorámica del teatro en España* (Madrid: Editora Nacional/Centro Español del Instituto Internacional del Teatro, 1973), p. 25.
4. See George H. Szanto, *Theater and Propaganda* (Austin: University of Texas Press, 1978).
5. See José Monleón, *Treinta años de teatro de la derecha* (Barcelona: Tusquets, 1971).
6. Martha T. Halsey, "The Politics of History: Images of Spain on the Stage of the 1970s," pp. 93–108 in Martha T. Halsey and Phyllis Zatlin (eds.), *The Contemporary Spanish Theater: A Collection of Critical Essays* (Lanham, NY and London: University Press of America, 1988), p. 93.
7. La Hoz (ed.), *Panorámica del teatro*, p. 18.
8. George Wellwarth, *Spanish Underground Drama* (University Park, PA and London: Pennsylvania State University Press, 1972).
9. Juanjo Guerenabarrena, "Siete festivales mayores," pp. 296–297 in Moisés Pérez Coterillo (ed.), *Escenarios de Dos Mundos: Inventario teatral de Iberoamérica* (Madrid: Centro de Documentación Teatral, 1988), vol. ii.
10. Patricia O'Connor, "A Theater in Transition: From Paternalism to Pornography," pp. 201–213 in Halsey and Zatlin (eds.), *Contemporary Spanish Theater*, p. 201.

FOR FURTHER READING

Delgado, María M. (ed.). *Spanish Theatre 1920–1995. Strategies in Protest and Imagination.* 2 vols. *Contemporary Theatre Review 7.1–2.* Amsterdam: Overseas Publishers Association, 1998.

Halsey, Martha T. and Phyllis Zatlin (eds.). *The Contemporary Spanish Theater: A Collection of Critical Essays.* Lanham, New York and London: University Press of America, 1988.

Holt, Marion Peter. *The Contemporary Spanish Theater (1999–1972).* TWAS 336. Boston: G.K. Hall, 1975.

O'Connor, Patricia (ed.). *Dramaturgas españolas de hoy. Una introducción.* Madrid: Espiral/Fundamentos, 1988.

Oliva, César. *El teatro desde 1936.* Madrid: Alhambra, 1989.

Ragué-Arias, María-José. *El teatro de fin de milenio en España (de 1975 hasta hoy).* Barcelona: Ariel, 1996.

Ruiz Ramón, Francisco. *Historia del teatro español. Siglo xx.* Madrid: Cátedra, 1977.

Toro, Alfonso de and Wilfried Floeck (eds.) *Teatro español contemporáneo. Autores y tendencias.* Kassel: Reichenberger, 1995.

VI

Culture and the arts

17

Painting and sculpture
in modern Spain

Contemporary Spanish art is generally portrayed in histories as an uneven agglomeration of outstanding moments, boasting isolated figures of genius, and separated by periods of apathy.[1] In contrast to the medieval era or the Golden Age, more recent art is largely disparaged. An exception is made, of course, for the works of a few major figures, though these products are often seen as heroic deeds of epic grandeur, conceived in a country that has otherwise failed to live up to its own glorious past tradition.

This is a conception that is both superficial and historiographically outmoded. Once a fuller understanding of the period in question is attained, a rich continuity of trends makes itself known, revealing numerous artists who not only represented their era masterfully but who also became figures of international standing in their own right. A history of European art would be incomplete if it claimed to value more than simple novelty or vanguardist movements, yet failed to take these artists into account.

Certainly by the nineteenth and twentieth centuries, Spain was no longer the world power of a bygone era. She was instead a nation struggling to modernize, burdened with a backward economy, a weak bourgeoisie, social and political instability, and periods of isolation – circumstances which could hardly be expected to inspire a flourishing of the arts. Yet for all this, the artistic production of Spain is more than just a minor chapter in the history of European art. Spain's output stands on its own as an indelible component of that tradition, and one need only cite the names of Joaquín Sorolla, Ignacio Zuloaga, Pablo Picasso, Joan Miró, Salvador Dalí, Julio González, Antoni Tàpies, Eduardo Chillida, Antonio Saura, Antonio López, or Miquel Barceló to highlight the significance of

the Spanish contribution. These were artists who forged their best works while standing at a crossroads, struggling between fidelity to a long and brilliant national tradition – unanimously praised outside of Spain since the romantic era – and the demanding challenge of being modern in a country that mostly lacked homegrown models which to emulate. It is this tension between tradition (*costumbrismo*[2]/Castilian values/regionalism) and progress (innovation/cosmopolitanism/the vanguard) that accentuates the intensity and originality of contemporary Spanish art.

As is also the case for other aspects of culture, the visual arts underwent a flourishing in the last twenty-five years of the nineteenth century. The realist school, which since the middle of the century had undertaken a renovation of romantic–classical conventions, was finally accepted by the academic tradition, thus effecting a widespread eclecticism. However, along with this backward-looking style, an assimilation of the most innovatory aspects of realism, joined with the echoes of impressionism and post-impressionism coming from Paris and Brussels, forced a modernization of Spanish painting from the 1880s, beginning in the Catalan and Basque regions.

Continuity with the past is very much in evidence in sculpture, and in historical and genre painting. Sculpture suffered few stylistic changes, maintaining the formal and thematic techniques of the classical tradition while spurning its abstract rhetoric in favor of a noted realist attention to detail. Mariano Benlliure's numerous commemorative monuments, for instance, stand out for their virtuosity and their display of technical ability, but this virtuosity more often than not tends to drown out the otherwise refreshing aspects of his more personal works. In painting, a continuity with tradition is clearly present in historical painting, the most perfect embodiment of the eclecticism so favored in the National Fine Art Exhibitions. While this is not a genre that is today held in very high esteem, its best works are undeniably of quality, and the Spanish school occupied a distinguished position among contemporary painters. Most noted among these Spaniards is perhaps Francisco Pradilla, recognized by his European contemporaries for his magnificent painting *Doña Juana la Loca* (1874). However it was the small-sized genre painting, the so called high-class painting begun by Mariano Fortuny, that was most in demand internationally. The commonplace scenes of a Francisco Domingo, undertaken with a refined technique, which is at the same time naturalist and loose, already foreshadow a modern sensibility.

But the truly original consequences of realism were given to the land-

scape artists to produce: the forfeiting of the picturesque in the selection of themes, and the diffusion of the *plein-air* painting in the way of doing it, facilitated Aureliano de Beruete's assimilation of impressionism, as well as Darío de Regoyos's adoption of post-impressionism. Both of these artists are good representatives of the spirit of the Generation of 1898, though in Regoyos's case his stay in Brussels proved decisive. Indeed, these foreign contacts were necessary for the generation born about the year 1860 to effect the profound change that signaled the emergence of modernism. This movement, moreover, is itself magnificently represented by the production of both Ramón Casas and Santiago Rusiñol whose scenes, framed in very original ways, introduce us to the gray atmosphere of the city or to brightly lit gardens. These two were followed by Isidro Nonell and Joaquín Mir, who moved on from considerations of lighting to accentuate the expressive value of color and brush-stroke, thus bringing about a unique form of expressionism.

The term "expressionism" can be used to characterize a number of young artists in the early years of the new century. Prominent among them was Ignacio Zuloaga, who produced somber visions of the soul of Spain, her landscapes, and Castilian types. José Gutiérrez Solana extended this presentation of the so-called "black Spain" and in doing so drew inspiration from the dramatic portrayals of urban Madrid contained in the novels of Pío Baroja. This bleak, regenerationalist vision was to contrast markedly with the sunny sensuality of Joaquín Sorolla, whose brightly lit beaches, glistening bodies, and sparkling waters relegated that sort of negativity to a decidedly minor role.

With Sorolla, Zuloaga, and the sumptuous and refined folklorism of Hermen Anglada Camarasa a new vision of the "Spanish school" was made known world-wide, the consummation of which took place a few years later with the "Spanish invasion" of Paris, the heart of the first vanguardist movements.[3]

Beginning in the 1920s the plastic arts in Spain found themselves characterized in two very distinct ways, either as representatives of realist regionalism or, alternatively, as followers of vanguardist movements. Yet however rigid these boundaries seemed at first, a great deal of overlap existed, for both movements in practice partook of an ambivalent mix of traditionalism and modernity. It is really only the degree to which each movement absorbed traditional or modern elements which distinguished the two schools. Spanish culture in the first third of this century can thus be understood as the confluence of a growing desire to

be integrated with the rest of Europe, its aesthetic and intellectual currents, and a will to define the national essence and its regional variants through an understanding of Spain's history, her land and her people. It is here, perhaps, that one discovers the compelling originality of this "Silver Age" of Spanish culture.

This concern for the question of national identity (initiated by the Generation of '98) is reflected in the regionalist painting of traditional Spanish themes (bullfighters, beautiful women or *majas*, and gypsy girls), though paradoxically these same themes were developed within the context of a decidedly modern language. Regionalism came into being as an attempt at an artistic nationalism which borrowed its themes from various vernacular traditions and found inspiration in a particular, retrospective vision of canonical figures (El Greco, Velázquez, or Zurbarán). The themes themselves experienced the renovatory impulses of a cosmopolitan aesthetics which, while it never quite crossed over into the vanguard, nonetheless served to distinguish clearly the regionalists from those nineteenth-century *costumbristas* who also chose to exalt national character through portrayals of local color. The movement flourished in the 1920s in the work of Zuloaga or Julio Romero de Torres. More innovative was the Catalan *noucentisme*. A classicist reaction to modernism, this movement proposed an aesthetic of Mediterranean (and more specifically *Catalan*) origin, and produced significant results in the paintings of Joaquim Sunyer and the sculptures of Josep Clarà. These works were innovative precisely in their classical aspects.

In the plastic arts as well as the literary and musical arenas, the vanguard itself found inspiration in popular art and in the past. This is because the vanguard arose in Spain as a synthesis of European "isms" which failed to break with tradition altogether. A similar situation occurred with the expatriate artists, in whom exile served to stimulate that same search for origins. Nonetheless, one must distinguish between the national and the expatriate vanguards. The finest of the Spanish vanguardists undertook their creative labors as members of the "Ecole de Paris," contributing in very important ways to the birth and development of both cubism and surrealism. First and foremost among these was Pablo Picasso, the most significant creative genius of the twentieth century. Picasso arrived in Paris in 1904, a promising symbolist–expressionist painter. Three years later he painted *Les Demoiselles d'Avignon*, a milestone in contemporary painting which marked the beginning of the cubist revolution which he would develop between 1909 and 1915 along

with Georges Braque, and later Juan Gris, who took the movement to its purest extremes. Picasso's creative versatility knew no limits: following his cubist work he moved through a classicist period (1915–1925), then another marked by surrealist influences (1925–1940) and up until his death maintained a protean dialogue with the history of painting, at once destroying and vindicating it. No less important for sculpture is the legacy of Julio González, who pioneered iron sculpture, joining traditional forging techniques with a multiplicity of primitivist and vanguardist suggestions. Also important, though less radical, is the production of Pablo Gargallo. In the 1920s a number of Spanish painters, newly arrived in Paris, actively joined the ranks of the surrealists. Joan Miró's first surrealist paintings coincided with the formation of the movement in 1924, and he thus became the principal exponent of its abstract wing. Between Paris and his summer residence in the small Catalan town of Montroig, Miró created an unmistakable colorist universe, for imagination's enjoyment. Beginning in 1927 surrealism's representational wing was largely embodied by another Spaniard of undeniable genius. Salvador Dalí created not only a spectacularly imaginative body of work but also made his own life into a work of art, thus carrying his surrealism to an extreme. These two great figures have in turn tended to eclipse the no less personal production of Oscar Domínguez.

Cubism and surrealism were also the two most significant ingredients of the homegrown vanguard, though they lacked their original coherence and radicalism, as was the case for much European art between the two world wars. Vanguardist movements were disseminated syncretically in an adverse environment, and so both cubism and futurism adopted a dynamic geometrization, though a clearly representational one. Daniel Vázquez Díaz was the best and most influential example of this neo-cubism that profoundly renovated realist painting. Nonetheless, a marked surrealist element was present even in those painters of the Republican era that most sought to break with tradition, an element displayed also in the work of sculptors such as Alberto Sánchez. Finally, the weight of political circumstances prior to the Civil War gave rise to a theoretical debate which favored political commitment on the part of artists. A re-evaluation of socialist realism, to the detriment of surrealism, gave birth to militant art such as Josep Renau's war posters, or Picasso's *Guernica* (1937).

The artistic fecundity of the pre-war era found itself dramatically cut short by the Civil War and its aftermath. The new regime, impelled by a

profoundly conservative ideology, strove to erase the vanguard from historical memory. Along with liberalism and democracy, vanguardist movements were labeled as decadent counter-currents to the natural flow of the nation's history. The post-war era witnessed a predominance of conventionalisms drawn from the artistic past: academicism, or the works of veteran masters such as Zuloaga, Solana or José María Sert, and the remnants of a moderate vanguardism present in the works of Vázquez Díaz or Benjamín Palencia. The original contributions of this period are found in landscape painting, where a new attempt at coming to terms with the national condition implicitly assumed the form of Fauvist chromaticism or cubist syntheticism.

However, the nexus that truly joined the young artists with the pre Civil-War vanguard was surrealism, due in part to individuals who bridged both eras, such as Miró (who returned to Spain in 1940) and the sculptor Ángel Ferrant. The so-called magical surrealism of the Barcelonan circle of Dau al Set (1948) – where Tàpies launched his career – is the best example of that slow process of recuperation of the vanguardist legacy that operated in direct opposition to officially sanctioned culture. Nonetheless, simultaneous with the lifting of the diplomatic blockade against Spain, the Franco regime began a slow process of opening itself to the outside world. Throughout the 1950s a string of exhibitions and other official events proclaimed a nascent acceptance of the "new art," including what was then considered its most radical form, abstraction.

Informalism soon proved to be the artistic current that allowed Spain to incorporate itself into the front rank of world art in the final years of the 1950s. This came about in large part because of a generation of artists born in the 1920s who transformed the nation's artistic landscape and in the process, quite unexpectedly, achieved international standing. The year 1957 was especially significant as it was then that these artists made themselves known through three collectives: El Paso (Madrid), Equipo 57 (Paris and Córdoba) and Parpalló (Valencia). Antoni Tàpies and Eduardo Chillida became pioneers in Spain's reintegration into the international vanguard. The most notable traits of Tàpies's production are the quiet poetry of his surfaces and the textures of the materials he uses, that is, the way in which he marks and imprints the materials he employs. In the case of Chillida one notices the material (iron, wood, stone) and the marks left by the forge or the chisel, elements that stand at the heart of his work and which spring from a profound metaphysics of mass and air. Through the years both of these artists have charted a course of uncompromising

quality and coherence which has helped maintain their international renown. Of the artists who formed El Paso two that stand out are Manuel Millares, whose monochromatic paintings of torn and shredded sackcloth convey a powerful emotional message, and Antonio Saura who has attempted to exorcise the weight of history through the deformed faces of historical figures rendered in grays and black.

The international success attained by the new style of Spanish art was in large part a direct result of its deliberate and genuinely Hispanic character; in its expressiveness and dramatism it was received as a vanguardist successor to the finest tradition of Spanish painting leading back to Goya. This, at least, was an interpretation propagated by the Franco regime at international competitions. Curiously enough, this same view was also held by the regime's opponents outside Spain who saw in the works an agonized cry of anti-Francoist sentiment. It is not altogether surprising that the constructive abstraction employed by other artists never attained the same international significance. This tendency, labeled normativism, is present in the imaginative vision of sculptor Jorge Oteiza and the experimentation of Equipo 57; and also in the bulk of Pablo Palazuelo and Eusebio Sempere's work – both painters. Along with the sculptor Andreu Alfaro these individuals imbued their works with a formal rigor that, at the same time, impeded neither communication nor lyricism.

The economic development of the 1960s and her increasing artistic integration notwithstanding, Spain remained politically apart from the rest of Europe. Responding to a lack of political freedoms in their own country, artists frequently adopted a militant anti-Francoism that conceived of the work of art as an instrument of protest. A critical realism emerged which employed the imagery of the mass media in much the same way as pop art, but with a more pronounced element of intellection and irony. It was a politicized art, true, but one of indubitably high quality: we discover Juan Genovés among its luminaries, as well as Equipo Crónica (1964–1981) and Eduardo Arroyo. And yet this decade also harbored a more intimate representationalism, quite removed from ethical commitment; it draws us into a more quotidian environment, though one which is not wholly without mystery. The latter tendency is most notably embodied in the work of Antonio López. Luis Gordillo undertook a personal representation of psychological character, constructed of arbitrary figures and doodling, which has influenced a younger generation of painters.

The death of Franco in 1975 eliminated the final obstacle to political modernization. Doing away with past misgivings and suspicions, the newly formed democratic institutions reinforced their own legitimacy by undertaking a cultural policy intent on disseminating contemporary art and on promoting the works of young artists within the country and abroad. Following the definitive return from "exile" in 1981 of so charged and emblematic a symbol as Picasso's *Guernica*, the country witnessed a succession of memorable expositions, exhibitions, prizes, and grants for young artists. Both the public and the mass media revealed a previously unrevealed appetite for these art shows. New galleries sprang up, the Feria Arco (an annual art show) came into being, and Spanish art was exhibited abroad in prestigious museums. The 1980s were years of euphoria and ephemeral triumphs, but also of serious undertakings and works of undeniable quality; collections were established and museums created to fill old lacunae, and a generation of artists responded eagerly to the challenges.

Following the political commitment of the 1960s, and the conceptual experiences of the 1970s, more contemporary artists rediscovered the craft and pleasure of painting, as well as the narrative possibilities of the canvas and the evocative potential of imagery. A few of the figures of this later period began their careers amidst the representationalism of the 1970s; Guillermo Pérez Villalta, whose bright and deeply narrative paintings abound in classical architecture and mythology, is one such example. Others – such as Ferrán García Sevilla who creates images which he then scatters capriciously over vast colored surfaces – emerged from conceptualism. Miguel Ángel Campano's series of paintings find inspiration in a modern tradition (Poussin, Delacroix, Cézanne) and are well known for their vigor, as are his landscapes and still lifes. A combination of geometry and colorist expressiveness lends a distinctive note to José María Sicilia's large canvases, even if in his recent works we find these aspects reduced to more muted transparencies. However, the one artist who best exemplifies the international prestige attained by Spanish art is Miquel Barceló, whose expressionistic representation is built upon an unmistakable plastic density.

While the transformation undergone by painting in the 1980s was significant, sculpture underwent a veritable revolution, thanks largely to minimalist and conceptual experiences that allowed sculptors to overcome the weight of tradition. Susana Solano, who has created a personal and sensitive minimalism, is the most widely recognized. Other

significant works are Miguel Navarro's *Cities*, Eva Loots's installations, and Juan Muñoz's scenic spaces, among others.

This is the new face of Spanish art, of a cosmopolitan generation that has managed to distinguish itself with its own voice, something that is not an insignificant accomplishment in a post-modern world saturated with images.

(*Translated by* DAVID FLORES)

NOTES

1. This prejudice abounds even among Spanish historiographers. One need only cite so influential a thinker as José Ortega y Gasset, who once resolutely stated that "Spanish painting has largely shown itself to be awful, and yet Spain has bred a few giants," in *Goya* (Madrid: Revista de Occidente, 1958), p. 8.

2. The term *costumbrismo*, which has no wholly adequate English equivalent, refers to a literary and artistic movement that sought to portray the national character through depictions of popular customs and local color.

3. Félicien Fagus, "L'Invasion espagnole: Picasso," *Revue Blanche*, Paris, 15 July 1901.

FOR FURTHER READING

Bozal, Valeriano. *Pintura y escultura española del siglo xx*. 2 vols. Madrid: Espasa Calpe, 1993.

Calvo Serraller, Francisco. *Escultura española actual: una generación para un fin de siglo*. Madrid: Fundación Lugar C, 1992.

 Del futuro al pasado: vanguardia y tradición en el arte español contemporáneo. Madrid: Alianza, 1988.

Dyckes, William (ed.). *Contemporary Spanish Art*. New York: Art Digest, 1975.

García Madariaga, Luis Ignacio. *Panorama de la pintura española contemporánea*. Madrid: Koragrafik, 1993.

Marín Medina, José. *La escultura española contemporánea, 1800–1978: historia y evaluación crítica*. Madrid: Edarcón, 1978.

Moreno Galván, José María. *The Latest Avant-Garde*. Greenwich, CT: New York Graphics Society, 1972.

Pérez Rojas, Javier and Manuel García Castellón. *El siglo xx: persistencias y rupturas*. Madrid: Silex, 1994.

Pérez Sánchez, Alfonso E. (ed.). *La pintura española*. 2 vols. Madrid: Electa, 1995.

Reyero, Carlos and Mireia Freixas. *Pintura y escultura en España, 1800–1910*. Madrid: Cátedra, 1995.

Sambricio, Carlos, F. Portela, and F. Torralba, *El siglo xx*. Madrid: Alhambra, 1978.

Smith, Bradley. *Spain: A History in Art*. New York: Simon and Schuster, 1966.

Vidal, M. Carmen Africa. *Pintura posmoderna española*. Alicante: Instituto de Cultura Juan Gil-Albert, 1991.

18

Culture and cinema to 1975

In his classic 1947 study of the representation of national identity in film, *From Caligari to Hitler: A Psychological History of German Film*, Siegfried Kracauer underscores the value of popular cinema, commercial genres with their "persistent reiteration of . . . pictorial and narrative motifs" in the cultural historian's reconstruction of the "inner life of a nation."[1] In my study of Spanish film before 1975 I have sought to attend, at least in part, to Kracauer's view. Thus where many histories of Spanish cinema have focused primarily on the development of a modern Spanish art cinema that largely coincides with the emergence of a dissident anti-Francoist culture, I have been guided by somewhat different concerns. I am more interested in examining the psychic, social, and ideological functions of film in Spanish society, particularly as regards the role of cinema in presenting images of nation and national identity.

To that end I have divided this essay into three chronological blocks, deliberately rejecting the temptation of a continuous historical narrative. This three-part structure allows for the observation of revealing continuities and discontinuities in the history of the Spanish film industry that do not always coincide with those of political history or with the boundaries between popular and art cinemas. The first section deals with the 1930s and 1940s, the period of the Republic, Civil War, and the first decade of Francoism. Concentrating on the folkloric musical *española*, I study its production in the years that span the ideological polarizations of the Republic and War as well as the subsequent era of political, economic, and cultural autarky during which Spaniards were most concerned with the pursuit of what Manuel Vázquez Montalbán has called "Spanish peculiarity."[2] The second section treats the 1950s as a period of transition as Spain emerged from the isolation of the immediate post-

war years and its cinema turned from the creation of identity myths towards the exploration of new realisms. Both the second and third parts – the latter devoted to the New Spanish Cinema of the 1960s and 1970s – are increasingly concerned with the institutional status of cinema within a planned cultural economy that sought to use film as an arm of foreign policy as the projection of a modern, liberalizing nation.

Out of the conviction that specific textual evidence is nearly always more compelling, and more persuasive, than historical synthesis and summary, I have devoted much of the space allotted to the analysis of a limited number of individual films. The selection of films reflects my intention to re-evaluate the production of this period in the context of the cultural issues sketched above. Consequently many of the better known titles and names are absent from this essay.

Despite its continuous presence throughout the history of Spanish cinema, the folkloric *españolada*, a hybrid genre of romantic comedy and/or melodrama incorporating regional, primarily Andalusian, song and dance, has been the object of critical opprobrium on the part of the great majority of cultural and film historians of both the left and right. Thus, speaking from a position of generalized disdain for the products of a commodified culture industry, Raymond Carr and Juan Pablo Fusi consign such films to the dustbin of a trivialized, escapist "culture of evasion,"[3] while Román Gubern gives voice to a more historically and nationally grounded critique of the *españolada*'s exaltation of a presumed Spanish "difference," a pre-modern Spain of rural, feudal underdevelopment, "dominated by religious superstitions, land-owning *caciques*, hunger, a cult of machismo, and *toreros*."[4] Paradoxically, however, despite such attacks from progressive quarters for its complicity with subsequent Francoist mystifications of a timeless, rural "Eternal Spain," influential sectors of the right condemned the genre's associations with the populist cinema of Republican Spain. A review in the Falangist magazine *Vértice* of Florián Rey's adaptation of Mérimée, *Carmen la de Triana* (Carmen, the Girl from Triana), filmed during the Civil War in the UFA studios in Berlin, questions the film's focus on a marginal underclass of matadors, bandits and gypsy smugglers to the exclusion of the virile protagonists of Spain's imperial history: "And where are our great discoverers, our missionaries, our navigators, our conquistadors" who should rightly represent to the world the "new Spain" of the Nationalist uprising, "the strong and heroic Spain that, mindful of past glories, has set

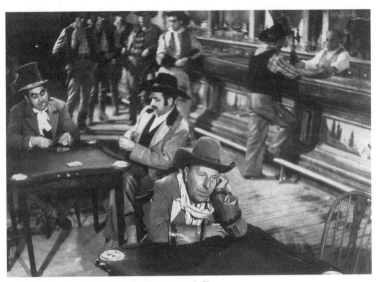

11. Still from Berlanga's *Bienvenido, Mr. Marshall*

upon the red beast that threatened to destroy justice, order, and civilization in Europe?"[5]

Though certainly indicative of the stakes involved in a discussion of the *españolada* and the deep polarizations that shadow and even structure the films' narrative, such charged ideological positioning has nevertheless served as an obstacle to analysis. In order to evaluate the impact of the *españolada* one must first set it in a broader conceptual framework that considers both the films' generic identity and their use of folkloric traditions.

Studies of the American film musical by Jane Feuer and Rick Altman provide important insights into the way an overtly escapist genre nonetheless conveys social and cultural meanings within a specific national, historical context. For both Feuer and Altman the musical is primarily concerned with the construction of community, both on the level of the fiction recounted, and in its address to the audience. Furthermore, the formulaic nature of commercial genre films, their redundancies, use of stereotypes, and binary oppositions signal a similarity to ritual and myth in their social functioning. Particularly relevant are the critics' analyses of the "American folk musical," with its small-town, often agricultural settings, local coloration attached to characters, emphasis on family groups and "nostalgia for . . . a mythical communal past."[6]

Although it is merely one current among several in the US tradition, the folk musical has proved the dominant form in Spain. This reliance on folklore has occasioned much of the criticism of the *españolada*, whether in the name of those who condemn outright its vision of an anti-modern Spain or cultural purists decrying the commercialized degradation of authentic folkloric traditions. A third view espoused in the work of anthropologist Timothy Mitchell, following the theories of Julio Caro Baroja, offers a functional approach to the analysis of folkloric practices. For him, the production of folklore is always "sociocentric," a form of collective behavior directed toward the constitution and maintenance of community identity. From this perspective, contrary to the romantic vision of folklore as the spontaneous expression of the *Volksgeist*, folk culture is stress-induced behavior, a response to a perceived threat, whether external or internal. Such a view of folklore is contextual and contingent: folklore is seen as a response to crisis, not the outpouring of an immutable essence. Questions of "authenticity" thus become moot. Folklore is always already an "invention of tradition," a method of constructing an identity myth of self versus other.

The corpus of *españoladas* under study was produced during a period of extreme stress and ideological divisiveness, the Republic, Civil War and the first decade of Francoism. Unlike the more overtly politicized films of these years – "crusade films" like the Franco-scripted *Raza* (Race), or the tendentious historical epics produced by the Cifesa studios that sought to evoke Spain's imperial past as a model for the present – the folkloric musical offered settings and stories apparently outside history and politics. Although this was not precisely the case, one can argue that the *españolada* existed on the margins of official Francoist culture. Unlike the overtly Nationalist historical films and adaptations of approved authors, the *españolada* was not generally favored by the subsidy policies and financing schemes that went into effect in 1941 and 1944. Of the sixty-nine films declared of "National Interest" during the years 1944–1956, only one, *La Lola se va a los puertos* (Lola Goes down to the Docks), belongs to the genre.

In fact, as critics on both sides have recognized, the *españolada* constituted an element of cultural continuity between the Republic and the Francoist period (Sánchez Vidal, *El cine*, pp. 241–247).[7] One of the four films directed by Luis Buñuel for Filmófono studios during the 1930s was an *españolada*. *La hija de Juan Simón* (Juan Simón's Daughter), starring well-known flamenco singer Angelillo and Buñuel's discovery, dancer Carmen

Amaya, was a box-office hit.[8] Florián Rey's *Morena clara* (The Fair-skinned Gypsy), the third film of his folkloric trilogy created for Cifesa studios and starring Imperio Argentina, was the most popular film of the Republican period. Even the outbreak of the Civil War could not stem its appeal; the film continued to be shown in both Republican and Nationalist zones until Rey and Argentina traveled to Nazi Germany in 1938 to make a series of films in the UFA studios. The success of the *españolada* in the 1930s was the result of a convergence of factors, technological and industrial as well as ideological. The introduction of sound cinema in Spain, as elsewhere, found producers anxious to capitalize on the popularity of established stars, music-hall and cabaret performers (think of Al Jolson, Carlos Gardel, Maurice Chevalier). The *españolada* developed as a vehicle to showcase primarily the talents of female singers, *folklóricas*, who were already associated with a musical repertory of Andalusianist popular songs or *coplas*. For its part, the *copla* drew upon the images and stereotypes codified in the Andalusian/gypsy iconography of writers of the period, such as Federico García Lorca, Antonio and Manuel Machado, and the Álvarez Quintero brothers.[9]

The Spanish musical of the 1930s and 1940s shares with its American cousin what Rick Altman has called a dual focus plot, an organization whereby the narrative conflict and its resolution are embodied in the relationship played out between the romantic couple. As obstacles to their union, class and ethnic differences and conflicting value systems are thus structured upon the male/female divide. The result is a series of highly predictable fairy-tale plots in an Andalusian folk setting that cast a smart-talking and sweet-singing female gypsy in an unlikely romance with her upper-class *payo* (non-gypsy) male "better." Emblematic in this regard is *Morena clara* in which Imperio Argentina plays Trini, a picaresque but honorable gypsy who wins over the upper-class lawyer who unsuccessfully prosecuted her and her brother Regalito for a clever swindle involving six cured hams, a pattern repeated by *folklóricas* Estrellita Castro in *Suspiros de España* (Sighs for Spain, Benito Perojo, 1938) as the Sevillian laundress who wins a singing/beauty contest and the heart of one of its Cuban sponsors, or Juanita Reina in *Canelita en rama* (Cinnamon Sugar, Eduardo García Moroto, 1942) as the orphaned Rocío, educated at a convent school by her "godfather"; she gains the love of his son Rafael despite the shadow of the incest taboo and the distance and disdain he acquired from a British education.

Yet the recurring thesis of these films is less the fairy-tale fiction of

love's triumph over gaping class divisions – most acute in fact among the *latifundista* economies of southern Spain – than a demonstration of the indelible stamp and seductive power of the protagonists' gypsy identity. Against expectations and genre conventions, removing the *gitana* from her environment does not result in her assimilation into high society. For despite attempts by their *payo* suitors to de-gypsify the protagonists more often the reverse is true; it is the man who undergoes a transformation. Thus, lawyer Enrique's attempts to assure Trini's reform, so that, in his own words, "nothing more remains of her gypsy-ness than the ruffles on her dress," fail; it is he who is shown as acquiring gypsy traits when near the end of the film he joins her brother in a drunken spree capped by a nocturnal reprise of Trini's first musical number, "Échale guindas al pavo." Similarly, fifteen years of convent education in northern Spain cannot take the gypsy soul or song out of Rocío, although the first thing the nuns do upon her arrival is to take away her castanets. Rocío's irrepressible southern charms seduce Rafael out of his foreign ways to the point that he takes up *cante jondo* (gypsy deep song) lessons with her gypsy relatives. And for love of Lola in Juan de Orduña's 1947 adaptation of Antonio and Manuel Machado's *La Lola se va a los puertos*, the aristocratic José Luis becomes a bullfighter.

The *españolada*'s embrace of the racial theme of gypsy identity carries multiple implications. On the one hand, the gypsy theme sounds an unexpected note of social realism, complicated by the historical and political context of the films' original production and release. Both José Caparrós-Lera and Diego Galán identify an explicit defense of gypsies as a persecuted minority in Republican-era films such as *Morena clara*,[10] in which the siblings' female defense attorney offers an impassioned indictment of society's guilt in the creation of a marginalized gypsy underclass. And in *María de la O* (Mary O, Francisco Elías, 1936, released in 1939), the title character, played by Carmen Amaya, presents a somber image of the female gypsy performer whose life choices reside in two starkly contrasted alternatives: "work, hunger, and misery" or "hembra de lujo" as the kept woman of a wealthy bullfighter. Several films of the 1940s (*Canelita en rama*, *La Lola se va a los puertos*, *Filigrana* [Luis Marquina, 1949]) evoke the economic reality behind the "romantic" relationships that link the *gitana* and the well-to-do *payo*. The payment or patronage for the gypsy's song and dance is but a cover for the trade in sexual favors, as Trini evokes in the refrain to "Falsa moneda": "Gitana, que tú serás / como la falsa monea, / que de mano en mano va / y ninguno se la quea" (Gypsy, you

are destined to be / like a fake coin / that travels from hand to hand / but which no one keeps). The Andalusian country estate settings of *Canelita* and *La Lola*, however they would idealize the relations between the land-owning *señorito* and his employees, lay bare the economic dependency that was the condition for upper-class sponsorship of gypsy flamenco culture.[11]

In the end, however, the significance of the *españolada's* treatment of gypsy themes lies not in a social realist exploration of gypsy life and culture but in the exploitation of its symbolic value in the representation of a larger national identity. For, despite the insistence on its strength, gypsy identity is repeatedly construed as unstable, as subject to question. At least two films of the period, *María de la O* and *Canelita en rama*, raise the specter of incest. María de la O's origins are unknown to her, although not to the spectator. Raised by La Itálica (Pastora Imperio), a Granadine gypsy, after her mother's murder in revenge for her marriage to a *payo*, María dances to escape poverty. When her father, who fled after killing his wife's murderer, returns fifteen years later, disguised as the anglophone Mr. Moore, he finds himself an unwitting participant in a bidding war for his daughter's favor. The inevitable revelation of her true identity allows for her reconciliation with her *gitano* suitor and her reintegration into the gypsy community through marriage and spares her from repeating her mother's "sin" as well as the latter's tragic fate. While the incest theme in *Canelita* is played to more comedic effect, the circumstances are similar: Canelita is also the hybrid issue of a union between *gitana* and *payo*.

In fact, this figure of the mixed-blood heroine is a constant of the genre. The trope of the *morena clara* (fair dark-skinned woman) – already present in the 1918 silent film, *La gitana blanca* (The White Gypsy), starring Raquel Meller – speaks of more than a poetic oxymoron. The split self of the *gitana blanca* is an acknowledgment of the divisive, exclusionary ideal of racial purity that shadowed the nation throughout its history. Thus the *españolada* employs the *gitana* not as an exotic other against whom Spanish identity is defined but as a figure of inclusion, her character an accumulation of exacerbated traits that conjure away threats to national integrity from within and without. Against the myth of the Numantine, masculine warrior hero, vanquisher of the "anti-España," promoted first in the political rhetoric and later in the films of the immediate post-war period, the *españolada* proposes a counter-myth, an inclusive, feminine image of stereotyped Andalusian/southern Spanishness.

Even before political events and government policy would confirm Spain's emergence from the period of economic, political, and cultural autarky, the appearance of three films, José Antonio Nieves Conde's *Surcos* (Furrows, 1951), Juan Antonio Bardem and Luis García Berlanga's *Esa pareja feliz* (That Happy Couple, 1951, released in 1953), and Berlanga's *Bienvenido, Mr. Marshall* (Welcome, Mr. Marshall, 1953), heralded a significant change in the modes of representing Spaniards' self-image on screen. Although the *folklóricas* did not disappear from theaters – they survived well into the 1950s, in increasingly saccharine form, along with epic heroes and heroines, and the newer stars of related fare, priests and child actors – the founding in 1947 of a state-sponsored professional film school, the IIEC (Instituto de Investigaciones y Experiencias Cinematográficas), laid the groundwork for an artistic and industrial shift that would transform the Spanish film industry over the next two decades. Whatever its deficiencies in equipment and even instruction, the film school offered students such as Bardem and Berlanga, members of the first entering class, a forum for debate and discussion, a chance to build contacts and alliances among future film professionals, and, perhaps most important, access to foreign films censored in Francoist Spain. Thus, for a new generation of would-be film-makers engaged in a search for alternative models of film practice, the IIEC gave them the opportunity to study the classics of German expressionism, Soviet epic cinema and, especially, Italian neo-realism, the movement that came to provide the dominant, although not exclusive, impetus behind the decade's cinematic innovation as well as the focal point for a more generalized cultural and political dissidence that would develop over the period.[12]

Despite obvious differences among the three films cited – *Surcos* has been generally acknowledged as the film that first applied neo-realist aesthetics to a Spanish context, whereas *Esa pareja feliz* and *Bienvenido* draw more directly upon Spanish traditions through the comic populism of the one-act comedies called *sainetes* – each explicitly signals its rejection of the mythogenic cinema of the previous decades. *Surcos, Esa pareja* and *Bienvenido* are to varying degrees reflexive films that allude to processes of film-making and film-going within their narratives. As such they offer a critique of the myth-making power of cinema even as they harness its magic in order to reveal the realities (urban unemployment, the housing crisis, the growth of a nascent consumer society fed by an increasingly influential mass media apparatus) that the films they criticize had suppressed.

The political repercussions provoked by Nieves Conde's *Surcos*, despite their potential to overshadow any reading of the film itself, clearly illuminate the forces at stake in the passage from the mythogenic cinema of the Republic and immediate post-war period to the 1950s. Although the Catholic church deemed *Surcos* "gravely dangerous" for its graphic treatment of the rural exodus from the nation's agricultural interior to the industrialized cities, the newly appointed Director-General of Cinematography, José María García Escudero, a former Falangist turned Catholic activist, championed the film, awarding it the category of "National Interest" (that is, films which fit Spain's idea of itself as a conservative, Catholic country) over *Alba de América* (American Dawn), the Cifesa superproduction of the Columbus story that had the backing of Franco's closest adviser, Admiral Carrero Blanco. While Nieves Conde, a follower of "left-wing" Falangist Manuel Hedilla, stemmed from a politico-cultural sector far removed from IIEC alumni Berlanga or Bardem, his clash with Francoist officialdom offers a glimpse of the political and ideological realignments taking place within the regime. In the meantime, García Escudero's support of *Surcos* cost him his job and shortly afterwards *Alba de América* received a revised ranking of "National Interest."

Surcos has consistently been linked with neo-realism despite the fact its director has denied the influence of the Italian model, whose films were entirely unknown to him at the time (Heredero, *Huellas del tiempo*, p. 295). Nevertheless, the striking documentary character of the exterior and interior shots of the growing workers' suburbs of Madrid, with their tenement apartments where unsupervised groups of children play in darkened courtyards, as well as the explicit references to unemployment, bread lines, and the black market offer eloquent testimony to an urban social reality previously unseen on Spanish screens. Ideologically, however, Nieves Conde's take on urban immigration could not be farther from the postulates of neo-realism. Echoing the regime's attempts during the 1950s to keep the rural poor out of the cities, the film's prologue overtly denies the wrenching poverty that drove farm families from their lands, attributing their flight to the pursuit of "temptations . . . of easy wealth."

In fact, as John Hopewell notes and Marsha Kinder brilliantly demonstrates, *Surcos* assimilates a range of seemingly contradictory discursive sources.[13] To be sure, neo-realism is singled out in a conversation between the black-marketer Chamberlain and his mistress after their

viewing of a presumed example of the genre (defined by him as treating "social problems in the *barrio*"). She reacts with incomprehension, wondering why anyone "would want to see so much misery, when millionaires' lives are so beautiful." Nonetheless, the film's Manichean plotting and visual style owe more to the family melodrama and gangster *film noir* than to any neo-realist analysis of socio-economic forces. The film's immigrant family is brought down not by economic pressures occasioned by a lack of work and decent housing, but by a crisis in paternal authority that sees wife, elder son and daughter subject to the nefarious machinations of the evil black-marketeer Chamberlain, the fatal influence of a bad woman, and the immoral effects of the city itself (daughter Tonia's dreams of becoming a *folklórica* lead to her perdition once she is transplanted to the city). One striking scene encapsulates the film's profound ideological ambivalence, caught between a denunciation of the dehumanizing effects of industrial labor and a more generalized demonization of urban life and faceless urban workers. Thus, the father of the family, sent by the employment office to a steel factory, sheds his individuality when he dons the characteristic jump suit (*mono*) worn by workers. When the focus shifts to the plant floor, oblique camera angles and an accelerating editing rhythm portray the factory as a hellish inferno where backbreaking physical labor reduces men to animals.

The opening scene of *Esa pareja feliz* stages a parodic recreation of Juan de Orduña's historical melodrama *Locura de amor* (Madness of Love, 1948), centered on the life of Juana la Loca. On a cardboard castle set, an actress dressed in queenly garb (Lola Gaos) is pressed by a group of nobles clamoring, "Palencia demands it." Refusing to cede power, the histrionic queen directs her lament, "Is there no one who will defend me?" to an off-screen public, loses her balance, and tumbles through the stage set onto the equipment and crew members hidden behind it. Filming is subsequently stopped for the day because the queen's fall damaged a spotlight. Despite this debunking, demystifying opening, Bardem and Berlanga's debut film proceeds to demonstrate that no one is immune to the lures of cinematic illusion, not least of all the "happy couple" of the title, Juan (Fernando Fernán Gómez), an electrical technician first introduced on the set of the ill-fated film, and his wife Carmen (Elvira Quintanilla), a seamstress. Cinema provides the only respite from their straitened life in a one-room sublet in a crowded city apartment. Little wonder that during one of their nightly film viewings Carmen is impervious to Juan's attempts to explain the workings of a traveling shot,

or, when she dreams out loud of taking an ocean cruise like the couple portrayed in a romantic film, to his comment that the voyage is a product of rear projection.

Later, Carmen's movie-inspired dreams appear to come true when the couple wins a radio contest sponsored by Florit Soap to live for a day as "esa pareja feliz." But the promised prizes are not what they hoped for – a shopping spree leaves Carmen with a pair of uncomfortable shoes (no Cinderella she) and Juan a harpoon for deep-sea diving, while dinner in an elegant restaurant finds them unable to decipher the menu, which is in French. The film's conclusion, a shot of Carmen and Juan strolling down the city street, flanked by park benches peopled with homeless men to whom they distribute the gifts, would seem to offer protagonists and audience a clear lesson on the need for resignation to reality and the fruit-lessness of taking refuge in temporary illusion. Yet the film as a whole works to undercut that message. Despite the glaring contrast between the falseness of cinema, whether the Cifesa epic evoked in the opening scene or Carmen's diet of Hollywood romances, and the meager reality of the couple's material existence, the film endorses no easy opposition between cinema and real life. In its exposition of the couple's life together, *Esa pareja* has recourse to a series of classic cinematic narrative tropes: a flash-back to the first meeting; their wedding and honeymoon capped by a movie-kiss, the self-referential nature of which is empha-sized by the camera receding through a window frame. The retrospective sequence closes with a lengthy shot that depicts Carmen and Juan on the roof of their building as spectators to their own past. In this context Juan's striving for upward mobility through a series of correspondence courses and disastrous stabs at entrepreneurship are revealed as no less an illusion than Carmen's attraction to films. The film's realism consists not in a denunciation of cinema's ephemeral magic but in an invitation to spectators to consider the illusions that drive their lives beyond the four walls of the movie theater.

No less than *Esa pareja feliz*, *Bienvenido Mr. Marshall* thematizes an explicit rejection of the dominant Spanish film genres of the previous decade, in this case both the *españolada* and the historical epic. Ironically, as Peter Besas recounts, the original commission for the film had called for an Andalusian setting and four musical numbers for the rising *folk-lórica* Lolita Sevilla.[14] The final result, a collaboration among scriptwrit-ers Bardem, Berlanga, and humorist and playwright Miguel Mihura, would offer instead a comic *reductio ad absurdum* of the Andalusia = Spain

equation that had sustained the myth-making *españolada*, as the inhabitants of a sleepy Castilian village disguise themselves and their town as a movie-set Andalusia to welcome the members of an American delegation. For, as the title's allusion to the Marshall Plan aid denied to Spain suggests, the nation imaged in the film's setting of the isolated *pueblo* of Villar del Río offers an ironic counterweight to those earlier folkloric or imperial fantasies.

As their clever, if ultimately unsuccessful (the Americans drive through the town without stopping) appropriation of cinematic techniques of self-representation makes clear, the citizens of Villar del Río, despite their marginalization, are figured as experienced film spectators. A mock documentary opening presenting the presumed highlights of the typical but unremarkable town calls attention to the central role of weekly cinema sessions in village life. Later a brilliant series of dream sequences invoke an array of cinematic genres and national film styles as a vehicle for expressing the wishes and fears of four of the town's inhabitants on the eve of the Americans' visit. Where the mayor imagines himself a sheriff in a Hollywood Western and the priest's suspicions towards materialistic American values are expressed in the paranoid style of *film noir*, the town's down-on-his-luck nobleman, also hostile to the Americans' visit, relives his ancestors' encounter with the original Americans as a parodic take-off on a Cifesa production, complete with a heroic conquistador who climbs from a cardboard sea into the natives' cauldron of boiling water. Still a fourth dream, attributed to the everyman Juan, juxtaposes the epic style of Soviet socialist realism with the *deus ex machina* appearance of the Three Wise Men (who, rather than Santa Claus, deliver gifts to children) piloting an American plane that delivers a tractor to the grateful Juan and family waiting in a field below.

Although certainly a reflection of the international horizons of production and reception afforded to and by students of the IIEC film school, the movie-dream scenes are notable for their assault on a certain myth of national cinema. In its equal-opportunity pastiche of various national film styles and genres, *Bienvenido* makes no distinction regarding the aesthetic or ideological superiority of one over another. Through its appropriation of a variety of national and international film languages, joined here in their common capacity to express the wishful contents of a specifically Spanish imaginary, the film effects a radical disjuncture between a nation's myths and its cinema.

In *The Dialogical Imagination*, Bakhtin characterizes such a process as

key to a passage from a mystifying, monological culture towards a dialogical model of contact and exchange. In his words: "This verbal-ideological decentering will occur only when a national culture loses its sealed off and self-sufficient character, when it becomes conscious of itself as only one among other cultures and languages. It is this knowledge that will sap the roots of a mythological feeling for language, based as it is on an absolute fusion of ideological meaning with language."[15] Nowhere is this concept of decentering more relevant than in the transitional Spanish cinema of the early 1950s, in the movement away from autarky and myth-making. As we have seen, contact with and the assimilation of the cinematic languages of neo-realism, Hollywood genre films, and the Spanish *sainete* tradition enabled film-makers like Nieves Conde, Bardem, and Berlanga to shape their portrayal of a changing Spanish society. Their work and that of subsequent, dialogical Spanish "realists" – Marco Ferreri, Fernando Fernán Gómez, and scriptwriter Rafael Azcona – constitute a crucial chapter in the analysis of cinematic representations of the national.

The 1960s in Spain confirmed the opening toward Europe and other western industrial nations glimpsed in the previous decade, and reflected in its cinema. Having secured Spain's diplomatic rehabilitation beginning with the US military base agreement in 1953 (which granted the US the right to create military bases on Spanish soil) and admission to the United Nations in 1955, the regime signaled its intended incorporation into the world market economy in 1957 with the entry of Opus Dei technocrats into Franco's sixth cabinet. By 1962, Spain had initiated negotiations regarding membership in the Common Market (the European Economic Community). With tourism as well as foreign investment fueling an economic revitalization that Francoist ideologues came to see as the best weapon against political unrest, the government gave increasing attention to promoting and manipulating its image as an economically modern, "open" nation abroad.

The New Spanish Cinema was the first sustained attempt to implement this revised strategy in the cultural arena. It came on the heels of the violent failure of a more *ad hoc* attempt to use cinema as an arm of foreign policy, the scandal provoked by Luis Buñuel's *Viridiana*, Spain's entry to the 1961 Cannes Film Festival. When Bardem and Ricardo Muñoz Suay approached Buñuel – after Picasso perhaps the most celebrated cultural figure of the post-Civil War diaspora – regarding his return to Spain to

make a film, the Ministry of Information and Tourism (tellingly, the then home of the cinema sub-ministry) saw only the possibility of a major public relations coup, tangible proof of the artistic freedom and lack of censorship in a "new" Spain. *Viridiana* carried off the top prize, the Golden Palm, the first and only Spanish film to do so, but a scathing editorial in the Vatican paper condemned the film as blasphemous. The resulting scandal brought down the then Director-General of Cinema, José Muñoz Fontán, shortened the career, and perhaps life, of Information and Tourism Minister Gabriel Arias Salgado, and abolished the production company UNINCI, which had been responsible for several of the most influential films of the 1950s.

The new Minister of Information and Tourism named in July 1962, Manuel Fraga Ibarne, was clearly determined not to repeat the mistakes of the *Viridiana* affair. After only a few days in office, Fraga named former Director-General García Escudero to the cinema post. In the context of the time, both Fraga and García Escudero passed for liberals. The latter, beyond his part in the *Surcos* debate more than a decade earlier, had also played a major role in the 1955 Salamanca Conversations, a week-long conference that brought together a diverse group of cinema professionals, critics, and intellectuals from all points on the political spectrum. Their harsh diagnosis regarding the pitiful state of the Spanish film industry and their somewhat more hopeful, and surprisingly consensual, prescriptions for its resuscitation ultimately provided the blueprint for the New Spanish Cinema that was born and developed under García Escudero. The reforms introduced by Fraga and García Escudero had two major components. For the first time the cinema sub-ministry issued written censorship norms; prior to 1963 the censors had adjudicated films on a case-by-case basis without reference to "objective" criteria. In retooling the subsidy system, García Escudero sought to promote the incorporation of film school graduates (the IIEC was renamed the Escuela Oficial de Cine, EOC, in 1962) into the national film industry and to encourage and promote a "quality cinema" with certain artistic and social pretensions that could also compete for recognition at foreign film festivals. Thus he replaced the old "National Interest" category with one deemed "Special Interest." While all films were automatically eligible for subsidies of up to 15 percent of box office gross, artistically superior films could qualify for financial support up to a total of 70 percent of production costs.[16]

As a result of García Escudero's efforts, Spanish cinema acquired a

visible profile abroad for the first time. The earlier international successes of Berlanga, Bardem, and Ferreri notwithstanding, the films of EOC graduates Carlos Saura, Mario Camús, Basilio Martín Patino, Miguel Picazo and others produced a trademark of sorts, "the New Spanish Cinema" – that served to situate the Spaniards among a would-be vanguard of 1960s European "independent" film movements, the *Nouvelle vague*, British Free Cinema. Of course the Spanish "new cinema" was hardly independent but rather the outcome of a double-barreled cultural politics of "possibilism," a *de facto* compromise between attempts at creative expression by dissident intellectuals and a government-sponsored reformist project itself torn between a Christian social agenda and an international exercise in image building.

Although García Escudero's mandate ended in 1967, both the spirit and substance of the New Spanish Cinema would continue to guide the production of an art cinema in Spain well into the 1970s (indeed, one could argue that a similarly bifurcated agenda, and the same ambiguities, lie behind the predominant Spanish cinema of the Transition and the socialist governments of the 1980s). Several of the directors who debuted under García Escudero in the 1960s went on to have influential careers. For example, Mario Camús, building upon his initial collaborations with writers Ignacio Aldecoa and Daniel Sueiro, codified a vein of Spanish critical realism that persists today. And Basilio Martín Patino, whose first film *Nueve cartas a Berta* (Nine Letters to Bertha, 1965) offered an expressive synthesis of documentary and fictional modes, created a unique body of work that continues to challenge formal and industrial boundaries. Although Carlos Saura's first two films, *Los golfos* (Ragamuffins) and *Llanto por un bandido* (Tears for a Bandit) precede the García Escudero period, his three films from the years 1965–1967, *La caza* (The Hunt), *Peppermint frappé* and *Stress es tres tres* (Stresssss) have been seen as some of the primary beneficiaries, and exponents, of the New Spanish Cinema project. The metaphorical, even allegorical style that communicated a sharp critique of Spanish society to sympathetic and informed spectators while at the same time eluding the censors' scissors, and the tortured characters whose modern problems – lack of communication between men and women, the pressures of urban, consumer society – elicited knowing recognition from a bourgeois intellectual audience, made Saura's cinema the most marketable and highly esteemed abroad. Rather than exploiting the image of a stereotyped Spanishness, the "difference" promoted by Fraga's contemporary tourist campaigns,

Saura's films embraced the narrative ambiguities and stylized language of the European art cinema.

Nevertheless, it would be reductive to equate the New Spanish Cinema exclusively with an art cinema auteurism and its cult of the director.[17] Marvin D'Lugo has argued convincingly regarding the larger political role exercised by Spanish auteurism as vehicle for social critique and in the development of an "anti-hegemonic [cinema] style that was a rebuke to the Francoist ideology of representation."[18] Auteurism, as practiced in Spain during the 1960s and 1970s, was frequently a collective affair, a collaborative process involving producer and production company as well as director. In fact, one of the most influential figures in the New Spanish Cinema, the individual, next to García Escudero, most responsible for its impact, was producer Elías Querejeta. A former professional soccer player from the Basque Country who counted several EOC students and alumni among his closest friends, Querejeta took advantage of the subsidy policies that allowed an individual to make films without investing his own funds and soon became a master at navigating the bureaucratic and political labyrinths regulating Spanish cinema production. His role in the films he produced ranged widely: from co-authorship of scripts to negotiating with the censors and Director-General, to appeals over subsidies and classifications. Querejeta also assembled a form of repertory company, a production crew composed of Luis Cuadrado (later Teo Escamilla) as director of photography, Pablo G. del Amo as film editor, production chief Primitivo Alvaro, and composer Luis del Pablo, that worked with him on all of his films. Between 1965 and 1975 Querejeta made nine films with Carlos Saura and produced the first features of two of the most celebrated directors of the following generation of EOC graduates, Víctor Erice (*El espíritu de la colmena*, The Spirit of the Beehive, 1973) and Manuel Gutiérrez Aragón (*Habla, mudita*, Speak, Mute, 1973).

A similarly collaborative model lies behind the production of one of the most emblematic, if less well known, films of the early 1970s, Jaime de Armiñán's *Mi querida señorita* (My Dear Young Lady, 1971), produced by José Luis Borau. Borau, an EOC graduate and later professor, had made two films during the García Escudero period, *Brandy* (1964) and *Crimen de doble filo* (Two-Edged Crime, 1965), both original variations on genre themes – the Western and thriller, respectively – out of favor with the ministerial strategies of the moment. His search for greater artistic freedom led him to found his own production company, El Imán. *Mi querida señorita*, co-scripted by Borau and Armiñán, takes place in a Spain riven by

conflicts between tradition and modernity. Indeed an early scene stages a literal collision between the two, as a car driven by the fortyish spinster Adela in her dark dress and black mantilla nearly runs down a mini-skirted teen with long flowing blond hair. Despite the presence of such symbolic moments the film mocks the allegorical imagery of the New Spanish Cinema (as in a later scene when the protagonist, traveling by train, emerges into the light from a dark tunnel onto a track that diverges in two directions), opting instead for a reflexively hybrid style that owes more to the absurdist farce of Berlanga and Ferreri.

In the small town of the film's setting, all the old certainties and identities are undermined. Daughters rebel against fathers. The parish priest speaks as the voice of liberalism and ecumenical tolerance. Even Adela herself is not what she seems; she shaves every morning and experiences a troubling attraction toward her maid, Isabelita. When a marriage proposal from an old friend and the resultant prospect of physical contact with a man finally force her to confront her feelings, Adela consults a physician (played by Borau himself in an unidentified cameo). Her problem, according to the doctor, is not a question of mental illness or physical imbalance, but "of a complete and total identity." Adela – like Spain? – has been living at odds with her true self. She undergoes surgery to become a man, bringing appearance into line with reality.

The rest of the film recapitulates a repertory of themes and motifs from the cinema of the 1950s, 1960s and 1970s: the escape from the provinces to the city, search for employment (with "her" traditional feminine education, the only skill Adela turned Juan possesses is sewing), and down payment on a high-rise apartment on the outskirts of the capital. In a playful elision between a sentimental love story and the sex comedies invading Spanish screens in the 1970s, a further plot twist unites Juan with Isabelita, now working in Madrid as a café waitress. The film's final images find Juan in bed with Isabelita after sexual relations, his successful passage to manhood complete. But a closing comment by Isabelita shatters this apparently successful closure as she addresses him as "señorita." This slyly ambiguous recognition scene brings the identity theme full circle.

Identity, whether of nation or gender, is never stable but always subject to redefinition. A historical overview such as this one reveals cinema's role in the process of national reinvention, and its ultimate unreliability as a vehicle for attempts to project an image of some fixed national character.

NOTES

1. Siegfried Kracauer, *From Caligari to Hitler: A Psychological History of German Film* (5th edn., Princeton University Press, 1974), pp. 7–8.

2. Manuel Vázquez Montalbán, *Cancionero general* (Barcelona: Lumen, 1972), p. 24.

3. Raymond Carr and Juan Pablo Fusi, *Spain: Dictatorship to Democracy* (2nd edn., London: George Allen and Unwin, 1981), pp. 118–120.

4. Augusto M. Torres (ed.), *Cine español 1896–1983* (Madrid: Ministerio de Cultura, 1984), p. 34.

5. Cited in Agustín Sánchez Vidal, *El cine de Florián Rey* (Zaragoza: Caja de Ahorros de la Inmaculada, 1991), p. 241.

6. Jane Feuer, *The Hollywood Musical* (2nd edn., Bloomington, IN: Indiana University Press, 1993), p. 16. See also Rick Altman, *The American Film Musical* (Bloomington, IN: Indiana University Press, 1987), pp. 273–277.

7. See also Román Gubern, "Six aspects du cinéma espagnol," *Les Cahiers de la Cinématique* 38/39 (Winter 1984), pp. 41–46; here pp. 42–44.

8. Francisco Aranda, *Luis Buñuel*. Trans. David Robinson (New York: DaCapo Press, 1976), pp. 112–113.

9. Aranda notes that Buñuel's *La hija de Juan Simón* was advertised with the slogan, "[The film] is like the music of de Falla or the Gypsy Romances of García Lorca – the triumph of the roots of popular culture" (*ibid.*, p. 112).

10. José Caparrós-Lera, *El cine republicano español, 1931–1939* (Barcelona: Dopesa, 1977), p. 161; Diego Galán, "Imperio Argentina," *Les Cahiers de la Cinématique* 38/39 (Winter 1984), pp. 93–99; here p. 96.

11. Timothy Mitchell, *Flamenco Deep Song* (New Haven, CT: Yale University Press, 1994), pp. 97–110.

12. The nature and role of neo-realism's influence in film and literature in Spain is complex. For varied perspectives on the question, see Carlos F. Heredero, *Las huellas del tiempo. Cine español, 1951–1961* (Valencia: Filmoteca de la Generalitat Valenciana, 1993); Barry Jordan, *Writing and Politics in Franco's Spain* (London and New York: Routledge, 1990), chapter 4; and Marsha Kinder, *Blood Cinema: The Reconstruction of National Identity in Spain* (Berkeley, CA: University of California Press, 1993).

13. John Hopewell, *Out of the Past* (London: British Film Institute, 1986).

14. Peter Besas, *Behind the Spanish Lens: Spanish Cinema Under Fascism and Democracy* (Denver, CO: Arden Press, 1985), p. 35.

15. Mikel M. Bahktin, *The Dialogic Imagination*. Michael Holquist (ed.) (Austin: University of Texas Press, 1981), pp. 369–370; see also Kinder, *Blood Cinema*, p. 37.

16. See Vicente Molina Foix, *New Cinema in Spain* (London: British Film Institute, 1977).

17. For a discussion of the evolution of the institution of the auteur in Spanish cinema, see Kathleen M. Vernon and Barbara Morris, "Pedro Almodóvar, Postmodern Auteur," pp. 1–23 in Kathleen M. Vernon and Barbara Morris (eds.), *Post-Franco, Postmodern: The Films of Pedro Almodóvar* (Westport, CT: Greenwood Press, 1995).

18. Marvin D'Lugo, "Authorship and the Concept of National Cinema in Spain," pp. 327–342 in Martha Woodmansee and Peter Jaszi (eds.), *The Construction of Authorship* (Durham, NC: Duke University Press, 1994), p. 336.

FOR FURTHER READING

D'Lugo, Marvin. *The Films of Carlos Saura*. Princeton, NJ: Princeton University Press, 1991.

Egido, Luciano G. "Le Cinéma d'intérêt national," *Les Cahiers de la Cinématique* 38/39 (Winter 1994), pp. 47–53.

Evans, Peter. "Cifesa: Cinema and Authoritarian Aesthetics," pp. 215–222 in Helen Graham and Jo Labanyi (eds.). *Spanish Cultural Studies* (Oxford: Oxford University Press, 1995).

Fanes, Félix. *Cifesa, la antorcha de los éxitos*. Valencia: Institución Alfonso el Magnánimo, 1982.

Gubern, Román. *El cine sonoro en la II República, 1929–1936*. Barcelona: Lumen, 1977.

Hernández Les, Juan. *El cine de Elías Querejeta, un productor singular*. Bilbao: Ediciones Mensajero, 1986.

Higginbotham, Virginia. *Spanish Cinema under Franco*. Austin, TX: University of Texas Press, 1988.

Kinder, Marsha (ed.). *Refiguring Spain: Cinema/Media/Representation*. Durham, NC: Duke University Press, 1997.

Mitchell, Timothy. *Violence and Piety in Spanish Folklore*. Philadelphia, PA: University of Pennsylvania Press, 1988.

19

Culture and cinema, 1975–1996

Arguably the single most important event in the history of cinema in Spain after 1975 was the official abolition of censorship in 1977, thus bringing to an end a system that allowed the state censor to cut or destroy a film during shooting and at pre- and post-shooting stages. The prime movers behind Franco's censors were the Catholic church. With the secularization of the state under the new constitution, the church's fading influence over the population as a whole (by 1991 only 49 percent of the population considered themselves practicing Catholics)[1] was quickly reflected in the cinema's eager neglect of all the old taboos. Since 1975 the church itself has forfeited the kind of reverential treatment which it had enjoyed under the *ancien régime* in pious films like *Marcelino pan y vino* (Marcelino Bread and Wine, Vajda, 1954) or *Balarassa* (Nieves Conde, 1950). Films like *Padre nuestro* (Our Father, Regueiro, 1985) took a more jaundiced view – almost approaching in tone the satirical treatment of the clergy in nineteenth-century novels like *La Regenta* (The Regent's Wife) – of the working lives of Spanish priests.

The easing of the censor's grip has meant the radical transformation of the Spanish cinema in its approach to questions related above all to national identity, sexuality and gender relations. The new tone may be measured by a film like *Gary Cooper que estás en los cielos* (Gary Cooper Who Art in Heaven, Miró, 1981) where the main character's profession as an investigative journalist draws attention to the new democracy's commitment to press freedoms. The early euphoric years delivered films that were impatient to tackle head-on issues that formerly could only have been raised indirectly. Among the films that began to unlock pre-Civil War memories, Carlos Saura's *Carmen* (1981) was exemplary in redefining Spain's relationship both to its past and to its future as a European nation.

Since *Carmen,* a wide variety of film-makers have addressed questions of national identity: for instance, Bigas Luna in *Jamón jamón* (Ham Ham, 1992), Julio Medem in *Vacas* (Cows, 1991) and Vicente Aranda in *Libertarias* (Women Freedom Fighters, 1995).

Carmen reflects the country's desire to balance renewed interest in regional cultures with embrace of a unifying European ideal. Here – as in the related "Gypsy" films *Bodas de sangre* (Blood Wedding, 1981), *El amor brujo* (Love the Magician, 1986) and *Flamenco* (1995) – Saura explores gypsy culture, treating it not as a tourist-trap synecdoche for the whole of Spain,[2] but as an important, even key element in the cultural fabric of the south. As the cast rehearse the staging of the Flamenco *Carmen* the true rhythms, nuances and aspirations of gypsy culture are teased out. But while old myths are deconstructed realism is not jettisoned in the film's representation of a society as yet not wholly liberated from some of the prejudices of the past, even as it strives to take up its place in the wider community of European nations. The point is made in a multitude of ways, nowhere more forcefully than through attempts to blend the gypsy rhythms of the music with the more western harmonies of Bizet's score. Nevertheless, the film's exposure of the reductive processes to which Spanish culture in general has been subjected both inside and outside Spain do not ultimately jeopardize the project for the country's assimilation – on equal terms, with distinctiveness intact – by the European Community. Both under the PSOE and PP administrations Spaniards have led the way in supporting the drive towards the greater unity of the European Community. Even now, as some countries hesitate over monetary union, the PP is said to be determined to make Spain take the initiative in fully implementing the Maastricht treaty, which mandated monetary union. Culturally, too, Barcelona and Seville projected themselves in 1992 as European cities for the Expo and Olympics. More generally, in cultural terms, the country opened itself up to currents – especially in relation to questions of gender – that had already been affecting other parts of Europe and elsewhere since the late 1950s.

Complementing these pro-European drives in films like *Carmen* were others that explored the realities and myths of the regions. Julio Medem's *Vacas* and Armendáriz's *Tasio* (1984) focus on the Basques; Aranda in *El amante bilingüe* (The Bilingual Lover) on the Catalans; Bigas Luna, in *Jamón jamón, Huevos de oro* (Golden Balls) and in *La teta y la luna* (The Teat and the Moon), ranges widely over the customs and rituals of different parts of Spain. These are witty narratives concentrating, in the former,

through the central conceit of ham as a key signifier of Spanish culture, on sexual desire and masculinity, and in the latter two, on Oedipal questions. *Huevos de oro* (1993), a film endorsing Bigas Luna's sustained obsession with virility, exposes with equal ferocity the consumerist ethos for which *felipismo* (after Felipe González, the prime minister), and many years of hardly radical Socialist government, was to a large extent responsible. In *Huevos de oro* Javier Bardem appears in the lead role of an individual motivated almost exclusively by materialistic drives. In his singleminded pursuit of wealth he is the inheritor of the more squalid ideals of the Socialist government, cutting corners and taking unacceptable risks in pursuit of his own selfish aims. Furthermore, in assigning to Bardem, the disreputable charmer, a tawdry taste for Dalí and Julio Iglesias, Bigas Luna highlights what he clearly regards as the country's fast fading cultural ideals of the early years in Spain's new-world democracy.

By the end of the 1980s and the beginning of the 1990s, of course, the scandals of the Socialist Party were beginning to remove some of the gloss from post-Franco politics, even though, despite these reverses, there was never any real threat of a return to the old order. The failed Tejero coup of 23 February 1981 had exposed the futility of the far right, and even when the center-right – in the shape of Jose María Aznar's PP – did finally wrest power away from the PSOE, the difference between the two parties was very close, a protest vote result reflecting perhaps more disappointment with those in power than the desire for a return to more conservative forms of government. The memories of the regime and the Civil War that legitimated its authority are etched too deeply in the minds of the population, even those born too late to have known either, something the cinema has continued to reflect.

The dictatorship's death throes were marked in the cinema by films like Camino's *Las largas vacaciones del 36* (The Long Vacation of 1936, 1976) and Saura's *Cría cuervos* (Raise Crows, 1975), the former exploring the rifts within the same family, as various members spend the summer in Catalonia while Franco's army is on the march; the latter recording the effects of reactionary ideology on a middle-class family in which the women and children become the primary victims. These films are early examples of 1970s Spanish cinema's impatience to release dictatorship-induced frustrations, above all those related to prohibitions on discussions of the Civil War and its aftermath. Saura's interest in the topic survived into the 1980s in *¡Ay Carmela!* (released in 1990), Carmen Maura's exuberant portrayal of the reluctant Republican heroine not entirely outweighing the

ultimately somber thematics and pathos surrounding the two other main characters, played by Andrés Pajares and Gabino Diego. The Spanish Nationalist officers here ridicule what they regard as the irredeemably effeminate nature of their Italian allies, but they in turn, above all in their resolute inhumanity, become the film's surest sources of contempt.

Where ¡Ay Carmela! is made in hindsight, in the safe and pleasing knowledge of the regime's dissolution, Cría cuervos, coming right at the end of the Caudillo's reign, can only long for change, in the hope, gratified eventually of course by subsequent developments following the succession of Juan Carlos, that the ravens of history would return to peck out the eyes of those who raised them. The film makes connections between private and public power structures, concentrating through its male army officers and female "angels in the house" (wife, mistress, daughters, grandmother, aunt, housekeeper) on the abuse by a hierarchical ideology of its mainly female victims. The wife has had to abandon a promising career as a pianist, the mistress is trivialized, the daughters are caught up in the crossfire of warring parents, the grandmother is mute, the aunt has internalized the authority of the regime, and the housekeeper had long ago become her master's sexual plaything.

The links between the private and public domains are also explored in José Luis Borau's splendid indictment of the regime, Furtivos (Poachers, 1975). Here, in a film that draws on myth as well as on recent history, women are not represented as mere victims; instead some are seen as willing collaborators in the ideological project of franquismo. The "castrating mother" (no mere Freudian allusion in this film) victimizes and infantilizes her offspring in ways that recall processes characteristic of the great films of Buñuel and Hitchcock. Borau has himself drawn attention to the family resemblance between Tristana's Saturna and his own Martina, both parts played by Lola Gaos, a woman from whose socialized subjectivity her disturbed offspring (a disturbance taking the form of deaf-muteness in Tristana, and diffidence in Furtivos) seek, in the name of a whole Franco-deformed population, final release.

The status and treatment of women during and after the Civil War has continued to fascinate directors in the 1990s, with Aranda's Libertarias (1995) and Azucena Rodríguez's Entre rojas (In with Reds, 1995) among the most interesting of recent Civil War or Francoist narratives. The action of Libertarias takes place in the early days of the Civil War, focusing on the lives of a group of women who decide to take an active role in the proceedings on the Republican side. Although eventually it is not exempt

from cliché – chief among which is to lay the blame for the most serious brutalities on Franco's Moorish, as distinct from Spanish, troops – the film reflects a trend in Spain for offering greater scope for women's narratives and her/stories, a characteristic borne out by the emergence in recent years of female film directors in Spain.

Pilar Miró and Josefina Molina are the two outstanding figures, especially in the 1980s and early 1990s, with films like *Gary Cooper que estás en los cielos* (1981) and *Lo más natural* (The Most Natural Thing, 1990) indirectly acknowledging the rise of feminism in Spain, a development reflected in the country's changing attitudes toward divorce, abortion, and the place of women both at home and at work. These trends affected at first by the absorption of American and European feminist writing and subsequently by the work of Spanish feminists in print as well as in the creation in 1983 of organizations such as the Instituto de la Mujer, designed to look after women's issues. In this changing climate a film like *Entre rojas*, by Azucena Rodríguez, was able to concentrate for a change not on the persecution of male dissidents, but on female victims and opponents of the regime. The film traces the life of a young woman (Penélope Cruz), imprisoned because of her relationship with a young political activist. In prison she is befriended by women from all walks of life, ranging from intellectuals to housewives and prostitutes. What she learns from them all is solidarity, finally reaching the conclusion, as she later remarks, "the difference between us and those who are outside these walls is that they are also in jail, but they just don't know it." The film is to a certain extent autobiographical, since Azucena Rodríguez had herself spent time in one of Franco's jails, accused of belonging to an outlawed political group. In both of these films may be seen some of the most vibrant ego-ideal actresses of the times: Ana Belén, Ariadna Gil, Victoria Abril, Penélope Cruz, Cristina Marcos. These, together with Carmen Maura, have been the screen surrogates of the Spanish New Woman. In their different ways all blend femininity with assertiveness, beauty with power. Ana Belén's appearances in films like *La petición* (The Petition, Miró, 1976), *Divinas palabras* (García Sánchez, 1987), or *La pasión turca* (Turkish Passion, Aranda, 1994) are characterized by forcefulness and charismatic presence, qualities further enhanced both by her association (alongside her husband the protest-song singer Victor Manuel) with left-wing politics and by her work not just as an actress but as a film director in the Carmen Rico-Godoy scripted *Cómo ser mujer y no morir en el intento* (How to be a Woman and Not Die Trying, 1991). These three films are all characterized

by the strongmindedness of a woman no longer content to fall into the entrapments of stereotype. Even *La pasión turca,* based on the novel by Antonio Gala, a film that has attracted criticism for its problematic treatment of the relations between the sexes, offers her an opportunity to continue the post-Franco theme of women's desire for emancipation from the taboos of the past. Here the bored housewife heroine hails, significantly, from a well-to-do provincial family from Ávila (changed from the novel's Huesca), deciding finally to risk everything by leaving her husband for a local tourist-guide lover whom she meets while on holiday in Turkey. Whatever its faults, the film captures an almost quixotic desire expressed by many modern women for release from the petty values of Castilian provincialism.

Like Ana Belén (formerly a child star appearing in light films), Penélope Cruz has pursued a career that has progressed from her appearance as girlish, victimized but ultimately resilient prostitute's daughter in *Jamón jamón* to the more forceful politically conscious dissident in *Entre rojas,* a transformation mirrored by her changed gold-haired look of the later film, replacing the earlier more adolescent image.

The changed circumstances and attitudes of women are even reflected in romantic comedies, of which there have been some wonderful examples that bear comparison with recent Hollywood successes. *Sé infiel y no mires con quién* (Be Faithful, but it Doesn't Matter to Whom, Trueba 1985) and *Todos los hombres sois iguales* (You Men Are All Alike, Gómez Pereira 1993) measure up to, say, *French Kiss* or *The Truth About Cats and Dogs.* As with Hollywood, the Spanish film industry recognizes the box-office appeal of romantic comedy, inheriting the classical traditions of its illustrious Hollywood progenitors (e.g. *Bringing Up Baby* or *The Lady Eve*) in often relying on narratives that concentrate on the female's subjection of the male to a necessary *éducation sentimentale.*

Whether in romantic comedy or in melodramatic roles, the Spanish cinema has in Victoria Abril and Carmen Maura two outstanding actresses of truly international stature. Both have made their mark not only in Spain but also abroad, Victoria Abril appearing in *Gauzon maudit* (1995), Carmen Maura in *Le Saut périlleux* (1992) and *Soleil levant* (1992). Carmen Maura, director Almodóvar's early inspiration, has become one of the most brilliant stars of the Spanish cinema. Appearing as a *progre* – a modern, progressive, "with-it" character – in early films like *Tigres de papel* (Paper Tigers, Colomo, 1977), she went on to star as a *comédienne* in such madcap films as *Pepi, Luci, Bom y otras chicas del montón* (Pepi, Luci,

Bom and Other Chicks Like That, 1980), progressing in Almodóvar's later films to roles characterized by a mixture of comedy and pathos, exemplified above all by films like ¿Qué he hecho yo para merecer esto? (What Have I Done To Deserve This?, 1984), La ley del deseo (The Law of Desire, 1987) and Mujeres al borde de un ataque de nervios (Women On the Verge of a Nervous Breakdown, 1988). If we study the lives of the stars we can see the important connections between their offscreen life and onscreen persona. In many ways Maura's career charted the changed circumstances of women's lives in post-dictatorship Spain; a member of a comfortably off family, married to someone from her own class, Maura became disillusioned with marriage, seeking her own identity through the pursuit of a career in acting. The early progre films identified her quickly as someone who was taking full advantage of the new freedoms, political, sexual, and sexually political, and that image of independence has remained an essential element of her screen persona to this day in films like El palomo cojo (The Lame Pigeon, 1995). Both as object of desire and as ego-ideal Carmen Maura represents the aspirations of many Spanish filmgoers, her appearances as a TV presenter further blurring the distinctions between art and life. Increasingly in the Spanish cinema the confusion of modes and genres serves, as in other national cinemas, to create an image of virtual reality, strengthening the processes of identification between spectator and star. Miguel Bosé (singer and actor), Penélope Cruz (actress and model), or Maribel Verdú (film and TV actress), for instance, are all caught up in strategies that increasingly narrow the distance between star and spectator. The ordinariness of the star – no longer in more democratic times as out of reach as before – is more in evidence than ever. Maura's TV appearances as a chat-show presenter, as well as her much publicized problems in her private life, seem therefore ideally suited to her role as a comic/melodramatic victim/heroine above all in the Almodóvar films. In the Doris Day comedy as Italian neo-realist melodrama ¿Qué he hecho yo para merecer esto?, she excels as someone finally provoked beyond measure by the despair of poverty, cultural banality, urban drabness, and a Nazi-sympathizing husband unmoved by democracy's New Man redefinitions of masculinity. In La ley del deseo the Maura body is transformed from the dowdiness of the earlier film, becoming instead the site for a projection of issues related to sexual ambiguity, her role here casting her as a transvestite, a constant theme of Almodóvar's as he tirelessly explores the ambiguities of gender and sexuality.

These two films edge closer to melodrama, while the narrative of

Mujeres al borde de un ataque de nervios, whose early scenes also firmly belong to the genre, move along an upward curve towards comedy. The upbeat tone of comedy here, though, is not associated with the union or reconciliation of the happy couple; the affirmative note on which the film closes – though the Maura character has nevertheless not given up entirely on sexual relations – is linked to the self-awareness and assertiveness of the Maura character fashioned in the crucible of life with Ivan "the terrible." The Maura star persona is identified with steely resistance and cheery survival, her roles often associated not only with freedoms of various kinds but also with a career. Maura's place is assured now as one of the major successes of the Spanish cinema in the 1980s and 1990s. And although her roles in films like Saura's *¡Ay Carmela!* have matched anything she has ever previously done, her work with Almodóvar – abruptly curtailed following rows during the Hollywood Oscar awards when *Mujeres al borde de un ataque de nervios* was nominated for best foreign film – remains unsurpassed, especially as regards the way Almodóvar captured the mood of a changing culture in a country eagerly throwing off the shackles of the past.

Maura's collaboration with Almodóvar is matched in this respect by the work of that other prominent "chica Almodóvar," Victoria Abril. Even when appearing in mediocre films by Almodóvar or other directors, she is, as José Luis Villalonga writes, someone who ". . . pueda encerrar tal carga de erotismo que incluso una mediocre película como *Tacones lejanos* [High Heels, 1989] resulta como una aprobación de la vida de más allá de la muerte" (someone who can embrace such an erotic charge that even a mediocre film like *Tacones lejanos* becomes an affirmation of life beyond death).[3] Major films like *Átame* (Tie Me Up, Tie Me Down, 1991) and *Amantes* (Lovers, 1990) see her in different roles – the former victimized by a pervert (Antonio Banderas), the latter a mature *femme fatale* in the *film noir* mold – overcoming difficult circumstances to stamp her authority on everyone around her. More recently, in *Gazon maudit,* she has made her own contribution to the greater awareness in mainstream Spanish cinema of lesbian sexuality and relationships. Through the star presence of actresses like Victoria Abril, the Spanish cinema has progressed from the inanities of the early post-dictatorship films in which nudity for nudity's sake was the norm (films described with the word *destape* – nudity – and featuring actresses like Barbara Rey, Nadiuska, and others), to more thoughtful representations of the body, gender, and sexuality, in realistic and provocative narratives that cover a comprehensive range of issues and situations. Almodóvar's films have led the way here. Their

appeal has been to all audiences, especially youth and dissident audiences at first, but increasingly to more varied tastes. The early films captured the mood of the Madrid *movida,* making of the capital the site no longer of sober social and political orthodoxies but of fantasy, experiment, color, style, and irreverence. Crammed with crazy characters, the films had a freshness and vitality that dramatized the needs and desires of newer generations. The formal qualities of these films reflect in their use of the strategies and drives of popular cinema, both indigenous and foreign (especially, of course, Hollywood), post-modernist disregard for generic hierarchies. Almodóvar's films are heavily indebted to the traditions of Spanish frothy comedies starring 1960s and 1970s favorites like Concha Velasco and Gracita Morales, as well as to Hollywood comedies, musicals, and melodramas like *All that Heaven Allows* (Douglas Sirk, 1954), *Funny Face* (Stanley Donen, 1954), or *The Apartment* (Billy Wilder, 1960). Even though his films have begun to iron out some of the zaniness, popular forms continue to fascinate him, as the Sirkian *La flor de mi secreto* (The Flower of My Secret, 1995) demonstrates, with Marisa Paredes's betrayed wife coming straight out of the Hollywood "Woman's Picture" gallery of suffering middle-class matrons.

If Almodóvar's films have been characterized by strong parts for women, their treatment of men, and their exploration of the complexities of masculinity and male sexuality (especially gay), has been no less remarkable. The camera in these films concentrates as often on the male object of desire as on the female, with Antonio Banderas, perhaps above all in Almodóvar's films, especially in *La ley del deseo,* reflecting a marked trend in the Spanish cinema to eroticize the male as well as the female. Banderas's Almodóvar films have led to international recognition and roles as the Latin lover stereotype in a wide variety of Hollywood films ranging from thrillers like *Desperado* (1995) to comedies like *Two Much* (1995). But the visual display of Banderas's gay lover in *La ley del deseo* belongs to a wider investigation of modern masculinity, ranging at one extreme from Saura's interrogation in *El Dorado* (1988) of resilient cruder forms to the feminized variants often identified with actors like Jorge Sanz (in films like *Belle époque* and *Amantes).* While many of these films are inspired by the post-1975 climate of inquiry, experiment and challenge, other films perhaps reflect in their grimmer accounts of male subjectivity the growing disillusionment with the scandal-dominated PSOE government of recent years, a frustration that eventually led, of course, to defeat in 1996 by Jose María Aznar's PP. Thrillers like *Días contados* (Numbered

Days, 1995), *El detective y la muerte* (The Detective and Death, 1995) or *Nadie hablará de nosotras cuando hayamos muerto* (No One Will Speak about Us when We're Dead, 1995) indirectly refer through their *noir* narratives to the survival or renewed embrace of less noble forms of masculinity, and by extension to the seedier, more self-centered ethos of the late 1980s and 1990s. Together with, say, a film like Montxo Armendáriz's *Historias del Kronen* (Tales from the Kronen Bar, 1995), with its portrayal of the new, Ecstasy-crazed members of the so-called 'generación X,' these brilliant films hold up a mirror to a society that to many was beginning to lose its way. The actors who perhaps most vividly represent these trends are Carmelo Gómez and Javier Bardem, both capable of gentler forms of masculinity, but neither a stranger to brutality. In *Días contados,* a film drawing inspiration from the running sore of the ETA question, Imanol Uribe creates two characters living on the edge, one – a ruthless *etarra* (an ETA sympathizer) played by Carmelo Gómez – ready to suppress finer instincts in the pursuit of political ends, and another, played by Javier Bardem, too wasted for other than selfish aims. The film is one of a multitude of outstanding films made in Spain in the 1980s and 1990s, a sign that despite the greater quota of exhibited foreign films, and despite the disappearance of the subvention system that flourished under the Miró law, the Spanish cinema is in a vigorous state of health. Over the last few years especially, the exhibition of Spanish films has risen to a healthy 10 percent or so of the total market. As regards the quality of the indigenous product, the industry is currently thriving, as Uribe himself said in reply to a question about what he considered to be the greatest period of the Spanish cinema:

> La que estamos viviendo. Hay un plantel de directores, actores y técnicos absolutamente fantástico. Si uno ve el panorama actual, inmediatamente te salen diez o quince directores importantes con algo que contar, con un *curriculum* interesante y además jóvenes, con un camino por delante.

> (The one we're living in now. There is a whole host of absolutely fantastic directors, actors, and technical people. If you see what's out there today, immediately you realize that there are ten or fifteen important directors with something to say, with interesting backgrounds, and who are in addition young, with the whole road open ahead of them.)[4]

Before democracy the Spanish cinema could still rise to the occasion, serving up extraordinary films that with greater distribution would have

taken their place alongside the work of the undisputed giants of European cinema. Buñuel's films were, of course, admired internationally, but with the exception of *Viridiana* and *Tristana* (and one or two scenes in *Cet obscur objet du désir*) these were made abroad, their thematics only indirectly inspired by Spanish realities. Despite all the difficulties, films by other directors – for instance, Berlanga's *Bienvenido Mr. Marshall,* Bardem's *Calle Mayor,* Saura's *Ana y los lobos* (Ana and the Wolves) – did manage to get made during this period, preparing the ground for the eventual explosion of impressive films that took place once all the restrictions were lifted. In one of the key films of the period immediately leading up to the Transition, Erice's *El espíritu de la colmena* (The Spirit of the Beehive, 1973), the desire of the little girls to assert their own individuality through identification with one of the great icons of the cinema, Boris Karloff's monster in the James Whale version of *Frankenstein,* proved prophetic, at the very least in film terms, as if proclaiming the determination of the Spanish film industry as a whole to rediscover its traditional but also transgressive forms once Francoism was well and truly buried.

NOTES

1. Rosa Montero, "Political Transition and Cultural Democracy: Coping with the Speed of Change," pp. 315–320 in Helen Graham and Jo Labanyi (eds.), *Spanish Cultural Studies* (Oxford: Oxford University Press, 1995), p. 316.
2. Jorge E. Urrutia, *Imago litterae: cine, literatura* (Seville: Ediciones Alfar, 1983), pp. 23–29.
3. José Luis Villalonga, "Victoria Abril," *El Semanal* (18 December 1994), p. 106.
4. Rocío García, "Personajes del cine español: Imanol Uribe," *El País* (22 January 1995), p. 30.

FOR FURTHER READING

Caparrós-Lera, José María. *El cine español de la democracia.* Barcelona: Anthropos, 1992.
D'Lugo, Marvin. *Guide to the Cinema of Spain.* Westport, CT: Greenwood Press, 1997.
Edwards, Gwynne. *Indecent Exposures: Buñuel to Almodóvar.* London: M. Boyars, 1994.
Monerde, José Enrique. *Veinte años de cine español: Un cine bajo la paradoja, 1973–1992.* Barcelona: Paidós Ibérica, 1993.
Payán, Miguel Juan. *El cine español de los 90.* Madrid: Ediciones J.C., 1993.
Sánchez Vidal, Agustín. *El cine de Carlos Saura.* Zaragoza: Caja de Ahorros de la Inmaculada, 1988.
 José Luis Borau. Zaragoza: Caja de Ahorros de la Inmaculada, 1990.
Smith, Paul Julian. *Desire Unlimited: The Cinema of Pedro Almodóvar.* London and New York: Verso, 1994.
Torres, Augusto M. *Diccionario Espasa cine español.* Madrid: Espasa Calpe, 1996.
Vincendeau, Ginette (ed.). *Encyclopedia of European Cinema.* London: British Film Institute, 1995.

Luis Fernández-Galiano

20

A century of Spanish architecture

278 Upon Antoni Gaudí's birth in 1852, less than ten years had passed since the foundation in Madrid of the first national School of Architecture, an institution born of the old Academy of Fine Arts. The vigorous urban development characteristic of Spain during the Restoration gave rise to a new generation of well-prepared builders. The young Gaudí, who had studied at the Facultad de Ciencias of the University of Barcelona, was now able to complete his education at the School of Architecture in Barcelona, established only a few years prior to his graduation. This wave of architecture graduates, educated in Madrid or Barcelona, would practice their profession within the framework of the new urban plans encouraged by the legislation of 1864, 1876, and 1892 which regulated the expansion of major cities. Barcelona, with its 1859 Plan Cerdá, and Madrid, with its 1860 Plan Castro, set the pace for the rest of the nation in urban design. This was further emphasized in the former case by the strategic talent of Ildefonso Cerdà, who put in place the cornerstone of modern urbanism with his *Teoría General de la Urbanización* (A General Theory of Urbanization). The bourgeoisie, a prosperous class which was made wealthy by mining, railroads, Basque metallurgy, and Catalan textiles, embraced urban development and real estate with a fervor that was further nourished by foreign investments and a dynamic stock market.

An increased historical awareness on the part of those architects educated in the official schools, the fashion of monument reconstruction, and the late romantic tenor that defines the latter third of the century, promoted the assimilation of eclectic historicist modes, most notably the neo-medieval. Both the influence of Viollet-le-Duc and the vigor of bourgeois catholicism, fostered by the ideological stimulus of Vatican I

(1869–1870), produced a spectacular revival of the neo-Gothic. This mode manifested itself in a multitude of religious buildings, some of such scale and ambition that they would remain unfinished for long periods of time. This was the case for the Almudena cathedral in Madrid, initiated in 1880 as a Gothic project and completed more than a century later with a neo-classical flavor. A well-known example of this phenomenon is the Sagrada Familia church in Barcelona. Begun in 1881 within a medieval framework, the project soon found itself under the direction of Gaudí, who would never see its completion despite his continuous dedication to it until his death in 1926. The final years of the nineteenth century also witnessed the massive introduction of iron-based architecture. Originally employed for the construction of railway stations, markets, or bridges, it soon extended to other types of buildings. This new type of architecture was immediately considered to be the highest expression of both technological progress and the positivist ideals extolled by the burgeoning bourgeoisie.

In Catalonia this industrial and commercial bourgeoisie expressed its power through *modernismo*. This style, of curved abstract forms, found its greatest interpreter in Gaudí, and its most characteristic architect in his peer, Lluís Domènech i Montaner. Domènech began his career in the neo-medieval mode typical of romantic nationalism, a mode that exalted the glory of Catalonia's medieval history, and established an admirable fusion with the iron-based construction of the industrial revolution. These characteristics are evident in his café-restaurant of the 1888 World Fair in Barcelona. Nonetheless, from this point on his work would be *modernista*. This rationalist and florid architectural language, influenced by the European *art nouveau*, was employed in the creation of his most important building, the Palau de la Música Catalana in Barcelona (1905–1908). The Palau is a polyphonic and polychromatic construction that achieves a Wagnerian dimension through the architectural integration of industrial and minor arts. Younger architects, such as archeologist Josep Puig i Cadafalch or Gaudí's disciple Josep María Jujol would prolong the *modernista* movement until well into the twentieth century. The friendly and optimistic forms of this style, however, would not survive the crisis undergone by traditional society in the 1920s.

Antoni Gaudí represents the zenith of *modernismo* while embodying an originality beyond the grasp of classification. His structural and naturalist expressionism unite the most severe constructive rationalism with

wildly exotic formal fantasies. From the bottle-shaped towers of the Sagrada Familia to his profuse use of parabolic arches, everything in his body of work amalgamates structural intelligence with an almost pantheistic religiosity. The towers evoke both the Berber constructions of northern Africa and the jagged peaks of Montserrat – a place sacred for the Catalans – whereas the parabolic arches are derived from his understanding that the aesthetic logic of this curve is a manifestation of the divine origin of natural laws. In the crypt of the chapel of the Colonia Güell, in the Parque Güell (both were constructed between 1898 and 1905, promoted by Gaudí's patron, Eusebi Güell), and in the Casa Milà (1906–1910) of Barcelona, Gaudí's constructive ingenuity, naturalist sensibilities, and sculptural expressiveness create unusual and disturbing forms close to surrealism.

In other parts of Spain, the first decades of the twentieth century experienced the co-existence of two architectural trends: academicism and regionalism. The more influential of the two was traditional academic monumentalism, represented by Antonio Palacios, creator of significant buildings in Madrid from the Correos (Post Office, 1903–1918) to the Círculo de Bellas Artes (Fine Arts Circle, 1919–1926). The other is characterized by the fervor of regionalisms, which drew inspiration from local architecture with the intention of championing their roots as well as crystalizing their separate identity. Nonetheless, both the *montañés* style of Leonardo Rucabado and the *sevillano* style of Aníbal González – designer of the Plaza de España at the 1929 Seville Expo – share the historicist attitude of Palacios's grandiloquent monumentalism, a style hardly distinguishable from complacent eclecticism. When Mies van der Rohe built the German Expo Pavilion in Barcelona in 1929, the radical novelty of his work exposed the timidity of the contemporary Spanish milieu. Thus, it became evident that the mainstream young architects of this era did not go beyond the emulation of the classicist forms they had been trained to design in school, or the cubist style that only the most audacious among them dared to propose.

Indeed, the most original and extreme proposal of this era was engineer Arturo Soria's Ciudad Lineal, a project that barely received any critical notice by his peers. This project was unique in its ability to identify with the experiences of the European avant-garde. It was designed in 1892 and constructed in Madrid as a development of a linear garden city, organized along the longitudinal axis of community transportation. This adventure persisted until the 1920s without receiving the praise and

support it deserved. Instead, civic energy was invested in the International Expositions of 1929 in Seville and Barcelona, and in the Ciudad Universitaria (University City) in Madrid. The Ciudad Universitaria, initiated in 1927, was modeled after the north American university campus. It was constructed during the Republican period (1931–1936), with the sober use of bricks that characterized the young architects known as the "Generation of 1925." The mentor of this generation was Secundino Zuazo, a severe, eclectic architect and rational urbanist. He created the Casa de las Flores (House of the Flowers, 1930–1932) in Madrid, an excellent example of urban living within block divisions. Additionally, in conjunction with the great engineer Eduardo Torroja, he created the Frontón Recoletos (Recoletos Sports Pavilion, 1935), a structure covered with delicate and spectacular shells of reinforced concrete. Torroja, for his part, would also use these techniques in the elegant, audacious stands of the Hipódromo de la Zarzuela (Zarzuela Racetrack), completed at the same time as the Ciudad Universitaria, shortly before the outbreak of the Civil War during the summer of 1936.

The Civil War destroyed a significant portion of the Ciudad Universitaria, where much of the Madrid combat unfolded. Furthermore, it halted the rationalist renovation of architecture, both in its moderate expression in Madrid and its orthodox and radical expression in Barcelona – where the Grupo de Artistas y Técnicos Españoles para el Progreso de la Arquitectura Contemporánea (GATEPAC), a group of architects who followed Le Corbusier – had its more significant nucleus. During the Republican era, the leader of this group, aristocrat and leftist Josep Lluís Sert, spearheaded the construction of two projects for workers: the Casa Bloc (Bloc House, 1932–1936) and the Dispensario Antituberculoso (Anti-TB Dispensary, 1934–1936). Both projects exemplify the hygienist rationalism that the members of GATEPAC had previously expounded in their urbanist proposals, such as the 1933 Plà Macià for Barcelona, a project drafted with Le Corbusier himself. Once the war had begun, Sert designed the Spanish Republic Pavilion in the International Exposition of Paris of 1937. This was a propagandistic effort on the part of the threatened Republic (for which Picasso painted his famous *Guernica*, an outcry in black and white against the barbarism of the war) that did not succeed in altering the course of events. The defeat of the Republic in 1939 was accompanied by the dissolution of the architectural avant-garde, many of whose members were now dead or exiled. Sert would continue his career in the United States, where he replaced Gropius as a Dean

at Harvard University, and completed an extensive, influential, and exemplary body of work.

The post-war reconstruction combined classical, national monumentalism, as manifested in the grand public buildings, and the neo-vernacular, as seen in the rural regions. The architecture of power had to evoke the language of the Spanish Empire (of which Franco considered himself successor), admirably represented by the great stone mass of the monastery of El Escorial, constructed by Juan de Herrera for Felipe II. Popular architecture, on the other hand, was to use local tradition as its source of inspiration. Thus, architects who had been modernist prior to the war, such as the versatile and gifted Luis Gutiérrez Soto, now constructed in neo-Herrerian style. Soto's Ministerio del Aire (Air Force Ministry) in Madrid (1942–1955) is an excellent example of empire architecture, a heavy building paradoxically entrusted to the fledgling Air Force. Others, such as Luis Moya, enjoyed the public support necessary to build structures of megalomaniacal dimensions. A representative structure is the Universidad Laboral (Workers' University) of Gijón, a classical citadel that stood as the polemical antithesis of the devastated modern campus of the university in Madrid. On the other hand, architects such as the rigorous Francisco Cabrero interpreted monumentalism in terms of Mussolinian rationalism. This interpretation is evident in Cabrero's Sindicatos (Labor Union) building in Madrid (1949), the disciplined sobriety of which would soon approximate the architect to the constructive abstraction of Mies van der Rohe.

During the 1950s architecture recuperated the modern language, a process catalyzed by the growing pragmatism of the political regime and the end of international isolation. Nonetheless, it was a modern language that had abandoned the functionalist fundamentalism of the avant-garde, declaring itself sensitive to the topographic, climatic, and constructive peculiarities of a given location. Architects in both Madrid and Barcelona used the rationalism of vernacular forms in order to reinterpret the tradition in abstract terms, an approach which worked particularly well for domestic projects. From Madrid, José Luis Fernández del Amo created new communities for rural residents. From Barcelona, José Antonio Coderch created vacation homes for the Catalan bourgeoisie. Toward the close of the decade the youngest and most radical architects, such as Oriol Bohigas of Barcelona and Antonio Vázquez de Castro of Madrid, had the opportunity to practice their empirical rationalism on the public housing projects initiated by the government. These projects,

concentrated in the outskirts of major urban areas, were designed to absorb the growing and uncontrollable rural immigration that came as a result of the modernization of the nation's economic and social structures.

Public buildings expressed renovation by means of technical and formal innovations. José Antonio Corrales and Ramón Vázquez Molezún created the Spanish Pavilion at the 1958 Exposition in Brussels, a mechanistic construction of hexagonal metallic umbrellas that became a symbol of change. Among other innovators were Miguel Fisac and Alejandro de Sota. Fisac created numerous research centers with his trademark bone-like structures of pre-stressed concrete. De Sota left two masterpieces in his wake: the Gobierno Civil in Tarragona (Civil Government Delegation, 1957–1964), an expression of rationalist abstraction, and the Gimnasio Maravillas in Madrid (Maravillas Gymnasium, 1960–1962), an experiment in technological neo-realism. The economic development of the 1960s and the corresponding boom in construction found its sculptural expression in organicist formalism, promoted by young professionals such as Fernando Higueras. Higueras constructed homes in the hills on the outskirts of Madrid for a growing middle class of intellectuals, progressive artists, and economically prosperous individuals. The influence of Frank Lloyd Wright is evident in his work, as is that of Alvar Alto in the work of Antonio Fernández Alba, creator of convents for a Catholic church under the deep spell of renovation cast by Vatican II (1962–1965). Nevertheless, the most characteristic building of this era would be designed by a seasoned architect, Francisco Javier Sáenz de Oíza. The sculptural volumes of his Torres Blancas (White Towers, 1960–1968), a residential, concrete skyscraper at the entrance to Madrid, was the most elegant representation of the optimistic prosperity of the period.

On the other hand, the 1970s witnessed the confluence of various crises: an economic crisis, instigated by two consecutive oil crises; a political crisis, resulting from the social conflicts inherited from the latter years of Franco's regime and the tense uncertainty that followed the dictator's demise in 1975; and an ideological crisis, caused by the youth rebellion of 1968. The ideological crisis was reflected in the revisions of modern postulates introduced by Aldo Rossi and Robert Venturi in their 1966 books. The young architects expressed their split with the bureaucratic modernity of many of their elders through the practice of radical classicism, anti-modern or post-modern, frequently summarized in small protest buildings. Several modes of architecture emerged to show-

case the opposing vitality of regional culture in the Catalan, Basque, and Galician historical areas. Ironic classicism was the sensual and Mediterranean expression of the Catalans, as demonstrated by Ricardo Bofill, Lluís Clotet, and Oscar Tusquets. Fundamentalist classicism was the Basque contribution, promulgated by José Ignacio Linazasoro, Manuel Íñiguez, and Alberto Ustárroz. Anthropological and ethnographic classicism was developed by Galicians such as César Portela and Manuel Gallego. These architectural movements fostered a process of affirmation for the identity of autonomous regions, which would soon obtain their own governmental institutions when democracy returned to Spain in the late 1970s. Indeed, this process was further accentuated by the creation of new architecture schools and professional associations in these regions.

In the final analysis the architectural style which would be the most influential in the modern period was Rafael Moneo's moderate, cultured, and contextualist classicism. Moneo, originally from Navarre, settled in Madrid and practiced as a professor in Barcelona. He built the central building for Bankinter (1972–1977) on Madrid's elegant Castellana boulevard. It is a discreet, refined, dry-pressed brick building that combines a respect for urban memory and a muted affirmation of modern abstraction. These civic and intellectual virtues would reach their summit in the Museo de Arte Romano in Mérida (Roman Art Museum, 1980–1986). This severe and scenic masterpiece, whose solemn red brick arches stretch over an archeological excavation, catapulted Moneo into the international limelight. He became an emblem of the new Spanish architecture, which at that time had achieved extraordinary international recognition and appreciation. During the 1980s, architecture in Spain was invigorated by several circumstances: the euphoric economic climate of the latter half of the decade, the generous patronage of the public administration (in the hands of the Socialists since 1982), and the popularity of exhibitions and specialized publications, which would help to diffuse works beyond Spain's borders.

The lyrical and self-satisfied architecture of this era was enriched by the individual languages of gifted creators. Juan Navarro Baldeweg, originally from Santander but settled in Madrid, is a notable painter and the architect behind the weightless cupola of the Palacio de Congresos (Convention Center) in Salamanca. Catalonia produced Esteve Bonell, author of the Palacio de Deportes (Sports Palace) in Badalona, and Enric Miralles, who created the inspired, poetic, and surreal cemetery park of Igualada in collaboration with Carme Pinós. From Andalusia came Antonio Cruz and

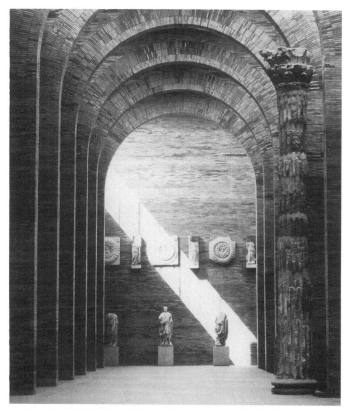

12. Interior of Rafael Moneo's Museo de Arte Romano in Mérida

Antonio Ortiz, architects of the sober and luminous Santa Justa railway station in Seville. The Valencia-born Santiago Calatrava, a sculptor, engineer, and architect who had studied in Zurich and Paris, constructed a significant number of bridges of great sculptural significance. The overwhelming harvest of artistic talent reached its point of culmination in 1992, a year which combined the celebration of the Olympic Games in Barcelona with the Universal Expo in Seville, an event commemorating the five hundredth anniversary of Columbus's arrival in America. Both events crystalized social and cultural energies, formally attesting to the increasing international character of the nation. In terms of architecture, the work of numerous foreign professionals in Spain further emphasized this phenomenon. Among these individuals were the British Norman Foster, the Portuguese Álvaro Siza, the Japanese Arata Isozaki, and the American Richard Meier. Yet 1992 also marked the end of the euphoria,

caused by the difficulties of the process of European unification, and the rise of unemployment and political scandals. The leaning KIO towers, two clumsy skyscrapers erected in Madrid by the American Philip Johnson, would be the most accurate symbol of this stage of uncertainty and the Guggenheim Museum in Bilbao, a magnificently sculptural stormy shape clad in titanium, built by another American architect, Frank Gehry, the best representation of Spain's incorporation into the new cosmopolitan society of spectacle.

(*Translated by* VANESSA GUIBERT)

FOR FURTHER READING

Cerdá, Ildefonso. *Teoría general de la urbanización.* Madrid: Imprenta Española, 1867.

Fernández-Galiano, Luis (ed.). *Rafael Moneo, 1986–1992.* Madrid: AviSa, 1992.

Flores, Carlos. *Arquitectura de España.* Barcelona: Fundación Caja de Arquitectos, 1996.

Moneo, Rafael. *The Solitude of Buildings.* Cambridge, MA: Harvard University Graduate School of Design, 1986.

Sert, Josep Lluis. *Can Our Cities Survive?* Cambridge, MA: Harvard University Press, 1942.

Sweeney, James Johnson and Josep Lluis Sert. *Antoni Gaudi.* New York: Praeger, 1970.

21

Spanish music and cultural identity

The music enthusiast probably knows Spanish music principally because of the well-recorded early masters, a few modern composers, and several international stars. Lovers of opera and song know of the many great Spanish voices, including those of nineteenth-century Manuel García (for whom Rossini wrote a role in his *Barber of Seville*) and of his famous daughters María Malibrán and Pauline Viardot-García. Today's best voices include Victoria de los Ángeles, Teresa Berganza, Montserrat Caballé, José Carreras, Plácido Domingo, Alfredo Krause, and Pilar Lorengar. Music fans will know of the work of the great Spanish instrumentalists such as Pablo Sarasate (violin), Nicanor Zabaleta (harp), Paco de Lucía, Emilio Pujol, Regino Sainz de la Maza, Andrés Segovia, and Francisco Tárrega (guitar), José Iturbi, Alicia de Larrocha, Ricardo Viñes, and Miguel Zanetti (piano), and Pau Casals (cello). They will likewise be familiar with the conducting of Ataúlfo Argenta and Rafael Frühbeck de Burgos. A few Spanish popular artists have reached international star status, among them, the popular 1960s rock group, Los Bravos, and while listeners from Chile to China swoon over the languid Spanish crooner Julio Iglesias, Hispanics all over the world buy the recordings of the flamboyant songstress Rocío Jurado and of the recently deceased "Queen" of Spanish music, Lola Flores. Flamenco music, too, has found a large international audience and has also produced several major international stars, among whom Paco de Lucía and Pepe Romero. However, even a quick glance at the world of Spanish contemporary classical, popular, and flamenco music reveals that it is not just a handful of composers and stars but, rather, a huge world of composers, songwriters, vocalists, instrumentalists, vocal, and instrumental groups, and musical genres. In order to explore the musical world in modern Spain, we shall

organize the present essay into (1) classical music (composers, the *zarzuela*, musical activity, musical education and musicology, prizes, festivals, publishing houses, the recording industry, radio-television), and (2) popular music (folklore, *copla*, pop, rock, rap, flamenco).

Felipe Pedrell, the eminent composer, folklorist and teacher, was the single most influential figure in Spain's recent musical history. Pedrell rediscovered the great tradition of folk music which had been set aside in the nineteenth century, and his idea that musicians should look for inspiration in Spain's musical history bore great weight among his friends, admirers, and students, and gave rise to a type of Spanish nationalism in music. He sought not to assemble a pot-pourri of music from the past but to reassemble the strong popular tradition which had been abandoned in favor of foreign musical models. Many of Pedrell's pupils promulgated his teachings, including Conrado del Campo, Manuel de Falla, Julio Gómez, and Enrique Granados. Among Spain's most revered composers are those of the "Generation of the Republic" (1931–1936), most of whom fled Spain because of the Spanish Civil War. Most had studied at Madrid's Royal Conservatory, many were students of Conrado del Campo and of Julio Gómez, and in many of their works the listener hears a strong Pedrellian influence. The romanticism and nationalism so frequent in the works from the first half of the twentieth century are still faintly heard in the works of young composers.

Though modern Spain's symphonic, instrumental, and choral production is vast, only a few works of Albéniz, Falla, Granados, Rodrigo, and Turina – all of whom studied in Paris – have attained international status. A child prodigy, Isaac Albéniz was initially denied matriculation by both the Paris and Madrid conservatories. He ran off to Puerto Rico at age thirteen, later enrolled in the Brussels conservatory, and at nineteen won an international piano competition. He studied with Pedrell and followed his lead by seeking inspiration in popular Spanish music. Albéniz wrote five operas, among them the very popular *Pepita Jiménez*, but he is best known for his piano works, especially his monumental *Suite Iberia*. Enrique Granados was also a close friend and student of Pedrell. In 1916, Granados accepted the invitation of New York's Metropolitan Opera to stage the theatrical version of his famous piano work, *Goyescas*, and was killed when the boat in which he was returning to Europe was sunk by a German torpedo. He left a large and much-played piano repertoire. The Andalusian Joaquín Turina also studied with Pedrell, and in Paris with Vincent D'Indy. Known for his orchestral works, Turina was also a pub-

lished historian and musical theorist. Blind since the age of three, the Valencian Joaquín Rodrigo studied in Paris with Paul Dukas. He has produced an impressive catalogue, and is best known for his beautiful *Concierto de Aranjuez* (for guitar and orchestra). The most celebrated modern Spanish composer is Manuel de Falla, who, in spite of a limited production (his complete catalogue numbers only some one hundred titles, many of them brief and/or unfinished), has a huge international presence owing to the originality and quality of his work. Falla was also a student of Pedrell, and he, too, followed the Pedrellian tradition of seeking inspiration in Spain's popular tradition.[1] In 1996, the fiftieth anniversary of Falla's death, his works were performed throughout the world, and his stature encourages the international performance of other Spanish music.

Unique to Spain, the *zarzuela* is somewhat similar to an operetta or a *Singspiel*, or even a Broadway show. It began in the mid-seventeenth century as a one-act "comedy with music," and, from around 1825, musical theater (including the various forms: *zarzuela, ópera, sainete, revista*, musically illustrated *comedia*, etc.), was the center of Spanish musical life for over a century. The *zarzuela* itself was transformed to three acts around 1850 (the original one-act form made a comeback some years later). Much of the *zarzuela's* music and libretti revolve around regional and local themes, all with a pronounced nationalism, and they have remained popular to this day. Among the best-known composers of *zarzuelas* figure Albéniz, Francisco Asenjo Barbieri, Tomás Bretón, Ruperto Chapí, Federico Chueca, Joaquín Gaztambide, Emilio Serrano, Pablo Sorozábal, and Amadeo Vives.

In 1995 Antonio Moral hailed the awakening of Spanish music from its "pronounced forty-year lethargy,"[2] while the distinguished conductor and composer Cristóbal Halffter averred that since 1985 there had been greater musical activity in Spain than ever before, but that it was hampered by ill-prepared bureaucrats, inadequate funding, political machinations, and autonomous rivalry.[3] Enrique Rojas, President of the National Association of Symphony Orchestras, agreed on the astounding amount of musical activity and pointed out the growing number of orchestras in Spain (there are currently twenty-two professional orchestras in the country).[4] Madrid's Ibermúsica orchestra season, for example, offers two series of fifteen concerts each, highlighting both Spanish and international orchestras. Spaniards love orchestras, but maintaining them is expensive: the fifty-year-old Spanish National Orchestra (ONE) is

beset with bureaucratic and financial problems (among them, distrust of the Ministry of Culture and resultant strikes). One major problem for the modern Spanish orchestra is the lack of symphony halls; many orchestras are forced to perform in churches and other large but inappropriate spaces. Two major incidents have hampered Spanish opera production: the fire which recently destroyed Barcelona's Liceo Theater, and the prolonged delays in the opening of Madrid's remodeled Teatro Real (the latter finally opened in October 1997). Several of Spain's many music festivals (Las Palmas, Oviedo, Palma de Mallorca, and Sabadell) center around opera.

Musical activity in Madrid in 1996 included not only the concerts of Ibermúsica and the opera season in the Teatro de la Zarzuela, but numerous other concerts, prizes, galas, and a myriad of concerts by the Municipal Symphonic Band, the Philharmonic Association, Juventudes Musicales, and the Liceo de Cámara, a *Lied* cycle, and Radio Clásica concerts. Amidst this musical activity, "market share" is important and house receipts are frequently small; only 5 percent of Spaniards went to a classical music event during 1995, and this audience was primarily middle class and between the ages of twenty and forty-five. The money problem gnaws at the roots of Spanish musical culture. The international financial crisis has had a further impact on all the arts and has necessitated an intense search for private funding; most major banks sponsor art activities, and many of the biggest monopolies (including Tabacalera, the tobacco monopoly) support the arts to varying degrees. No one is quite sure what the recent ousting of the Socialist government will mean for cultural life, and while for the last ten years financial support has come from the European Union (EU), the EU is itself now besieged with increasing need from all sides, while the future for musical funding seems vague.

Several central problems mark the field of musical education: bureaucracy, tightening budgets, poorly trained staff, few scholarships, poor libraries, and the general lowering of standards of music education in schools.[5] In spite of these problems Spain can draw on the facilities and faculty of Madrid's Real Conservatorio de Música (RCM), founded in 1830, whose new building opened in 1992. In addition, Madrid's Conservatory and Barcelona's excellent Liceo have been the training grounds for most Spanish classical composers (of the composers whose catalogues have been published by the Sociedad General de Autores Españoles [SGAE], for example, over half studied at the RCM). Other important

music schools in Spain are the Gerona Conservatory (with 500 students in a newly remodeled building) and the Municipal Conservatories of Barcelona and Terrassa. The Escuela Superior de Canto in Madrid is the première Spanish school of voice. Founded by the great singer Lola Rodríguez de Aragón, it has produced major singers of note, including Teresa Berganza and María Orán. Housed in a splendid eighteenth-century building with a lovely theater, the school offers at present seven levels of study, organizes voice recitals, and produces two complete operas each year.

Recent musicological activities have included the location, identification, cataloguing, and publication of musical manuscripts as well as the preservation of Spanish instruments, particularly organs in cathedrals, guitars, and medieval instruments. A National Plan for Musical Documentation fell apart, but did help in the publication of several volumes of "Music Resources in Spain." The Spanish Musicological Society was founded in 1977, and in 1985 the Ministry of Culture hosted in Salamanca a conference on "Spain in Western Music." The International Musicological Society held its 1992 Conference in the RCM. One of the results of recent collaborative endeavors has been a movement toward examining Spanish and Latin American music. In higher education, the University of Oviedo established a specialty in Music History in 1984, and other universities – Valladolid, Salamanca, Granada, and Madrid – soon followed suit. In 1995 the Ministry of Education established a Bachelor's degree in Musical History and Science.

The largest national musical organization is the musical branch of the SGAE. One of its most important endeavors at present is the final revision of the immense *Dictionary of Spanish and Latin American Music*, the Spanish equivalent of the London-based *Grove's Dictionary of Music and Musicians*. The SGAE is important, too, for its holdings in Spanish music: some 800 lyric works, 1,800 *zarzuelas*,[6] 2,000 symphonies, a copy of all discs (vinyl, CDs, videos, cassettes, *et al.*) published in Spain, several important donated archives, and a huge selection of photographs. One of the most important musical institutions in Spain is the Juan March Foundation's Library of Contemporary Spanish Music, whose 1993 catalogue lists over 500 pages of musical scores, recordings, and documents in its collection of works by nineteenth- and twentieth-century Spanish composers. Other musical archives fill in the gaps: each of Spain's autonomous regions has its own archives and musical societies, as well as entities which publish books, magazines, and music scores.

One of the most interesting facets of Spanish musical life is the abundance of competitions (many with sizable prizes) which bring national attention to exceptional young artists and which further enrich musical life by bringing talented foreign performers to Spain. The young Portuguese soprano, Elisabete Matos, was a recent winner of the prestigious Guerrero prize, and among 1996 winners in the Francisco Viñas competition were a Korean soprano and a Polish bass. Indeed, in the last (twelfth) Andrés Segovia "Certamen," no Spaniard was among the finalists. Among other international competitions are the piano prize in Santander known as the "Paloma O'Shea" (1996 was its twelfth year, with seventy-six pianists from twenty-six countries), and the Tárrega guitar competition now in its twenty-ninth year. Spaniards do win many and perhaps most of the contests in Spain, and they compete successfully outside of their country as well. Four Spaniards, for example (Enrique Reixach, Tomás Marco, David del Puerto, Jesús Torres), have won the prestigious Gaudeamus prize, a monetary recognition of the best in the field, awarded by a jury in Amsterdam.

The list of Spanish music festivals is long and diverse, the most significant being the forty-six-year-old Bach Festival in San Sebastián, the forty-five-year-old Granada Festival, the forty-four-year-old Santander Festival, the La Coruña Opera Festival, the "Semana de Música de Cámara" in Oviedo, the Contemporary Music Festival in Alicante (now in its twelfth year), Madrid's Mozart Festival, and the Quincena Musical Donostiarra Festival in San Sebastián. Justo Romero points out that in the province of Barcelona alone there are forty-eight annual music festivals.[7] Among the most international of all the Spanish festivals is that of the Canary Islands, begun in 1985, and which in 1996 had a budget of over $5 million. Madrid's twelfth Autumn Festival in 1995 had a budget of more than $2 million, over half provided by the Fundación Caja de Madrid. Over 300,000 spectators attended its eighty-two performances of theater, *zarzuela*, orchestra, opera, voice recitals, chamber music, flamenco, and dance (in music alone, almost 70,000 people attended thirty-one activities). New festivals include Barcelona's Twentieth-Century Music Festival. Jazz has its festivals in Madrid, Barcelona, Valencia, Málaga, and Salamanca, and even has its own magazine, *Cuadernos de Jazz*, since 1990.

Many nineteenth- and early twentieth-century music publishing houses (Pujol, Romero, Zozaya) have folded. Even the flagship of Spanish houses, the Unión Musical Española, was recently sold to an English pub-

lishing firm, but its huge archives were fortunately saved from exportation and are now housed (and in the process of being catalogued) in the SGAE. Part of this decline in music publication is due, of course, to changes in musical tastes, to the replacement of the home piano with a compact disc player, and to the decline of the "female" arts (sewing, playing and singing). Other reasons include the classical and romantic emphases in musical education, a tradition which calls for Mozart, Bach, and Beethoven, and not contemporary Spanish composers. Little contemporary music is published, because Spanish music students have not been expected to know it.

Perhaps no one who has entered a record store in the mid-1990s could have missed hearing the ubiquitous and best selling re-release of Gregorian chants sung by the monks of Santo Domingo de Silos, the latest in the long history of recordings of Spanish medieval and renaissance music. In the past, few other Spanish discs (other than those with music by Albéniz, Falla, Granados, Rodrigo, Turina, and the recordings of the great Spanish vocal and instrumental stars) ever reached the international market. The recent surge in the Spanish economy and the concomitant proliferation of recording companies has promoted "other" Spanish music and has offered a wider opportunity to modern music. The CD market is booming, and the public avidly buys recordings of the music of Catalonia and other autonomous regions, as well as of all types of classical, pop, and folklore. Of import for the future of recorded Spanish music is the increasingly strong Latin American market (which grew some 33 percent in 1995).

Though plagued by budgetary restrictions, the radio is of prime importance in Spanish musical life. Radio Nacional de España (RNE, part of Radiotelevisión Española, RTVE) offers live performances of its own productions, has its own symphony orchestra and chorus, offers festivals and prizes, and publishes its own informative booklets. RNE's Radio 2, "Radio Clásica," highlights Spanish composers and performers in such programs as "The History of Recording," "Classics of Our Time," "Young Interpreters," and "Our Flamenco." RTVE also markets its own recordings. Radio Catalunya Musica gives ample time to Catalan composers. SinfoRadio, a young station which has already won over 100,000 listeners, has the irritating habit of chopping off the ends of pieces, repeating the well-worn top hits, and mixing fragments of Rossini with bits of Wagner or with pieces of Stravinsky, all without apparent reason. The Internet will change the habits of radio listeners – in Valencia, Barcelona,

and Bilbao there are already "Internet bars" where one can have a drink and listen to the radio on Internet.

Under increasing international pressures of north American television dramas and sitcoms and of seemingly interminable Latin American soap operas, Spanish television has limited room for Spanish programming and for Spanish music. The viewer can occasionally find music, particularly on the pay channel Canal +, but little of it is Spanish. The state channels sporadically offer TVE-Radio productions, particularly RTVE Orchestra and Chorus performances, and there are occasional homages to singers, variety shows, recitals by the winners of competitions, a Karaoke program popular with children, and such interesting programs as Telemadrid's recent "Origin and evolution of the *villancico*" (the Spanish carol) and "Children's songs of now and yesteryear."

In the information age, Spanish folkmusic is fast disappearing since children no longer play in the streets making up games and singing songs, but instead stay inside, watch television and play with video games. The *romance* (ballad) form, for example, has all but become extinct. Fewer children know the words to traditional songs and young people no longer memorize poetry. Rock music, particularly American, has largely displaced folk music, and fewer young people learn folkdances. The present emphasis on regional autonomy has brought about a perhaps artificial renaissance, some would say petrification, of certain folkloric elements. What does seem to be on the upswing is the *copla*, the popular song which, unlike folklore, has an identifiable author. These songs, sung particularly by women stars, and frequently dealing with tragic love affairs, are in vogue at present and promise to be perhaps the "folklore" of the future (just as perhaps the Beatles' songs might be future English "folklore"). However, the surge of recent interest in traditional music has prompted the bibliography compiled by Emilio Rey García.[8]

Popular music in Spain is a wide-ranging mix of international sounds. Depending on age bracket, everyone knows the music of Bruce Springsteen, Frank Sinatra, and Nine-Inch Nails. Truly *Spanish* popular music has a complex recent history which can be divided generally as follows.

The 1940s–1950s was the age of the *copla*, with its mostly female stars and the *canción española* (love ballad), with its mostly male stars. Beginning in the 1950s and continuing into the 1970s, the *canción ligera*, or pop rock, produced performers comparable to the Everly Brothers or Petula Clark, artists such as heart throb Miguel Bosé, the Dúo Dinámico, Gelu, José Guardiola, Julio Iglesias, Raphael, or Miguel Ríos. Rock groups from

the 1960s included Los Bravos, Los Pekeniques, Los Sirex, Los Ángeles, Fórmula V, and Los Diablos. Spanish young people have long adored Elvis Presley, Jimi Hendrix, the Beatles, and the Rolling Stones, and Spain has produced its own rock heroes (the Cómplices, Gabinete Caligari, La Guardia, Héroes del Silencio, Olé olé, Los Ronaldos, and Sin Recursos are the most widely known). The 1960s also produced a strong protest movement with the *canción protesta* from the *cantautores* or "singer-writers" who waged a cultural war against oppression: Joan Manuel Serrat, Lluís Llach, Paco Ibáñez, Mari Trini, María del Mar Bonet, Patxi Andión, Luis Eduardo Aute, Raimón, Victor Manuel, Ana Belén, and Amancio Prada. With the death of Franco and the emerging democratization of Spain, the protest movement lost strength, and though Serrat, Llach, Bonet, Belén and others still sell well, the later 1970s and 1980s produced other stars, among them the very showy Rocío Jurado, Isabel Pantoja (who gained fame and attention not only as a young, fiery beauty but also as the widow of Paquirri, a handsome bullfighter killed in the ring), and the balladeer with the mellifluous voice, Carlos Cano. In the late 1970s, Rockabilly (with Los Coyotes, for example) produced music with Spanish American rhythms, while the 1980s saw an international "boom" in the Andalusian folkdance, the *sevillanas*. In the 1980s, too, a new wave of pop rock (called *la movida*) swept the country, and brought several refreshing performers and bands to the forefront, among them the aforementioned Gabinete Caligari and Los Héroes del Silencio (The Heroes of Silence), as well as Alaska y los Pegamoides, Los Secretos, Nacha Pop, Caca de Luxe (Doo-Doo Deluxe), Parálisis Permanente (Permanent Paralysis), Mecano, La Unión, El Ultimo de la Fila (Last in Line), Radio Futura, Luz Casal, and Duncan Dhu. Most appeared in Madrid's Rock-Ola, a performance hall for alternative groups. There was a brief flirtation with "Agro pop," with the group No Me Pises Que Llevo Chanclas (Don't Step on Me 'Cause I'm Wearing Slippers), and "Rock andaluz" triumphed with the groups Medina Azahara and Triana. Punk had its Spanish variety with Las Víboras (The Snakes) and Los Perros (The Dogs), and there was a brief flash of power pop and rap. The most remarkable phenomenon of the 1990s is the appearance and growth of flamenco rock, a stirring mixture of pop, Latin, rock, and flamenco music, among whose stars number Ketama, Azúcar Moreno (Brown Sugar), and Rosario and Antonio Flores. Some new music is hard to qualify because the artists mix styles; Mac Parrot, for example, a twenty-something Catalan, is an eclectic musician who mixes rap, rock, machine, *copla,* and techno (with emphasis on rock and roll).

In spite of its widely divergent forms and styles as well as its great inherent strength, by the early twentieth century flamenco music had been reduced to a few great performers and a host of not-so-good "stars" who performed for tourists who wanted to hear "typical" Spanish music. In 1922 Manuel de Falla, the poet Federico García Lorca, and a multitude of composers, musicians, writers and other intellectuals decided to try to reverse the trend toward decay. They organized the highly successful Concurso de Cante Jondo (gypsy deep song contest) in Granada, and this event rejuvenated interest in flamenco. Paco de Lucía, a pioneer in bringing flamenco together with other forms (jazz, salsa, classical, etc.), is perhaps the most internationally known flamenco performer. Late 1995 saw the re-edition of his complete work (over twenty CDs). The most recent development in flamenco is this "new flamenco," the mixing and blending of musical styles, dominated by the group Ketama. The importance of flamenco music in modern Spanish culture cannot be overstressed; Carlos Saura's movies *Flamenco* and *Sevillanas* became best-selling videos.

What is the future of Spanish music? Surely the shrinking world will continue to undermine Spanish folklore and traditional music. Younger composers of classical music will continue, too, their struggle to have their music performed. The economic crisis may or may not improve, but the likelihood is that private funding will have to replace some public money. The problems of clanking bureaucracy will probably not abate, and the entertainment and recording industries will continue to produce what sells. Cristóbal Halffter sees the future in a dim light when he writes that he does not doubt the creative capacity of Spain's composers, but that he sees little hope in the fight against the tendency toward commercialization, marketing and "spectacle" and away from true "culture."[9]

NOTES

1. See M. García Matos, "Folklore en Falla," *Música* 1–2 (1953), pp. 41–68 and 33–52.

2. Antonio Moral, "Tempus fugit," *Scherzo* 100 (1995), pp. 5–6, p. 5.

3. Cristóbal Halffter, "Componer en España," *Scherzo* 100 (1995), pp. 20–21, p. 20.

4. Enrique Rojas, "Cada vez más orquestas," *Scherzo* 100 (1995), pp. 22–23.

5. Antonio Gallego, "Sin novedad en la enseñanza," *Scherzo* 100 (1995), pp. 14–15.

6. See Nieves Iglesias Martínez (ed.), *Catálogo del teatro lírico español en la Biblioteca Nacional*. 3 vols. (Madrid: Ministerio de Cultura, Dirección General del Libro y Bibliotecas, 1989–1991).

7. Justo Romero, "Diez años de fiesta," *Scherzo* 100 (1995), pp. 28–30, p. 30.

8. Emilio Rey García, *Bibliografía de folklore musical español* (Madrid: Sociedad Española de Musicología, 1994).

9. Halffter, "Componer en España," p. 21. I should like to thank the following individuals whose help was indispensable in the preparation of this essay: Emilio Casares Rodicio, María del Carmen Casas, Isidoro Comino Nava, Gabriel García Fernández, Israel J. Katz, José Marcial Muñoz Fuentes, Manuel Peña la Torre, and Aurelio Puente Alarcón.

FOR FURTHER READING

Alier, Roger. *La zarzuela*. Madrid: Daimon, Manuel Tamayo, 1984.

Blas Vega, José. *La canción española*. Madrid: Taller El Bucaro, 1996.

Blas Vega, José and Manuel Ríos Ruiz (eds.). *Diccionario enciclopédico ilustrado del flamenco*. 2 vols. Madrid: Editorial Cinterco, 1988.

Chase, Gilbert. *The Music of Spain*. New York: Dover, 1959.

Katz, Israel J. "Flamenco," in *The New Grove Dictionary of Music and Musicians*. Stanley Sadie (ed.). London: Macmillan, 1980, vol. VI, pp. 625–630.

"The Traditional Folk Music of Spain: Explorations and Perspectives," *Yearbook of the International Folk Music Council 6* (1974), pp. 64–85.

Marco, Tomás. *Spanish Music in the 20th Century*. Trans. by Cola Franzen. Cambridge, MA: Harvard University Press, 1993.

Muñoz, Matilde. *Historia de la zarzuela y el género chico*. Madrid: Tesoro, 1946.

Plaza, Sixto. "La zarzuela, género olvidado o malentendido," *Hispania 73* (1990), pp. 22–31.

Sopeña, Federico. *Historia de la música española contemporánea*. 2nd edn. Madrid: Rialp, 1976.

Tinnell, Roger D. *An Annotated Discography of Music in Spain before 1650*. 2nd edn. Madison, WI: Hispanic Seminary of Medieval Studies, 1990.

Federico García Lorca y la música: Catálogo y discografía anotados. Madrid: Fundación Juan March en cooperación con la Fundación Federico García Lorca, 1993.

22

To live is to dance

Spain is a country of dancers. Residents of small towns and villages perform ancestral folk dances during the local festivities. Crowds gather on Sundays before the cathedral of Barcelona to perform Catalonia's emblematic *sardana* and young people fill the discotheques every weekend. When Felipe González, a native of Seville, was elected prime minister in 1982 the Andalusian folk dance *sevillanas* enjoyed a popular revival that still endures.

Blessed with one of the most diverse dance cultures in the world, Spain is invariably identified with Andalusian flamenco. Today's Spain, with its well-defined autonomous regions, presents a much wider spectrum of dance than that which was promoted by the Franco regime. A new generation of artists is leading flamenco into the twenty-first century, while Spanish modern and ballet dancers and choreographers are well equipped to hold their own anywhere in the world.

Born as a melding of Spain's gypsy, Moorish and Jewish heritages, flamenco furnishes an outlet for individual temperament. Centered around rhythm, or *compás*, its musical structures provide opportunities for improvisation and communication between singers, guitarists, and dancers. The contrast between driving staccato heelwork, pressed downwards towards the earth, and the majestic lifting of the upper body illustrates the dichotomy of the flamenco essence, as eloquent an expression of intense sorrow as it is of uncomplicated, sheer love of life and joy.

Spanish dance had already begun to capture the imagination of travelers during the nineteenth century. By then flamenco had made the transition from an intimate form of personal expression to the stage. *Cafés cantantes* or singing cafés flourished from about 1869 to 1929 and were responsible for the flowering of flamenco as a performing art while fos-

tering many outstanding performers. The programs presented at these venues combined popular dances from Andalusia and flamenco, as well as dances from Spain's eighteenth-century *escuela bolera*, or bolero school, which has its roots in popular Spanish dances. Performed in soft slippers, with stylized arms and castanets, its rapid aerial footwork has much in common with ballet. It had an important influence not only on ballet technique, but on classical ballet repertory as well. Modern *tablaos* derive from the *cafés cantantes* and still provide employment and valuable stage experience for dancers, guitarists, and singers trying to make a name for themselves.

The transition from the small *cafés cantantes* to the larger stage came about, as has most of the evolution of flamenco, thanks to the innovations and temperaments of individual artists. Antonia Mercé, known professionally as La Argentina, was instrumental in bringing Spanish dance to the attention of an international public. Possessed of strong technique, an outstanding stage presence and great artistic vision, Mercé toured her solo concerts worldwide until her death in 1936. She introduced the concept of the repertory dance company, taken up with great success by other Spanish dance artists. La Argentina's concerts included not only stagings of traditional dances, but new choreographies set to the music of contemporary Spanish composers such as Isaac Albéniz, Enrique Granados, and Manuel de Falla, for which she stylized traditional movements and steps to create elegant pieces suitable for the concert stage. These collaborations with other Spanish artists resulted in productions such as Falla's *El amor brujo* and *El sombrero de tres picos*. The latter was produced in 1919 by Sergei Diaghilev and his Ballets Russes after the company's visit to Spain, and featured sets and costumes designed by Picasso.

Mercé and the artists who followed her – Vicente Escudero, Encarnación López "La Argentinita" (encouraged by her friend Federico García Lorca to found her own company), her sister Pilar López, and Antonio Ruiz – were vital members of Spain's intellectual and artistic community. For thirty years, until her death in 1963, the incomparable gypsy Carmen Amaya set new standards for female flamenco dancers with her intense energy and lightning-fast footwork. Daring to don male costume, she went beyond the sinuosity and delicacy prescribed for women in flamenco.

These companies popularized Spanish dance throughout the world and provided new generations of artists with performing opportunities as well as outlets for experimentation. Antonio Gades, one of Spain's

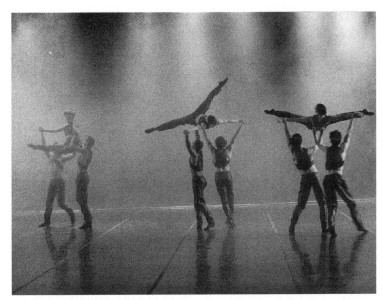

13. Compañía Nacional de Danza

finest dancers and choreographers, performed with Pilar López's company during the 1950s, along with numerous other artists who later founded their own ensembles.

Spirited, vigorous and passionate, Spanish dance enjoyed great popularity at home and was also a success with audiences abroad. As a non-controversial international commodity, flamenco was used by the Franco regime to promote an image of Spain associated with bullfights, wine, sun, and sand. This worked well abroad, but many residents of the Basque Country, Catalonia, Galicia and other regions with distinct cultures of their own resented being represented universally by an art they considered to be indigenous to Andalusia alone. While Franco's government did its best to squelch Euskara, Catalan, and Galician as spoken vernacular, after the Spanish Civil War La Sección Femenina, the women's branch of the Falangist Movement, was instrumental in preserving folk music and dances from all of Spain in a theatrical setting through the groups known as Coros y Danzas, open only to women until the late 1940s. Many of these groups still exist today as cultural associations without direct political connotations.

Spanish artists were not immune to the desire to create works that reflected contemporary concerns and tastes. One of the first flamenco art-

ists to channel traditional material into new modes of expression was Antonio Gades. In 1973 his spare and powerful rendition of García Lorca's *Bodas de sangre* was well received by audiences, and in 1981 became the first of three film collaborations with director Carlos Saura, followed by *Carmen* (1983) and *El amor brujo* (1986). This popular trilogy helped spur a new revival of interest in flamenco dance abroad after growing expenses reduced foreign touring by Spanish dance companies. Saura went on to direct *Sevillanas* (1992) and *Flamenco* (1995), both expressions of his profound respect for the art.

Gades was not the only innovator working in the flamenco idiom. Pioneers such as Granada's Mario Maya, Rafael Aguilar whose touch of the outrageous left no theatrical stone unturned, José Granero, and José Antonio have worked to open flamenco and Spanish dance to today's issues and aesthetics.

The Transition from dictatorship to democracy was manifest on stage as well as on the streets. In 1978 the Spanish Ministry of Culture founded the Ballet Nacional de España under the direction of Antonio Gades. The company's mission was to act as a living archive for historic repertory while presenting a varied program of Spanish dance and fostering the creation of new works. The following year the Ministry created the Ballet Nacional Clásico, a ballet company directed by Víctor Ullate, a former star with Maurice Béjart's Ballet of the Twentieth Century. When the Ministry announced in 1983 that distinguished ballet teacher María de Ávila would oversee both companies, Gades and Ullate, feeling that their independence would be compromised, resigned from their posts.

María de Ávila tried to widen the scope of the ballet company by adding works by Balanchine and Tudor, among others, to its repertory. The Ballet Nacional de España premièred José Granero's *Medea*, considered to be an outstanding example of contemporary flamenco dance-drama, in 1984. When de Ávila resigned two years later, the Ministry hired Soviet prima ballerina Maya Plisetskaya to take over. The lack of a training facility and rapid succession of artistic directors made it difficult for the newly named Ballet del Teatro Lírico Nacional to achieve the kind of stability necessary for a first-class classical ballet company.

In 1990 the Ministry offered the job to the young Spanish dancer and choreographer Nacho Duato. His long association with the Netherlands Dance Theater has left a clear mark on his choreographic and directorial style. Duato's work combines ballet technique with the mobile torso and sense of groundedness found in modern dance, seasoned with a

Mediterranean sensuality and musicality. The group's new name, Compañía Nacional de Danza, reflects this new direction. Duato has become something of a cult figure in Spain. His personal charisma, combined with the company's new image and excellent dancers, attracts wider and younger audiences to the Compañía Nacional de Danza's performances. The repertory at present consists of works by Duato, Jiri Kylian, William Forsythe and other names in contemporary ballet, with occasional opportunities for Spanish choreographers and annual workshop performances for company members with an interest in creating dances.

This change in focus has been controversial, as there is now no national classical ballet company in Spain. Other companies exist, but the Ballet de Víctor Ullate, recently named the official regional ballet company of Madrid, is currently the country's most prestigious ensemble and receives the lion's share of government grants for dance. Originally conceived as a neo-classical and contemporary ballet company, the change in direction taken by the Compañía Nacional de Danza prompted an astute Ullate to incorporate classics such as *Giselle* into the repertory.

During the second half of the nineteenth century major theaters in the country maintained resident ballet companies. Talented performers such as Barcelona's Rosita Mauri found fame in Europe as well as at home. Today dancers from Spain continue to enhance the rosters of international ensembles. The inauguration of Madrid's refurbished Teatro Real in 1997, and the reconstruction of Barcelona's Teatre del Liceu (destroyed by fire in 1993) have raised the subject of restoring resident ballet companies to these historic venues. Although both have enjoyed a long and illustrious relationship with ballet in the past, there is little interest among the authorities to create such companies in times of economic austerity.

After de Ávila stepped down, dancer-choreographer José Antonio took over as director of the Ballet Nacional de España and devoted much of the repertory to original works. José Antonio resigned in 1993 to create his own company. The Ballet Nacional de España was directed by Aurura Pons, Nana Lorca and Victoria Eugenia until 1998, when Aída Gómez was put in charge.

A new concept of training which embraces other dance styles has greatly improved the technical level of Spanish dancers and broadened the movement vocabulary available to choreographers. This new tendency can be seen in an entire generation of young dancers whose virtuosity (not to be equated necessarily with artistry) far surpasses that of previous generations.

Since the 1970s Spain has become increasingly well known as the home of a vital contemporary dance movement. Dancers and choreographers, chafing against the cultural isolation of the Franco dictatorship, began to study abroad. As the reins of the regime gradually loosened, they felt the need to show previously experimental work before a wider audience. Dance companies were born, then showcases that gradually became festivals and annual seasons. Barcelona, with France just across the border, became Spain's window onto Europe and was a logical starting point for creative ferment in dance.

Already in the early 1920s self-taught dancer Tórtola Valencia captivated Barcelona and the Catalonian modernist movement with her exotic choreographic character studies. Forty years later the classes in American modern and jazz dance offered at Anna Maleras's school helped train Barcelona's first generation of dancer-choreographers. José and Concha Laínez's company Anexa, from San Sebastián, inspired a new way of looking at movement and company structures when they performed in Barcelona in 1972. The Ballet Contemporani de Barcelona, founded by Ramón Solé in 1974, became the city's first modern dance company and a training ground for many independent choreographers. For many years the Ballet Contemporani de Barcelona sponsored a choreography showcase open to Spanish and Latin American contemporary dance choreographers.

Barcelona's Institut de Teatre created the only ongoing modern dance conservatory program in the country in 1980. It has been instrumental in forging a tradition of contemporary dance in the area, although most dancers and choreographers receive at least part of their training abroad, bringing new perspectives to Spain upon their return. La Fábrica, which sponsored informal performances as well as classes in the 1980s, or the programming of new work nowadays by La Porta dance collective, have created important outlets for young choreographers. Municipal and regional government sources responded with (limited) grants to support dance in Catalonia.

These combined factors helped contemporary dance to develop earlier and more consistently in Barcelona than in the rest of Spain. Although political changes and budget cuts have affected the arts everywhere and new infrastructures in other parts of the country have resulted in the emergence of new choreographers, Barcelona still has the largest concentration of established contemporary dance companies in Spain. Cesc Gelabert, whose background in architecture lends a clarity and precision to his

work, Danat Dansa's raw energy, Mal Pelo's tender, quirky movement portraits, the exquisite imagery of Angels Margarit's Mudances, the restrained yet passionate dance phrases of Juan Carlos García's Lanónima Imperial or Toni Mira's astute musicality and clever imagery are well known to European audiences.

In Madrid Carmen Senra also looked to the United States for sources of dance training. Her school and dance company produced many talented young performers, including the founders of Diez y Diez Danza. The best-known contemporary dance company in Madrid, their work often deals with the intricacies of relationships and sexual identity. Carmen Werner's Provisional Danza and dancer-choreographers María José Ribot, Blanca Calvo, Teresa Nieto, and Olga Mesa, are also active.

Valencia is home to a dynamic dance scene, with companies such as Ananda Dansa and the one led by Vicente Sáez. Ananda Dansa, a repertory dance-theater company, has used events in Spanish history and culture as themes for their work. Their evocative *Crónica Civil v-36/39* is a portrait of Valencia, seen through the eyes of its children during the city's time as capital of the wartime Republican Spain. Since 1988 Valencia has hosted *Dansa a Valencia*, a festival for Spanish contemporary dance that attracts programmers from all over Spain and abroad. In 1995 the creation of a national choreography center in Valencia was announced during the festival. It opened its doors as a regional initiative in 1998.

The 1990s have seen the emergence of contemporary dance choreographers in the Basque Country and Andalusia. The Centro Andaluz de Danza was founded in 1995 as a facility devoted to dance training, co-production, and production of works by Andalusian choreographers working in traditional and contemporary Spanish dance idioms. The center produced several works for its resident company as well as a series of choreography workshops and has access to the Teatro Central, a magnificent mid-sized performing space built for Seville's Expo 92 World Fair. The Center has since been absorbed into the Regional Arts Council.

In 1987 a national choreography competition was founded in Madrid to serve as an annual platform for young contemporary dance and ballet choreographers and to stimulate international exchange. The Certamen Coreográfico de Madrid celebrated its twelfth anniversary in 1998. A similar competition was instituted in Madrid in 1992 to help choreographers working in Spanish dance and flamenco.

Foreign dance companies perform in most major Spanish cities and

dance has remained an important part of arts festival programming. The field of contemporary dance, however, has grown faster than the implementation of a coherent cultural policy to support it. Ongoing training and audience development programs are almost non-existent. Indeed, contemporary Spanish choreographers often receive more support and awaken more interest among audiences abroad than at home. Small independent theaters have been instrumental in creating performing opportunities for contemporary dance companies, encouraging exchange between artists.

Flamenco has also acquired a new energy in the past several years, attracting wider audiences among young people. Both flamenco music and dance have been enriched by other sources. This diversity shows in performances and choreography, with the use of long, open lines, dynamics, costumes, and music not seen in traditional flamenco dance even ten years ago. Guitarists and singers are often accompanied by percussion, violin, bass, and flute and explore beyond the boundaries of traditional musical structures. The removal of stylistic barriers has also resulted in new collaborations between choreographers working in contemporary and Spanish dance idioms. Dancer-choreographers such as Carmen Cortés, Antonio Canales or Joaquín Cortés (whose charisma as well as talent have given him the status of a matinée idol in Europe) are examples of flamenco artists concerned with expanding the parameters of a traditional art form.

Dance experienced a period of relative growth under the Socialists (1982–1996). The two national dance companies enjoyed an increase in budget, the Ministry of Culture undertook a campaign to improve theaters and auditoria across the country and established grants for independent companies, festivals, and scholarships for study abroad. Unfortunately, the majority of national, regional, and local cultural policies did not take into consideration the need for long-term measures designed to reduce artists' dependence on public funds. With the election of a conservative government in 1996, funding for culture has been reduced. Private donations and corporate funding for the arts are still new in Spain, and are mostly limited to activities with high publicity value. A recently approved national law (called the "Ley de Mecenazgo" after its classical reference to Maecenas) regulates private contributions to charities and the arts but will not change the reality of cultural activities, which were previously funded by the government, struggling to survive in a market economy. Ballet and Spanish dance, with their mass audience appeal

(albeit higher overheads) will most likely have fewer problems than contemporary dance companies. They will have to call on all of their imagination and creativity to survive in an environment where popular taste and box office figures are considered the most important factors in determining what gets put on stage.

FOR FURTHER READING

Blas Vega, José and Manuel Ríos Ruiz, (eds.). *Diccionario enciclopédico ilustrado del flamenco*. 2 vols. Madrid: Editorial Cinterco, 1988.

Llorens, Pilar *et al. Historia de la danza en Cataluña*. Barcelona: Creaciones Gráficas for the Caja de Cataluña, 1987.

Matteo. *The Language of Spanish Dance*. Norman, OK: University of Oklahoma Press, 1993.

VII

Media

23

The media in modern Spanish culture

Until the advent of radio in the 1920s, the principal medium of social communication in Spain was the press. In the first decades of the twentieth century newspapers continued to be vehicles of opinion, owned and directed by parties, groups, and individuals wishing to impress their views on society at large. As society changed they became more commercial enterprises, dependent on readers and advertisers; their aim was to satisfy the multiple interests and enthusiasms of their increasingly literate, urban audience. In spite of the domination of companies whose ownership was spread amongst mostly anonymous shareholders, pressure groups like the Catholic church, political parties (including Basque and Catalan nationalists) and trade unions figured as major players. Nevertheless, publications promoting narrow political and social ideologies led a precarious existence and were subject to restrictions when the political tide ran against them. In Barcelona the no longer party-inspired daily *La Vanguardia* (founded 1881) thrived, as did the Madrid-based *ABC* (1905), both run by family companies. Though at heart the major dailies favored particular political options, they mixed variety of coverage with political moderation in order to appeal to a wide readership.

As the Restoration system crumbled, major new titles, *El Sol* (1917), *La Libertad* (1919), and *Informaciones* (1922) were launched, in accord with the financial and political mood of the moment. Governmental restrictions on political discussion under Primo de Rivera's dictatorship (1923–1930) forced the press to expand coverage of general interest topics: popular culture, literature, philosophical and scientific matters. A wealth of talented intellectuals embraced journalism, ready to engage a wide readership in a format more immediate than the printed book, brilliantly

exploiting such genres as the essay, polemical article, and critical review. The cultural effervescence of the 1920s and 1930s encouraged coverage of bullfighting, sport, the cinema, and theatrical life. The daily and weekly press provided the main forum of cultured discussion, and leading intellectuals of the period – Ortega y Gasset, Unamuno, Azorín, Baroja, Gómez de la Serna – made journalism their second career, achieving national fame.

Though press freedom was much vaunted, Primo imposed prior censorship, while Catholic dailies such as *El Debate* (1910) also submitted copy to ecclesiastical approval. Governments of differing complexions limited freedom of expression by manipulating laws on states of emergency or employing direct threats. The press seemed buoyant, but circulation was low compared with European neighbors. Madrid's thirty-two dailies sold 656,000 copies in 1918, two-thirds of which were read outside the capital, while Barcelona's eighteen papers sold 311,000 copies.[1] Only in the 1920s did leading newspapers – *ABC, La Vanguardia, Ahora* – exceed 100,000 copies. Madrid and Barcelona were the principal centers, with Valencia, Bilbao and Zaragoza far behind.

The first regular radio programs in Spain were broadcast by Madrid's Radio Ibérica in late 1923. They comprised music, cultural and educational talks, and weather reports, soon extending to news, concerts of jazz and classical music, children's programs and competitions. Radio sets required licenses, as did broadcasting stations, initially all in the private sector. In 1925 equipment manufacturers set up Unión Radio, which spread rapidly to dominate broadcasting until the Second Republic.[2] Revenue to finance commercial stations derived from advertising. From élitist beginnings, coverage extended to sport (bullfighting and soccer), serial stories, music, variety and quiz shows. Lofty educational ideals were not forgotten and programming included language courses and drama.

On the proclamation of the Second Republic in 1931, radio was considered an essential vehicle of mass communication for news and entertainment. Microphones were present at every event of political, social, and cultural importance. In the following years new broadcasting licenses were granted, many to municipal authorities, and, reflecting the medium's popularity, radios were installed in public places such as bars and casinos. Political coverage was central to the new medium, stopping short only at transmitting parliamentary debates from the Cortes for fear of excessively arousing listeners. However, politicians used radio to

manipulate public sentiments at moments of national importance. During the revolutionary events of October 1934 radio helped both government and rebels in Asturias and Barcelona to put across their opinions. By January 1936 *El Sol* could claim that radio had surpassed the press as a source of information (Timoteo Álvarez (ed.), *Historia*, p. 139).

During the subsequent Civil War, radio was the principal medium of news and propaganda. Its impact was immediate and its message could cross battle lines. Newspapers were slow to reach their readers, especially in remoter areas, and their effectiveness was further impaired by the war. Broadcasting was taken over by the military and made to serve the war effort. In 1937 Franco's military government established Radio Nacional de Salamanca, the germ of the future Radio Nacional de España (RNE).

Once the war had finished, control over all media was arrogated to the state. An order of 6 October 1939 subjected radio to blanket censorship. Furthermore, it gave RNE exclusive responsibility for news, obliging all stations to relay its bulletins. Initially the only alternative to state-run programs was the Sociedad Española de Radiodifusión (SER), deriving from Unión Radio. Faced with a censorship which extended to most of social and economic life, the SER embraced the area where its rival was less competent: entertainment. The bitter post-war years, with purges, imprisonment, and executions, not to mention food shortages, impoverishment, and social upheaval consequent on war, encouraged escapist programming. Finance derived, as previously, from advertising; only RNE could rely on government subsidy to make up any shortfall.

Initially run by militant Falangists, RNE passed in 1945 to the Ministry of Education, before becoming in 1951, like the press and cinema, the responsibility of the new Ministry of Information and Tourism. Presided over by the reactionary Gabriel Arias Salgado, media subservience to the regime and the moral teachings of Roman Catholicism was absolute. With the added importance of Catholicism in political life after the Concordat signed between Spain and the Vatican in 1953, the church entrenched its position in radio, culminating in 1960 in its own chain, the Cadena de Ondas Populares Españoles (COPE) (Timoteo Álvarez (ed.), *Historia*, p. 285).

The pre-war diversity and power of the press made it a particular target for control by Francoism. Newspapers in territory occupied by rebel forces were confiscated, and in April 1938, a press law made newspapers mouthpieces of the new state. The principal weapon was censorship; in addition, journalists would be regulated by government. Less

than half the 4,000 individuals whose cases were examined in the post-war purge (24 May 1939) could continue working. Once the Escuela Oficial de Periodismo (Official Press School) was created (November 1941), all new journalists had to possess an official press card.

Initially only the two monarchist dailies (*ABC* and *La Vanguardia*) were allowed to remain in private hands, though with editors imposed by the regime. Confiscated newspapers reappeared under new names as part of the Prensa del Movimiento (Movement Press), given official status in 1940. Foreign news was controlled through a sole, government-run press agency, Efe. Journalism was now a problematic profession. In addition to censorship, journalists had to follow orders (*consignas*) detailing how government propaganda should be inserted, disguising its origins. On sensitive issues *consignas* gave explicit instructions concerning treatment. Speeches by regime notables had to be covered and aspects to be highlighted were specified.

Television was launched in 1956 and a second channel added in 1965. Control of the medium was of supreme importance to the regime. The list of early Directors-General – Falangists, military officers, Opus Dei members – indicates that ideology rather than expertise was uppermost. Television, unlike radio, was a state monopoly. Finance derived from a tax on sets (abolished in 1966), plus revenue from advertising and government subsidy. Given the sedative role of television, financial control was lax, and subsequent investigations indicate that corruption was widespread and unchecked. Reception spread slowly, geographical conditions impeding its extension to outlying areas. Color transmissions began in 1969, enabling the regular bullfight coverage (live and recorded highlights) to make its full spectacular impact. A peculiarly Spanish phenomenon had made its appearance in 1964, the Teleclub; in less affluent areas communal sets would be provided in village halls or community premises in order to make programs widely accessible. By 1974 it was estimated that the country contained some 4,500 clubs.

Production centered on Madrid with few programs originating from the Barcelona studios. Eurovision membership (1959) gave Spaniards access to events beyond their frontiers, often soccer matches in an era when Real Madrid enjoyed success in European competitions. National pride was similarly enhanced by the Spanish song "La la la la" winning the Eurovision song contest in 1968. The aim of RTVE was twofold: to provide news and entertainment. News coverage was subject to tight government control with critical attitudes effectively silenced. Investiga-

tive programs highlighting abuses in Spanish society were inconceivable to a regime maintaining that "Spain is different" and, it implied, better. If Spain suffered outside criticism, as when the Burgos trial of ETA activists took place in 1970, television acted as mouthpiece for the regime. Foreign news emphasized negative features – strikes, political confrontation – as if to suggest how much better life was in Spain. Programs were purchased from abroad on a large scale, especially light entertainment series; other formulaic items such as quiz shows were adapted from established international models. Soccer was a regular feature of Sunday programming, as were a religious service and symphony concert.

Radio, however, was not eclipsed by television; diversity of ownership allowed a variety of perspectives, though from interests loyal to the regime. In the 1960s the increased sound quality of FM radio became apparent and enthusiasm for popular music was satisfied by stations playing best-selling recordings, a constant feature thereafter.

Economic advance in the 1960s encouraged media expansion. When Spain failed to enter the European Common Market in 1962, the rebuff brought changes in regulatory strategy, ushered in by the new, outward-looking minister, Manuel Fraga Iribarne. New press ventures were permitted, the most important being the revival of the pre-Civil War journal *Revista de Occidente* (1963) and the launch of the socio-political monthly *Cuadernos para el diálogo* (1963), promoted by former Education Minister, Joaquín Ruiz Giménez. *Cuadernos* devoted supplements to issues like Catalan culture, the middle classes, television and women, all of topical interest, and both journal and its book publishing arm (Edicusa) allowed non-regime authors to express alternative views.

Fraga's 1966 press law abolished prior censorship but materials which publishers thought risky could be presented for prior consultation. Given that most of the press was directly subservient to the state, the change was not substantial, yet independent publications could now mention protests and "work stoppages." Whereas dailies were keenly controlled, weeklies managed to publish material which kept alive opposition attitudes. The Barcelona-based *Destino* and, more emphatically, the Madrid-based *Triunfo* abandoned orthodox origins to become, like *Cuadernos*, essential reading for an assertive intellectual opposition. In retrospect the list of contributors to *Cuadernos* seems a roll-call of the leading political figures of post-Franco Spain.

When Franco finally died in November 1975, the press was best placed to respond to the new era, even though restrictions were slow to be lifted.

When Adolfo Suárez became Prime Minister in July 1976, magazines like *Triunfo*, *Cuadernos* and newcomer *Cambio16* informed the public and reflected the excitement at the possibility of change. Shortly before, the new daily, *El País*, had been allowed to launch. Modern design, a direct style, and overt political independence while proclaiming basic liberties (expression, pluralism, regionalism, secularism) conspired to win instant success, which in turn fueled reform. Infra-national pluralism was reflected by dailies in Catalan (*Avui*) and Basque (*Deia*) appearing a few months later.

Other changes followed. By 1984 the government had divested itself of all newspapers, selling them to entrepreneurs who re-launched them as regional dailies, often part of medium-sized chains; some closed down altogether. A few blossomed in the hands of innovative owners. Outstanding was *Marca*, the soccer paper which in 1992 became the most read, and in 1994 the most sold, daily (421,000 copies), reflecting popular enthusiasm for sport. Yet total circulation of dailies remained stubbornly low, not reaching the UNESCO minimum for culturally developed countries (a hundred copies sold per thousand population) until 1992, and the overall 4 million mark until 1993.[3] Various promising new ventures failed – *El Independiente* (1989–1991), *El Sol* (1990–1992), *Claro* (1991). Only *El Mundo* (1989), born of a disagreement between the editor of *Diario 16* and its owners, established itself. *El País*, however, dominated the market from its inception. The paper increased in sophistication, with special sections (e.g. education) on particular days, a weekend color magazine, a Saturday cultural section (*Babelia*), and a financial supplement. Sunday sales constantly topped the million mark in the 1990s. By way of recognition, *El País*'s founding editor and subsequent chief executive, Juan Luis Cebrián, was elected to the Real Academia Española in 1996, a choice which balanced the parallel elevation of Luis María Ansón, dynamic editor of the conservative *ABC*.

Spain's membership of the European Community (1986) encouraged financial adventurousness, and deregulation increased the presence of foreign players in the market (Bertelsmann, Finivest, Hachette, Pearson), as well as encouraging Spanish banks to invest in media companies. Foreign enterprises are prominent in the area of special-interest publications. Most hobbies now have supporting magazines: computing, classical music, biking, even books. Social escapism is nurtured by ¡Hola! (average circulation 1986–1995: 622,000), shadowed by several successful imitations, including the cheaper, even larger circulation *Pronto*

(792,000). In marked contrast, the rejection of censorship after 1976 led to the launch of the glossy weekly *Interviú*. Acceptable color photographs of nudes (mostly female) were set in a conventional general-interest magazine format, more sensationalist in style than hitherto. *Interviú*'s initial success led Antonio Asensio's Grupo Zeta to expand into dailies (*El Periódico de Catalunya* and *Sport*), more magazines (*Tiempo*), including comics, books, and finally television (Antena 3).

Faced with competition from television, radio might have declined, but nevertheless found its niche. Prisa, owner of *El País*, purchased the SER network in 1984, before becoming leading shareholder in Canal+ television in 1988. The pattern was repeated across the media spectrum. The Godó group (*La Vanguardia*) controls Antena 3 radio, and originally owned a share of Antena 3 television. The symbiotic relationship, described as multi-media, is common. Morning discussion programs on television are broadcast simultaneously on radio. The cult of personality results in radio stations promoting programs via presenters who are personalities in their own right. As radio has diversified, so economic imperatives hold sway, and phone-ins engage with listeners' opinions to produce immediate, topical, and inexpensive, entertainment.

Television was the last medium to be transformed in democratic Spain. Under Suárez's UCD and Felipe González's PSOE, the subservience of the monopoly provider to government was evident. Article 20 of the 1978 Constitution guaranteed freedom of expression, assuring access to the media by significant social and political groups, while affirming the principle of government control. In spite of the 1980 Statute of Radio and Television ceding supervision of RTVE to a proportionally representative parliamentary committee, news and current affairs coverage has pandered to governmental sensibilities. The spirit of the Statute, drafted at a time of consensus between the major political groups, has been ignored. The post of Director-General falls vacant at general elections, and when the governing party changes a purge occurs in RTVE. The remedy proclaimed in the press, a not disinterested spectator, was competition from independent, commercially financed television.

The 1980 law prepared the way for regional television; the Statutes of the Basque and Catalan autonomous communities envisaged a channel designed to promote their linguistically differentiated cultures. Basque TV (Euskal Telebista) and Catalan TV (TV3) began broadcasting in 1983 and 1984, though the commitment to regional culture in practice embraces dubbed versions of US-produced series. Following the leading

"historical nationalities," other autonomous communities – Galicia (TVG), Andalusia (Canal Sur), Valencia (Canal 9), even Madrid (Telemadrid) – set up television services. Their umbrella organization, the Federación de Organismos de Radio y Television Autonómicos (FORTA) of 1989, facilitates joint bidding for foreign imports and rational sharing of resources. Yet FORTA views RTVE as uncooperative and resents its priority rights to certain "national" events. Finance for the third channel derives from advertising and subsidy, in a proportion of 30:70 in 1987, and each company runs at a substantial operating loss.[4] Criticism of political manipulation by an autonomous community's ruling party is frequent.

Competition to state-run television, at national and autonomous community level, arrived in 1988 when legislation authorized three nation-wide independent channels, with safeguards to prevent international domination both in ownership (an individual maximum of 25 percent) and programming (minimum 40 percent from the European Community). The opposition Partido Popular criticized the scheme, calling for a free market with unlimited stations. The winners of the ten-year franchises began broadcasting in 1990. Antena 3, originally set up by the Grupo Godó and various lesser interests, subsequently passed to Antonio Asensio (Grupo Zeta); Tele 5 is controlled by Silvio Berlusconi's Fininvest, Kirch and RTL; Canal+ (partially encoded) centers on the French station Canal Plus and Jesús de Polanco's Prisa group, supported by leading Spanish banks. Sophisticated measuring techniques reveal precise audience figures, and advertising costs vary accordingly. RTVE's two channels (TVE-1 and La 2) are accused of unfair competition because their advertising income is supplemented by state subsidy – an estimated 26,700 million *pesetas* in 1995. In 1996, after five years of competition between state (national and regional) and independent television, TVE-1 enjoyed a 27.7 percent audience share (La 2: 9.2 percent), compared to the 25 percent of Antena 3, 19.5 percent of Tele 5, 2 percent of Canal+, and 15.4 percent for the channel of the autonomous communities. While Tele 5 and Antena 3 compete with TVE-1 in programming – news, documentaries, imported drama series and soap operas – Canal+ concentrates on films, sport and children's programs, higher-cost products paid for by subscription. The largest audiences are for soccer, soap operas, and big-budget films, whatever the channel.

Plans for digital satellite television in 1997 brought unexpected alliances. Canal Satélite Digital (85 percent Sogecable, controlled by

Prisa, and 15 percent Antena 3 TV), began transmitting from Luxembourg in January 1997 as Spain's first pay-per-view television channel. In order to ensure the attractiveness of its state-of-the-art system, Canal Satélite Digital had already secured exclusive rights to soccer coverage. Competition is intense and aptly reflects the overall picture since Spain's incorporation into Europe. Concentration of ownership, links with international groups, commercial acumen, increased focus on the product, and exploitation of technical innovations (CD-ROM, Internet, digital encoding), are characteristic features of the exuberant media world of democratic Spain.

NOTES

1. María Cruz Seoane and María Dolores Saiz, *Historia del periodismo en España*, vol. III, *El siglo XX: 1898–1936* (Madrid: Alianza, 1996), p. 34.
2. Jesús Timoteo Álvarez (ed.), *Historia de los medios de comunicación en España. Periodismo, imagen y publicidad (1900–1990)* (Barcelona: Ariel, 1989), pp. 132–135.
3. *Anuario El País* (Madrid: Ediciones El País, 1997), p. 211.
4. *Cambio 16* (14 October 1996), p. 20.

FOR FURTHER READING

Alférez, Antonio. *Cuarto poder en España. La Prensa desde la Ley Fraga 1966*. Barcelona: Plaza y Janés, 1986.

Barrera, Carlos. *Sin mordaza. Veinte años de prensa en democracia*. Madrid: Temas de Hoy, 1995.

Bustamante, Enrique and Ramón Zallo (eds.). *Las industrias culturales en España*. Madrid: Akal, 1988.

Crespo de Lara, Pedro. *La empresa periodística en vivo. Del autoritarismo a la democracia*. Barcelona: Ariel, 1995.

Deacon, Philip. *The Press as Mirror of the New Spain*. Department of Hispanic, Portuguese and Latin American Studies Occasional Papers Series 15. University of Bristol, 1994.

Díaz, Lorenzo. *La radio en España 1923–1993*. Madrid: Alianza, 1993.
 La televisión en España 1949–1995. Madrid: Alianza, 1994.

Maxwell, Richard. *The Spectacle of Democracy. Spanish Television, Nationalism, and Political Transition*. Minneapolis, MN: University of Minnesota Press, 1995.

Index

318

Abril, Victoria 271, 272, 274
Acín, Ramón 148, 149
Agirre, Imanol 60
Aguilar, Rafael 301
Agustí, Ignacio 139
Alarcón, Pedro Antonio de 123, 124
Alas, Leopoldo (Clarín) 3, 12, 14, 123, 127, 131, 180
Albéniz, Isaac 288, 289, 293, 299
Albert, Caterina 43
Alberti, Rafael 112, 138, 183, 185, 187, 188
Albiac, Gabriel 171
Alcalá Zamora, Aniceto 82, 83, 84
Aldecoa, Ignacio 141, 262
Aldecoa, Josefina 149, 157, 159
Aleixandre, Vicente 112, 184, 185, 190, 202
Alfaro, Andreu 245
Alfonso X, king 29
Alfonso XII, king 67, 68, 178
Alfonso XIII, king 69, 70, 74, 81, 106, 109
Almodóvar, Pedro 2, 232, 272, 273, 274, 275
Alonso, Dámaso 190
Alonso, Francisco 218
Alonso, José Luis 226, 229
Alonso de Santos, José Luis 230, 232, 234
Alonso Millán, Juan José 227, 228, 234
Altamira, Rafael 27, 32
Altman, Rick 250, 252
Alto, Alvar 283
Altolaguirre, Manuel 184
Álvarez, José María 201, 202
Álvarez, Rafael 234
Álvarez Junco, José 3, 5
Álvarez Quintero, Joaquín and Serafín 215, 223, 252
Alvaro, Primitivo 263
Amaya, Carmen 252, 253, 299
Amo, Pablo G. del 263
Anderiu, Clementina 44

Anderson, Benedict 6, 23, 24
Andión, Patxi 295
Andrade, Jaime de 137
Andreev, Leonid N. 217
Andrés Álvarez, Valentín 219
Andreu, Alicia 14, 124
Andreu, Blanca 199
Ángeles, Victoria de los 287
Angelillo 251
Angiolillo, Michele 72
Anglada Camarasa, Hermen 241
Anouilh, Jean 244, 228
Ansón, Luis María 314
Antonio, José 301, 302
Antonioni, Michelangelo 140
Arana, Sabino 58, 61, 62, 72
Aranda, Vicente 153, 268, 270, 271
Aranguren, José Luis 1, 6, 169
Arano, Mario de 59
Areilza, José María de 108
Arenal, Concepción 125
Argenta, Ataúlfo 287
Argentina, Imperio 252
Argullol, Rafael 171
Arias Navarro, Carlos 108, 109
Arias Salgado, Gabriel 261, 311
Aribau, Bonaventura-Carles 42
Armendáriz, Montxo 63, 154, 268, 276
Armiñán, Jaime de 263
Arnao, Antonio 177
Arniches, Carlos 215, 219
Arnold, Matthew 11
Arrabal, Fernando 2, 229, 230
Arroyo, Eduardo 245
Asenjo Barbieri, Francisco 289
Asensio, Antonio 315, 316
Atxaga, Bernardo 2, 63, 64, 149, 150, 160, 161
Aub, Max 135, 141
Aute, Luis Eduardo 295

Ávila, María de 301, 302
Ayala, Francisco 132, 170
Azaña, Manuel 82, 83, 84
Azcona, Rafael 260
Aznar (family) 59
Aznar, José María 55, 269, 275
Azorín (*see* Martínez Ruiz, José)

Bach, Johann Sebastian 293
Bacon, Francis 164
Baeza, Ricardo 217, 219
Bahamonde, Ángel 3
Bakhtin, Mikhail 259
Balanchine, George 301
Ballarín, Josep Maria 48
Balzac, Honoré 124
Banderas, Antonio 275
Barbal, Maria 50
Barceló, Miquel 239, 246
Bardem, Javier 269, 276
Bardem, Juan Antonio 255, 256, 257, 258,
 260, 262, 277
Barea, Arturo 142
Barella, Juliá 200
Baroja, Pío 72, 127, 129, 143, 166, 241, 310
Barral, Carlos 147, 154, 194
Bartra, Agustí 45
Bartrina, Joaquín María 177
Baulenas, Lluís-Anton 153
Beckett, Samuel 228
Bécquer, Gustavo Adolfo 175, 177, 179, 180,
 181, 183
Beethoven, Ludwig von 293
Béjart, Maurice 301
Belbel, Sergi 235
Belén, Ana 271, 272, 295
Benavente, Jacinto 215, 216, 217, 219, 223
Benet, Juan 112, 144, 159
Benet i Jornet, Josep Maria 48, 232
Benítez Reyes, Felipe 204
Benlluire, Mariano 240
Berganza, Teresa 287, 291
Bergson, Henri 144
Berlanga (*see* García Berlanga, Luis)
Beruete, Aureliano de 241
Besas, Peter 258
Bigas Luna, José Juan 158, 268, 269
Bizet, Georges 1, 268
Blasco Ibáñez, Vicente 76, 123, 127
Bleiberg, Germán 188
Boadella, Albert 230, 232
Bofill, Ricardo 284
Bohigas, Oriol 282
Bonaparte, Pauline 152
Bonell, Esteve 285
Bonet, María del Mar 38, 295

Borau, José Luis 112, 263, 270
Bosé, Miguel 273, 294
Botrel, Jean-François 12, 15, 124
Bousoño, Carlos 191
Boyd, Carolyn P. 5
Braque, Georges 243
Brecht, Bertolt 225, 228, 230
Brenan, Gerald 104
Bretón, Tomás 214, 289
Brines, Francisco 193, 194, 198, 204
Brooks, Peter 211
Brown, Norman O. 171
Buero Vallejo, Antonio 3, 112, 225, 226, 227,
 232
Buñuel, Luis 251, 260, 270, 277
Bürger, Peter 217
Burgos, Carmen de 127, 130
Bustelo, Gabriel 154, 156

Cabal, Fermín 230, 234
Caballé, Montserrat 287
Caballero, Ernesto 235
Cabanero, Eladio 191
Cabrero, Francisco 282
Calatrava, Santiago 285
Calderón de la Barca, Pedro 211, 216, 218
Calvino, Italo 63
Calvo, Blanca 304
Calvo, Ricardo 178
Calvo Sotelo, Joaquín 225
Calvo Sotelo, Leopoldo 113
Camino, Jaime 269
Campano, Miguel Ángel 246
Campión, Arturo 61
Campo, Conrado del 288
Campoamor, Ramón de 177, 178, 180
Campúa, José 218
Camus, Albert 138, 228
Camús, Mario 262
Canalejas, José 76, 78
Canales, Antonio 305
Canelo, Pureza 199
Cano, Carlos 295
Cano, Leopoldo 212
Cano Ballesta, Juan 187
Cánovas del Castillo, Antonio 27, 58, 67, 68,
 69, 70, 72, 74, 77
Caparrós-Lera, José 253
Capmany, Maria Aurèlia 38
Cardwell, Richard A. 5
Carlos (pretender to throne) 69, 70
Carlos III, king 164
Carlos V, king 27, 28, 166
Carner, Josep 45
Carnero, Guillermo 195, 196, 201
Caro Baroja, Julio 251

Carr, Raymond 249
Carranque, Andrés 134
Carreras, José 287
Carrero Blanco, Luis 101, 102, 256
Carrillo, Santiago 111
Casals, Pau 44, 287
Casas, Ramón 241
Caso, Ángeles 159
Casona, Alejandro 220, 222, 223
Cassola (general) 70, 78
Castelar, Emilio 68
Castellet, José María 195, 200, 201
Castillo, Julia 199, 203
Castillo Puche, José Luis 146
Castro, Américo 165
Castro, Estrellita 252
Castro, Luisa 155
Castro, Rosalía de 180, 181
Catalá, Víctor (*see* Albert, Caterina)
Catany, Toni 38
Cebrián, José Luis 314
Cela, Camilo José 3, 112, 127, 138, 140, 146, 151,
 154, 225
Celaya, Gabriel 188, 191
Cerdà, Ildefons 42, 278
Cernuda, Luis 184, 202
Cervantes, Miguel de 34, 168, 234
Cézanne, Paul 246
Chacel, Rosa 132, 150
Chapí, Ricardo 214
Chapí, Ruperto 289
Charnon-Deutsch, Lou 126
Chávarri (family) 59
Chevalier, Maurice 252
Chillida, Eduardo 63, 239, 244
Chirbes, Rafael 156
Chueca, Federico 289
Clarà, Josep 44, 242
Clarín (*see* Alas, Leopoldo)
Clark, Petula 294
Clemenceau, Georges 76
Cleopatra 152
Clotet, Lluís 284
Cocteau, Jean 217
Coderch, José Antonio 282
Colinas, Antonio 201
Colomo, Fernando 272
Conde, Carmen 188
Conde, Mario 118
Coronado, Carolina 181
Corrales, José Antonio 283
Cortés, Carmen 305
Cortés, Joaquín 305
Cortiella, Felip 216
Costa, Joaquín 32, 74, 164, 166
Cremer, Victoriano 190, 191
Cruz, Antonio 285

Cruz, Juan de la 33
Cruz, Penélope 271, 272, 273
Cuadrado, Luis 263
Cuenca, Luis Alberto de 206

Dalí, Salvador 44, 239, 243, 269
Darío, Rubén 179, 181
Dato, Eduardo 78, 80
Deacon, Philip 2, 5
Deane, Seamus 50
Debicki, Andrew P. 5
Delacroix, Eugène 246
Deleito y Piñuela, José 213
Delibes, Miguel 16, 143
DeSica, Vittorio 140
Dhu, Duncan 63
Diaghilev, Sergei 299
Díaz-Más, Paloma 152
Dicenta, Joaquín 212
Dickens, Charles 124
Diego, Gabino 270
Dieste, Rafael 220
D'Indy, Vincent 288
Diosdado, Ana 227, 234
D'Lugo, Marvin 263
Domènech i Montaner, Lluís 279
Domingo, Francisco 240
Domingo, Plácido 287
Domínguez, Oscar 243
Donen, Stanley 275
D'Ors, Eugeni 43, 167
Dougherty, Dru 5
Drove, Antonio 153
Duato, Nacho 301, 302
Dukas, Paul 289
Durán, Álvaro 156
Dylan, Bob 204

Echegaray, José de 212
Eco, Umberto 152
Elías, Francisco 253
Erice, Víctor 155, 263, 277
Escamilla, Teo 263
Escrivá de Balaguer, Josemaría 137
Escudero, Vicente 299
Espert, Nuria 229
Espina, Concha 127, 130
Espriú, Salvador 44, 49
Espronceda, José 179
Eugenia, Victoria 302
Evans, Peter W. 5
Everly, Don and Phil 294
Evreinov, Nicolai N. 224

Fabra, Pompeu 43
Falla, Manuel de 288, 289, 293, 296, 299
Faulkner, William 144

Feijoo, Benito Jerónimo 163, 164, 165
Felipe II, king 282
Fernán-Gómez, Fernando 231, 257, 260
Fernàndez, Lluís 50, 150
Fernández Alba, Antonio 283
Fernández Cubas, Cristina 156
Fernández del Amo, José Luis 282
Fernández Florez, Wenceslao 145
Fernández-Galiano, Luis 5
Fernández Grilo, Antonio 178
Fernández Santos, Luis 143
Fernández Shaw, Carlos 214
Fernando VII, king 73, 164, 167, 226
Ferrán, Augusto 176, 177
Ferrant, Ángel 244
Ferrater, Gabriel 37, 39, 44, 46
Ferrer Guardia, Francisco 76
Ferreri, Marco 260, 262
Ferres, Antonio 142
Feuer, Jane 250
Fichte, Johann Gottlieb 30, 167
Figuera, Ángela 191
Firmat Noguera, Jaime 216
Fisac, Miguel 283
Flaubert, Gustave 14, 124
Flores, Antonio 295
Flores, Lola 287
Flotats, Josep Maria 231
Foix, J. V. 44
Fola Igurbide, José 216
Folch i Torres, Josep Maria 44
Fontana, Josep 38
Fontcuberta, Joan 38
Forqué, Verónica 235
Forsythe, William 302
Fortuny, Mariano 240
Foster, Norman 286
Fox, E. Inman 5, 6, 166
Foxá, Agustín de 135
Fraga Iribarne, Manuel 108, 261, 313
Francis of Assisi 162
Franco, Francisco 1, 2, 3, 16, 17, 32, 37, 38, 39,
 41, 44, 45, 56, 62, 74, 87, 90, 91, 92, 93, 95,
 97, 98, 99, 101, 102, 104, 106, 107, 108, 110,
 111, 132, 134, 136, 137, 149, 151, 153, 169,
 170, 195, 198, 226, 228, 230, 231, 245, 246,
 251, 260, 267, 269, 270, 271, 282, 283,
 295, 298, 300, 303, 313
Freixas, Laura 157
Freud, Sigmund 171
Frühbeck de Burgos, Rafael 287
Fuertes, Gloria 191, 194
Fusi, Juan Pablo 58, 249
Fuster, Joan 38

Gades, Antonio 299, 301
Gala, Antonio 157, 226, 227, 231, 234, 272

Galán, Diego 253
Galdós (*see* Pérez Galdós, Benito)
Gallego, Manuel 284
Ganivet, Ángel 127, 165, 167
Gaos, Lola 257, 270
García, Dionisia 199, 206
García, Manuel 287
García, Víctor 229
García Álvarez, Enrique 215
García Berlanga, Luis 255, 256, 257, 258, 260,
 262, 277
García de Cortázar, Fernando 58, 59
García de la Concha, Víctor 189
García Escudero, José María 256, 261, 262,
 263
García Hortelano, Juan 142
García Lanónima, Juan Carlos 304
García Lorca, Federico 183, 184, 185, 188, 189,
 202, 215, 218, 219, 220, 222, 227, 229, 234,
 252, 296, 299, 301
García Montero, Luis 205, 206
García Moral, Concepción 201, 204
García Morales, Adelaida 155, 157
García Moroto, Eduardo 252
García Nieto, José 189
García-Posada, Miguel 199, 203, 205, 206
García Prieto, Manuel 79
García Sánchez, José Luis 271
García Serrano, Rafael 136
García Sevilla, Ferrán 246
García Tassara, Gabriel 177
García Vargas, Julián 119
Garcilaso de la Vega 33, 190
Gardel, Carlos 252
Gargallo, Pablo 243
Garmendia, Joseba Irazu 63
Garrigues, Antonio 108
Gaspar, Enrique 213, 214
Gaudí, Antoni 43, 278, 279, 280
Gaztambide, Joaquín 289
Gehry, Frank 63, 286
Gelabert, Cesc 303
Gelabert, Fructuós 44
Gellner, Ernest 24
Genet, Jean 228, 229
Genovés, Juan 245
Ghelderode, Michel de 219
Gil, Ariadna 271
Gil, Ricardo 181
Gil de Biedma, Jaime 193
Gil Robles, José María 83
Gimferrer, Pere 38, 195, 196, 201
Giner de los Ríos, Francisco 30, 164, 167
Gironella, José María 141
Gomá y Tomás, Isidro 93
Gómez, Aída 302
Gómez, Carmelo 276

Gómez, José Luis 235
Gómez, Julio 288
Gómez de la Serna, Ramón 131, 132, 183, 310
Gómez Ojea, Carmen 158
Gómez Pereira, Manuel 272
Góngora, Luis de 177, 183
González, Ángel 191, 193, 196
González, Aníbal 280
González, Felipe 2, 16, 39, 111, 113, 118, 119, 269, 298, 315
González, Julio 239, 243
Gopegui, Belén 155
Gordillo, Luis 245
Goya, Francisco de 214, 218, 226, 245
Goytisolo, Juan 18, 142, 144, 150, 151, 154
Goytisolo, Luis 50, 143, 151, 154
Graham, Helen 4
Granados, Enrique 288, 293, 299
Grandes, Almudena 2, 158
Granero, José 301
Grau, Jacinto 217
Greco 32, 33, 34, 242
Grimm, Jacob and Wilhelm 25
Gris, Juan 243
Gropius, Walter 282
Grosso, Alfonso 142
Gual, Adrià 217
Guardiola, José 294
Gubern, Román 249
Guelbenzu, José María 155, 157
Güell, Eusebi 280
Guerra, Alfonso 117, 118
Guillén, Jorge 184, 185, 188, 192, 198, 199, 203
Guimerà, Ángel 42, 212, 216
Guimón, Pedro 61
Guirao, Olga 155, 156
Gutiérrez Aragón, Manuel 263
Gutiérrez Solana, José 241
Gutiérrez Soto, Luis 282
Guzmán, Almudena 203

Habermas, Jürgen 26
Halffter, Cristóbal 289, 296
Haro Ibars, Eduardo 156
Hedilla, Manuel 256
Hegel, Georg Wilhelm Friedrich 30
Hendrix, Jimi 295
Herder, Johann Gottfried von 30, 167
Hernández, Jesús 90
Hernández, Miguel 187, 188
Hernando, Violeta 149, 150, 154
Herredero, Carlos F. 256
Herrera, Juan de 282
Herrero, Gerardo 158
Hierro, José 190, 194
Higueras, Fernando 283

Hitchcock, Alfred 270
Hitler, Adolf 97
Hobsbawm, Eric 25
Hooper, John 49
Hopewell, John 256
Huidobro, Vicente 183
Huyssen, Andreas 14, 17

Ibáñez, Paco 295
Ibarra (family) 59
Ibarrola, Agustín 63
Ibsen, Henrik 219
Icaza, Francisco de 181
Iglesias, Ignaci 216
Iglesias, Julio 269, 287, 294
Imperio, Pastora 254
Íñiguez, Manuel 284
Ionesco, Eugène 228
Isabel II, queen 2, 69, 125, 178
Isozaki, Arata 286
Iturbi, José 287
Iturralde, Juan 61

Jaén, Maria 48, 50
Jagoe, Catherine 14, 126
Jameson, Fredric 41, 47
Janés, Clara 199, 202
Jardiel Poncela, Enrique 224
Jarnés, Benjamín 131
Jiménez, Juan Ramón 179, 181, 182, 183, 184, 185, 188
Jiménez-Lozano, José 171
Jiménez Martos, Luis 199, 200
Johnson, Philip 286
Johnson, Roberta 5
Jolson, Al 252
Joyce, James 131
Juan Carlos, king 2, 101, 102, 107, 270
Juan de Borbón 97, 101
Juaristi, Jon 199
Jujol, Josep Maria 279
Juliá, Santos 5
Junyent, Sebastián 235
Jurado, Rocío 287, 295

Kaiser, George 217, 219
Kant, Emmanuel 30
Karloff, Boris 277
Keating, Michael 48, 49, 50
Kinder, Marcha 256
Kracauer, Siegfried 248
Krause, Alfredo 287
Krause, Karl Christian Friedrich 30, 123, 167
Kumin, Laura 5
Kylian, Jiri 302

Labanyi, Jo 4, 5
Laforet, Carmen 127, 139
Lafuente, Modesto 27
Laín Entralgo, Pedro 112, 166, 169
Laínz, Concha 303
Landero, Luis 149, 161
Largo Caballero, Francisco 82
Larra, Mariano José de 163, 164, 166, 167
Larrañaga, Amparo 234
Larrocha, Alicia de 287
Le Corbusier 281
Leibniz, Gottfried Wilhelm 179
Lenormand, Henri-René 217
León, Luis de 33, 166, 191
León, María Teresa 138
Lerroux, Alejandro 76, 83
Lertxundi, Ángel 63
Linazasoro, José Ignacio 284
Linz, Juan 57
Lipsitz, George 17
Llach, Lluís 38, 295
Llamazares, Julio 160
Llorente, Ángel 2
Loots, Eva 247
López, Antonio 239, 245
López, Encarnación 299
López, Pilar 299, 300
López de Ayala, Adelardo 211, 212
López Heredia, Irene 219
López Pacheco, Jesús 142
López Rubio, José 224, 225
López Salinas, Armando 142
López Silva, J. 214
Lorca (*see* García Lorca, Federico)
Lorca, Nana 302
Lorengar, Pilar 287
Loriga, Ray 149, 154, 156, 161
Luca de Tena, Cayetano 223
Lucía, Paco de 287, 296
Lynch, Enrique 171

MacCabe, Colin 41, 42
Machado, Antonio 17, 32, 166, 181, 182, 183, 252, 253
Machado, Manuel 181, 252, 253
Maestre, Pedro 156
Maeztu, Ramiro de 72, 166
Mainer, José Carlos 149
Malera, Anna 303
Malibrán, María 287
Malla, Gerardo 234
Mallarmé, Stéphane 203
Mañas, José Ángel 154, 156
Manent, Marià 44
Mann, Thomas 131
Manrique, Jorge 33

Manuel, Víctor 271, 295
Marañón, Gregorio 166, 168
Marco, Tomás 292
Marcos, Cristina 271
Marfany, Joan-Lluis 43, 44
Margarit, Angels 304
María Cristina of Habsburg 69
Marías, Javier 150, 151, 152, 154
Marías, Julián 169
Márquez (colonel) 78
Marquina, Eduardo 216, 223
Marquina, Luis 253
Marra-López, José R. 141
Marsé, Juan 50, 142, 145, 153, 159
Marsillach, Adolfo 226, 228
Martín Gaite, Carmen 17, 143, 151, 157, 158
Martín Martínez, José 5
Martín Patino, Basilio 262
Martín Recuerda, José 225, 226, 232
Martín-Santos, Luis 143, 144
Martínez, Jesús A. 3
Martínez Campos (general) 70
Martínez Mediero, Manuel 229
Martínez Ruiz, José (Azorín) 32, 34, 127, 129, 130, 145, 166, 218, 310
Martínez Sarrión, Antonio 196, 204
Martínez Sierra, Gregorio 219
Marx, Karl 151
Matilla, Luis 229
Matos, Elisabeta 292
Maura, Antonio 74, 76, 79
Maura, Carmen 269, 271, 272, 273, 274
Maura, Miguel 82
Mauri, Rosita 302
Maya, Mario 301
Medem, Julio 63, 268
Medin, Vicente 180
Meier, Richard 286
Meller, Raquel 254
Mendoza, Eduardo 2, 153
Menéndez Pidal, Ramón 32
Menéndez y Pelayo, Marcelino 166, 176
Mercadé, F. 50
Mercé, Antonia 299
Mérimée, Prosper 249
Merino, José 157
Mermall, Thomas 5
Mesa, Olga 304
Mesa Toré, José 206
Mestre, Apel·les 43
Mies van der Rohe, Ludwig 280, 282
Mihura, Miguel 224, 258
Millares, Manuel 245
Millás, Juan José 155, 156, 157
Miller, Arthur 225, 228
Mir, Joaquín 241

Mira, Toni 304
Miralles, Enric 285
Miras, Domingo 226
Miró, Gabriel 130, 131
Miró, Joan 44, 239, 243, 244
Miró, Pilar 267, 272, 276
Mitchell, Timothy 251
Moix, Ana María 158, 159
Moix, Terenci 38, 152, 154, 157
Molas, Joaquim 38
Molina, Josefina 232, 271
Molina Foix, Vicente 152
Mompou, Frederic 44
Moncada, Jesús 50
Moneo, Rafael 284
Monleón, José 224
Monserdà, Dolors 43
Montaigne, Michel Eyquem de 164
Montero 2, 157
Montseny, Federica 132
Monzó, Quim 50
Moral, Antonio 289
Morales, Gracita 275
Moreno, Ricardo 215
Moreno, Toni 38
Moya, Luis 282
Mozart, Wolfgang Amadeus 202, 204, 293
Muguerza, Javier 172
Mulder de Daumer, Elizabeth 145
Munárriz, Jesús 204
Muñoz, Juan 247
Muñoz Fontán, José 261
Muñoz Molina, Antonio 2, 149, 152, 154, 160
Muñoz Seca, Pedro 218, 219, 223
Muñoz Suay, Ricardo 260
Murdoch, Iris 161
Mussolini, Benito 81

Nadiuska 274
Nagel, Andrés 63
Navarro, Miguel 247
Navarro Baldeweg, Juan 284
Nelken, Margarita 132
Neruda, Pablo 187, 189
Nieto, Teresa 304
Nietzsche, Friedrich 128, 182
Nieva, Francisco 229, 232, 234
Nieves Conde, José Antonio 255, 256, 258, 267
Nonell, Isidre 43, 241
Nora, Eugenio de 190, 191
Norman, Marsha 235
Nuñez de Arce, Gaspar 175, 176, 177, 178, 179, 180

Oliva, César 222, 223, 228
Oller, Narcís 42

Olmo, Lauro 225, 226
O'Neill, Eugene 217
Orán, María 291
Orduña, Juan de 253, 257
Ortega y Gasset, José 30, 32, 34, 163, 164, 166, 168, 169, 170, 182, 183, 310
Ortiz, Antonio 285
Ortiz, Lourdes 159
O'Shea, Henry 61
Oteiza, Jorge de 63, 245
Otero, Blas de 190, 191, 194, 196

Pablo, Luis del 263
Pajares, Andrés 270
Palacio Valdés, Armando 123, 126
Palacios, Antonio 280
Palau, Melchor de 177
Palazuelo, Pablo 245
Palencia, Benjamín 244
Palenque, Marta 176
Palomero, Mari Pepa 201, 202
Panero, Leopoldo María 188, 196
Pantoja, Isabel 295
Paquirri 295
Paraíso, Basilio 74
Pardo Bazán, Emilia 123, 125, 128
Paredes, Marisa 275
Parrot, Mac 295
Paso, Alfonso 227, 228
Paso, Manuel 181
Pasqual, Lluís 231, 234
Pedrell, Felipe 288
Pedrero, Palomo 235
Peiró, Juan 82
Pelo, Mar 304
Pemán, José María 188, 223
Pereda, José María 123, 126
Pereda, Rosa María 201, 204
Pérez de Ayala, Ramón 130, 131, 181, 215, 219
Pérez Fernández, Pedro 218
Pérez Galdós, Benito 12, 14, 67, 123, 124, 125, 126, 127, 211, 212, 213, 214
Pérez-Reverte, Arturo 152
Perezagua, Facundo 59
Perojo, Benito 252
Pestaña, Ángel 82
Perriam, Chris G. 5
Picasso, Pablo 44, 239, 242, 246, 260, 281, 299
Picazo, Miguel 262
Pidal, marqués de 70
Piera, Carlos 171
Pineda, Mariana de 232
Pinos, Carme 285
Piquer, Conchita 17
Pirandello, Luigi 217, 218, 219, 224
Piscator, Erwin 217

Pitarra, Serafí 42
Pitoeff, Georges 217
Plà, Albert 50
Plà, Josep 44
Plaza, José Carlos 234
Plisetskaya, Maya 301
Polanco, Jesús de 316
Pombo, Álvaro 156, 157, 161
Pons, Aurura 302
Pope, Randolph D. 5
Portela, César 284
Poussin, Nicholas 246
Prada, Amancio 295
Pradilla, Francisco 240
Prados, Emilio 184
Prat de la Riba, Enric 43
Presley, Elvis 295
Primo de Rivera, José Antonio 92, 95, 137
Primo de Rivera, Miguel 32, 74, 75, 77, 80, 81, 184, 211, 309, 310
Proust, Marcel 131
Puerto, David del 292
Puértolas, Soledad 150, 154
Puig i Cadafalch, Joseph 279
Puigserver, Fabia 231
Pujol, Emilio 287
Pujol, Jordi 39, 50

Quejereta, Elías 150, 263
Quevedo, Francisco de 191
Quintana, Manuel José 176, 177
Quintanilla, Elvira 257

Raimón (singer-songwriter) 38, 295
Raphael (singer) 294
Regoyos, Darío de 32, 241
Regueiro, Francisco 267
Reina, Juanita 252
Reina, Manuel 179, 181
Reina, María Manuela 235
Reixach, Enrique 292
Renan, Ernest 24, 25
Renau, Josep 243
Rey, Barbara 274
Rey, Florián 249, 252
Rey García, Enrique 294
Riba, Carlos 44
Ribot, María José 304
Rico-Godoy, Carmen 271
Ridruejo, Dionisio 112, 138
Riera, Carme 38, 149, 158
Ríos, Julián 151
Ríos, Miguel 294
Riquer, Martí de 38
Rivas, duque de 191
Rivas Cherif, Cipriano de 217, 222
Roca, Maria Mercè 48

Rodoreda, Mercè 45, 143
Rodrigo, Joaquín 288, 289, 293
Rodríguez, Azucena 270, 271
Rodríguez, Claudio 193, 194
Rodríguez de Aragón, Lola 291
Rodríguez Méndez, José María 225, 232
Rodríguez Rubí, Tomás 212
Roig, Montserrat 37, 38, 157, 159
Rojas, Enrique 289
Rojas, Fernando de 214
Romero, Justo 292
Romero, Pepe 287
Romero de Torres, Julio 242
Rosa, Javier de la 118
Rosales, Luis 188, 190
Rosillo, Ernesto 215
Rossellini, Roberto 140
Rossetti, Ana 2, 202, 203, 206
Rossi, Aldo 283
Rossini, Gioacchino Antonio 287, 293
Rousseau, Jean-Jacques 202
Rubert de Ventós, Xavier 38, 170
Rubio Jiménez, Jesús 216
Rucabado, Leonardo 280
Rueda, Salvador 178, 179, 181
Ruiz, Antonio 299
Ruiz, Juan 29
Ruiz Aguilera, Ventura 177
Ruiz Giménez, Joaquín 313
Ruiz Zorrilla, Manuel 69
Rusiñol, Santiago 43, 241

Sáenz de Oíza, Francisco Javier 283
Sáez, Vicente 304
Sagarra, Josep Maria de 44
Sagasta, Práxedes, Mateo 68, 69, 70, 73, 74, 76
Sainz de Maza, Regino 287
Sainz Rodríguez, Pedro 94
Saizarbitoria, Ramón 63
Salaün, Serge 214
Salinas, Pedro 131, 184, 188
Salom, Jaime 226, 231, 235
Salvat, Richard 229
Sánchez, Alberto 243
Sánchez Ferlosio, Rafael 140, 141, 145, 171
Sánchez Rodríguez, José 181
Sánchez Valdés, Julio 160
Sánchez Vidal, Agustín 251
Sanchis Sinisterra, José 231, 235
Sanz, Jorge 275
Sanz del Río, Julián 123, 164
Saramago, José 63
Sarasate, Pablo 287
Sartre, Jean-Paul 17, 138, 228
Sastre, Alfonso 225, 228, 234
Saura, Antonio 239, 245

Saura, Carlos 112, 262, 263, 267, 268, 269, 274, 277, 296, 301
Savater, Fernando 63, 170
Schelling, Friedrich Wilhelm 30, 167
Segovia, Andrés 287, 292
Seguí, Salvador 79
Segura, Pedro 82
Selgas, José 177
Sellès, Eugenio 212
Sempere, Eusebio 245
Sender, Ramón 127, 132, 142
Senra, Carmen 304
Serra, Narcís 119
Serrano, Emilio 289
Serrat, Joan Manuel 295
Sert, José María 244
Sert, Josep Lluís 281
Sevilla, Lolita 258
Shakespeare, William 219, 223
Shaw, George Bernard 219
Sicilia, José María 246
Sieburth, Stephanie 5, 124
Siles, Jaime 203
Silvela, Francisco 72, 74
Silver, Philip 5
Sinatra, Frank 294
Sirk, Douglas 275
Sisa (singer) 38
Siza, Alvaro 286
Solano, Susana 246
Solé, Ramón 303
Sophocles 223
Soria, Arturo 280
Sorolla, Joaquín 239, 241
Sorozábal, Pablo 289
Sota, Alejandro de 283
Sota, Ramón de la 59
Springsteen, Bruce 294
Stravinsky, Igor 293
Suárez, Adolfo 2, 39, 102, 109, 110, 111, 112, 113, 314, 315
Subirats, Eduardo 170
Sueiro, Daniel 262
Sybilla (couturier) 2
Szanto, George 224

Talens, Jenaro 205
Tamayo, José 229
Tamayo y Baús, Manuel 212
Tàpies, Antoni 203, 239, 244
Tarradelles, Josep 39
Tárrega, Francisco 287, 292
Tavora, Salvador 230
Tejero, Antonio 269
Teresa de Jesús 33
Thiebaut, Carlos 172

Tierno Galván, Enrique 111, 169
Timoteo Álvarez, Jesús 310
Tinnell, Roger D. 5
Tomeo, Javier 155
Torrado, Adolfo 223
Torrent, Ferran 156
Torrente Ballester, Gonzalo 137, 151
Torres, Jesús 292
Torroja, Eduardo 281
Triadú, Joan 38
Trías, Enrique 170
Trini, Mari 295
Trueba, Antonio de 177
Trueba, Fernando 272
Tudor, Antony 301
Turina, Joaquín 288, 293
Tusquets, Esther 50, 149, 150, 155, 156, 158
Tusquets, Oscar 284

Uceta, Acacia 199
Ugarte, Eduardo 220
Ullate, Víctor 301, 302
Unamuno, Miguel de 32, 34, 72, 81, 127, 128, 129, 163, 165, 166, 167, 168, 182, 183, 214, 218, 310
Ungaretti, Giuseppe 203
Uribe, Imanol 63, 276
Urquijo y Ussía (family) 59
Urretairzcaya, Arantxa 63
Ustárroz, Alberto 284

Vajda, Ladislao 267
Valencia, Tórtola 303
Valente, José Ángel 193, 194, 198, 203
Valera, Juan 123, 124, 177, 180
Valéry, Paul 37, 203
Valis, Noël 18
Valle-Inclán, Ramón María del 18, 75, 127, 129, 135, 214, 216, 217, 218, 219, 222, 228, 229, 234
Vallejo, César 189
Valverde, Álvaro 203
Vargas Llosa, Mario 149
Vázquez de Castro, Antonio 282
Vázquez Díaz, Daniel 243, 244
Vázquez Molezún, Ramón 283
Vázquez Montelbán, Manuel 50, 153, 159, 248
Vega, Lope de 33, 216, 223
Vega, Ricardo de la 214
Vega, Ventura de la 212
Vela, Joaquín 215, 218
Velasco, Concha 234, 275
Velázquez, Diego de 32, 33, 202, 242
Venturi, Robert 283
Verdaguer, Jacint 42

Verdú, Maribel 273
Vernon, Kathleen M. 1, 5
Viardot-García, Pauline 287
Vicens Vives, Jaime 35
Victoria, queen 74
Vilarós, Teresa 5, 18
Villacampa, Pedro 70
Villaespesa, Francisco 179, 181
Villalonga, José Luis 274
Villalonga, Llorenç 44
Villalonga, Miguel de 145
Villena, Luis Antonio de 199, 201, 202, 203
Viñas, Franscisco 292
Viñes, Ricardo 287
Vives, Amadeo 289
Vives, Luis 166

Wagner, Richard 293
Weiss, Peter 228
Wellwarth, George 229
Werner, Carmen 304
Whale, James 277
White, Hayden 2

Wiard, mademoiselle 218
Wilder, Billy 275
Williams, Raymond 4, 11, 17
Wolfe, Roger 206
Woolf, Virginia 131, 161
Wright, Frank Lloyd 283

Xirgu, Margarita 217, 222

Yxart, José 214

Zabaleta, Nicanor 287
Zambrano, María 170, 198
Zanetti, Miguel
Zatlin, Phyllis 5
Zola, Emile 126
Zorrilla, José 1, 191, 216
Zuazo, Secundino 281
Zubiaurre, Ramón and Valentín 60
Zuloaga, Ignacio 32, 239, 241, 242, 244
Zúñiga, Juan Eduardo 149, 159
Zurbarán, Francisco de 242

Cambridge Companions to Literature

The Cambridge Companion to Old English Literature
edited by MALCOLM GODDEN *and* MICHAEL LAPIDGE

The Cambridge Companion to Dante
edited by RACHEL JACOFF

The Cambridge Chaucer Companion
edited by PIERO BOITANI *and* JILL MANN

The Cambridge Companion to Medieval English Theatre
edited by RICHARD BEADLE

The Cambridge Companion to Shakespeare Studies
edited by STANLEY WELLS

The Cambridge Companion to English Renaissance Drama
edited by A. R. BRAUNMULLER *and* MICHAEL HATTAWAY

The Cambridge Companion to English Poetry, Donne to Marvell
edited by THOMAS N. CORNS

The Cambridge Companion to Milton
edited by DENNIS DANIELSON

The Cambridge Companion to British Romanticism
edited by STUART CURRAN

The Cambridge Companion to James Joyce
edited by DEREK ATTRIDGE

The Cambridge Companion to Ibsen
edited by JAMES MCFARLANE

The Cambridge Companion to Brecht
edited by PETER THOMASON *and* GLENDYR SACKS

The Cambridge Companion to Beckett
edited by JOHN PILLING

The Cambridge Companion to T. S. Eliot
edited by A. DAVID MOODY

The Cambridge Companion to Renaissance Humanism
edited by JILL KRAYE

The Cambridge Companion to Joseph Conrad
edited by J. H. STAPE

The Cambridge Companion to Faulkner
edited by PHILIP M. WEINSTEIN

The Cambridge Companion to Thoreau
edited by JOEL MYERSON

The Cambridge Companion to Edith Wharton
edited by MILLICENT BELL

The Cambridge Companion to Realism and Naturalism
edited by DONALD PIZER

The Cambridge Companion to Twain
edited by FORREST G. ROBINSON

The Cambridge Companion to Whitman
edited by EZRA GREENSPAN

The Cambridge Companion to Hemingway
edited by SCOTT DONALDSON

The Cambridge Companion to the Eighteenth-Century Novel
edited by JOHN RICHETTI

The Cambridge Companion to Jane Austen
edited by EDWARD COPELAND *and* JULIET MCMASTER

The Cambridge Companion to Samuel Johnson
edited by GREGORY CLINGHAM

The Cambridge Companion to Oscar Wilde
edited by PETER RABY

The Cambridge Companion to Tennessee Williams
edited by MATTHEW C. ROUDANÉ

The Cambridge Companion to Arthur Miller
edited by CHRISTOPHER BIGSBY

The Cambridge Companion to the Modern French Novel
edited by TIMOTHY UNWIN

The Cambridge Companion to the Classic Russian Novel
edited by MALCOLM V. JONES *and* ROBIN FEUER MILLER

The Cambridge Companion to English Literature, 1650–1740
edited by STEVEN N. ZWICKER

The Cambridge Companion to Eugene O'Neill
edited by MICHAEL MANHEIM

The Cambridge Companion to George Bernard Shaw
edited by CHRISTOPHER INNES

The Cambridge Companion to Ezra Pound
edited by IRA B. NADEL

The Cambridge Companion to Modernism
edited by MICHAEL LEVENSON